The Storied South

The Storied South

VOICES OF WRITERS The University of

AND ARTISTS North Carolina Press

WILLIAM FERRIS Chapel Hill

Designed by Richard Hendel

Set in Utopia and Klavika types

by Tseng Information Systems, Inc.

The paper in this book meets the guidelines
for permanence and durability of the Committee
on Production Guidelines for Book Longevity of
the Council on Library Resources.

The University of North Carolina Press has been a
member of the Green Press Initiative since 2003.

Library of Congress
Cataloging-in-Publication Data
Ferris, William R.
The storied South : voices of writers and artists /
William Ferris.
pages cm
Includes bibliographical references and index.
Includes filmography.
ISBN 978-1-4696-0754-2 (cloth : alk. paper)
1. American literature—Southern States. 2. Southern
States—Literary collections. I. Title.
PS551.F47 2013
810.8′0975—dc23 2013010406

17 16 15 14 13 5 4 3 2 1

A list of works from which some material in this
book was drawn appears on page 271.

For the three most important
women in my life,
my mother, SHELBY FLOWERS FERRIS,
my wife, MARCIE COHEN FERRIS,
and my daughter, VIRGINIA LOUISE FERRIS,
whose stories are intimately tied to my own
and whom I love more than life itself

Contents

Acknowledgments

This book tracks my intellectual and artistic growth through friendships with the individuals featured on these pages. I owe so much to them, and I hope that this work fully expresses my gratitude and respect. The conversations we shared together are now gathered in this volume. Many friends helped me along the way.

Transcriptions and initial edits of interviews were done by Clayton Butler, Sandra Davidson, Tom O'Keefe, Virginia Thomas, Emily Wallace, and Amy Wood. This essential work required many hours of listening and editing the recorded word into printed text.

Gail Goers scanned, cleaned, and made high-quality digital copies of my 35 mm negatives. Thanks to her, the photographs in this book are of the very best quality. Gail's patience and her keen eye were invaluable in assembling these images.

Ashley Melzer worked tirelessly to edit the films that are included on the DVD. She also edited sound recordings from my interviews that are featured on the CD. These motion picture and recorded sound resources significantly deepen the reader's connection to each speaker and make the book a far richer resource.

Emily Wallace devoted countless hours to improving the manuscript. She developed the Selected Bibliography, Discography, and Filmography, and she transcribed interviews from both sound recordings and written text. Emily also incorporated my extensive handwritten edits into the final electronic file of the manuscript.

Dana Di Maio provided important support in copying the manuscript and in assisting with details at every step. His patience and good humor were welcome additions to my work on the project.

Ayse Erginer and Dave Shaw, the talented editors of *Southern Cultures*, worked closely with me over the years in editing and publishing some of these interviews. Their enthusiastic support and keen editorial suggestions have been invaluable in shaping this book.

Katy Vinroot O'Brien incorporated my final edits into the manuscript and made important editorial changes in the Filmography. Her encouragement and support of this work are greatly appreciated.

My archive is housed in the University of North Carolina's Southern Folklife Collection, and I relied heavily on SFC staff to locate sound recordings, films, photographs, and transcriptions. Steve Weiss, director of the SFC, and his colleagues Aaron Smithers and Tracy Jackson never failed to find the resources I needed. Research librarian Jacqueline Solis tracked down publications and provided invaluable counsel during my research. Her ability to negotiate the Internet to locate materials was an especially important resource.

My UNC colleagues Bill Andrews, Barb Call, Bob Cantwell, Bruce Carney, Bill Friday, Karen Gil, Darryl Gless, Sally Greene, Minrose Gwin, Jacquelyn Hall, Mae Henderson, Bernie Herman,

Reg Hildebrand, Glenn Hinson, Fred Hobson, Jerma Jackson, Joseph Jordan, John Kasson, Joy Kasson, Randall Kenan, Lloyd Kramer, Jim Leloudis, William Leuchtenburg, Malinda Maynor Lowery, Townsend Luddington, Genna Rae McNeil, James Moeser, Jocelyn Neal, Dan Patterson, Jim Peacock, Della Pollock, Ruth Salvaggio, Patricia Sawin, Debbie Simmons-Cahan, Bland Simpson, Lee Smith, Elizabeth Spencer, Ann Stuart, Holden Thorp, Daniel Wallace, Harry Watson, and Heather Williams offered encouragement at every step. With their generous support, I was able to secure a W. N. Reynolds Leave during the fall semester of 2011 and a History Department Research and Study Leave during the spring semester of 2012 to complete this book. I also received support from UNC's University Research Council, the Institute of African American Research, and the Joel R. Williamson Eminent Professor of History research fund to produce the CD and DVD included in the book.

It was a pleasure to work with friends at the University of North Carolina Press on the development of this book. My editor, Elaine Maisner, patiently led me from my initial proposal to the book's completion. Her editorial suggestions were always right. She saw the importance of storytelling in the life of each speaker and suggested that I use that theme to give the book a clear sense of direction. Elaine's editorial assistant, Caitlin Bell-Butterfield, followed up on many details as the book developed. As with my last book, *Give My Poor Heart Ease: Voices of the Mississippi Blues* (2009), Paula Wald served as project editor. Thanks to Liz Gray for editing the manuscript into a far more readable text and to Stephanie Wenzel for her careful proofreading. I am forever grateful to Cynthia Crippen for working her magic in preparing the index for this book, as she did for *Give My Poor Heart Ease*. Reading through the index helps me see the overall work with greater clarity. Dino Battista and Gina Mahalek ably oversaw the marketing and promotion of the book. Heidi Perov supervised production of the CD and DVD that accompany the volume. Ivis Bolin, Kim Bryant, Ellen Bush, Jennifer Hergenroeder, Beth Lassiter, Joanna Ruth Marsland, Mark Simpson-Vos, and Vicky Wells have been invaluable in their support. Former press director Kate Torrey and editor-in-chief David Perry are dear friends who encouraged me in special ways. And last, but not least, Rich Hendel brought his seasoned eye as a designer to this book and laid out its photographs and text with exceptional care.

Since it was founded in 1922, UNC Press has pioneered the publication of books on the American South. It is a distinct honor to have my book appear under the press's imprint and to know that it is part of a long list of distinguished works that explore this region.

I was deeply saddened by the death of my agent, Wendy Weil, on September 22, 2012. Wendy enthusiastically supported this book from its beginning. Alice Walker introduced me to Wendy in 1970, and since that time Wendy worked closely with me on every book I published. Her counsel and her knowledge of the publishing world were invaluable. Like her husband, Michael Trossman, Wendy understood and deeply loved this work.

My folklore colleagues Bruce Jackson and Tom

Rankin offered insightful readings of both my book proposal and my completed manuscript. Their insights into oral history, photography, and film helped me understand this work in special ways. I am forever grateful to Bruce and Tom for their friendship and support over the years and especially for their comments and suggestions on this project.

John Powell is a spiritual brother in this work. He understands my lifelong effort to explore the American South and those who have labored in its vineyards. Without his generous support, the book would not exist.

My early interviews were informed and inspired by Judy Peiser at the Center for Southern Folklore in Memphis. Judy and her impressive colleagues Marie Connors, Frank Fourmy, Sharon Hesse, Robert Jones, Kini Kedigh, Brenda McCollum, Jane Moseley, Jerry Pevahouse, Randy Robertson, George Walker, and Carol Lynn Yellin have made a significant contribution to preserving southern voices.

Friends in the universities where I taught when I conducted these interviews all believed in my work. At Jackson State University, Doris Ginn, Richard Jefferson, John Peoples, Cephus Smith, and Estus Smith were always supportive. At Yale University I learned from and greatly admired Jeff Bewkes, Kingman Brewster, Charles Davis, Henry Louis Gates, Donald Gallup, Bart Giamatti, Steele Hays, John Hill, Warrenton Huddlin, Howard Lamar, Michael Lesy, Shirley Mero, David Milch, Charles Montgomery, Vivian Perlis, Al Raboteau, Chris Rachlis, Michael Roemer, Willie Ruff, Sue Steinberg, Robert Stepto, Rose Stone, Eustace Theodore, Robert Farris Thompson, Alan Trachtenberg, Joe Warner, and Howard Weaver. At the University of Mississippi Center for the Study of Southern Culture I was honored to work with Ann Abadie, Dorothy Abbott, Larry Brown, Jim Cobb, Motee and Lucille Daniels, John T. Edge, Suzanne Flandreau, Porter Fortune, Ann Granger, Barry Hannah, Evans Harrington, Sue Hart, Beckett Howorth, Lisa Howorth, Mary Hartwell Howorth, Richard Howorth, Robert Khayat, Lynn Knight, Edward Komara, Clarence Mohr, Ted Olson, Jim O'Neal, Ted Ownby, Sarah Dixon Pegues, Shelley Ritter, Warren Steel, Cheryl Thurber, Gerald Turner, Amy Van Single, Tom Verich, Maude Wahlman, and Charles Wilson.

My sisters, Shelby Fitzpatrick, Hester Magnuson, and Martha Ferris, and their spouses, Peter Fitzpatrick, Jim Magnuson, and Kos Kostmayer, understand and support this work in the deepest way. I am profoundly grateful for their love and support over the years. And my beloved father and mother-in-law, Jerry and Huddy Cohen, and family members Jamie Cohen and John August encouraged me at every step as I wrote this book.

Since we first met fifteen years ago, Bob Rudolph has helped me deal with the computer and its complex worlds. His knowledge of technology and his ability to explain it to a novice like me is a special blessing. And Meredith Elkins has spoken with me almost daily about my work. She has a deep interest in southern literature and music, and her belief in this project is greatly appreciated.

My mother, Shelby Flowers Ferris; my wife, Marcie Cohen Ferris; and my daughter, Virginia

Louise Ferris, all write with enormous skill, and they offered me counsel and support that sustained my work and allowed me to finish this book. I bounced ideas off Marcie each day, and she penned the title we finally selected, *The Storied South: Voices of Writers and Artists*.

To all who have shared their stories and patiently listened to mine, I am deeply grateful.

The Storied South

Introduction

The South is a land of talkers whose stories are as old as the region itself. We tell stories at home, on the street, in settings familiar to every southerner. Our stories transport the listener, like a leaf turning on water, into another world. The story is the inescapable net that binds southerners together. Southern writers translate the story into fiction. Scholars use story to explain the region's history. Musicians transform story into song. And photographers and painters capture story in images. Through storytelling, the South reveals its soul. As the people in this book talk about the South, they capture its story with their distinctive voices. Unlike the traditional folk storyteller, these speakers are formally educated and consciously choose the story to define their craft as artists and thinkers. They ground their identity in story.

The Storied South: Voices of Writers and Artists is a collection of interviews I conducted over the past forty years. They feature a broad range of people—southerners and nonsoutherners, men and women, black and white. Together, they share a common interest in, a passion for, and an obsession with the American South that define how they write, compose, photograph, and paint. Their stories give us a unique lens through which we can explore the region. Gathered together in this book, they remind us why the human voice is key to the southern experience.

Eudora Welty told me about the day she went sailing with William Faulkner on Sardis Lake:

I went out there, and there was not any shore. . . . I did not want Mr. Faulkner to think that I was inept. So what I did was just walk on into the water and go on out and get in the boat. It was very simple. One, two, three. I just waded out. I do not know if I took my shoes off or left them on. It would not have mattered—through the muck. Then I got in his sailboat. Of course, I was wet. But you cannot ask William Faulkner to wring you out. It had not occurred to me until this minute that I might have. He did not say anything. I did not say anything. Neither one of us said a word. We took a long sailing trip, and it was real comfortable. Nobody tried to make conversation. I am sure he never made conversation. I never got to know him well. But it was so kind of him to do that, and he was so much fun. I was lucky I got to meet him. I never dreamed I would.

Welty's story reminded me of the narrative voice she uses in her short stories and novels. In her hand, she transforms the story into a universal form with which she captures a special moment. Just as Welty felt privileged to spend a day with William Faulkner on his boat, we are privileged to visit with her and with others whose stories follow.

The story is the tie that binds each person to this book. Their tales help us feel the region's

powerful sense of place. Each reveals his or her world with a distinctive voice. Carroll Cloar remembers his childhood in Arkansas and his playmate Charlie Mae, a young black girl who appears in his paintings:

> Charlie Mae lived across the pasture from us, and this painting is about the time we found an abandoned hay mower in the field. Charlie Mae lived with her grandmother, Mattie, and her uncle Disheye. About half a mile from our houses, there was a thicket that I refer to as the "forbidden thicket." It had been put off-limits by my mother because of mosquitoes and water moccasins. Charlie Mae and I were sure there were panthers in it. Charlie Mae said she had been there, and there were panthers. "But," she said, "they friendly." We finally went, and we saw something. And when we stopped running, we decided that we had seen panthers.

This story reminds Cloar of how he "grew up in the midst of white and black people. They both appear in my paintings, and I feel their cultures are very intermingled."

People in this book are grouped by their fields as writers, scholars, musicians, photographers, and painters. All focus on the South in their work, and they often draw on other fields to express themselves. Writers Eudora Welty and Ernest Gaines are gifted photographers. Artists Rebecca Davenport, Maud Gatewood, and George Wardlaw create sequenced paintings that they compare to short stories and essays. Photographer William Christenberry told me that his strongest influence is the writer Walker Percy, while William

Eggleston feels that "a series of photographs is like a novel." And historian C. Vann Woodward worked at his desk beneath a photograph of his hero, William Faulkner.

I sought out these individuals because their work helps me understand my life as a southerner. They come from diverse backgrounds, and they constitute a chorus of voices, all of which are deeply connected to the region. Each is a nationally recognized leader in his or her field, and each has spent his or her life examining the South. Their works include Walker Evans's *Let Us Now Praise Famous Men*, Alex Haley's *Roots*, Pete Seeger's "We Shall Overcome," Alice Walker's *The Color Purple*, and Robert Penn Warren's *All the King's Men*. They capture an authenticity, a truth that they frame through books, art, and music that are admired throughout the world. I approached each person with awe, for he or she wrote "the book," took "those photographs," composed and sang "the song," or painted "that painting," all of which shaped my life. When they agreed to speak with me, I was surprised and grateful. To meet them as friends was moving beyond words.

Each person reflects on how the South shaped his or her career as writer, scholar, musician, photographer, or painter. Together, they created a body of work that defined both their region and their nation in the twentieth century. These interviews and photographs capture an intimate portrait of each speaker.

During the twentieth century, these writers, artists, and musicians significantly shaped our nation's cultural worlds. They view themselves as both southerners and Americans. Cleanth Brooks says his friend Robert Penn Warren is "in-

tensely southern and intensely American. I think the South is a part of America, a very true part." Robert Penn Warren and Cleanth Brooks introduced generations of American students to literature through their textbooks on poetry, fiction, and drama, and they forged lifelong friendships with Eudora Welty and C. Vann Woodward. As a measure of their leadership in American letters, Cleanth Brooks, Robert Penn Warren, and C. Vann Woodward each delivered the National Endowment for the Humanities annual Jefferson Lecture, and Warren was our nation's first poet laureate.

The American South is framed by stories of the Civil War, Reconstruction, the civil rights movement, and the New South. These stories affect black and white southerners in profound ways. To understand and embrace this complex history, we turn to thoughtful voices like those represented here. Cleanth Brooks connects to southern history through his grandfather, who "rode in the cavalry with Nathan Bedford Forrest and was very proud of it. I knew him when I was a child of six, seven, and eight. He spent the last years of his life fighting the Civil War all over again. He would tell about how he used his wits to keep himself from getting hanged."

To understand these stories, we must understand the contested memory of black and white southerners who offer opposing views of the region's history. The perspective of white writers often contrasts with that of black writers, and together they offer a rich, diverse portrait of the region.

Alex Haley's childhood in Henning, Tennessee, was the inspiration for *Roots*. Haley vividly remembers how his grandmother and her sisters "would talk there on the front porch night after night after night about the family. They didn't tell it so much in the form of a story; they told it as it had been passed down. Their grandfather was a man named Chicken George. And his mother was Miss Kizzy. And her father was an African. I grew up hearing those stories so much that they became a part of me."

While race is elemental to southern memory, class is equally important. Stories told by working-class southerners complement the literary worlds of southern writers. Those who wield the pen and those who tell the tales both define and preserve the region's culture in distinctive ways. If we understand the South's written word and its oral tradition—and how the two connect—we possess the key to the region. Oral and written traditions complement each other, and when viewed together, they provide a clear lens on the region's history and culture.

As a folklorist who has spent his life studying the American South's oral traditions and their intersection with literature, visual arts, and music, I believe that the blending of these worlds shapes how Americans think and talk about the South. The South is the place where writing and storytelling converge. Nail by literary nail, southern writers become carpenters of the imagination as they construct their region's literature. The tale and its telling are their raw materials.

Eudora Welty learned as a young child to listen for stories, a passion that foreshadowed her career as a writer. She recalls how "the family tales while away a long winter evening, and that is what they have to draw on. You feel that in Faulk-

ner a lot, you know, especially in the little hamlets where people sit on the store porch and talk in the evenings. All they have to talk about is each other, what they have seen during the day, and what happened to so and so. It also encourages our sense of exaggeration and the comic because tales get taller as they go along. Beneath all of that is a sense of caring about one another."

Stories

As a folklore teacher, I remind my students of the importance of the story for musicians, tale tellers, and craftspeople with an African proverb: "When an old man or woman dies, a library burns to the ground." The story is equally important for formally trained artists, musicians, and writers.

These interviews are part of my compulsive drive to preserve every piece of southern culture, whether it be a scrap of paper or a recorded conversation. Using the folklorist's tools of still and motion pictures and taped recordings, I documented storytellers, quilters, and blues singers in the sixties. In the seventies, I focused my camera and microphone on those who explored the region through photography, poetry, fiction, and scholarship. Each looked at the South carefully. They studied its worlds, as a potter examines the clay that slowly turns on the wheel before him or her.

It is essential to connect southern folk culture with writers and artists who chronicle that culture in their work. My interviews allowed me to explore both folk and academic sides of these worlds. When we view them together, we understand why the South has inspired so many cultural treasures. Southern folk and academic worlds are joined at the hip, and they are best understood as part of a cultural spectrum.

Childhood on the Farm

I grew up on a farm in Warren County, Mississippi, fifteen miles southeast of Vicksburg. The farm lies at the end of Fisher Ferry Road, named for the Fisher family, who operated a ferry that carried travelers across the Big Black River between Warren County and Claiborne County in the nineteenth century. Driving east on the bridge across the river, the road enters Claiborne County and rises up a long, steep hill that finally levels at "the Crossroads," an intersection of two roads that lead east to Utica and south to Port Gibson. Two homes and two country stores stand on corners of the intersection. The Crossroads is located north of the Scutchelo Hills, a mythic place that local residents speak of but can never exactly locate. My effort to understand the South is like searching for the Scutchelo Hills. I make the journey knowing I will never find answers to my questions. The search begins on the farm where I grew up, a place I still struggle to understand.

When I was a child, my father often took me to the Crossroads store run by Mrs. Aden Fisher White, just up the hill from the Big Black River. East of her store lay the Natchez Trace, a 440-mile historic road that connects Natchez, Mississippi, with Nashville, Tennessee. White told me how as a child she saw abandoned wagon wheels lying beside the road. She also told me that her father was fatally shot in his store by a customer. When friends carried her dying father home, he looked at his wound and said, "What a small hole to lose a life out of."

On our farm, across the Big Black River from the Crossroads in Warren County, Virginia Peal Davis ran a small store in the front room of her home, where customers bought crackers, cheese, sodas, sardines, and cookies. Inside, a large, brightly colored Coca-Cola poster featured boxers Kid Galahad and Sugar Ray Robinson, and a Coca-Cola cooler pumped water around the bottles inside it. Like Aden White's Crossroads store, Virginia Peal Davis's store was the heart of its community. Her customers saw it as the center of their universe. During spring, summer, and fall, visitors sat on front-porch benches at both stores and shared tales and gossip with each other. In the winter, they moved inside and sat around a woodstove that provided warmth and shelter from the cold. I spent many happy hours at both stores listening to stories and marveling at the two women who ran them with such grace and efficiency.

It was on the farm that I learned to love stories. In his log cabin in the woods behind our home, my grandfather, Eugene Ferris, told me the long, spellbinding story of Ali Baba and the Forty Thieves. At the end of the story, I would say, "Grandad, tell it again." To my delight, he would repeat the story. My grandmother, Martha Reynolds Ferris, told me stories about her ancestors, whose names I struggled to remember as I grew older.

When I was a very young child, Mother would put a pillow in front of the saddle on her horse. She held me firmly as we rode across fields to find my father at work and share a picnic together. Mother and Daddy had five children, of whom I was the eldest. The first two were named for our

Aden White, Crossroads Store, Reganton, Miss., 1974

Virginia Peal Davis, Rose Hill, Miss., 1969

parents, William and Shelby; the next two, Hester and Grey, for our maternal grandparents; and the fifth, Martha, for our paternal grandmother. Given their names, we also inherited their stories.

Connected by my name to earlier generations, like looking through a glass darkly, then face to face, I tried to understand myself and my southern world. I identify with Shreve's request that Quentin "tell about the South. What's it like there. What do they do there. Why do they live there. Why do they live at all." Much of my life has been spent telling about the South. To tell about the South is to recall its stories. I remember how my grandfather often sat on his back porch looking into the woods. When I asked what he was doing, his housekeeper, Eliza Price, remarked, "He is thinking about that long time behind and that short time ahead."

My study of the South began as I tried to understand the farm, which is the anchor of my life. As a young child, I looked up to Robert Appleton, a dwarf who was known in the community as "Shorty Boy." Each time he and I met, we stood back to back and measured each other to see who was tallest. As a teenager, I wrote my first short story, entitled "Shorty Boy," about Robert Appleton and published it in the Brooks School literary journal, *The Bishop* (May 1960). Later, at Davidson College, I wrote dramatic monologues and a one-act play based on families on the farm. Their stories inspired me to study the place where I was born and to connect that place to the larger South.

I was not the first in my family to write about the farm. My grandfather was an agronomist who spent his life studying agriculture in Mississippi. After he and my grandmother retired to the farm,

he wrote with pride about my father's work there. In October 1934, he wrote his daughter Frances Ferris Hall, "Bill is always busy with some improvement, and has built a house for a gristmill, with machinery for grinding corn—and building wagon-bodies for hauling corn. He is a genius when it comes to doing things with his hands."

Forty-six years later, in 1980, his daughter Frances reminisced about the farm and its importance for our family. "That Mississippi 'world' which William and Shelby have built . . . is one to which all the Family returns. It has nurtured each one of us over the years, and given us our sense of Place, and of belonging."

Today, at the age of ninety-four, my mother also writes about life on the farm. She recently mourned the loss of a beloved oak tree near her home that was damaged by lightning and had to be cut down. "As I sat in the shade of the arbor nearby and watched four men skillfully amputating the leafy branches, I felt that an irreplaceable treasure was being sacrificed before my eyes. After all the limbs had been removed down to about ten feet above the ground, five thick bare branches reached up as if to plead for her life. Then came the executioner with his long power saw and cut the trunk to the ground."

Many of my family who wrote about the farm encouraged me in my career as a folklorist and student of the South and saw my work as an extension of their own writing. They also understood why I wanted to reach across the chasms of class and race that defined the world into which I was born as a privileged white southerner. As I tried to build bridges between black and white people, between formally educated and folk worlds, the

Robert Appleton, Rose Hill, Miss., 1969

memory of families on the farm inspired me to tell their stories and through them the story of the South.

Off the Farm

My first folklore interviews were with blues singers, quilt makers, and storytellers. Through their stories I penetrated the veil of race and was transformed by the people whom I recorded. But I was not the first to reach across racial barriers to bridge black and white southern worlds. Each speaker in this book was there ahead of me, and their work gave me the courage to follow my own convictions.

My love for William Faulkner's work led to my first published interview, which appeared in the *South Atlantic Quarterly* (Autumn 1969). In the interview, Emily Stone described the friendship she and her husband, Phil Stone, shared with Faulkner: "You know, Bill's short stories, some of them are as good as any in the language. . . . They sent off all those stories, and the magazines sent them back. They just wore the manuscripts out sending them off. Things like 'A Rose for Emily,' all those stories. . . . Then when *Sanctuary* made a success, they began to write Bill for short stories. Phil said, 'Bill, I never have asked you for anything before, but I'm going to ask you to do one thing for me. Don't have those stories retyped. Don't do anything to them. Take them, ragged as they are, and send them to the first magazine that rejected them and put your price tag on them.' He did, and they took them."

As a graduate student studying English literature at Northwestern University in 1964–65, I listened each week to Studs Terkel's interviews on WFMT and was fascinated by how Terkel used his tape recorder to document the civil rights movement. He inspired me to think of the interview as a way to understand the South. My camera and tape recorder became the eyes and ears with which I tracked the region. I identify deeply with James Joyce's Stephen Dedalus and with William Faulkner's Quentin Compson. Like them, I bear a love-hate relationship with my home. My deep love for family rests painfully beside the memory of racial violence in the South. It is a burden I always carry.

My approach to the South has been interdisciplinary. As a student, I wrote poetry and fiction. My heroes and spiritual teachers worked in diverse fields as artists, ethnomusicologists, folklorists, folk singers, historians, literary critics, photographers, poets, sociologists, and writers. My father often told me, "You can learn a lesson from each person you meet in life." I was drawn to each of these artists, writers, and scholars because they focused on the South and tried to understand how it relates to the human experience. They are an important part of my own journey to understand the South.

While teaching in the American and Afro-American studies programs at Yale University from 1972 to 1979, I drew on fields such as literature, history, and music to better understand the American South. Many who had inspired my work were at Yale, and I interviewed them as mentors for my own study of the South. They helped me frame my earlier work on blues, storytelling, and folk art, and we built lasting friendships.

I brought musicians, storytellers, scholars, and writers into my classes. Blues artists B. B. King

and James "Son" Thomas and ballad singer Ola Belle Reed were regulars. Poets and writers Sterling Brown, Ernest Gaines, Alice Walker, Margaret Walker, and Eudora Welty and photographer William Eggleston also spoke with my students. I arranged honorary degrees at Yale for both B. B. King and Eudora Welty.

My apartment on the second floor of Calhoun College—one of Yale's residential colleges—overlooked the Cross Campus Green. From my window, I photographed the changing seasons and student activities that ranged from graduation ceremonies to human chess matches on the green. While at Yale, I was given a yellow-head parrot named Ogie (for Oglethorpe) who sang and shouted to all who passed below his window. I tethered Ogie on a perch in the Calhoun College courtyard one spring, and he learned to say "ouch" after he bit several students who tried to pet him.

At that time, Yale was home to important writers, scholars, and photographers who wrote and taught about the South. They included John Blassingame, Cleanth Brooks, John Dollard, Walker Evans, Robert Penn Warren, and C. Vann Woodward. Each shaped my understanding of the American South in significant ways. Brooks told me that "southerners tend to fare rather well at Yale. Whatever New England has thought about the South, the concrete individual southerner has been treated rather handsomely at Yale. We are valued, maybe overvalued, for certain traits, which our friends notice as being different."

The transition to Yale for southerners was never easy. My friend and faculty colleague Willie Ruff told me that when he first came to New Haven from Lick Skillet, Alabama, as a freshman, he

Bill Ferris, photo by Walker Evans, 1974. Courtesy of The Metropolitan Museum of Art, Walker Evans Archive, 1994 (D.1994.252.675), © Walker Evans Archive, The Metropolitan Museum of Art.

took his clothes to be cleaned. In his small shop on Temple Street, Rosie the Tailor advised Willie that the best way to survive at Yale was to "dress British and think Yiddish."

When I arrived in New Haven in the fall of 1972, I went to a shoe store to buy a pair of boots for the winter. The salesman heard my southern accent and asked, "Where are you from?" I replied, "Mississippi," and he said, "I thought you didn't wear shoes down there." I answered, "We don't. That's why I came here to buy a pair."

At Yale I interviewed many who are my teachers in the deepest sense. Gathered together—like separate pieces in a quilt—their stories gave me a deeper understanding of the South. They also

prepared me to serve as director of the University of Mississippi Center for the Study of Southern Culture from 1979 to 1997, where we developed the *Encyclopedia of Southern Culture* and the nation's first BA and MA degrees in southern studies. These programs were supported by people in this book who understood and blessed our work "back home."

While conducting these interviews, I discovered that each person uses the story to explain his or her attraction to the South. The intellectual tools with which they work differ, but their love for the region and its stories is a bond they share.

Writers

American literature abounds with stories of the American South. Like the hunters in Faulkner's "The Bear," southern writers stalk the wild, indomitable voice of their region. They listen carefully, thoughtfully, and the literary cage in which they contain that voice may be the novel, short story, poem, or play.

During my conversations with writers, I learned that Eudora Welty, Ernest Gaines, and Alice Walker share a love for Russian writers. They each find common ground between characters they discovered in Russian fiction and those in their own work. Walker explains, "Russian writers have a kind of essential passion, and they engage in questioning the universe and human interactions. They really care. I like that. . . . I think writers should care desperately."

Growing up in a family of storytellers instilled in Alex Haley, Alice Walker, Robert Penn Warren, and Eudora Welty a deep respect for oral tradition. Walker reflects, "I live in a culture where storytelling is routine, where memory is long and rich. I was born into this huge family where everybody told stories, and it was my function to make some sense out of all of it, to write it down and present it."

Each writer grew up in a home where reading, listening, and education were sacred. There were, however, significant differences between access to books in the homes of Eudora Welty and Alice Walker. Welty is grateful that she grew up in a home where her parents "were always buying books and encyclopedias and dictionaries and things like that. . . . We were brought up with the encyclopedia in the dining room, always jumping up from the table to settle an argument and look up things in the unabridged dictionary and haul out the atlas."

Walker recalls how her parents found books whites had discarded and brought them home for their children. "Whenever books were thrown out by the white person they worked for, they were happy to have them. They would bring them back, and they would read to us. We always had books in the house."

Some southern black writers draw inspiration from slave memoirs, autobiographies, ex-slave narratives, and oral history interviews. These historic documents reveal the horror of slavery, Reconstruction, and Jim Crow, as well as the resistance, courage, and dignity of black families. Richly illustrated with folktales, these sources capture the history of African Americans in the region and are an important resource for twentieth-century black writers.

Ernest Gaines drew on ex-slave narratives in writing *The Autobiography of Miss Jane Pittman.*

Gaines explained that he "heard the voices of not only all these ex-slave narratives I had read, but also what I knew of the voices of my Louisiana people." Both written and oral sources inspired his description of Miss Jane's life as a slave, her emancipation by northern troops, and the rejection of her slave name, Tycie. Gaines relied heavily on stories he heard growing up in Louisiana and never thought "about the difference between an oral style of conversation and a written one when I was writing. I try to write what I hear. That is all I try to do."

Robert Penn Warren and Cleanth Brooks co-authored *Understanding Poetry* (1938) and *Understanding Fiction* (1943). For over four decades, these texts introduced the study of literature—including the voices of southern writers—to students throughout America. Brooks recalled that he and Warren, nicknamed "Red," wrote the first of these texts when they taught English at Louisiana State University: "We worked very hard on the textbooks. We began with word-by-word collaborations, discussing them again and again until we got consensus on what we wanted to say. Red came into my office one day and had mimeographed twenty-five or thirty pages, mostly about meter and imagery. I wanted to add a little on imagery, and Red said, 'Fine.' We put that little thing between cardboard covers and sold it for a quarter to the class. That was for our first literature class."

In 1935, Brooks and Warren founded the *Southern Review* at Louisiana State University, where they published aspiring young southern writers such as Eudora Welty. Brooks recalls that he discovered Welty soon after the publication was launched. "We received a letter from someone we had never heard of, a young woman in Jackson, Mississippi, named Eudora Welty, who said she was interested in writing fiction and doing photography. She did not know which she really was most concerned about. She would like to submit a story. The story was awfully good. We published it right away in the *Southern Review*, and the first thing we knew, we had published six or eight of her stories."

Writers in this book understand the power of the spoken word and have the skill to translate that word into fiction and poetry. This process is the key to understanding how writers forge stories into literature through their imaginations. Eudora Welty has loved stories and the spoken word since childhood, and she is instinctively drawn to language and dialogue. "You get that, of course, by your ear, by listening to the rhythms and habits of everyday speech. I listen all the time. I love it." Welty explains how she transforms everyday speech into literature through a process we might liken to magic, conjuration, or sleight of hand. "You are giving what seems to be reality, but it is really an artistic illusion."

Gaines reminds us that being able to write stories as literature does not mean one can tell them. "I wish I could get up on stage and tell a story, but I am really not a storyteller. If I go to a bar and tell a joke, people say, 'Get outta here. Go home and write your novels.' I cannot tell a story. None of my friends will listen to my stories. They walk out of the room. I come from a tradition of storytellers, but I am not good at it. My brothers and my mother tell fantastic stories."

C. Vann Woodward understands that the writer must tap history through stories, but "whenever

oral sources are used by a writer, they are consciously molded and shaped if they are to be used in literature."

Scholars

Race is a central issue for scholars who work in the South. Racial codes divide black and white worlds, and sociologist John Dollard explains how these codes limited his fieldwork in Indianola, Mississippi, where he did research for *Caste and Class in a Southern Town* (1937): "One of the instructive mistakes that I made was to make a date with a Negro teacher. He was a little bit brassy apparently because he came to the front door of my boardinghouse, and my landlords did not turn him away, which was very decent of them according to their code. I came out and talked with him for a while. When he left, they bawled me out and said that I had broken a point of caste etiquette."

Charles Seeger encountered similar racial barriers when he traveled in the South. At the time, he worked for a New Deal program and was not allowed to visit black schools because of their conditions.

> I had just visited a school—I think it was the first eight grades—in South Carolina. You could look through the boards and see the ground underneath. We passed another building and did not stop. So I called out to my guide, "Oh, let's go in there. It looks interesting."
>
> It looked more like a cow barn than anything else. But we kept right on driving, and I waited for an answer. The answer was, "Mr. Seeger, we cannot go in there."

"Why not?"

"That is a Negro school." In the South I was not allowed to visit any Negro schools.

C. Vann Woodard suggests that race and the civil rights movement inspired important historians to study the American South. He believes that the issue of race lies at the heart of southern history: "During the past thirty years, the South has attracted a great many talented historians, and they have come from all over. I think it marks a healthy change that the subject has ceased to be appealing only to southerners, as it once did, and has become instead a subject that attracts historians from all parts of the country. . . . The subject has an inherent fascination for Americans because it offers so many contrasts with the predominant American story. It has the appeal during recent years of the civil rights movement and the black rights movement. Since the South was the seat of that activity, it naturally attracted attention."

Musicians

Blues captured the imagination of some African American writers who adapted the music as a recurring theme in their work. Sterling Brown and Alice Walker both saw blues verses as a literary resource for their work as writers. For each, blues embodies fundamental truths about black experience because the music plumbs the depths of despair and offers both listener and performer the strength to endure. Brown learned blues from a musician named Big Boy, who "was broad shouldered with a scar down his cheek. He was much taller than I am and a hell of a ladies' man. . . . He

could play the hell out of a guitar with a bottle on his finger."

Alice Walker is attracted to the blues and to bluesman B. B. King. She declares, "I love B. B. King because he loves women. They can be mean. They can be bitchy. They can be carrying on. But you can tell he really loves them. He is full of love. I would like to be the literary B. B. King."

Walker reminds us that black women who were abused sang about their pain through the blues. Because the music expresses women's suffering in powerful ways, she believes, "what is truly disturbing is how frequently when women are singing, they are telling about abusive relationships. I am struck by that time and time again. . . . I remember once, Quincy Jones laughed and said, 'You know, Celie is the blues.' That is so true. If Celie were singing, she would be like Mamie Smith, Bessie Smith, and Ma Rainey, all of whom were abused. Those women were abused by men."

Blues artist Bobby Rush believes his mission as a musician is to reach out to women and give them special attention through his lyrics. Rush makes this appeal to women because he understands their history of abuse, and he "leans to" them through his music:

I lean to the women. . . . When you talk about a mother, . . . you are talking about someone who loves you probably a little bit harder than your dad. . . . I lean to the ladies. I put them in my arm, and give them the upper hand. . . . I have an old album called *What's Good for the Goose Is Good for the Gander Too*. So many times guys want to do what they want to do, and they do not want the lady to do anything.

I have a brand new album called *A Man Can Give It, but He Sure Can't Take It.* . . . That is the truth. I am not saying that is every man. I am saying that out of a hundred men, ninety-five of them are like that. So that is why I lean to the ladies. I am leaning to things that I know about.

During their trips to North Carolina, Charles Seeger and his son Pete discovered musicians who inspired their work as composers of classical and folk music, respectively. Charles Seeger founded the field of ethnomusicology. Pete Seeger helped compose the civil rights anthem "We Shall Overcome." And both embraced southern music as a force for social change.

As a child, Pete Seeger thought of the South as a distant, romantic place chronicled in song. "I first started learning about the South when we sang, 'Oh, Susannah, . . . I come from Alabama with a banjo on my knee.' The South was a distant, romantic place. . . . I did not think I would ever go down there."

Seeger traveled as a young child from Washington, D.C., to Pinehurst, North Carolina, with his father, Charles, and his stepmother, Ruth Crawford Seeger. The South at that time was largely rural, and

the roads were dirt roads. . . . Once it rained, and the puddles got bigger and bigger. Finally the entire road was one big puddle. My mother said, "Charlie, aren't you going to turn around?"

He said, "I can't turn around. The road is too narrow. I have to go ahead."

The road went completely out of sight, but

my father said he could tell where he was going by the fence posts on either side. He stayed in the middle of the road. The water was up to the hubcaps. It got over the hubcaps. My mother was getting hysterical. They could not see anything except fog and rain on all sides. They kept putt-putt-putting ahead. Finally, away in the distance, they saw the road rising out of the water.

Pete Seeger, Charles Seeger, and Ruth Crawford Seeger survived their harrowing trip to North Carolina and were enriched by the rich musical worlds they found there.

Photographers

Southern photographers William Christenberry, William Eggleston, and Walker Evans each create a visual history of the American South, and their work demonstrates why photography is an essential tool for understanding the region. Evans and Christenberry both photographed in Hale County, Alabama, at different times, and they returned there together for a memorable trip in 1973 to revisit the places Evans had photographed in 1936 when he worked with James Agee. Evans remembers these worlds as an "Old America, which goes so far back that some of the people speak with something reminiscent to Elizabethan English, and their faces are like that too."

With their cameras, Christenberry and Evans capture buildings that they view as decaying monuments to the past. Christenberry reflects, "I find old things more beautiful than the new, and I go back to them every year until sooner or later they are gone. They have blown away, burned, fallen down, or just simply disappeared."

Evans has an aesthetic preference for unpainted homes and explains that "the texture of unpainted wood is very attractive to me. It is hard to say why—just an instinctive love. That is just America, and I am deeply in love with traditional old-style America."

Christenberry's family lived in Hale County, where Walker Evans and James Agee's classic study *Let Us Now Praise Famous Men* is set. Although Evans's photographs of white sharecroppers and their homes strongly influenced Christenberry, he feels his art owes more to southern writers such as Walker Percy: "Southern literature has had a greater influence on my art than the work of other visual artists. I do not deny that visual artists have played a big part in what I do. In more recent years, however, Walker Percy has had a profound influence on what I try to express in my work. I do not know if it is possible to do visually what he has done with the written word. But I feel very strongly that it is worth a challenge. That is what it is all about for me."

William Eggleston pioneered the use of color photography to document the South, and his Museum of Modern Art catalog and exhibit *William Eggleston's Guide* was the first one-person show of color photography in the art world. Like Christenberry, Eggleston is influenced by southern writers and believes his "series of photographs is like a novel. . . . If a person went slowly through that body of work, it would be roughly like reading a novel."

Southern writers also did important photography in the South. While working for the Works

Progress Administration, Eudora Welty took more than a thousand photographs, and she recalled that she "just took the pictures because I wanted to. Just impulse. . . . Nothing could have been written in the way of a story without such a background, without the knowledge and the experience that I got from these things. It provided the raw material. And more than that, it suggested things in a valid way that could never have been made up without this reality. It was the reality that I used as a background and could draw on in various ways, even though indirectly."

Ernest Gaines shares Welty's love for photography, and he took photographs of people and places at his home in Louisiana that later influenced his writing. Through these photographs, Gaines connects with worlds that have disappeared. When we spoke in San Francisco, he explained: "I always take a camera when I go back to Louisiana. I take both black-and-white and color photographs. . . . I keep the photographs because most of these places are gone now. The stores are gone. The houses are gone. This river is all built up, and this man is dead. They are things of the past. I do not think that anything like that will ever be there again, ever, ever again." Gaines and Welty both use photographs as a resource for their fiction and underscore the affinity southern writers have for the visual arts. Their desire to capture and preserve their southern worlds is shared by writers, photographers, and painters in the region.

While he loves photography, Gaines stresses that memory and imagination are his best resources when he writes about Louisiana. He explains how "my mind's eye sees the area just as well as that photograph does, maybe even better, because the photograph is limited. The mind's eye can travel down the road like a movie camera."

Painters

Southern painters are deeply tied to the region's physical landscape. Generations of painters have documented places such as the Great Dismal Swamp, the Mississippi Delta, and the French Quarter. They capture the beauty and untamed spirit of these worlds and their people.

Benny Andrews began drawing with no formal training when he was a student in a small school in rural Georgia. His family took him out of school to pick cotton each fall, and he made up the schoolwork he missed with his drawings: "These are my report cards. That is cotton-picking time. What happened is that the principal would take my drawings around to the different teachers after I was back in school in the latter part of November or December. And he would negotiate with the teachers to give me credit. So I drew my way through high school."

Sam Gilliam finds inspiration in his painting from the memory of how the Ohio River flooded his home in Louisville. He is in awe of the Ohio's power and beauty because "rivers constitute the most amazing, dynamic forces. They always flooded, and one was always conscious of them. They elicited fear and amazement. I remember one time when there was a flood. In the morning, the water was at the end of the street. By the afternoon, it was suddenly in the front yard, and everybody had to move."

Inspired by the writing of Flannery O'Connor, Rebecca Davenport did a series of paintings of poor whites that she called White Soul. She feels these paintings embody a particularly southern mix of defeat and success, and she views them as a white counterpart to black soul:

> This is how my idea of painting poor rural whites started. I call it White Soul because it is about pride, race, and dignity all mixed up with feelings of both defeat and success—the very same thing as black soul. I worked on that series of paintings for five or six years. There is a lot of anger and a lot of strength in them. I have been criticized by people who say that I make these people into freaks, which is not at all true. This goes back to reading Flannery O'Connor. Her characters are freaks, but they are also whole people because they have a dignity of the human spirit. I hope that spirit comes through in my work as well. There is a story behind every painting in White Soul. I did one painting called *The Arkansas Madonna* of this enormously fat woman with these enormous breasts, holding a baby's bottle with a child on her shoulder.

George Wardlaw's Chickasaw and Choctaw heritage shapes his paintings in significant ways. When he paints a canvas, he sometimes feels his Indian ancestors speak to him: "I did a series of works based on rivers and places in Mississippi named after Indian tribes. The pieces were named *Choctaw, Chickasaw, Tishomingo, Iuka,* and *Itawamba*. . . . I felt like my ancestors were coming forward and speaking to me in a new tongue, with a new language."

Ed McGowin's paintings are inspired by his memory of childhood in Alabama. McGowin had a dream of the black woman who nursed him as a small child. In the dream, he was injured and in pain when suddenly "these huge black hands were caressing me from the top of my head to my toes. The hands were the size of my entire body. In the dream these very soft hands were warmly holding me completely. When I thought about it later, I realized that was the situation for much of my infancy. The person who took care of me was black. I was being held. I was seeing a vision of the most soothing and affectionate caress that I could anticipate as a baby, the one from the nurse who would pick me up and take care of me. The connection between the black and white cultures in the South is more than I could ever try to elaborate on."

Recurrent Voices

Speakers acknowledge how important figures—William Faulkner, Langston Hughes, Zora Neale Hurston, and Malcolm X—inspired and influenced their work. William Faulkner's long shadow touches each speaker, and their remarks suggest how his writing defines the literary and artistic work of all who deal with the American South. Welty, Warren, Brooks, Woodward, and Wardlaw all either met or saw Faulkner, and they treasure that memory. Others such as Gaines, McGowin, and Eggleston consciously shape their work as writer, painter, or photographer in response to Faulkner's literary voice.

Welty writes eloquently about the importance of place in fiction and acknowledges how Faulkner's fictional Yoknapatawpha County has in-

spired other writers. "I understand the idea of fiction as a map of a place. Faulkner's marvelous work really is a triumph of the first order, in that respect. But I have no such abilities or ambition. I locate a story, and that is all."

Cleanth Brooks wrote two important books about Faulkner but spoke with him only once—in the Random House office of Faulkner's literary agent, Albert Erskine. To open their conversation, Brooks avoided asking Faulkner serious literary questions and instead "started talking to him about coon dogs. I do not know much about coon dogs, but I knew he would be interested. I know a little about them."

When Ernest Gaines struggled to deal with the father-son conflicts in writing his novel *In My Father's House*, friends at Louisiana State University encouraged him, saying, " 'If Faulkner did it, you can do it too.' It took me seven years to do it." Gaines keeps a photograph of Faulkner above the desk in his study and acknowledges that when he first began reading, "I started with Faulkner."

C. Vann Woodward once stood behind Faulkner in line at the cashier's desk in the Algonquin Hotel. He was too shy to introduce himself to the writer he greatly admired. Woodward feels every southern historian "ought to know Faulkner's work. . . . They can profit from it—not as a source of history—but through an awareness of its richness and its distinctiveness. It is impossible to think of the South without some reference to Faulkner and his perception of the region."

Painters Sam Gilliam and Ed McGowin eloquently describe how Faulkner's writing shapes their work as visual artists. Both see a parallel between Faulkner's stream-of-consciousness literary style and their painting. Gilliam explains that his abstract work is inspired by Faulkner's use of long narratives. In his paintings, "the abstract content, the sense of void and nonform have their parallels in Faulkner, where they are similar to his long, historical narratives. My visual solutions are analogous to his verbal and literary ones."

Ed McGowin feels that his work, like that of Faulkner, emerges from the southern storytelling tradition. Both are inspired by the vernacular story in oral tradition, and McGowin and Faulkner transform the southern story into paintings and literature, respectively. "I try to do narrative work with a visual metaphor, whereas Faulkner did this same kind of work in literature. The problems are very much the same. Faulkner was not simply telling stories in southern dialect. He was telling stories in southern dialect that were great literature."

Langston Hughes had an important influence on Alice Walker and Margaret Walker. He befriended and encouraged both women to write, and he strongly supported their careers. Alice Walker met Hughes at the beginning of her literary career and regrets that she did not ask him more questions about what lay ahead. "When you start, you have the vaguest notion of where you are going, and you do not know what things are important to work with. My regret is that Langston Hughes died before I knew what to ask him."

Margaret Walker discovered Hughes's poetry at the age of twelve when her parents gave her "a little booklet called 'Four Lincoln Poets.' They brought it home and gave it to me. Langston Hughes first impressed me then. . . . My sister and I memorized both Countee Cullen's and Lang-

ston Hughes's verses." Margaret Walker fervently admired Hughes and over the years saw him in New Orleans, Chicago, and New York. She recalls, "Our friendship dated from that first night we met in February 1936 until the day he died in May 1967. I saw him last in New York in 1966, in October, and remember until now his big bear hug at that meeting."

Zora Neale Hurston's role as an outspoken female writer during the Harlem Renaissance also inspired Alice Walker and Margaret Walker. Alice Walker remembers how she first read Hurston's *Their Eyes Were Watching God* when she lived in Jackson, Mississippi. "I had never read a book that was so true to my southern black culture—full of music, full of humor, full of just craziness—people living their lives, people having good times, people fussing and fighting. As with my mother and father, Zora's characters are absolutely rooted in the earth."

Margaret Walker was a young girl when she met Hurston in New Orleans and was struck by her stylish dress. "I remember she had on a knee-length, sleeveless flapper dress and wore bobbed hair. I was impressed with how short her dress was." She reflects how "Zora is a gal after my own heart. . . . She did not take cover because she was a woman. She put up her dukes and stood her ground with the best of them. . . . She died a pauper, after having worked as a domestic for a pittance. But she remains one of the brightest stars in the Renaissance. . . . Sleep well, Zora. We love you."

Malcolm X's radical voice inspired Alice Walker, Alex Haley, and Robert Penn Warren. Walker reflects on what might have happened to Malcolm X had he not been assassinated. "Malcolm could have started a little farm in Detroit and been ready to come back another time. . . . I would love to have had Malcolm or Martin Luther King teach my child."

Alex Haley spent many hours interviewing Malcolm X and views himself as "a conduit who saw the Malcolm book come into being. Malcolm's life without that book would be a mass of gratuitous tales, told by people who were in varying degrees of closeness to him. People come up to me—grown men—and say, 'I used to go to school with Red in Boston.' Malcolm never went to school in Massachusetts. You hear these things, and you realize these people really believe them. . . . Malcolm was a symbol of a lot of things."

Robert Penn Warren interviewed Malcolm X in New York and recalls that his first words were, "'You newspapermen are all liars, but I will give you ten minutes.' I said, 'I am not a newspaperman, and I am not a liar. I have a tape recorder here. You will have the transcript, and the only thing that will be published will be your correction of the transcript.' He said, 'Well, let's go talk.' We went back to a little room, and he said, 'I can give you ten minutes.' I left three hours later, and I was the one to break up our talk. When a man is talking about himself, he gets very interested in the subject. He loves the topic." Warren describes Malcolm X as "the most impressive man I ever met. . . . He was just like a welterweight coming out of the corner. He came out at the questions just like a fast boxer moving in. I put him on the spot, and he rose to it."

These memories of William Faulkner, Langston Hughes, Zora Neale Hurston, and Malcolm X

suggest the complexity of how the speakers view their work and its relationship to the South. The speakers clearly see themselves as part of a tradition in which their stories are linked to earlier stories.

The WPA

During the New Deal era under the administration of President Franklin Roosevelt, many writers and artists in this book were employed by the Works Progress Administration (WPA). These work experiences powerfully shaped their understanding of the American South. Margaret Walker worked with Richard Wright on the WPA's Federal Writers' Project in Chicago, where Wright introduced her to Arna Bontemps.

Walker Evans worked as a photographer with the WPA, and his images of the region resonate with those that Eudora Welty took during the same period. Welty recalls that she "was in the state office and was called a junior publicity agent. . . . That job took me to practically every county in Mississippi. It was an eye-opener for me because I had never been in those places before. It hit me with great impact to see everything first-hand like that."

Sterling Brown collected oral histories of blacks in Virginia for the WPA and explains that "there were very few Negro writers on the Federal Writers' Project interviewing ex-slaves, because there were very few Negroes making a living from writing. When I became editor of Negro affairs, I worked to get Negroes on the project. . . . When we finally got a few Negro interviewers, they would come up with different stories from the ex-slaves than the white interviewers. Of course, the

editors would say, 'The first story is right because a white interviewer got it. You can't expect Negro interviewers to get this right, can you?'"

Charles Seeger worked for the WPA in Washington, D.C., "trying to put 300 good musicians into 300 of President and Mrs. Roosevelt's resettlement communities for displaced farmers and other rural populations within six months. . . . I took the job because I saw a marvelous chance to carry out my idea that we should work with music they could sing themselves."

Julien Binford painted his first mural on the wall of a post office in Forest, Mississippi. "I entered a competition at the Section of Fine Arts in Washington, which was a branch of the Treasury Department. . . . I went down there and spoke to the postmaster. Logging and the sawmill business were important in that section of Mississippi. So I decided to do a logging scene, and I used the local people. . . . It was the first mural that I had ever hung myself."

Part of a later generation of writers, Ernest Gaines and John Blassingame used oral histories gathered by WPA workers to shape their fiction and scholarly work. In his research before writing *The Autobiography of Miss Jane Pittman*, Gaines explains how he "read interviews done with former slaves by the WPA workers during the thirties. I got their rhythm and how they said certain things."

Historian John Blassingame makes extensive use of oral histories recorded during the WPA period. "The people who were involved in the collection of the WPA interviews did—from the standpoint of scholars of the nineteenth century—the single most important thing that was

ever done. They collected so much data that other people will be able to use, whether they write about folklore or music or history."

Writers and artists who worked on the South were deeply influenced by the WPA. The federal government made a significant contribution to their lives and bonded their work to the region.

A Gathering of Friends

Throughout these conversations, friendship helps us understand these writers and artists. Some of the people whom I interviewed are old friends who have known each other for many years, and those friendships have enriched both their lives and their work.

Eudora Welty feels strongly about the power of literary friendship and told me, "Friendship certainly means a lot to me. It is rather hard to put it into words. I would say that friendship really has love in it. It has meant everything to me both personally and in the art of writing. . . . It is hard to conceive of living and working without it. It is an essential part of your life."

I view this book as an extended conversation shared among friends, many of whom never actually met or corresponded. These interviews are the web that connects them.

As in my last book, *Give My Poor Heart Ease: Voices of the Mississippi Blues* (2009), and in my earlier oral history, *Mule Trader: Ray Lum's Tales of Horses, Mules, and Men* (1998), these interviews include only the speaker's voice. I choose this format—as opposed to including my questions—because it allows the reader to focus solely on the

voice of the speaker. The format is inspired by the dramatic monologue, a literary form that uses a single voice through which the reader discovers the world of the speaker. Southern writers use the dramatic monologue effectively in their work. Eudora Welty's "Why I Live at the P.O.," Alice Walker's "To Hell With Dying," Ernest Gaines's *Autobiography of Miss Jane Pittman*, and Alex Haley's *Autobiography of Malcolm X* are excellent examples of how the form is used by writers in this book.

The dramatic monologue develops an intimate, uninterrupted relationship between the reader and the speaker. As John Blassingame notes, "Every interview has two authors, the person who asks the questions and the person who answers them." My presence in each interview and in the photographs is oblique—unheard and unseen— but very much felt by the reader. While my voice does not appear in these interviews, they reflect my intellectual and artistic growth over the years, as well as my friendship with people whose work inspired my work on the American South.

In a brief introduction to each speaker, I explain how we met, after which the speaker's voice follows uninterrupted. The length of interviews varies. Some are more richly detailed than others. The tone of interviews varies, as both humor and seriousness mix in the conversations. Together, they form a diverse gathering of speakers, all of whom share a deep connection to the South.

These stories shaped me and helped me understand my own life. They led me back to the place where I was born, to people whom I deeply love.

Writers

I think one of the great mysteries of life is how, in some centuries, a section of the country will just produce everything—like New England at one time, the Middle West at some time, then the South. Who knows why these things happen? I do not know, but I am glad they do.

—Eudora Welty

Southern writers dominated American literature during the twentieth century. Movements such as the Harlem Renaissance and the Southern Literary Renaissance produced literary figures whose work is rooted in the American South and its storytelling tradition. Writers in this section and their literary circles were an important part of these worlds. While Eudora Welty, Alex Haley, and Margaret Walker remained in the South, Sterling Brown, Ernest Gaines, Alice Walker, and Robert Penn Warren lived outside the region.

When I taught at Jackson State University from 1970 to 1972, I visited regularly with Alice Walker, Margaret Walker, and Eudora Welty. Each had a special presence in my life. They brought a distinctive voice to fiction as writers who explored gendered worlds such as gardening, cooking, and hairdressing. Welty and Alice Walker both admired their mothers' skills as gardeners and learned from them. Walker told me how her mother would "visit a house, and if there was a sprig of anything lying that had broken off of any plant, she would take it home, stick it in any little bit of soil, and would have absolute certainty that it would do well, and it did. That was her way."

Welty remembers her mother as similarly gifted with plants, "a great gardener, and really a horticulturist by inclination and study. She taught herself. I grew up in a house that liked things growing. This big oak tree out here in the yard, my mother planted it. She refused to cut it down, although we had seven giant pines stand-

ing around it. Now the pines are gone, and the oak tree is majestic. She said, 'Never cut an oak tree.' And that is a fact."

All of these writers lectured and taught at colleges and universities. Eudora Welty and Alice Walker taught courses on writing at Millsaps College and Tougaloo College, respectively. Margaret Walker, Robert Penn Warren, and Sterling Brown taught for many years at Jackson State University, Yale University, and Howard University, respectively. Ernest Gaines taught a creative writing workshop at the University of Louisiana at Lafayette, and Alex Haley frequently lectured on campuses. Their readings and classes inspired generations of students.

Just as Langston Hughes befriended and encouraged Margaret Walker and Alice Walker, Robert Penn Warren and Cleanth Brooks recognized and supported Eudora Welty's literary career. Warren recalls how he "met Eudora Welty through the mail when I was working on the *Southern Review*. We published five of her stories, one right after another."

All of these writers admire southern storytelling and weave it into their fiction and poetry. Robert Penn Warren remembers warmly an evening of storytelling that he shared with Eudora Welty and Charlotte Capers. "One of the most delightful evenings I have ever had in my life was with Eudora and her friend Charlotte Capers. We had dinner together in Jackson and stayed up all hours, just talking, drinking, and talking. Those two women together are just a circus. They are two great wits at tale-telling."

In addition to their shared love for stories, these writers are indelibly shaped by the American South and the places within it. For black writers, their attachment to the region is especially complex. Sterling Brown reminds us that "slave masters with Negro children were widespread. Zora Neale Hurston says we are a mingled people. So when the man says to me, 'Go trace your roots to the Congo,' I can also trace them to some river in Ireland and to some damn river in the Cherokee country."

The relationship of black writers to southern places gives deeper meaning to Quentin Compson's declaration that he "does not hate the South." Ernest Gaines explains that he "left the South when I was quite young because I could not get the kind of education my people wanted me to have there. I still write about the South because I left something there. I left a place I could love. I left people there that I loved. I left my aunt. I left brothers and sisters. I left friends."

Alice Walker is uncomfortable with the term "southern writer" because it often refers exclusively to white southern writers. She has no "interest in integrating southern writers" and insists, "I do not consider myself a southern writer. I am dealing with regions inside people. . . . The region is the heart and the mind, not the section."

In their fiction and poetry, however, these writers remain rooted in the South. They constantly draw on the voices and stories of their region. Their work emerges from a sense of place that frames how they write. Welty explains how "place produces the whole world in which a person lives his life. It furnishes the economic background that he grows up in, and the folkways and the stories that come down to him in his family. It is the fountainhead of his knowledge and experience."

Eudora Welty 1909–2001

BORN IN JACKSON, MISSISSIPPI

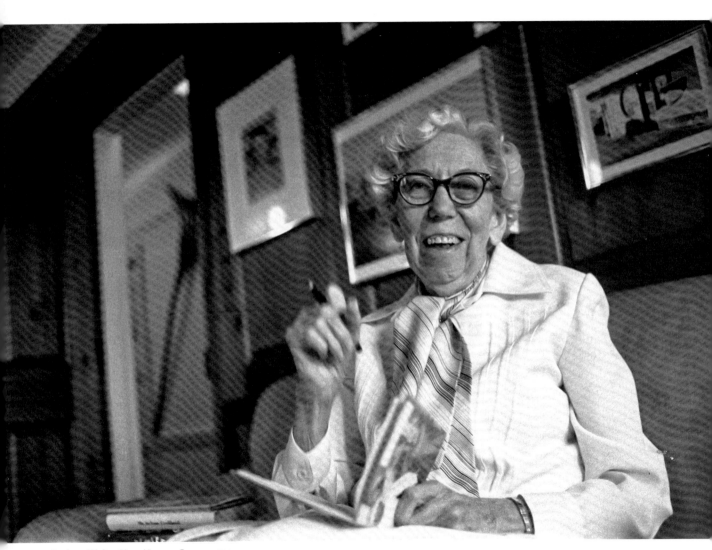

Eudora Welty, New Haven, Conn., 1974

As for my own work, I think of it more as an internal map than a map of a geographical place. It is a map of minds and imagination. It has to be laid somewhere. What guides you is inside of the characters, to show what they are doing.

In 1929, my grandparents Eugene and Martha Ferris moved to Jackson and bought a home on Laurel Street. The Welty family lived three blocks away with their children, Walter, Edward, and Eudora. My grandmother often told me about the Weltys, who were close friends in Jackson.

At the age of twelve, I remember seeing Eudora Welty and a group of her friends when they visited our farm to picnic and sketch the landscape. They sat on a hillside below our home, and after they left, my mother told me that Welty was an important writer.

I first read Welty's work at Brooks School, and in my senior year at Davidson College, I invited her to be our book-of-the-year speaker. Much to the amazement of our faculty in the English Department, she accepted. I borrowed a school car and met her when she arrived by train one evening at the Charlotte depot. The next morning she read "A Worn Path" before the student assembly in her soft voice, and during the afternoon we walked around the campus where wisteria vines were in full bloom. At the end of the day, Welty's old friend Reynolds Price drove up sporting a white linen suit and escorted her away to give a reading at Duke University.

Four years later I was working in the folklore collections at the Mississippi State Archives when Charlotte Capers, the director, showed me unpublished photographs that Welty had taken for the Works Progress Administration. In these photographs Welty captured the faces and landscapes of Mississippi with a power and honesty that became a standard for my research as a folklorist.

During the summer of 1975 I visited Welty at her home on Pinehurst Street, and we spoke about those

photographs and her writing. Over the years that followed, I visited her regularly and recorded other interviews on tape, film, and videotape with her.

Each time we visited, I brought a large bottle of Maker's Mark that we opened and shared together. Welty's wit was always unexpected and refreshingly on point. One day I phoned her and asked, "Eudora, I wondered if we might get together on Saturday."

She replied, "That would be fine. What time would suit you?"

"Would ten thirty be all right?"

"Did you say seven thirty?"

"No. Ten thirty."

"Oh, good. For a moment there I thought you were testing our friendship."

We visited many times over the years. She came to Yale twice, the first time to speak to my students and the second to receive an honorary degree. Later at the University of Mississippi she read from "Why I Live at the P.O." when the William Faulkner postage stamp was issued. She visited our farm and had dinner there with Cleanth Brooks, Tinkham Brooks, and Charlotte Capers.

Our visits in her home were always memorable, intimate moments as we sat in her living room and spoke about friends and ideas. Welty kept a framed note from Bill Clinton on her mantel, and her oil portrait hung on the wall across from it. When I left, she always walked me to the front door and stood inside the screen door until I walked to my car and drove away.

Welty's voice reminded me of my grandmother Martha Ferris. Its familiar, nurturing sound assured me I was with a friend who understood all that I knew and would ever be.

This conversation is drawn from a series of interviews that I did with Welty in her home in 1976, 1994, and 1996, and from several questions I asked her about literary friendships at the Mississippi Old Capitol Museum in 1998. My questions at the Old Capitol Museum come at the end of an interview that Caroline Taylor did with Welty and Cleanth Brooks for *Humanities Magazine*. I filmed the conversation, and its highlights are included on the DVD with this book. I also filmed Welty speaking and reading from "Why I Live at the P.O." for the opening of the film *Four Women Artists* (1977) that I directed at the Center for Southern Folklore in Memphis. That film segment is also included on the DVD with this book.

As for Jackson, I have always liked being here. My family—my father and mother—were both from away, and they came here when they married. It was kind of adventurous for them. They were making a new life. And my father—he was a businessman—had decided that Mississippi was a place with a future. He was interested in civilized life. I was the firstborn of the first generation in Jackson. He was from Ohio, and my mother from West Virginia. I always felt very lucky—and they did, too—that they had come here.

When I was growing up, Jackson had much more of an identity than now because it was smaller. It was so small that one knew everybody, practically. It was a very free and easy life. Children could go out by themselves in the afternoon and play in the park, go to the picture show, and move about the city on their bicycles, just as if it were their own front yard. There was no sense of

danger happening in town. That was a nice way to grow up. The town was easier to know, all of which is gone now, of course, because Jackson is a city.

We had wonderful school principals and teachers that I still remember with great affection and awe. I am sure I was ignorant of all kinds of things. I had no political knowledge. My father was a Republican in Jackson. I do not think anybody but the Pullman porter was a Republican—he was a black man. You know, there were not any Republicans extant around here. My mother was a Democrat. And of course they argued politically at the breakfast table. I early got an idea that there were complications about our system down here.

I met Robert Penn Warren and Cleanth Brooks in Baton Rouge, and our friendship was certainly warm and long lasting. They were so good to me from the beginning. When I was totally unknown, they encouraged me and helped me in every way. I was indebted to both of them. You did not meet people like them, at least in my world. It was a long time before I got to meet them, either one. But when I did go down to Baton Rouge and met them, we had a grand time. I felt so picked out, so favored. They published me in the *Southern Review*. They were the first people to publish my work anywhere. I was very close to them, even though we did not meet very often.

Then Red came and did a lecture at Belhaven College, across the street from my house in Jackson. I told him about Governor Ross Barnett, and he laughed so hard I thought he was going to strangle. He just loved all those political tales from Mississippi. He said, "Every time I think about that night I still laugh till my ribs hurt." He loved choice things like that.

I remember going out after programs at the National Institute of Arts and Letters when the Warrens were living in Connecticut. They invited me to come home with them, and that was lots of fun. I always had such a good time with Red, in particular, because his sense of humor was laid right around here, you know, Mississippi and our politics and everything.

At the time I met Red and Cleanth, I was living in Jackson, just beginning to write, and it did not occur to me to think about the world of writing. It is really like a little network. I felt it was solitary to write. Just do a book, and somebody reads it. But they helped me realize what a network it is, a mutual learning society with readers and writers everywhere. They made me see the whole world of writing in a different way, in an exciting way. I did not know how lucky I was. But I became more appreciative as I learned more. They lived in that world, and it was just natural to them. If they saw something they thought was good, they did something about it. There are not many people like that. They made all the difference to my work and to me. And I am sure that was repeated in many other cases.

New York has always been my dream city. I went to Columbia's School of Business just so I could spend a year in New York and go to the theater. This was during the Depression. In fact, Roosevelt was elected while I was up there. My father and mother both wanted their children to be well educated. They wanted me to go where things were more exacting and liberal and under-

Cleanth Brooks and Eudora Welty, Rose Hill, Miss., 1985

standing. They wanted me to have all of that, and I did too. I went to the University of Wisconsin, which was then run by Mr. Glenn Frank. I believe that was his name. "This is a college, not a country club"—that was their motto. This was in the twenties. So I did get a good education. I was very grateful to my parents. I felt very aware of my blessings, because I saw how miserable things were down here. I could see the difference.

At the time I arrived in New York, I did not know any other southerners because I was just a schoolgirl. Lehman Engel was one of the people I met. He was an old Jackson friend, a wonderful person, and open armed with hospitality for anybody from Mississippi who went to New York. He knew everybody in the arts, because he was in the musical theater. He was a conductor and a composer, and he knew people in the entertainment end. I remember once he told me, "Keep your eye out for a young man named Gene Kelly." I remember that. Lehman was a good friend, and he knew absolutely everybody in New York who would be of interest to a writer or musician. He was so generous and shared everything.

Herschel Brickell was another friend who was from Yazoo City. He was a sweet, good man. I got to know him better down here than in New York. I did not go and look people up. I just could not do that. Herschel was so kind and so abundantly helpful to people. He knew Stark Young, who I knew was up there, although I never got to meet him. I was much too shy. I have been reading his correspondence, which is just beautiful. I read his reviews, of course, in the paper. Such a learned man. I like to think of his living within a stone's throw of William Faulkner. They could

just call out to each other, I should think. I used to see him at the theater. I had a job at the *New York Times* as a book reviewer. It was just a slight job, but it kept me in the city. I could be there and get off any time I wished and go to the theater. It was just like a fairy godmother had given me something I wanted. That was when Stark Young was writing his southern version of Chekhov. All kinds of things were going on up there. And Lehman's great friend was the dancer Martha Graham. You could learn the whole world by going to her concerts.

Mississippi had a regular little group. They were a tight-knit, self-conscious group. They all knew each other and invited each other around. And they were good to us kids who were going to Columbia. When you are young, you do not realize how lucky you are. There I was, put down in the middle of all these wonderful things, and I just took it for granted. I thought that was being in New York. I certainly appreciated it. I would have been deaf, dumb, and blind not to see what was there. And besides which, I realized later how exceptionally generous they all were as people to the young.

Another person I saw in New York was Katherine Anne Porter. When she was at the *Southern Review*, married to Albert Erskine, they invited me down to Baton Rouge. That was my first trip down there. I was petrified to go and meet her, but I did. She invited me to lunch, and that is how I got to meet her. She had always been kind to me in her work, and in promoting mine. That was just like standing under a shower of blessings. This was the time Red was writing his political novel on Louisiana, *All the King's Men*, and it was fun to

hear them talking about it. They were so generous and warm hearted. I am a shy person. I never would have approached them, but they wrote to me. That was their way. I will never cease to be grateful.

From the time I was a child, I loved films. You could go to them in Jackson. I always loved film. It spoke to me through the imagination. It was something you could do without any money to amount to anything. Now you have to pay untold money for a seat. But in those days, in Jackson, you could go for a quarter. I was lucky in every way growing up in Jackson. For a quarter you could go to the movies and see a cat man named Dr. Caligari. You walked where you went. You look back through rose-colored glasses, but I know life was made easy for me and for my imagination. When I went to New York and Columbia, I did the same things. I went to the theater and the movies and read good books. I had books in my family home that I could read and was always encouraged to read as a child.

As for writing, I do not remember making a conscious decision to write. I was a big reader, and I thought in terms of the imagination and words. It was natural, I think, to want to write. But it is an entirely different matter to be a serious writer. I do not know when that began—I guess after I went to college at the University of Wisconsin. There were some good professors in writing and in literature who made me feel that I was in touch with something.

My father died young, and my mother always encouraged me to write. She took it for granted that I wanted to be a writer. I knew she was behind me. In those hard days of the Depression, she thought nothing of paying for me to go to Columbia. Without words, she was encouraging me and channeling me in the right direction. I do not know what my father might have done. He died so young. He was just fifty-two. He did not live long enough to read anything I had written in print, anything professional. I do not know whether he would have encouraged me or not. He was not much for fiction, as he told me. He thought fiction was not the real world, that we should face up to what was out there. In the twenties, that was the way people thought. He was smart, and he read all the time. I grew up in a house where they were always buying books and encyclopedias and dictionaries and things like that.

My family thought learning was a good thing. We always had books. That was a marvelous background. We were brought up with the encyclopedia in the dining room, always jumping up from the table to settle an argument and look up things in the unabridged dictionary and haul out the atlas.

My father was a photographer. He had nice cameras. I began to use a camera when I was young and developed my film in the kitchen at night. The times were conducive too. Everything was in such poverty here. It was there to be photographed. Anybody could have seen it. Even I, as a child, could recognize it. It was telling its own story in human terms. I do not know what my father would have thought of my photographs because what he wanted was accuracy. And the actual picture taking—that was fine. That was part of it.

My parents nurtured my imagination. From the beginning, we had books in the family. They

were both readers, with very different kinds of minds. My father was factual and historical, and mother was imaginative. Fiction was what she liked to read. We read in this house all the time, all of us did. I think that is the luckiest thing you can do for a child, and I cannot imagine how different and bad life might have been to have grown up in a house where there were no books and no interest in the imagination or in what was happening in the world. We had that wonderful advantage.

I would not have dared think that I had a kinship with Tolstoy, or Dostoyevsky. But that is what led me on in reading them. I recognized so much, and I thought, "How good this is. He understands." I was just an ignorant person reading—a teenager in the case of Chekhov, my favorite of all. I learned so much from reading the Russians—not only in a human way, but as a writer. It opened up the whole world to read the Russians.

I enjoy talking to young Russian writers who come to visit. We have an affinity in that we both have a sense of the human problems in the world. And the material out of which you write interests both of us. It is wonderful to grow up and realize that you can have insight into the whole world of people. I never knew that as a child.

It takes time to come to these things for people who want to be writers. The word "career" will stop me. But as for the work you do yourself, I think it is right there for you to learn and find out, and that is what beckons you on and charms you. Writing comes from reading, from learning what can be done to understand the world around you. But it all comes from inside, of course. Every writer writes from within, but reading is what opens up that world. I am pretty old now. I am

in my eighties. I better hurry up and learn some more quick.

I met William Faulkner when I was in Oxford. I never would have looked him up. Miss Ella Somerville was a friend of his, and she invited him to dinner one night as a treat for me. I was visiting in her house with some mutual friends from Jackson. He came, and also his wife. Miss Ella was tremendous. She was one of the great ladies of the South, with a wonderful sense of humor, well educated. And she had an open house there for everybody with pictures on the wall that Stark Young had done for her. She was part of that world up in north Mississippi. I did not know she was going to invite Mr. Faulkner over. She did it as a surprise for me. He and his wife came to dinner, and I think there was one other couple. We just had a grand time. That was the way to meet him. I would have been petrified to just stand up and formally be introduced to Mr. William Faulkner. It was very informal. We stood around the piano and sang hymns after supper (which we all knew, of course—the same ones). He did not have much to say. But he did invite me to go sailing the next day. I was kind of scared to do it, but I did. How could I not have? They had just finished making that lake up there—Sardis Lake. He said, "Just be down there, and I will come up in the boat." He had made the boat, you know. "I will come up in the boat, and you come out and get on it."

So I went out there, and there was not any shore. It was nothing but a lot of "stobbs" around it, if that is a word, and these old trees. I did not know what to do. I did not want Mr. Faulkner to think that I was inept. So what I did was just walk on into the water and go on out and get in the boat.

It was very simple. One, two, three. I just waded out. I do not know if I took my shoes off or left them on. It would not have mattered—through the muck. Then I got in his sailboat. Of course, I was wet. But you cannot ask William Faulkner to wring you out. It had not occurred to me until this minute that I might have. He did not say anything. I did not say anything. Neither one of us said a word. We took a long sailing trip, and it was real comfortable. Nobody tried to make conversation. I am sure he never made conversation. I never got to know him well. But it was so kind of him to do that, and he was so much fun. I was lucky I got to meet him. I never dreamed I would.

I never passed a literary word with him. I would not have brought it up, and he never did. It was pleasant and nice, but it was not like a literary discussion. I was crazy about him. He was one of the gentlest, funniest people to talk to I have ever seen. He was quiet and shy appearing. I was very fond of him, in addition to my admiration for his work.

I never could have just driven up to his house and stopped to introduce myself. But people did. I used to get phone calls. "Do you have the ear of Mr. Faulkner?" "No sir." "How could I meet him?" "I have no idea."

I have only been there a couple of times, to Mr. Faulkner's home. It was a very remote feeling, but maybe anything in that part of the county is. I do not know. I do not mean I was lonesome. But I felt it was very private. I felt sort of like an intruder, an intruder in the dust.

Friendship certainly means a lot to me. It is rather hard to put it into words. I would say that friendship really has love in it. It has meant everything to me both personally and in the art of writing. The existence of your friends, whose words you find such meaning in—it is hard to conceive of living and working without it. It is an essential part of your life. I think that goes without saying. I am lucky to have come along at a time when there were so many people whose words I love. I suppose every writer does. You normally gravitate to the ones who are congenial.

My father was very progressive, and he was not happy with the newspaper situation in Jackson, or Mississippi. He wanted something reliable and quick with dispensing the real news. Radio was new, and it sounded full of possibilities. He wanted radio to have a future in Mississippi.

The year my father died, 1931, the radio station was brand new. My father got Mr. Wiley Harris to say he would be manager of the station and the announcer. He was a friend, a darling man. Out of the kindness of his heart, he asked if I would like a job down there. I had never had a job before, but I thought I could do it. You know, at that age, you think you can.

Since Mr. Fred Sullens refused to carry the schedule of the radio broadcasts in the paper, we got out a little weekly paper. We sent it out to anyone who wanted it, with the schedule, with the programs that came on, the timing. It was a little leaflet kind of thing, four pages long, and I was the editor of it. I had to make up whatever was in it. It was fun because I could write things about the people who appeared on the programs. It was exciting because everything was new.

I was not on the air. I was just publicizing the radio with a complete schedule of programs every day. You know, something like, "Leake County Revelers, the string quartet from across the Pearl

River." "Miss Magnolia Coullet." It was wonderful. Everybody was learning their jobs, they said. But they all knew so much more than I did to start with.

I do remember that the station manager, Mr. Wiley Harris, was absentminded. Every fifteen minutes he was supposed to say, "This is station WJDX in Jackson, Mississippi." He would forget, and we would say, "Mr. Harris, Mr. Harris." He would go to the microphone and say, "This is station, er, um, hmmm, this is station, er, um." We would write it down on a cardboard and hold it up: WJDX. He was real absentminded, but he was so sweet. Everybody was crazy about him. I do not know what he was thinking about. He had the programming on a blackboard over his desk. I got the program off the blackboard and put it in the newsletter that we mailed out. The most popular program was the Leake County Revelers.

When my father died, I was going to Columbia, and I came home. I did not go back to school. I always thought my future lay in New York City if I was going to be a writer, which was not true. But I thought it was. This was the Depression, I should mention, when nobody had jobs.

I got a job with the WPA, the Works Progress Administration. I was in the state office and was called a junior publicity agent. That meant I had to travel around Mississippi talking to people about various projects. There was every sort of project—farm-to-market roads, juvenile-court judges, airfields being made out of old pastures, library work, Braille, even setting up booths at county fairs. I would go on the bus to Meridian or Forest. I went to Tupelo soon after the devastating tornado that was there, because the WPA was helping them to build it back. That job took me to practically every county in Mississippi. It was an eye-opener for me because I had never been in those places before. It hit me with great impact to see everything firsthand like that.

It was a discovery. I was so ignorant about my native state. I was in my early twenties. I had gone to Mississippi State College for Women for two years, and that should have taught me, because I met girls from all over the state. But I did not really get an idea of the diversity of the different regions of the state, or of the great poverty of the state, until I traveled and talked to people—not schoolgirls like myself who were at college with me, but people in the street. I discovered the great kindness of everybody. They were all so glad to see someone in those days, somebody from away coming through. They were glad to see me. Hospitality was everywhere. Nobody was suspicious. It was innocence on both sides.

So I began taking the pictures, not in connection with my job, but for my own gratification on the side. I was not the photographer of the WPA. I was a journalist, and I was doing a newspaper job, interviewing. Everybody I had to see lived in courthouse towns like Canton and Yazoo City— you know, county seats.

Usually, there is one good-sized little town in each county. That is where everyone converged on Saturday. That is where the stores were, the hub of life. If you went on Saturday, you saw everything going on. We usually stayed in a hotel. I can remember the electric fan I would have to turn on me all night in some little hot town. The telephone was out in the hall or down in the lobby, which did not matter a bit.

You did not have to plan ahead. You could just hit town, and everything opened up for you. You could always get a room. That was before people stayed in tourist courts or motels, except for nefarious reasons. So you would stay in hotels.

The people whom I met were strictly acquaintances. I did not make lasting friendships. I would see a person probably only once in my life. Both black and white people never seemed to hold back anything. I would not have expected it. Everything was perfectly open.

I began with no end in view. I just took the pictures because I wanted to. Just impulse. I was not trained and had no good camera. But for that reason, I think, they may constitute a record. I think that is the only value they could have now. I had no position I was trying to justify, nothing I wanted to illustrate. They were pictures because I would see something I thought was explanatory of the life I saw.

I think those experiences are bound to have shaped my stories, indirectly. Never in my work have I used actual happenings transposed from real life into fiction, except perhaps once, because fiction amalgamates with all kinds of other things. When it comes out as fiction, it has been through a whole mill of interior life. But I think nothing could have been written in the way of a story without such a background, without the knowledge and the experience that I got from these things. It provided the raw material. And more than that, it suggested things in a valid way that could never have been made up without this reality. It was the reality that I used as a background and could draw on in various ways, even though indirectly.

My father had died by that time. But my mother was very interested in my traveling and my photographs. She wanted me to be a writer. She knew my wish to be one. But I had to have a job. This was the Depression. I was lucky to have a job. I could have done it better, probably, in better-off times if I could have had a car instead of having to go by bus or train and catching rides. But I could not take the family car away for a week at a time. A lot of the pictures that were taken when I was in my car were close to Jackson for that reason. I would just go out to Raymond or Utica or Port Gibson, or somewhere that I could drive to and come back in a day. And the farthest places I went to, I was not my own commander of where I went. You cannot stop a Greyhound bus to take a picture. Some of the things I could have done better, but that does not matter.

One thing I remember did have an effect later in a story. We had to put up booths at county fairs. I loved that because I always loved fairs, being on the midway and hearing things. I heard about an act that was almost like "Keela, the Outcast Indian Maiden." I did not see such a thing, thank God. That was not my story, although it was the background of my story. My story was about three different reactions of people that have come in contact with such a hideous human event. I heard that, and some time later on I made it into a story because it bothered me for so long—how people could put up with such a thing and how they would react to it. That is one thing I remember, because I did some work that came out of it.

Mostly I remember things visually. I remember how people looked standing against the sky at the end of a day's work. Something like that is indelible to me. Most of the conversation I had was in

Eudora Welty, Jackson, Miss., 1978

the way of interviewing people and writing them up. They were telling me about the project, but not about their lives, except indirectly.

I did stories in school, but they were not any good. There were not any courses given in so-called creative writing when I was in college, which is probably just as well. I think you have to learn for yourself. You could be helped, certainly. I could have been spared a lot of mistakes. But I think you have to learn from your own mistakes. I believe 1936 was when I sent my first story out, and it was published that year. I was working for the WPA right up until it was disbanded with the reelection of Roosevelt. We were through on the day he won. We did not know that was going to be the end, but it was.

For me, doing journalism for work was not preferable. It may be for other people. Everyone has to find out. I would rather do something unconnected with words to earn my living because I like to keep my tool for one thing. But that does not mean it would trouble the next person, or the next. You just have to go by your own wishes.

To me, Mississippi is a special place. Since it is the only one I really know, it is the whole foundation on which my fiction rests. It is a way to test the validity of what you think and see, and it also sets a stage. It helps to identify characters, helps you to make up characters because your characters grow out of place. That is the way you test them as to their validity and their propriety in your work. I have not read the essay I wrote about "Place in Fiction" in an awful long time, but I know I can say anything much better on paper than I can in conversation.

Place—geography and climate—shapes char-

acters. I do not see how it can help it. Place is the world in which they act that makes their experiences—what they act for and react against. Place produces the whole world in which a person lives his life. It furnishes the economic background that he grows up in, and the folkways and the stories that come down to him in his family. It is the fountainhead of his knowledge and experience. If we do not have that base, I do not know what we can test knowledge by. It teaches you to think.

Sense of place defines things for me and fills me with a sense of history. I cannot imagine writing without the base of place, any more than I can imagine writing without the other things a writer needs to make his story valid both to himself and to the reader. In the South, we have an inherited identification with place. It still matters. Life changes, as it always will and should. But I think the heritage of place is too important to let slide away.

There is a sense of continuity in a community where you know the grandparents and the parents and the children in a family. You can understand the people better when you know them in the context of their families. That has probably changed some now. We move around a lot more than we used to, and that continuity has been broken in lots of places. But the sense of it remains in all of us. We have family memories even if we move around more. The sense of a person's full life, what happens to him in the course of it, and how that influences his children's lives, is part of place and part of time. The two things work together.

The knowledge that another person has all

this behind him can help give a background to his opinions and his feelings. It is an easy way to begin to understand other people. You miss that in our urban life where you meet somebody cold and have no idea of his background. Everything has to start from scratch, and for that reason can remain more superficial unless you really work at it. With your best friends, you overcome everything. The ordinary acquaintanceship of life is so much easier in a place with continuity. I think not only southerners but New Englanders and many other people feel the same way.

I have no explanation for the great number of writers who have grown out of Mississippi. All Mississippi writers are asked about this, and some people have come up with theories. But I do not know. I think one of the great mysteries of life is how, in some centuries, a section of the country will just produce everything—like New England at one time, the Middle West at some time, then the South. Who knows why these things happen? I do not know, but I am glad they do.

As for my own work, I think of it more as an internal map than a map of a geographical place. It is a map of minds and imagination. It has to be laid somewhere. What guides you is inside the characters, to show what they are doing. I understand the idea of fiction as a map of a place. Faulkner's marvelous work really is a triumph of the first order in that respect. But I have no such abilities or ambition. I locate a story, and that is all.

The ability to use dialogue, or the first person, is just as essential as the knowledge of place in a story. Dialogue has special importance because you use it in fiction to do subtle things and very many things at once—like giving a notion of the

speaker's background, furthering the plot, giving a sense of the give-and-take between characters. Dialogue gives a character's age, background, upbringing, everything, without the author's having to explain it on the side. The character is doing it out of his own mouth. A character may be telling a lie, which he will show to the reader, but not to the person to whom he is talking, and perhaps not even realize himself. Sometimes he is deluded. All these things come out in dialogue. You get that, of course, by your ear, by listening to the rhythms and habits of everyday speech. I listen all the time. I love it. I do not do it because I have to, but because I like to.

I do not think you can transfer anything as it is spoken onto the page and have it come out at all convincingly. What comes out as a sound is not what the speaker thinks he said, or, really, what he did say. It has to be absolutely rewritten on the page from the way it happens. But if you did not know how it happened, you could not start. It is a matter of condensation and getting his whole character into speech. It is a shorthand. It is like action. It is a form of action in a story. People do not talk that way. You have got to make it seem that they talk that way. You are giving what seems to be reality, but it is really an artistic illusion. You have to know that, just the way you have to know other things in a story to make them seem believable. They are not duplicates of life, but a rendition of it—more an impression, I guess.

Color is different from dialogue. One comes through the eye, and the other through the ear. Color is emotionally affecting to me, and I use it when I write. I may not use it exactly as I see it. I use it as I think it ought to be in my story to con-

vey a certain emotion—just as I would use a time of day or a season of the year. Color is part of that. It gives the sense of a real place and the time of it. Life does not happen in monochrome. It happens in color. So it belongs in the story.

"Why I Live at the P.O." does not have any background. I once did see a little post office with an ironing board in the back through the window. This was in some little town—less than a town—some little hamlet in Mississippi. That made me think, "Suppose somebody just decided to move down there." It was an exercise in using the spoken word to tell a story. And I made it up as I went along. It was an early story. It would have been improved by more thought and better construction.

It is interesting to me to use the spoken word to drive a story. While you do not use exact things people say in a situation, you can use an exact phrase someone has said and adapt it to your situation, where it is the perfect way to say it. You do that by a fund in your head, by having heard people talk and noted in your mind all your life the way people say things. It will come back to you at the right time. It is not taking it out of one box and putting it in another. It is a transformation, a magic act—if it is good.

I want everything to be right. So much can be revealed in a detail that seems insignificant. It makes me feel better to think things are right. So much of the belief of a reader depends on not having things wrong. An editor a long time ago told me, "Don't ever have the moon in the wrong part of the sky." And that is important. I notice when I read other people's works, often a man will have something blooming at the wrong time.

He has never been out in the garden. He does not think it matters. He just names some flowers. Well, that destroys something for me when I read it, and I try not to make those mistakes. You cannot always know that you have made a mistake. I am a natural observer, and to me the detail tells everything. One detail can tell more than any descriptive passage in general. That is the way my eye sees. It goes back to place again. You have to have everything truthful. Having the world truthful—the setting—helps to make your story more easily believed.

I once got a letter from a stranger after I published a story called "The Wide Net." He wrote and said, "Dear Madam, I enjoyed your stories, but blue jays do not sit on railroad tracks." And sure enough, they do not. But you know, I did not think anything of it. I did not know anything about birds. Probably blue jay was the only name I knew at the time. But that is the kind of thing that you do not want to get wrong. That was somebody that that offended, and rightly. Birds have as many peculiar habits as people. So you had better watch out what you have birds doing, just as you had better watch out what you have people doing. That was a good lesson.

One of the phrases that I overheard and used in stories is "He looked like he was going home." I think I used it in *Losing Battles*. You know, "Which way? Did he look like he was going home?" They really knew. I have heard people say, "He looked like he was going down the road to turn around and come back." It was knowing this person and how they drove.

Since I am not an outdoor person except by love of it, my knowledge has come the hard way,

by observation and wish to know. To have slept on the ground covered with stars is growing up in intimacy with the earth. Both my parents came from farms in a different part of the world—Ohio and West Virginia. And they knew everything. A lot of what I know comes from my father, who could predict the weather. He had all these signs. "It is all right to play golf, because if the birds begin to sing, it means the rain will be over in a certain number of minutes." I heard things like that all my life, and he knew that from a boyhood on the farm.

My father was not interested in flowers. He used to tell Mother, "I will plant the trees. You take care of the posies." It used to upset him—being from Ohio—to see how farmers in Mississippi never planted their corners. They would let everything straggle out. They did not have everything neat and in rows. It was done so slap-dash. He would say, "That is a sorry way to plant a field."

My mother was a great gardener, and really a horticulturist by inclination and study. She taught herself. I grew up in a house that liked things growing. This big oak tree out here in the yard, my mother planted it. She refused to cut it down, although we had seven giant pines standing around it. Now the pines are gone, and the oak tree is majestic. She said, "Never cut an oak tree." And that is a fact.

I still take the *Mississippi Market Bulletin*. I used to order flowers through it from the ladies. I always wanted to write them letters when they sent the flowers. They would sign them, "your shut-in flower friend. Please sit down and write me your news." They would write me all kind of things from way off in Neshoba County. They would offer to sell you bulbs. I suppose they had somebody to dig them. They measured things as a "soda box full" or a "gourd full." You could buy "two thousand seeds, no two the same," kind of like I said in "Why I Live at the P.O." When you ordered daffodils, you did not know what kind they were. If they did say what kind, it was never right. One lady wrote and said, "I got your order for double blooming pink hyacinths, but I can't go out and dig these things now." You know, like it was my fault, and she sent my money back.

Southerners probably have some of the same background as those Irish and Scots and the other people who have long memories in this part of the world. It has been said by people who know more about it than me that one of the reasons southerners have this to talk about is that they do not have much else to talk about. It is their source of entertainment, besides their source of knowledge. The family tales while away a long winter evening, and that is what they have to draw on. You feel that in Faulkner a lot, especially in the little hamlets where people sit on the store porch and talk in the evenings. All they have to talk about is each other, what they have seen during the day, and what happened to so and so. It also encourages our sense of exaggeration and the comic, because tales get taller as they go along. I think beneath all of that is a sense of caring about one another. It is a pleasure and an entertainment, but it is also something of deep significance to people. I think southerners care about each other, about human beings, in a more accessible way than other people. We can reach our feelings more easily.

I look at everything through the light of characters who find answers to what they are look-

ing for in their past. It is part of our makeup that we think about the past. It would be a mistake to dwell there and have no sense of the present and no expectation of the future. But you cannot understand the present or hope for the future without the background of the past. The narrative of someone's life extends both into the past and the future. You have to have that sense of something propelling it, joining it, making sense of it.

I do not write as a woman. I just write. I am a woman and totally one. So totally that I cannot imagine writing outside of what I know and feel and understand. But I am not conscious of being a woman any more than I am conscious of sitting in this chair. It is just part of my equipment.

I do not believe I could write a novel from a man's point of view. It is much more natural for me to write as a woman. I have always written from the point of view of a woman in a novel. But a short story is different. You are writing about a character, and the character takes the role that you assign him in the story. You do not have to go any further in the character than the short story calls for. So you can write from the point of almost anybody.

The hard part is putting yourself in the mind of another human being. It is less a question of whether you can do it as a man or woman. Once, I put myself in the role of a black jazz piano player with the same temerity or lack of temerity as I did in "Why I Live at the P.O." I did it because it was a dramatic conception in a story I wrote.

I think we have a native love of the tale. I remember once Robert Penn Warren was at my house, and there were a lot of us sitting around talking. He laughed so hard, and he stayed so late.

When he left, he said, "I had a perfectly wonderful time—not a serious word was spoken all evening." I thought he had something there. We told so many tales. He had Kentucky ones, and I had some from West Virginia and Mississippi. Charlotte Capers was there, and she had some Tennessee ones.

I think our love of writing grows out of the love of the tale and the love of talk which goes on in this part of the world. I think that love leads naturally to writing. Writing is a very solitary art. It comes out of a love for the story, out of the inside of the individual.

I do not believe that a work of art has any cause to be political. There are places for political outspokenness. But in my mind, it should be done editorially and in essays that are exactly what they seem. I think a work of art—a poem or a story—is properly something that reflects what life is exactly at that time. It should try to reveal life. Not to be a mirror image, but to be something that goes beneath the surface of the outside and tries to reveal life the way it really is, good and bad, which in itself is moral. I think a work of art must be moral. The artist must have a moral consciousness about his vision of life and what he tries to write. To write propaganda is a weakening thing to art.

I got lots of phone calls in the bad sixties when we were having all the troubles here. People—especially from Boston, somehow—saying, "What do you mean sitting down there and not writing stories about your racial injustice?" I think I have always written stories about that, but not as propaganda. I have written stories about human injustice. It was not anything new to me that people

were being unjust to one another then, because I had written about that in all of my work, along with other things people have done. I was looking at it in the human—not the political—vision, and I was sticking to that. I did not want to be swerved into preaching disguised as a work of fiction. I did not think that was required of me, or necessary.

I was glad to say what I thought about anything straightforwardly, but not to write a story as an illustration of something per se. I still feel that way. All great works have been moral documents. It is nothing new. The part that seems so strange is that people would say, "Have you ever thought before about such things?" They did not mean it that way. But that is the way it sounded, coming in the dead of night.

I would not say I share a sense of community with other southern writers. I am very fond of the ones I know, but I did not meet most of them until much later on. I had been writing for twenty-three years before I met Red Warren, who was one of my first publishers. He was editor of the *Southern Review* and had written me letters and accepted my work and encouraged me. But I did not meet him until he came to lecture across the street at Belhaven College, and I was delighted. I met Katherine Anne Porter earlier. She invited me down to Baton Rouge, but Red was away. I met her and Cleanth Brooks at that time.

You know, the South is a big place. As Reynolds Price points out, it is as big as France. And we do not live in each others' parlors. I came along a little late for the Allen Tate–Cleanth Brooks–Robert Penn Warren group, the Fugitives. They had already formed and dispersed before I came along. They were a community. I love to see writers when they coincide with my friends, but not just as writers. You work by yourself. And I am grateful to a great number of them, and love many of them as friends.

I work alone in my room. That is the only way I can work. Writers do not live in groups, and that suits me. I like to work in peace and quiet. But here there are always distractions, and you have to cope with them. Like that mockingbird. It is not scared of anything. It is just like a chicken. When I come outside to move the hose, he just keeps walking around. I have two deadlines for articles. I have been working all day every day. In fact, I was so tired last night I could not sleep.

As for black southern writers, I know Margaret Walker and Alice Walker. There are two Walkers here, and Margaret is the one I really know well. She is out at Jackson State, and I like her very much. They have all been here in my house. I know Ralph Ellison. I have known him over the years—since the forties in New York—and like him very much. He is a fine, delightful man and a good writer. It is very hard to do what he does. He is writing fiction, but it sounds like it has been recorded and transcribed, though he is doing much more than that. It takes art to make something read as though it were spoken, art of a very high kind.

The experience that inspired "A Worn Path" was out on Old Canton Road. At that time, Old Canton Road was in the country. I was with a painter friend who was doing a landscape, and I came along for company. I was reading under a tree, and looking up, I saw a small, distant figure come out of the woods, move across the whole breadth of my vision, and disappear into the woods on

the other side. I knew she was going somewhere. I knew she was bent on an errand, even at that distance. It was not casual. It was a purposeful, measured journey that she was making. What I felt was—of course, that was my imagination, since I never knew—was that you would not go on an errand like that, so purposefully, unless it were for someone else. Unless it were an emergency. I made her journey into a story by making it the one you would be most likely to go for—a child. So I wrote that.

Another time, on this same road and in similar circumstance, an old woman came down the road. I do not know whether she was the same person or not. She stopped and talked to us, and she used the words to me, "I was too old at the Surrender." Maybe it was learning to read and write. I do not know. That was indelible in my mind—"too old at the Surrender." I put that into my story because it belonged in it. It was a case of joining two things I had thought of, and making them into one. That is a simplified way to state it, but it is a good example because it is explicit. Folklore and fiction are different branches of the same tree, and there are many connecting lines between them.

As for film, I have not worked in it. I have been a subject of films. But I have not done anything of my own in film, although I would like to. I think film is a marvelous thing. I have been interested in it in the past, and once I tried to write a scenario. I did not think it was worth even showing anybody. I did not know enough.

I see a relationship between film and short stories in technique. I am thinking about film, not in the documentary sense, but in a feature film with the use of flashbacks and memory, of a dream sequence. There are things you could not show on a stage that you can show in the fluid form of film. You can move back and forward, and back and forth in time. You can speed up life or slow it down, just the way you do in a short story. Film can elide. It can compound. And it can exaggerate. It can do all the things you do as a short-story writer. As a short-story writer, I feel that I must have absorbed things from film. I have been a constant moviegoer all my life. I must have absorbed some lessons that have come in handy. It is just like—in the way of folklore—these things come into your mind, and you learn from them without really knowing.

I have not seen any films recently that make me want to be an avid moviegoer—except *The Return of the Pink Panther*, which I think is marvelous. Do you remember the French film *Breathless*? It is a beautiful film. I saw it two or three times. I felt very strongly when watching that how film techniques are like a short-story writer's skills. I think most films that are made from fiction do better to work from the short story rather than try to condense the great ramifications of a novel into a film. It is better to expand from a short story.

When we were young, we never missed a film. Part of my life in New York was spent running out to the Thalia and every little foreign cinema, seeing all those films. I like detective stories, but I do not think they make good films. Hitchcock is a trickster and a magician, and so are writers. His transitions are old hat now, but at the time he began, they were new—showing a person screaming, and all of a sudden that scream turns into a train whistle which is the next scene of a

train going along. A short-story writer uses transitions like that in a less obvious way, more in a symbol or detail of observation which becomes a figure in the next section. You use something that will transport you from one scene to another, even if you do not know it, even if you do not realize it. That is like a film. Perhaps Hitchcock was using short-story techniques. I do not know who thought of it first. It has been there forever.

I think the lyric film teaches you more than the adventure film. The mood films show you how atmosphere is used. The French always do it better than anyone. They have so many people who were trained in a world of art—like Jean Renoir. How could he not have amassed his great knowledge of the making of a film from the painter's household he grew up in?

I knew lots of painters growing up here. But Hubert Creekmore, up the street, was the only writer I knew. There were not many people writing around here. Hubert started before I did. He was a good friend and a very talented and wonderful person.

I knew a lot of people who were interested in writing, which was good. I never did show anybody my early work. I was too shy to show it to a living human being. When I asked Hubert to whom I could send my writing, he gave me some addresses, and that worked. Once they were in print, I did not mind showing them to someone.

I have been a lucky person all my life. I always have around me congenial, helpful, sensitive people. I was lucky in my agent and my publishers. Everything worked out beautifully, and I am grateful.

Ernest Gaines 1933–

BORN IN POINTE COUPEE PARISH, LOUISIANA

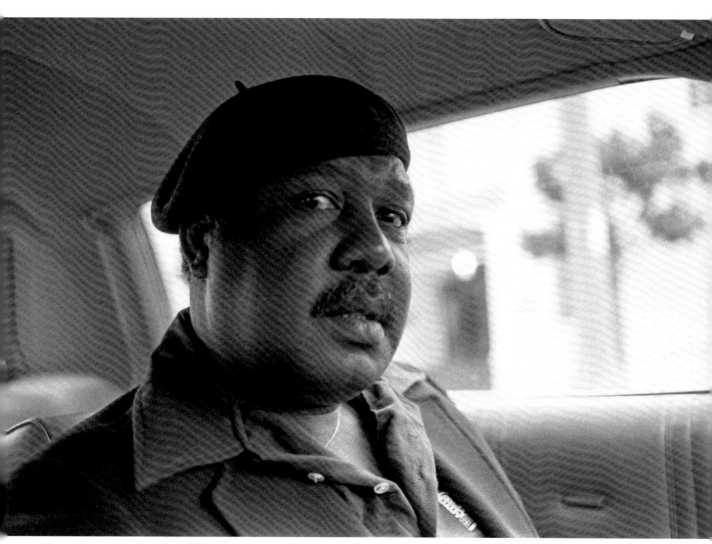

Ernest Gaines, San Francisco, Calif., 1980

I was trying to recall what people do in the South—they come together and talk at events such as funerals or baptisms or weddings or wakes or the birth of a child. They come together, and they do a lot of talking. You might have a dozen or more people sitting around talking.

Alice Walker introduced me to the work of Ernest Gaines in 1971 when I taught at Jackson State University. At that time Alice and her husband, Mel Leventhal, lived in Jackson with their young baby, Rebecca. Alice had recently sent Gaines her manuscript of *The Third Life of Grange Copeland*, and he in turn shared his galleys of *The Autobiography of Miss Jane Pittman* with her. Alice spoke enthusiastically about Gaines's literary talents and his generosity in helping younger writers.

The following year I began teaching American and Afro-American studies at Yale University, where I used Gaines's recently published *The Autobiography of Miss Jane Pittman* as a text in my class on American literature and the oral tradition. I invited him to speak to my students, and to my delight he accepted. During a master's tea in Calhoun College, Gaines read passages from his new novel and spoke about his craft as a writer. His soft, gentle voice animated his characters with special power. When he arrived on campus, Gaines told me, "You know, until we met today, I thought you were black." I told him that I was deeply honored.

In 1980, I interviewed Gaines at his apartment in San Francisco. Before the interview, he showed me beautiful black-and-white photographs he had taken at his childhood home of New Roads, Pointe Coupee Parish, Louisiana. Majestic oak trees, country roads, and the houses of family and friends were lovingly framed and hung in his front hall. Those photographs in his San Francisco apartment clearly connected to his fiction.

During the interview we sat together in Gaines's study, where a photograph of William Faulkner hung above his desk. He recalled his childhood in Louisiana

and the beloved aunt who had raised him. We also spoke of southern storytellers and how their voices inspired his fiction.

We visited again during a reading Gaines gave at the University of Mississippi and in 1992, when he spoke at a symposium on African Americans in Europe held at the Sorbonne in Paris. The weeklong event was cosponsored by our Center for the Study of Southern Culture at the University of Mississippi with Michel Fabre at the Center for Afro-American Studies at the Sorbonne, Henry Louis Gates at the W. E. B. Du Bois Institute at Harvard University, and Jack Salzman at the Center for American Studies at Columbia University. Wearing his signature beret, Gaines read from his fiction and was lionized by his French admirers. While at the National Endowment for the Humanities, I was present when President Bill Clinton presented both Toni Morrison and Gaines with the National Humanities Medal in 2000.

During the summer of 2010, Marcie and I spent two days with Ernie and Diane Gaines at their beautiful home on False River Road in Oscar, Louisiana. They built their home on land they purchased that was originally part of the plantation where Gaines's ancestors worked as slaves. The plantation manor stands several hundred yards south on False River Road. During our visit, Marcie and I walked with Diane through sugarcane fields and visited the historic cemetery that Gaines has restored where his ancestors are buried. He also moved to his property and restored the school/church where he studied and worshipped as a child. His black-and-white photographs that hang on the wall of that building reminded me of how the memory of his childhood worlds has shaped his literary career. In Gaines's living room, a framed photograph of the aunt who raised him and was later his inspiration for Miss Jane Pittman is prominently displayed.

In May 2011, Gaines received an honorary degree from the University of North Carolina at Chapel Hill. Before the ceremony, Ernie and Diane Gaines had lunch with Marcie and me in our home, along with my former student Rudolph Byrd, who was writing Gaines's biography.

Each time we meet, I am struck by the gentle voice of this large man who has created loving portraits of both black and white characters. In his fiction, he forges relationships of love between black and white figures in uniquely beautiful ways. Ernest Gaines has immeasurably enriched our lives, and this interview offers a glimpse at the vision that inspires his writing.

I recorded this interview with Gaines at his apartment in San Francisco in 1980.

I left the South when I was quite young because I could not get the kind of education my people wanted me to have there. I still write about the South because I left something there. I left a place I could love. I left people there that I loved. I left my aunt. I left brothers and sisters. I left friends.

When a lot of black and white writers leave the South, they want to totally wipe it out of their minds. They do not want to remember it. Or, if they remember it, they remember it as not a happy place in their lives. I have always known it as a place I loved. And the people there, of course, I loved very much.

I have a very strong imagination. I can sit at my desk and see roads and bayous and towns and

houses and hear voices. I can write about it because I left something there. I have never been really rooted in California. I love San Francisco like no other place. I have been quite comfortable here. My people are here. My mother is here. My brothers and sisters are here.

I go back to Louisiana. I go back all the time. And there are many Louisianans here in San Francisco. When I was writing *The Autobiography of Miss Jane Pittman*, my grandmother was alive and living here in San Francisco. She was always cooking Louisiana food all the time—gumbo all the time, jambalaya all the time, shrimp creole all the time.

I always take a camera when I go back to Louisiana. I take both black-and-white and color photographs. I have taken a lot of pictures. Most of these pictures were taken ten or twelve years ago. I have tried to get some good shots of railroad tracks lately. I shot several railroad tracks in my part of Louisiana around Baton Rouge, but I have not gotten the perfect track yet. I have some good photographs of roads and lines of houses, and rivers and bayous, but I have not gotten the tracks that I want. Sometimes I look at my photographs when I write, but I seldom ever do. I think that my mind's eye sees the area just as well as that photograph does, maybe even better, because the photograph is limited. The mind's eye can travel down the road like a movie camera.

I keep the photographs because most of these places are gone now. The stores are gone. The houses are gone. This river is all built up, and this man is dead. They are things of the past. I do not think that anything like that will ever be there again, ever, ever again. This man cannot come back, and you will never see these places again—never again, and surely not there.

I left Louisiana when I was fifteen. I left my aunt there, who raised me until I was fifteen. And I left brothers and sisters and friends. When I first started writing, I wanted to write about them. I wanted to write about how we lived, because I did not see those worlds in any books that I read. I saw nothing about how we lived. I was trying to write about us.

When I started writing *The Autobiography of Miss Jane Pittman*, I had written several other books. I had written *Catherine Carmier*, *Of Love and Dust*, and *Bloodline*, which were all about my area in Louisiana. From the beginning, I wanted to write about that area, and I continued to write about it. My first novel, *Catherine Carmier*, takes place in the early 1960s. After finishing that book, I felt I had not gotten everything in it that I wanted. So I wrote *Of Love and Dust*, and that went further back to the 1940s. Then I wrote the *Bloodline* stories, and they took place between the 1930s and the 1960s. I found that the more I wrote, the further back I was getting. I was getting back into what I thought of as the experiences that my people—my own immediate family—could have experienced.

Some people have asked me whether or not *The Autobiography of Miss Jane Pittman* is fiction or nonfiction. It is fiction. When Dial Press first sent it out, they did not put "a novel" on the galleys or on the dust jacket. A lot of people were thrown off by the introduction where a young professor from Baton Rouge goes to this plantation to interview an old lady with a tape recorder. I wanted to prepare you for Miss Jane's language, and I tried to

Ernest Gaines, San Francisco, Calif., 1980

show you that the story could not be told without help. I do not think a 110-year-old lady could tell her story of 400 pages without some help, so I had other people help her out. The introduction is fiction, just as the novel is.

I think a lot of people read the introduction and stopped. They thought this was a book about Ernie Gaines taking a tape recorder down and finding an old lady. He threw away all the stuff he did not want and then called the rest a novel.

I never conducted any interviews. I created it all. I did a lot of research in books to give some facts to what Miss Jane could talk about. But these are my creations. I read interviews done with former slaves by the WPA workers during the thirties. I got their rhythm and how they said certain things. But I never interviewed anybody. I never have. Since *The Autobiography of Miss Jane Pittman* came out, I have gotten letters asking me to interview old people. I said, "Listen I do not know anything about interviewing old people! I wrote a book! I do not know a damn thing about interviewing people."

There are certain things you capture in fiction that historical texts can never render. That is where the imagination plays its role. I read a lot of slave narratives, a lot of biographies, and a lot of history by both blacks and whites, by both southerners and northerners. Then I listened to rural blues and to sermons by ministers. I read and digested it all. Then I listened to the old people. I spent a lot of time in Louisiana. I kept talking and asking questions. Then I said, "Okay, I have this thing in me now. Imagination must take over."

My intention at that time was to put all of this accumulated knowledge of black experience into the mind of a Louisianan, an illiterate ex-slave who had basic common sense, but who did not have the advantage of books.

I did not go to history books for truth. I went to history books for facts, but not truth, because history and truth are different. With Miss Jane, I worked to find events that she might remember from the past—locally, statewide, nationally. I did a lot of reading and a lot of research. I talked to a lot of people, chewed all this up and tried to get a 110-year-old woman to talk about it. It takes a little time.

I did not plan on writing a historical novel that would rewrite American history. If I walk out on the street in Harlem, I am sure I am going to see a black lady who is uneducated, and I am going to wonder, "What is her story?" That is what I had in mind when I started out. That is what I was trying to do. I wanted to write different sketches about things that she could go through. It was not about her life, but sketches of things that happened to her. When I was writing, I was listening to Mussorgsky's *Pictures at an Exhibition*. The way Mussorgsky uses music as sketches for those paintings was the inspiration for what I was trying to do with the sketches of Miss Jane's life.

The novel is made up of four books. It begins around 1864, and it goes to 1962. I cut it off just before Kennedy's death. Everything is created except for the historical facts that there was slavery in America and there was a civil war.

Booker T. Washington said there were three things that the slaves actually wanted to do after they had their freedom: One, leave the planta-

tion, even though they might have to come back to it; two, change their names; three, learn to read and write. The first part of the book was based on those first two things—movement and names.

I know through reading slave narratives that freed slaves sang, applauded, and said, "We are free!" When I was writing this story, I remembered that white kids had said they were free too when Kennedy was assassinated. At that time, a lot of white kids felt that Mr. Kennedy was making them slaves. I was in Louisiana in 1963, and I know how a lot of the white people in Louisiana felt. I suppose they could have felt the same way in Georgia or Mississippi or anyplace else.

One character, Albert Cluveau, is based on a man who actually existed. In 1903, a Cajun assassin killed a black professor on the river that I write about. That was a story people told all my life. When I was back in Louisiana recently—on the place where I grew up on the river—I visited the Palange mansion. I met Madame Palange, an old lady of about eighty something, and she had read my book. She remembered that terrible Cajun assassination, and she told me she knew exactly who I had based it on. This man, who would kill for whomever was paying him, was quite friendly toward people. He would sit around and talk about his killings. Since I heard that he did these things, that is the way I put him in the book. There is that relation between black and white. That is all there is to it. I grew up around it.

During the time I was writing, I heard the voices of not only all the ex-slave narratives I had read, but also the voices of my Louisiana people. After I got really moving, Miss Jane's voice just fol-lowed. I hate to say things like, "I hear the voices," because then people think I am nuts. But when I sat down at my desk, her voice took over, and I started where I left off the day before.

I had lived with that book all my life. When I first thought about writing the book, I tried to tell it from multiple points of view. I was trying to recall what people do in the South—they come together and talk at events such as funerals or baptisms or weddings or wakes or the birth of a child. They come together, and they do a lot of talking. You might have a dozen or more people sitting around talking.

That was the approach I used in the beginning. Miss Jane was already dead, and I wanted her story told through a group conversation. They would start off by talking about her. If a group of people start off talking about a certain subject, the conversation will spread out and go in all directions. They start out talking about Miss Jane, and they might include themselves and history and philosophy and jokes and tales. And that is what happened.

For about a year, I used this multiple point of view. But I was not getting what I wanted. I put what I had written aside and started over from her point of view. I already had voices coming from all directions, so her voice was not hard to concentrate on. I had been concentrating on different voices before then. They had talked so much about Miss Jane, you see. So I just got her to talk.

People say to me, "Oh, Miss Jane sounds so real." I found something that I could deal with—grab this oral voice and put it in on paper. I lucked out and was able to do it. Had I not done a lot

of reading, I would never have been able to do it. That is what I found in Turgenev's *Fathers and Sons*, or Joyce's *Dubliners* or *A Portrait of the Artist as a Young Man*, or Sherwood Anderson's *Winesburg, Ohio*. They showed me how to use the oral tradition that I had grown up in.

I never think about the difference between an oral style of conversation and a written one when I write. I try to write what I hear. That is all I try to do. I never think about the difference between the written word and the oral word. I just write as truly as I can—as simply as I can—to communicate with anyone who reads my book.

I wish I could get up on stage and tell a story, but I am really not a storyteller. If I go to a bar and tell a joke, people say, "Get outta here. Go home and write your novels." I cannot tell a story. None of my friends will listen to my stories. They walk out of the room. I come from a tradition of storytellers, but I am not good at it. My brothers and my mother tell fantastic stories.

I think the relationship between storytelling and writing is definitely an American thing. I think all of our greatest books have been in the first person—starting with *Moby Dick*, then Twain's stories, and then Faulkner's stories. Hemingway once said that anyone can tell a story from the first-person point of view. I do not know if that is true, but we Americans do tell it better from that point of view. The books that I read by American writers that seemed truer and had more influence on me are those told in the first person. I am thinking about *Catcher in the Rye*, which is a fantastic book told in the first-person point of view.

I admire good writing done from the omni-scient point of view. I read something by Joseph Conrad and say, "Goddamn!" I do not know American writers who can write like that. But when you come to the first-person point of view, man, I do not know who can beat us.

When I was in Africa, the writers were concerned with how to find a voice—not only in Afro-American writing, but in African writing. In Nigeria they told me that sometimes they pick up a piece of writing, and unless they know the writer's name, they probably will not know whether he is white or black. They asked me if I have that identity problem here. If I just picked up a piece of writing, could I identify that piece of work as being by a black writer or a white writer? I told them that if I knew the writer, if I had read enough by him, I would know. For example if I picked up a Hemingway book, I would know it was Hemingway. If I picked up a book by Baldwin, I would know it was Baldwin. But I also explained to them that I could not separate my association with white writers because I was so much influenced by them. The first writers I read were Steinbeck, de Maupassant, Turgenev, and Faulkner. I started with Faulkner.

The novel itself—the literary form of the novel—is the creation of white writers. So if we write a novel, we are already working in a form that was established by white writers. Then, of course, we are using the English language, which is a white, European language. I bring other things into that language because of my background. I come from the rural South, so I am influenced by jazz and blues and spirituals and telling stories. I listened to these as a child, and I bring them into

my own work. They give my writing its distinct flavor.

A lot of black writers I know do not use these methods because they do not come from my background. A lot of northern black writers come out of the black city ghettoes. Amiri Baraka, for example, might use jazz language, but he would not use the rural locales or the southern language that I use. Afro-American writers have very different approaches to the novel, and we bring our own things to it.

In my work, I like extremes. I might describe a subservient black man, and then in the next moment I might describe one completely opposite to him. I might get a cowardly type, and the next one will do anything in the world, take any kind of risk. In one story I might use complete darkness, then I use complete light. I might use complete cold, then I use complete heat. These things are as much a character in the story as anything else.

Nature plays a very important role. In books like *Of Love and Dust* and *In My Father's House*, nature is as much a character as the actual characters. If it is cold, there is a reason for it being cold. Cold has an effect on the person's character, on the movement of the story, and on the story itself. When there is heat, there is violence, especially in southern literature like Faulkner's "Dry September."

Students come up now and ask me, "Did you know you put those symbols in there?" I never think of symbols. I never think of those damn things. I do know that nature has its place in the stories. For example, in *Of Love and Dust*, it is always hot. It is always hot as hell. And it is pitch black dark at night. But in *In My Father's House*, when the father is looking for his son, there is coldness—the gray sky, dreariness, mud, dingy bars, and that sort of thing. You need that kind of atmosphere.

Lots of people thought I was using a different approach in my last book, *In My Father's House*. I tried to write that book years before. It was supposed to be my second novel, but I just could not get it done. I tried writing it soon after I finished *Catherine Carmier*. Phillip Martin was just another character for me to deal with, and he is a product of the time in which the book came out. If I had tried to write the book fifteen years earlier, he could not have been a civil rights leader. But the father-son conflicts were always there.

The book is built around two moments in life. One moment is when the father cannot answer the door when the family is leaving, and the second is when the sister is raped and the oldest son kills the man who raped his sister. Those themes could take place any time. They are the same themes that *Absalom! Absalom!* is about. When I was trying to write that book, years ago, I talked to people at Louisiana State University about it. They said, "If Faulkner did it, you can do it too." It took me seven years to do it. Those were themes that I had thought of very early. I brought in the civil rights demonstrations because the story took place in the late sixties.

I try to write as truly as I possibly can during the period of time that I am writing about in the book. If I write a book in the 1980s, I bring in things that occurred in the eighties that molded the personality of the character. If I had written the book

twenty years earlier, something else would have molded the personality of the character. I try to make the character work with the times.

I never compared Phillip Martin to Martin Luther King. The other characters did. I wrote him as a man who tried to follow the philosophy of King, but I never compared him to King. He has his own personality, and things happen to him that he must deal with.

In a lot of my books, I deal with black kids and white kids who grow up together, and then suddenly one day someone tells them, "You cannot play together anymore because you are black, and you are white." They find it the most ridiculous thing in the world, but they must go by the rules. One must go his way, and the other one must go his way. Because of the rules of the game, they will have conflicts. This is what happens with Philip Martin and the white sheriff in *In My Father's House*. I did the same thing in *Of Love and Dust*. Bobo recognizes the situation, and it makes him uneasy. He says, "You know, they are playing with me, and they are playing with you. We are just here, and the big man is just playing with us both. We recognize it, but that is the rule. I must fight you and kill you, or you will kill me," like the Christian and the lion in the arena.

When I write a book, I never think about who the characters are going to be and how they will react to one another. If I have white characters, I make them as real as I possibly can. And if there are black characters—and there are always black characters—I make them as true as I possibly can. I never think about their liking or loving or disliking or not loving or hating one another. We all have much more in common than we have differences. I say that about people all over the world. They do not know how much they have in common.

If white and black people live as close together as my characters live around each other every day, there will be some kind of reaction. Despite all the rules and laws that say there is not supposed to be any mixing, there will be. If people see each other, live around each other, eat the same food, drink the same water, use the same language, wear the same clothes, there will be mixture.

Robert Penn Warren 1905–1989

BORN IN GUTHRIE, KENTUCKY

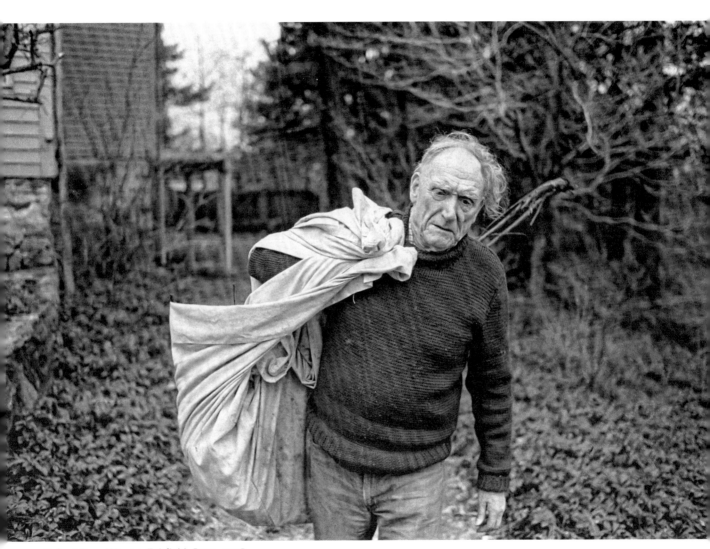

Robert Penn Warren, Fairfield, Conn., 1978

My father was full of poetry. I learned to read from poetry. My favorite poem was Marshall's "Horatius at the Bridge." When I was five or six, I would make my father read it to me over and over again, until finally he lost patience and told me I could learn to read it myself. I looked at it over and over and puzzled it out.

By any measure, Robert Penn Warren is one of America's most prominent literary figures. His published work includes twelve books of poetry, eleven volumes of prose, and twelve novels. Warren is best known for *All the King's Men* (1946), a novel based on the life of Huey Long, for which he received the Pulitzer Prize. In his later years Warren produced his finest poetry and received two more Pulitzer Prizes for his poetry volumes, *Promises: Poems, 1954–1956* (1957) and *Now and Then: Poems, 1976–1978* (1978). In recognition of his poetry, he served as a chancellor of the Academy of American Poets from 1972 to 1988 and was appointed the first U.S. poet laureate in 1985.

Warren coauthored, with Cleanth Brooks, *Understanding Poetry* (1938) and *Understanding Fiction* (1943). These texts shaped the study of literature in classrooms throughout the nation for over four decades and introduced generations of students to the study of literature. Warren taught at Louisiana State University, the University of California at Berkeley, the University of Minnesota, and Yale University.

Warren maintained lifelong friendships with Cleanth Brooks, Eudora Welty, and C. Vann Woodward. Their combined achievements in the fields of literature, literary criticism, and history significantly shaped our understanding of American and southern literature in the twentieth century.

When I taught at Yale in the 1970s, Cleanth and Tinkham Brooks invited me to their home for dinner to meet Robert Penn Warren and his wife, Eleanor Clark. The evening sparkled with talk of writers and animated tales about the South. Both Warren and Brooks spoke passionately about the English language and its use in the American South.

I visited Robert Penn Warren and Eleanor Clark each year at their home in Fairfield, Connecticut, and

at their summer home in West Wardsboro, Vermont, until Warren's death in 1989. In 1987, the University of Mississippi Center for the Study of Southern Culture and the Gorky Institute of World Literature in Moscow cosponsored a Robert Penn Warren symposium with Yale University at the Beinecke Rare Book Library. Russian and American scholars, including Cleanth Brooks and C. Vann Woodward, presented papers on Warren. After the conference, we all traveled to Vermont and spent the Fourth of July weekend with the Warrens.

Warren and Clark often shared their home and hospitality with admirers and aspiring writers. A devoted friend to so many, Warren's deepest love was reserved for his wife, Eleanor, and their children, Rosanna and Gabriel. He continued to write poetry until the end of his life. After his death, I visited Eleanor Clark at their home in Fairfield to personally express my sadness over the loss of her husband. Snow was on the ground as we walked through the field behind their home, and we both felt Warren's spirit was with us.

This interview draws from two that I did with Warren. I recorded the first interview before dinner at his home in Fairfield, Connecticut, in 1978. He told me that he had spoken often about *All the King's Men* and preferred to discuss other parts of his life and work. He reminisced about childhood memories, the Fugitives at Vanderbilt, and his interviews with black civil rights leaders such as Aaron Henry in Clarksdale, Mississippi, and Malcolm X in New York City. The second interview took place at Warren's summer home in West Wardsboro, Vermont, in 1987. I filmed it with a Super 8 camcorder, and portions of that film are included on the DVD with this book.

I was a bookish boy. My family was very bookish. My father always read to his children at night. My grandfather was very bookish. He lived on a large, remote farm, five miles from town, very isolated. He had moved there late in life, around 1894. His daughter always said, "Papa is very visionary. He is not practical," which was quite true, because he read all the time. I think he thought himself a failure.

He had been a captain in the cavalry under Nathan Bedford Forrest. He was a very young man, a volunteer infantryman, when the war began. He owned slaves, but he was against slavery because it was an obsolescent institution. He was also against secession. He said, "When the war came on, I went with my people." That is what a lot of people did who did not believe in either secession or slavery. Lee is one of the most glamorous cases, but it was very common. My grandfather was at the Battle of Shiloh, and afterwards he was made captain and commissioned to raise a company. So he had a long and active war. He was full of military history and was a passionate follower of Napoleon's campaign.

When I was a little boy, he was well into his seventies. He would draw a battle plan on the ground with a stick. He would use his cane to point and made me move cartridge shells or shotgun shells around to explain the tactics or strategy of a certain operation. He would tell about the battles he knew about and some he had not been in but knew about because he read a lot of American history. And he was mad for poetry. His head was full of long fragments of Byron and Pope.

Nobody ever came to see him except for one family. They would come on Sundays and have

dinner there. They had a daughter who took elo-cution. My grandfather would sit on the porch with her after dinner, and she would have to re-cite poems. He liked poetry.

I was the first male child since his son. He had a son and five daughters, and he liked the idea of having a grandson. He spent a good part of his time with me, and he infected me with the ro-mance of war and also—more than I knew at the time—with a sense of poetry. He was a strange companion for my boyhood, from the age of six or seven on through the age of fourteen or fifteen.

Guthrie, Kentucky, where I grew up, was a fighting world, very rough indeed. It was a rail-road town. The railroad boys were a tough gang. Any boy who made decent grades in high school was persecuted. It was as simple as that. Oddly enough, the teachers and the schools there were very, very good, particularly the high school. In those days they required at least two years of Latin.

I had only two friends during my years in Guthrie. One was Kent Greenfield. He pitched for the New York Giants later on. He was a year older than I. Kent was a natural-born woodsman. He had trained birddogs since he was seven or eight, and he always had dogs around him. We spent a lot of time in the woods—first with a BB gun and then a .22. It was his .22 because my father would never let me have a firearm.

I finished high school in Guthrie at age fif-teen. Then I went to school in Clarksville, Ten-nessee, for a year. It was wonderful. I was away from home for the first time, and I had a feeling of being grown up. I made friends, and we had weekend parties out in the country. It was fine.

I started college early because I jumped two or three grades. I boast to say this, but it was all due to my father, who was an extraordinary man. My father was a disappointed writer and lawyer. He was born in 1869, just after the Civil War. His father had been a veteran and had battle fatigue, what they called shell shock in World War I. My grandmother died when my father was very young, and there were four or five other children. My grandfather then married the first girl that came along who would take care of the children. What could he do? She was not that much older than my father. There was a good deal of land, but my grandfather was no manager financially. He died young. When his estate was settled, they had to mortgage the land, and my father was stuck. He was young and had to support a large family of half-brothers and -sisters, but he raised them.

At the same time he was totally ambitious intellectually and studied all the time. He studied law on his own, late at night. He went to Clarks-ville and got a good job. He learned French from an Alsatian he met in Clarksville. He then hired a Greek professor at Southwestern Presbyterian University so he could learn to read Greek.

And he wrote poetry. I had one of the most shocking experiences of my life when I was about twelve. I found this big, black book stuck back be-hind other books in his bookcase. It was called *Poets of America*. When I opened it up, there was my father's face as a young man. I guess it was a vanity publication with poems at the end. I was puzzled and unsettled. I showed it to him when he came home that night. He said in a very strange, cold, distant way, "Give me the book." I gave it to him, and I never saw it again. He de-

stroyed it. Later, when he was an old man, he said, "There came a time when I realized it was too late for me. I saw I could not make it, and it was not fair to your mother." So he went into business. It was a great disappointment.

We had a cook and nurse, Celie, who was with us for years. My earliest recollections are of her. She had a hand in my raising. The whole family was so fond of her. After my mother died, Celie was dying. After my mother's funeral, my father and brother and sister and I went to see Celie. She was propped up in a chair, dying. I remember her reaching out and touching my face, and I kissed her. As I leaned to kiss her, she just put her hand on my face and said, "You," touching me. It shook me.

I have a poem about that episode. It is called "Tale of Time," a long, strange poem about my mother's death. I wrote it and threw it away. I got caught in a blank verse trap, and it died on me because it was just dull. But several years later, quite a few years later, I came across it. I keep scraps of poems that die, and I sometimes rifle through them. I get germs for other poems when I take them apart. I picked this fragment up, and I suddenly saw it not as blank verse but as a freer form. I began rewriting it, and it is one of my best poems. It was a strange, exciting, visionary switch. I suddenly freed myself and worked on it for about six weeks. It is about going to Celie's house when she was dying on the evening of my mother's funeral in October 1931.

When we left her house that night, my father put twenty dollars on the table. He quietly put it down on the table, went outside in the starlit night and said, "Twenty dollars. My God, what is

that in the world?" He was awed by the futility of his gesture. He was a very reserved man. He had been very affectionate, but he was very reserved. He was shaken that his wife had just been buried. He was mad for her. Theirs was an incredible relationship. I never heard their voices in any irritation with each other. It was a love affair. At family picnics on Sunday, they would wander off in the woods together, hand in hand, deep in conversation.

My father was full of poetry. I learned to read from poetry. My favorite poem was Marshall's "Horatius at the Bridge." When I was five or six, I would make my father read it to me over and over again, until finally he lost patience and told me I could learn to read it myself. I looked at it over and over and puzzled it out. That is how I learned to read. The first time I tried writing a poem, I was about eleven or twelve. I was ill and in bed. I had a strange feeling that I had to write a poem, and so I dictated it to my father. My father said, "Well, that is no good. You are not ready for it." I did not try writing poems again for four or five years.

I did not have any idea as a boy that I would be a writer. I was more interested in nature and collecting butterflies and stuffed birds. I had no desire to be a writer. I had no desire to go to college. I was determined to be an admiral for the Pacific fleet. It was a boyhood dream that stuck. I wanted to go to Annapolis and become a naval officer. My father knew our congressman, R. Y. Thomas. In those days, appointments at Annapolis were made primarily on political grounds. My father got an appointment for me from R. Y. Thomas. I was finishing Clarksville High School, and I had just turned sixteen. I took the physical

57

examination. I had not received a letter, although I knew it was coming.

Then I had an accident. I was struck in the eye by a stone. I was lying on my back looking up at the sky at the sunset, and my little baby brother threw a rock over the hedge. It hit me in the face and injured me. When the formal letter came saying my appointment at Annapolis had been officially accepted, I could not go because of the injury.

So I went to Vanderbilt to be a chemical engineer. Three weeks disillusioned me. Chemistry was badly taught, with no sense of science, just mechanics. But I was in John Crowe Ransom's freshman English class, and he was fascinating to me. He was an extraordinary man, with a lot of charisma. He was not the best teacher in the world, but he would fire you up. He would get an idea and set your mind working. That was very exciting. He proposed that I come into his advanced class in writing. I found myself soaking in poetry. Ransom was the first live poet I had ever seen. It was like looking at a camel.

The Fugitives became a group long before my time, before America got in World War I. Ransom was a classicist teaching at a prep school in Connecticut, and he did not like it. He was nostalgic for the South and went back. He was hired at Vanderbilt by Donald Davidson. They made friends with businessmen in town and started the group. It was not a college organization. They met every week or two as a philosophy club. They were centered around a strange Jewish mystic named Sidney Mttron Hirsch, who had no formal education. He had run away from home, joined the navy, and became a boxing champion in the Pacific fleet. He was terribly handsome and worked in Paris as a male model for various painters. He was a student in a totally scattered and crazy way. He was full of Jewish mysticism, the Kabbalah, and crazy philological ideas about poetry. I had very little time for him, and Ransom rebuked me for that.

Then the war came along, and that changed the Fugitive group. When Ransom came back after the war, he had been a lieutenant and published a group of poems. Davidson was in the army and was also full of poetry. There was a Jewish merchant who took care of Sidney Hirsch because he dreamed something was wrong with his back. He was taken care of like an idol in his house. We all sat around, and he would lie propped up on the couch and at our sessions. I have a picture of him like Jesus, stripped to the waist.

I was reading with Allen Tate, who was then a young man back from the war and finishing his degree. He was six years older than I, and he had been in and out of college. He was brilliant. I was writing poetry a lot. They would read my poems and give me critiques on them. They moved the meeting place to the theological dormitory, a dirty place with half-empty bottles of whiskey, dirty shirts, and poems. I made a mural on the wall with crayon of episodes from *The Waste Land* and Sherwood Anderson. The Fugitives had a poetry contest, and the businessmen put up the money. They published my poem, a longish, full-bodied poem. Well, my cup ran over. I did not think anything else in life could be this good.

I'll Take My Stand was written after I left Vanderbilt. It came out in 1930, when I was at Oxford. I was away for five years. I followed the fellow-

ships for a while after I left Vanderbilt. The University of California at Berkeley gave me a teaching fellowship for seventy-five dollars a month. That was a lot of money then, and I was selling a few poems and making a little bit extra. The level of poetic taste and knowledge in that California community was not far behind Vanderbilt's. It is very funny that a little, isolated place like Vanderbilt knew more about modern poetry and art than places like Harvard or Berkeley. I graduated from Vanderbilt without knowing about Marx or Freud. But those who were advanced on Freud and Marx knew nothing about modernism and the world of poetry. It was strange that this group at Nashville knew all about poetry and read everything that was around.

Some of the Fugitives talked about Irish writers and their colonial relation to England. The Irish were producing great writers, and they were having a vengeance on the English through their literature. The Fugitives talked about the parallels between the South and Ireland. The South was outside the great industrial establishment of the North, and they saw a parallel with the Irish writers.

The Fugitives had no time for the middle-western renaissance—Theodore Dreiser and Sherwood Anderson. But I was bowled over by Dreiser. I first read *American Tragedy* in the fall of 1925. I remember the exact time I read it, and the room I read it in. I read all of Dreiser very thoroughly, and I wrote a book about him for his centenary. I still think he was one of the two great novelists of this century in America—he and Faulkner.

I was barely aware of Faulkner at Vanderbilt. I got to know his work when I was in England and I met John Gould Fletcher in London. When I was at Oxford, Fletcher came to see me. He had not gone completely off his rocker, as he did later on. He became very insane and paranoid toward the end. But I liked him. Fletcher talked modern poetry the whole evening. He brought me some gifts, one of which was the English edition of Faulkner's *Soldiers' Pay* [1926]. He said, "You ought to read Faulkner. He is going to be great." I read him right away, and I was awful hit by it. I saw a book about a world I knew. It was how Ransom's first book of poems hit me when I was a freshman at Vanderbilt. I suddenly saw this man making poetry out of things that I knew. I had that same kind of recognition in this first book I read by Faulkner. It is not much of a novel, but he was a promising young novelist. I had not written any fiction yet when this happened. I did not begin writing fiction until the next year.

There was a professor who wrote a manuscript on fiction and poetry about the Civil War. He said that the Agrarians and the Fugitives hated Faulkner because he was not southern enough, and they only took him up after he won the Nobel Prize. There was never a bigger lie in the world. I reviewed his first book of stories, *These Thirteen* [1931]. Ransom was mad for him. Frank Owsley, the historian, talked about Faulkner constantly. He was knocked over by *The Sound and the Fury* [1929].

I only saw Faulkner twice in my life, in New York during the 1940s. Albert Erskine was an old friend of mine who had worked on the *Southern Review*. And he was Faulkner's editor during the last years of Faulkner's life. Albert was an old

friend of Faulkner and a nursemaid and a care-taker as required. He was living in New York, and he invited me to come have dinner with Faulkner.

There were attacks on Faulkner all over New York City. They called him a "crypto fascist." And even worse, he was a southerner—from Mississippi, of all places! I read all the reviews of his work during that period. Then Malcolm Cowley started reviewing him in *The New Republic*. Cowley was not overwhelmingly favorable, but they were serious reviews. He was wrestling with Faulkner. But he got converted. He fought it all the way, but he got converted.

Malcolm Cowley came south in 1934. I was living out in the country at that time. He came down to prove to the world, as it were, that the tales about the South were not true. He was going to investigate it. So he lived on a farm in Kentucky for a whole year—through a whole set of seasons—and wrote letters to his wife every night. Of course it became a book—a beautiful book. He came down to Nashville, and he stayed at our place in the country for two or three days. Then he went to see Faulkner. They both got along well, and that started Malcolm on the Faulkner business. Every book Faulkner published after that, Malcolm reviewed. If not every book, damn near every one. That was a big turning point.

I met Cleanth Brooks in the fall of 1924. We were at Vanderbilt together. I was a little ahead of him in college, and I did not know him terribly well then. Then we were at Oxford together and became very close friends. When he was at Louisiana State University as an assistant professor, he arranged somehow for LSU to offer me a job. We had exactly the same way of teaching poetry and

fiction, and that is how we got into writing textbooks together.

I met Eudora Welty through the mail when Cleanth and I were working on the *Southern Review*. We published five of her stories, one right after another. One of the most delightful evenings I have ever had in my life was with Eudora and her friend Charlotte Capers. We had dinner together in Jackson and stayed up all hours, just talking, drinking, and talking. Those two women together are just a circus. They are two great wits at tale-telling.

That is the difference between the South and the North. Nobody tells any tales up North. There is gossip. But no one just tells a tale for tale's sake. During my time as a student and teaching in the South, parties were almost always either playing charades or poker or tale-telling. Andrew Lytle was a great actor and a great improviser of tales. He was one of the best raconteurs and conversationalists I have ever known. There are only a few people who can even touch him. Stark Young could and Lyle Saxon in New Orleans could.

Poetry is my basic interest and has been since I was in college. I am focused on it all the time. I came into writing fiction by pure accident. When I was in college, I read a lot of fiction. But I did not have any deep commitment to it. All the people I admired were into poetry. And the two extraordinary poets I was closely associated with were Ransom and Tate. There must have been a dozen students at Vanderbilt who knew *The Waste Land* by heart within two or three months after it came out in 1922. There were an enormous number of people interested in and writing poetry there. It was a strange disease.

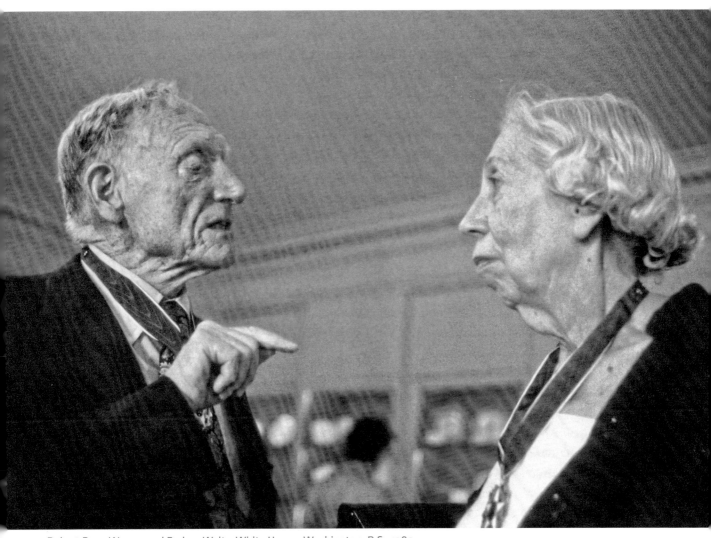

Robert Penn Warren and Eudora Welty, White House, Washington, D.C., 1980

I met people like Katherine Anne Porter, whom I knew very well. She was a close, close friend. I knew her in Greenwich Village, before I went to Yale. The Tates were there too. Tate's wife was the novelist Carolyn Gordon. She knew a lot about fiction. Some of her stories are wonderful. I liked her extremely. But she and Allen got a divorce, and I never saw her but once again. She had great talent and knew a lot about fiction. I knew Ford Maddox Ford too and talked with him once or twice. These people were talking about fiction from the inside, and it made me want to try my hand at it.

My last year at Oxford I was writing a thesis, and in the middle of it I got a cable from Paul Rosenfeld, who was one of the editors of *The American Caravan* [1927], the anthology of new writing, asking me to do a novelette for the *Caravan*. I had never thought of doing such a thing, and I said, "Well, why not? Try." Writing the dissertation bored me, so I wrote a novelette in the evenings. I was nostalgic for home, and the notion of the tobacco war was very romantic to me. I made up a story about a southern farm family, like my people, in "Prime Leaf" [1931]. I sent it in, and it got very good press.

It was the first fiction I ever wrote. I was hooked. Then I wrote two novels in the next several years, and every publisher turned them down. They were bad novels. This was in the early 1930s, and the Depression was in full bloom. They were finally published, but by that time it was 1936. I was writing poetry all the time during that period, but there is no money in poetry, of course.

Then, in 1936, I got a telegram from the publishing company Houghton Mifflin. They had a prize, a thousand-dollar prize, for a novel to be selected. This letter said I could have the award. A friend of mine published at Houghton Mifflin, and she had given someone there my novelette to read. They said, "He has got to write a novel out of this." So they paid me in advance. If she had not showed these people my novelette, it would not have happened. I was teaching in 1936 at Louisiana State University, and I wrote the novel *Night Rider* [1939] there in the summers. I did not research it. I just went and talked to people. It came out in 1939, and that is how I made my first full step.

The last novel I wrote, *A Place to Come To* [1977], is a very funny one for me. There was a man whom I had known when I was sixteen—my freshman year in college at Vanderbilt—that I remember distinctly. He was a big, grown man—not in age, so much, but in his whole attitude, in experience. He did not seem like a college boy. He somehow was different. He was very intelligent. I got to know him pretty well. He said, "I can't stand it anymore. This is not real. I am going to go where the action is. I am going to Chicago right now." He did, and he never came back.

Years later, in Minneapolis, I was in my apartment one afternoon, and the desk called and said, "A man wants to see you." I did not recognize him at first. He said, "Red? I have not seen you since 1921." He was dressed in extraordinary, expensive clothes. I could sense that he had big money. He sat down and had a drink and started to give me his life story. He had a big briefcase with him. He told me about his great house in Chicago, his summer home on the lake, his big yacht. He proved his whole career for me with documents and pictures that he had in his briefcase. He was

Robert Penn Warren, Fairfield, Conn., 1978

so pleased with himself. He had come with the intention of telling me his life story, but something went wrong in the telling. He told me his whole life, his success, with pride. But then he fell forward with his face in his hands and said, "Oh my God. Oh my God." That started the germ of the idea—a man discovering his past and the shock of it. That was the germ of *A Place to Come To*, the image that started it.

Joseph Blotner wrote to me some years ago and asked if he could write my biography. I said, "If I say yes, it would involve interviews and digging through papers and gathering what not. It would kill my life! I could not live any more if you start fooling with that stuff." At the same time I could not say, "No, you can't do it. If you want to do it, it is just you. I cannot cooperate. I will do certain things—maybe answer certain questions that you could not get otherwise. But I do not want to sit around for two or three years digging through papers. It would be like dying before I am dead." I like Joe, but it was too disturbing. It would be like I was not living anymore.

There are lots of changes in the South, particularly in my part of the country. It used to be tobacco country, but tobacco is a rarity there now, rather than the main crop. Now the land is used for grain and cattle. My brother's friend and chief hunting partner started out as a tobacco farmer. It was a very handsome farm with an old house on it. It only had four hundred acres, but that is a big farm for tobacco. They had about thirty tenants on the farm. Then he began expanding and raising cattle, and tobacco was out. Now he has got over two thousand acres, and his son, who graduated from agricultural school at the University of Kentucky, runs the place with four men, all mechanics.

My brother's wife has a great deal of farmland, and she gave three thousand acres to her son. He mechanized it when he got out of agricultural school. He has five thousand acres. He has tractors, these enormous diesel things with gangplows.

They cut down the trees that made the country beautiful. They plowed over the fields. It is all mechanized now. There has been a decline, I think, in human values.

The tenants are mostly gone. The farms are getting bigger and bigger, and the homestead farm is disappearing. The tenants have gone to Harlem, Atlanta, Nashville, and other cities. There is nothing left in the way of a social sense of responsibility. The people of my father's generation were thoughtful, widely read, and had a real sense of community—an old-fashioned sense of community, of working for the common good.

A large farm has to have machines. I am not saying it is good or bad. It is just a different kind of life. Machines are not the cause of it. It is the result of big technological changes in the western world. The South is the part I know best. It is much less attractive than it was. Guthrie, my hometown of thirteen hundred people, has not grown much since I was born. It was a market town then, where the tenants and farmers came on Saturday to trade. It was a period of modest prosperity. The streets were choked with buggies and men on horseback, mounted men.

When I came back, after living for years outside the South, to live in Tennessee and Louisiana, I had a new awareness of the injustices there.

I was more sensitive to the things I had written about in *I'll Take My Stand*. I had written a piece, "The Briar Patch," for the book which some of the others did not want to publish. I found out later that Davidson wanted to take it out of the book. Davidson and I were great friends, but he was a fanatic. I have not read my piece since I wrote it. But I remember my line—"Justice will end the separation." All the sociologists said the same thing. Practically everybody in the world said it. My notion was simply "separate but equal." I saw no immediate chance for any change then. But World War I changed everything. That is what kicked the South. The war broke open a frozen culture in the southern world. You can see that in Faulkner.

When the Supreme Court decision *Brown v. Board of Education* [1954] was made, I was at Yale, and I felt left out. I wanted to go back in the South to see what had happened. Others felt the same way. Allen Tate was living in Minnesota then, and he wrote me a letter saying, "We are missing the show. We ought to be back south. We ought to be back home." I was feeling the same thing. I really felt left out. I did the book *Segregation: The Inner Conflict of the South* [1957] for my self-indulgence to see the South again. You have to go see it. But I had to support myself. I lived on my writing. I could not have lived on my Yale salary. It was a good salary, but I had a lot of obligations. My brother-in-law was an editor at *Life*, and he arranged something. I never asked him for anything, but I told him how I was missing the show. *Life* gave me a contract to do an article. So I went down South, traveled around, and wrote the article. I talked to a lot of blacks and whites and

got a sense of what was happening. But I was not satisfied. It was not enough.

My agent said, "How would you like to do a book of interviews with black leaders?" So I was on the road for two years. I went to Negro colleges and talked with college students and other blacks. I went to a nonviolence convention at Howard University in Washington, and I got very chummy with Stokely Carmichael there. Stokely was a very interesting character. He was a brilliant guy. Later on, he said to me, "You know, I am torn. I do not know enough. I have not thought enough. I should study some more. If I just had the money, I would go somewhere and study the things that I think I need to know." I had friends at Swarthmore. I called them, and they offered him a fellowship that he could live on comfortably. But he refused it. He hesitated for quite a while, and then he said, "No, I think I had better be an activist."

I spent a lot of time in Mississippi in 1963 with Aaron Henry and Charles Evers, Medgar's brother. When I went to Clarksdale to see Henry, a couple of black fellows, just out of college in the North, drove me up there. We started at dusk in my rented car. I do not like to drive at night, and one of these students was driving. He whipped on at about ninety miles an hour. I said, "Can we go a little slower?" He said, "Not me. With a white man sitting in this front seat with me?" He said that there had been too many cases of people driven off the road when a black and a white were driving together. He said, "You will not catch me going less than ninety miles an hour. Mister, you will just have to take it. I am saving your life."

When we got to Aaron Henry's house that night, all the windows were blacked out. He said

he was in war time. There was a man sitting by the window with a loaded revolver and a shotgun. Henry had told the sheriff, "If you are not going to protect me, I will protect myself."

Malcolm X was the only tough one to see. I tried many times to interview him, and I could not. Finally, he said he would see me. When I went there, he was sitting at a desk at one end of this large ballroom, with two of the Fruit of Islam on each side of the desk. I was put in a chair at the other end of the room. They kept me waiting a long time. It was quite deliberate. Then one of the Fruit of Islam came and said, "You may go." He pointed at the desk way over across the room. I walked over—across this long space—to where Malcolm was sitting behind his desk. He said, "You newspapermen are all liars, but I will give you ten minutes." I said, "I am not a newspaperman, and I am not a liar. I have a tape recorder here. You will have the transcript, and the only thing that will be published will be your correction of the transcript." He said, "Well, let's go talk." We went back to a little room, and he said, "I can give you ten minutes." I left three hours later, and I was the one to break up our talk. When a man is talking about himself, he gets very interested in the subject. He loves the topic. He got very chummy with me before it was over. He was the most impressive man I ever met. He had the biggest mind, in a terribly forceful, personal sense. He was very pale, redheaded almost, freckles showing, and had a kind of green glance. He liked an argument. If a question was posed, he boxed it in from side to side. He was just like a welterweight coming out of the corner. He came out at the questions just like a fast boxer moving in. I put him on the spot, and he rose to it.

When I lived in Baton Rouge and taught at LSU, I went to a Negro church once. They were having a celebration for this pastor who looked like a Mongolian warlord, only he was black. He sat on a throne under the pulpit, and he had two black, beautiful little girls on his lap. He was an enormous man. These girls were asleep, one on each shoulder, and they were covered with lilies. The pastor did not move. He did not even blink the whole two or three hours of the celebration. He had such honor and stature. And there were these two sleepyheads with ribbons in their hair and a sheaf of lilies across them. It was an incredible sight.

They had a real fancy preacher from Boston talk. He was being very sociological, talking about flying kites on the Boston Common. He said, "This is a parable. Send your kite as high as you can, and fix your eyes on achievement. Raise our race." Then he said, "You talk about dying too much, do not think about dying. Think about achieving. Religion is not about worrying about the next world and dying." And an old man in the corner said, "Dying? It is not dying you think about. It is death. It is death." The fancy preacher from Boston was totally bamboozled by that. The whole thing was wonderful.

Alice Walker 1944–

BORN IN PUTNAM COUNTY, GEORGIA

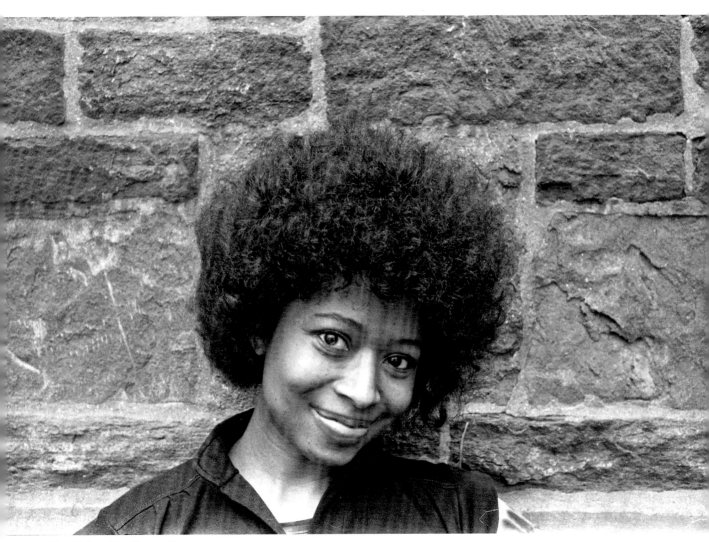

Alice Walker, New Haven, Conn., 1977

I learned that you could put things on paper, but a safer method was actually to just keep them in your head. So I have a habit of writing very long and complex works in my mind before I write them on paper because I feel that is the safe way.

My friendship with Alice Walker began in the fall of 1970 when I taught in the English Department at Jackson State University in Jackson, Mississippi. Walker lived in Jackson and had recently finished her manuscript of *The Third Life of Grange Copeland*. She shared with me encouraging comments that Ernest Gaines wrote her about the manuscript. During that time Walker also published her poetry collection *Revolutionary Petunias*, and her interview with Eudora Welty appeared in the *Harvard Advocate*.

When Walker visited Yale University in 1976 to conduct a seminar for Michael Cooke, we photographed each other standing in a bed of jonquils. I served as a consultant on the film *The Color Purple* in 1985, and in 1994, we organized a reading and book party for her at Square Books in Oxford and a tour of the University of Mississippi's Blues Archive and William Faulkner's home, Rowan Oak. During her stay, I spoke with Walker about her work as a writer and her love for the blues.

In 2004, Walker visited the University of North Carolina with her agent Wendy Weil. It was a special reunion for me because after Walker introduced me to Weil in 1970, she became my agent as well. Walker's reading was packed with admirers, and she and Weil gave a memorable colloquium in which they compared their long, close relationship as writer and agent to a marriage.

This interview was recorded at my home in Oxford, Mississippi, in 1994.

I wanted to play the piano, and I think I would have been good at it. But piano lessons were fifty cents. I tried very hard, but I could not raise it. Then I wanted to draw, but I was not that good. I

think writing was all that was left. I became interested in writing because of my oldest sister, Molly, who left Eatonton when I was an infant. There was no high school for black people, so she had to go away. She is twelve years older than I am. When she was thirteen, she left to go to Macon High School. She was a great reader, and she went off to Morris Brown College in Atlanta. When she came home in the summers, she would read to us. She would tell us stories. She introduced us to a new kind of aesthetic.

My mother was Cherokee, and she had the Indian belief that you let things live where they grow. And when you grow them, you do not cut them. You just let them be. But my sister, who looks very much like my mother's grandmother—very Cherokee looking—had gone to school. She knew that there were people who actually cut flowers and brought them into the house. That was a different way of looking at things.

My father and mother only went through the fifth grade and the fourth grade, respectively, but they loved education. They really worshipped education. They were that generation of black people who would do anything to educate their children. They wanted us to be educated. They read us the newspaper. Whenever books were thrown out by the white person they worked for, they were happy to have them. They would bring them back, and they would read to us. We always had books in the house. That was unusual because most people like my parents did not have books around. They did not appreciate them and take them out of the trash when someone threw them out. My parents worshipped reading. They thought it was the greatest thing. But by the time

I came, I was the sixth or seventh child, and they were exhausted. That is where my sister came in. She came back for the summers, and she would read. You know the song "God Bless Mother Africa"? When I was six or seven years old, my sister taught me that song. The African National Congress was trying to teach people what was going on in South Africa. She was obviously very moved by the struggle, and she learned that song and taught it to me. That influenced me a lot.

I also had great teachers who loved me. They knew my family, and they cared about me. I was not just another little face. My mother took me to the fields, and I would trail along behind her as she chopped cotton. I would fall asleep at the edge of the field. She could not really look after me because she had to work. When I was four, I went to school, and my first-grade teacher, who is still alive, gave me books for my birthday and gave me my first clothing.

When I was eight or nine or ten, I began to write, and I kept a notebook. My life has had its trials. I learned very early that writing was a way to deal with pain and isolation. I had brothers, and they were very brutal in some of their ways. They were brought up not to be gentle with animals or younger siblings. I learned that you could put things on paper, but a safer method was actually to just keep them in your head. So I have a habit of writing very long and complex works in my mind before I write them on paper because I feel that is the safe way.

In my early stories, it is true that the women end badly. That is because they belong to the generation of my mother and grandmother, when women had nowhere to go. They could not be

Bessie Smith or Billie Holiday, so they ended up doing destructive things. Most of that generation did not have fame or glory. Those women are much older than I am. They exist in a historical place that is removed from my generation of women. It was not until *The Third Life of Grange Copeland* that I wrote about my generation. My writing starts far back because I wanted to have a good understanding of the historical progression.

I wrote about those women in *In Search of Our Mothers' Gardens*. Those women have been, almost of necessity, self-destructive. They have been driven insane. The ones who managed to survive were the ones who could focus their enormous energy on art forms—on quilting, on flowers, on making things. It is a very human need to make things, to create. To think that by having a baby you fulfill your whole function is absurd and demeaning.

When I lived in Mississippi was when I first connected with Zora. The oddest thing is that in that same anthology where Langston Hughes published my story "To Hell with Dying," there is a story by Zora. At that time I was convinced that only men wrote literature that I had to read, and I read that anthology without noticing it. Then I read Zora's *Their Eyes Were Watching God*, and it was so much my culture. I had never read a book that was so true to my southern black culture—full of music, full of humor, full of just craziness—people living their lives, people having good times, people fussing and fighting. As with my mother and father, Zora's characters are absolutely rooted in the earth.

People in *Their Eyes Were Watching God* are really pagan. They are not bamboozled by religion

as it is taught in the South. They are always poking fun at hypocrisy. And the passages that are so incredible are when they drop a bean in the soil, and up comes food. The Indians knew when a storm was coming, and they started leaving. The animals knew, and they started moving. Most people are not as connected. They are two or three steps removed from the natural rhythm of the earth, so they do not know. They have to sit, be scared, and pray to the sky god.

This carries forward my sense of the transformation that people have to go through to shed a deadening sky-god religion, to come back to their rootedness in nature as the source of divinity. *The Color Purple* is a book about learning to believe in your own god or goddess—whatever is sacred to you. It is not about what other people are telling you. You get rid of the Charlton Heston–type God. You get rid of Yahweh. You get rid of these people who, while you are worshipping, try to convince you that you are nothing. You begin to be a child of what you actually are, a child of the earth. That is why at the end, Celie understands that if God is anything, God is everything. And so the birds, the trees she sees—she makes a long list of all these things—that is what this book is primarily about.

People may need religion to further their social programs, their political agendas, or even their spiritual desires. But essentially what is divine is in front of you all the time. You cannot separate yourself from the earth. If you understand that, you lose all fear of dying. You may be grass. You may be a cow. But you will always be here, even if they shoot you. I was thinking, what would they do to me to punish me for being an earth lover? They could shoot me to another planet. But be-

cause I am made of earth, I could never leave. That is my home. That is what I am. I love the feeling of always being at home, of always being with what is sacred to me, with what is divine to me. That knowledge was a gift from my mother without her knowing. Before she died, she became a Jehovah's Witness. Part of those people's belief is that if your own child is not also a Witness, you do not speak to the child. Is not that amazing? Imagine having that as your guiding light.

Because my work is grounded in spirituality rather than in politics, I follow my intuition and my sense of being one with other people much more easily than I ever thought possible. When I write about African children who are mutilated, I do so without getting bogged down in all the cultural baggage and the political resistance of African governments and African people. I understand what they are saying.

I have this theory that Martin Luther King— had he lived—would have become a violent revolutionary rather than a nonviolent one simply because he would have perceived that he had met an object—specifically, this country—that is not going to be changed nonviolently. I think his dedication was so intense that he would have tried other strategies. In my poem, I talk about his love in front and his necessary fist behind. I also mention that people who may be crucified should decide not to be crucified. They should do as much as they can, but they should know when to stop. They are much more valuable farming, or raising tulips, than they are dead. If they would only understand that.

A good example is Bob Moses, who was in Mississippi in the early sixties and was rapidly be-coming a legend. He was with the Student Non-violent Coordinating Committee, and he knew how to go into a community and let people lead him rather than trying to tell people what they needed. He would listen to what they wanted done, and then he would try to help them do it, which is the true revolutionary way. People started saying that this man was their Moses because they make these quick religious connections, and he decided he did not want to be their Moses. He wanted to disappear. So he changed his name, took his mother's name, and he walked away. The last time I heard about him, he was teaching school in Tanzania. I think that is brilliant. That is exactly what people should do.

After King spoke against the war in Vietnam, it would have been lovely if he had known somehow. He had premonitions, but he was into the propelling force of history, where you have to go right to the end and be shot. He never considered not listening to the things telling him that the end was coming. He knew the end was coming. But would not it have been terrific if after his "I've Been to the Mountaintop" speech he had gone back to Atlanta and said, "Coretta, get the children. We are going to California. Let somebody else lead. I have had it." He was tired. Or think about Malcolm. Malcolm could have started a little farm in Detroit and been ready to come back another time.

If people think that is taking the easy way out, well, to hell with people. I think the symbols are wrong. I think the symbols have always been wrong. I think the worship of death is really stupid. To hound people until they feel they have to be shot is sick. We got to a point when people were saying, "Well, now it is time for King to be

assassinated for him to be any good." Now that is sick. Here is a man who gave every ounce of his energy, absolutely everything he had. And there we were saying, "Well, he screwed up in Chicago. He could not reach people in Harlem. The only thing left for him to do is to stand there and be shot." I have thought about it constantly. I would like for people to think they can have more than one life. There are more ways to be committed than to give your absolute life's blood. Going to teach in Tanzania or Harlem or Mississippi, that is a commitment. I would love to have had Malcolm or Martin Luther King teach my child.

The culture does not deserve those good people if violence is the only thing that will move them. If people are going to sit back in front of the television set and only be moved because you are dying, they do not deserve you. I think the culture is sick. The thing to do is to think of ways not to give in to the culture—to affirm what you believe to be stronger and more important. Great importance is attached to an assassination, as if people will rise up and great changes will happen. But that does not happen. People forget overnight.

Flannery O'Connor said that anybody who has outlived her childhood has enough material to last her the rest of her life. I draw heavily on my childhood and what I knew and what I saw and felt. But after *Meridian*, I slowly moved away from that. Now I am creating situations and characters that are removed from what I knew as a child.

I was very much into my community, but at the same time I had this sense of knowing I was observing it. Even at my father's funeral, I was very aware that my father was dead, and that meant great, weighty stuff. But I was also observant about everybody's reaction and remembered with great alertness everything that was said.

I draw on my background because it was so rich, and I always recognized it as being rich. Richard Wright found very little in his childhood to like and admire. He felt it was barren. I feel just the opposite. When I go back to Eatonton, Georgia, I get new enlightenment. I understand on a deeper level. But *Meridian* was set equally in New York and Mississippi, and I think that means something. In my own life I have had the kind of mobility that has taken me not just all over the South, but all over the country.

I would not have missed having a child. It was tough going at times, but I think children connect us to the natural world, to the natural processes of life, in a way that you cannot really grasp. In my long labor and the sheer pain involved I felt like I connected to women—wherever they are and whatever condition they are in—in a way that I had never felt before. It was a bonding with my mother, with her mother, with my great-grandmother. I understood as never before what it was like for women and what it is still like for women all over the world.

I thought about my mother. They gave me a saddle block so that I did not have all the pain at the end. But you know she had eight children, and I remember her saying that the pain increased with each child. It did not diminish. They claim it diminishes, but I do not think so. I felt like, with Rebecca, I was given this information, this knowledge, and I think it made me more humble in the face of what women go through in order to populate the earth. They provide all the workers, they provide all the teachers, and they provide the

labor force that keeps everything moving. That is why I think there should be a moratorium on birth until the planet can sustain a high quality of life. I just do not see the point of everybody continuing to have children, even one. I think that one is good, but I think it is really very thoughtless for people to continue to populate an overpopulated earth when they have not attended to the earth.

There is much revision in my novels. I started *The Third Life of Grange Copeland* at MacDowell, a writer's colony in New Hampshire, and I worked on it through several winter months. Three years later, when I finished it, I had changed everything except one line, and then I changed that line. I have four or five complete drafts of that novel. Since *Meridian* was written in a different way—not chronological—I revised the sections a great deal. I had a great fight with my editor because the original jacket was of a little black girl who looked exactly like a cockroach wearing a dress. They tried to sneak that cover over on me. We had this huge fight, and I made them change it. Novels take a lot of revision. They do not write themselves.

The ideas for my novels come from wanting to understand something. With *Grange* I wanted to understand what happened in family life over a period of years. And I wanted to understand the concept of self-hatred, family hatred, the kind of destructive thing that Brownfield exemplified. I wanted to understand Brownfield and also to understand people who could be Brownfield but were not. I wanted to know what made the difference. Everything starts from wanting to understand something, whether it is a per-

son or an event. For instance, in *Grange*, Brownfield notices that whenever a white man comes around, Grange's behavior changes completely. Those scenes come from living in a culture that produces that kind of reaction. I have seen people change their behavior because there are white people around them. My father's behavior changed. He lived in a culture that was intent on destroying him, so he built up defenses.

In *Meridian* I started out being really concerned about the things that people did to each other in the sixties in the name of change, in the name of revolution. I wanted to see the qualities we were giving up in exchange for other qualities. Part of it is understanding the questions, not just understanding the answers. When you start, you have the vaguest notion of where you are going, and you do not know what things are important to work with. My regret is that Langston Hughes died before I knew what to ask him.

I live in a culture where storytelling is routine, where memory is long and rich. I was born into this huge family where everybody told stories, and it was my function to make some sense out of all of it, to write it down and present it. It is not just me knowing. It is what they have let me know.

In college, I loved Camus. He is just a beautiful man. I also really love the Russian writers. I am a moralist. I am very concerned about moral questions, and I have definite feelings about what is right and what is not. Russian writers have a kind of essential passion, and they engage in questioning the universe and human interactions. They really care. I like that. I do not like writers who do not care. I think writers should care desperately.

Victor Hugo was another influence. He was a

moralist, very compassionate and big. I like big writers who have scope, who see things in a distance. I love Flannery O'Connor. But it was very upsetting when I read in some of her correspondence that she referred to black people as "nigger." The Brontës were influential. *Jane Eyre* was one of my favorite books. I love the intensity that you see in Mr. Rochester. I love writers who make you feel the cold when it is a cold, gray day.

There are people who influence you. There are people you discover later on, and you know that you are on the same wavelength and that you would give anything to have read them earlier. That is where Tillie Olsen comes in. That is where Zora comes in. That is actually where Toomer comes in. I did not read *Cane* until 1967, and I did not read Zora until the seventies.

I do not consider myself a southern writer. I think I am dealing with regions inside people. The people in my work are in the South, but I really just leave that up to other people to decide. If people can only understand the work by placing it in a context, that is fine. I am trying to understand people and how they get to be the way they are. For me, the region is the heart and the mind, not the section.

There are many reasons I am not at ease with the southern label. Any kind of label limits. It tends to make what you are dealing with seem localized, when in fact your focus is to find out why people act the way they do. Wherever people are, that is where you are. And when you think of southern writers, you think of white southern writers. I have no interest in integrating southern writers. On the other hand, how can I possibly not be considered a southern writer since I am a southerner and since I write?

The only time I know that an autobiography did not work was Zora Hurston's autobiography. An autobiography is very difficult to write. It is the hardest writing if it is going to mean something, if it is going to be honest. The hardest thing in the world is to write down what you really think, what you really feel. The tendency is that you think, "I am a rotten person." But by the time you get it down on the paper it is, "I am not so rotten." Zora suffered from that.

She also had to placate this "godmother" of hers. This woman financed Zora's expeditions into the South to collect folklore. She gave money to almost all the Harlem Renaissance people, including Langston Hughes. She really thought that black people were wonderful, exotic primitives and that she could read their minds. She thought she could read Zora's mind. Zora would have a party with her friends and would say, "Let me call Godmother." So at five o'clock in the morning, Zora would gather her friends around and call Godmother. Zora would say, "Godmother?" and Godmother would say, "Yes, Zora?" "Godmother, do you know what I'm thinking now?" And Godmother would say, "Oh yes, you are thinking this, or that." And Zora would have a big laugh. It was really hokey and a sad example of how, in order to get work done, people have to do so many terrible things.

This godmother would not allow Zora to publish things that she wrote until godmother said she could. Her work was really controlled. In addition to her writing, Zora made films. They were on

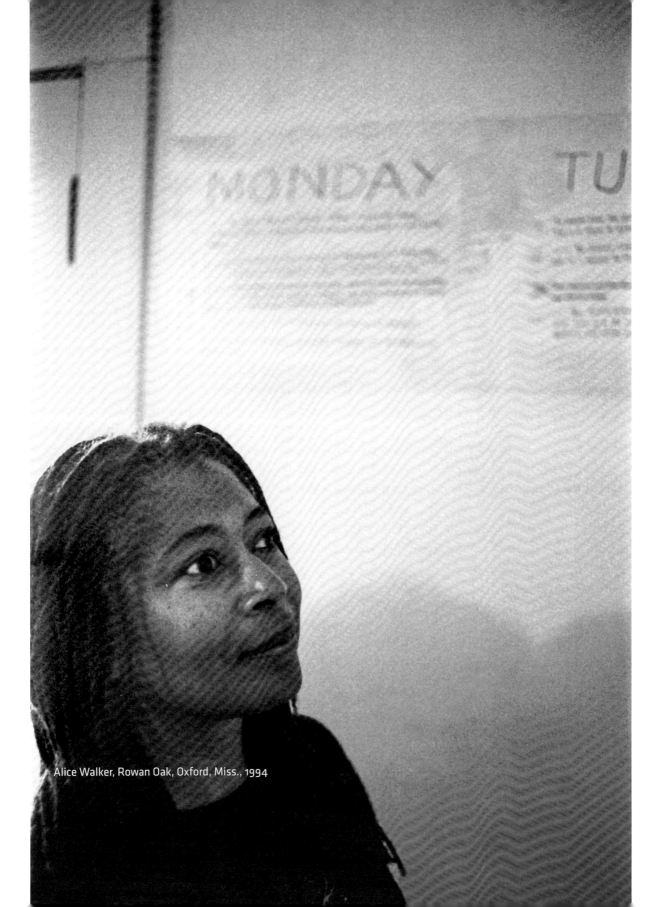

Alice Walker, Rowan Oak, Oxford, Miss., 1994

children's games, Mardi Gras, and on some of the conjurers whom she met in New Orleans. Among the things that she learned from these voodoo doctors and conjurers was how to kill. She became a converted soul.

I do not know the nature of her relationship to Carl Van Vechten, but supposedly she placed a spell on him, albeit playfully. The problem with rich and poor is that the poor person can never forget that the rich person is rich. No matter how hard one may try, it is impossible to forget that the rich have more than they need, and you do not have enough. There was a lot of that in Van Vechten and Zora's relationship. She kept saying, "I love you, and it is not because I need anything. Please do not think I am asking for money." And she was not. It is just that he happened to be so bloody rich, and she happened to be so bloody poor.

It is hard to love people who have all the advantages that you do not have. It is very difficult, and I say that with a great deal of experience. Even with much effort, I still find it difficult to love those people who control, who have everything. It is so sad because no matter what they do, the feeling remains. They can be ever so wonderful, and yet this barrier rises like a ghost.

I believe in voodoo as much as I believe in any other religion. It works for the people who need it to work. There are probably some definite medicinal qualities the people use. In Haiti, for example, the thing that Hurston discovered about Zombies is that they know this secret ingredient that they brought from Guinea. It apparently puts part of the brain to sleep and people appear to die. But they are not really dead. They can be brought back, and they can be put to work, to just work and do nothing else. But the part of the brain that controls memory and speech is gone. I think that is entirely possible. I do not see why it could not be. All of these things can probably be explained.

Zora talked about the way people would collect dirt from graveyards to use to destroy people. It is in *Tell My Horse*. What she discovered after taking some of this dirt to a chemist was that it is full of disease and germs. So if you went to the grave of someone who died of smallpox, the dirt keeps its potency up to twenty years. You could actually give a horrible disease to someone.

With my own mother I understand new layers of meaning in our relationship. She was devoutly Christian and went to the church regularly as a mother of the church for most of my life when I lived at home. Yet behind that, I think she was the most sincere worshipper of nature. I know that because I am also. And I know that what is different about the way that I relate to nature and to the earth is that I do not feel compelled to put a Christian face on what is essentially a pagan mark. I just love the earth and love nature. I worship it and think of it as my source of life. I know there is a galaxy and a cosmos. But if there is a divine intelligence that orders everything, it is too much for me to comprehend. I am happy to just love what I can feel. And I do feel.

This was true of my mother. She had absolute faith in nature. But if you had asked her about that, she would not have understood what you meant. I have seen her visit a house. If there was a sprig of anything that had broken off of any plant, she would take it home, stick it in any little bit of soil, and would have absolute certainty that

it would do well. And it did. That was her way. I grew up with a woman who was connected to life and in sync with the source of all that there is. It was wonderful watching her exist in the world. This was true, even though we were poor and we had to deal with people who hated us or could not really see us. There is no doubt in my mind that my mother was a great, great spirit. I actually think of her as a goddess.

I love B. B. King because he loves women. They can be mean. They can be bitchy. They can be carrying on. But you can tell he really loves them. He is full of love. I would like to be the literary B. B. King. There is something about him that has remained true and has remained genuine. He is authentic. Average people respond immediately to what he is and what he says. I like that. That is the best kind of acceptance.

The blues can be very disturbing, but I love it. I love some songs much more than others, some musicians more than others. What is truly disturbing is how frequently, when women are singing, they are telling about abusive relationships. I am struck by that time and time again. It makes me think about all the stories those women were trying to hint at that they were not able to say. I remember once, Quincy Jones laughed and said, "You know, Celie is the blues." That is so true. If Celie were singing, she would be like Mamie Smith, Bessie Smith, and Ma Rainey, all of whom were abused. Those women were abused by men. I always feel so deeply when I listen to them. Then I think about how people took it for granted that your man would be this way. Of course you will be abused. They were not heard, and they got used to it, actually dancing to the music. It was like a spi-ral that was going down. People sing about this and then expect it in relationships. It was self-perpetuating. I doubt if any of these people had relationships that nourished them. They had relationships that prompted cries of anguish that were then used to entertain. The people who were entertained modeled themselves on what they heard, and it was a very bad cycle.

What I love about the blues is the honesty with which people were trying to sing about what was actually happening. I hate the kind of music that was popular back then, and is popular now. No matter what is happening, it is a kind of, "La, la, la, la"—all sweetness and light. You can hear phoniness in their voices. You would not want to go across the street with those people because they are totally dishonest about their emotions. They do not know what emotions they were feeling. They are very unauthentic. But with the blues, you feel like you are hearing authentic feeling. People are struggling to find joy in life. Look at Bessie. She has all the vitality in the world. She is connected to the source, and she knows it. And the rest of the world is trying to tell her that she is not anybody big. There are all these little ways that this is done. Your hair has to be straight if it is kinky. You must wear powder, do something to your nose. All those things are designed to convince you that you are not what life and poetry are about. But Bessie used the power she had to affirm constantly, "Absolutely, I am what this is all about. I do not care what you are doing. I know what I am doing. I am here."

I know what the earth says. The earth says, "Be like me. I grow bananas. I grow strawberries. I have trees dropping nuts. I have waterfalls." The

earth says constantly, "I am not a poor person." The earth says, "I have everything." And so do we. That is one of the reasons why people who have everything are constantly robbed of it. People come up on something that is magnificent, and they cannot stop until they have stripped it and killed it. This is what is happening to the earth. And we are no different. We are the same. There is no such thing as mankind or peoplekind owning the earth. I mean, please, have a little humility before all of this. Just one little red clover—you cannot make that. We live in paradise.

Alex Haley 1921–1992

BORN IN ITHACA, NEW YORK

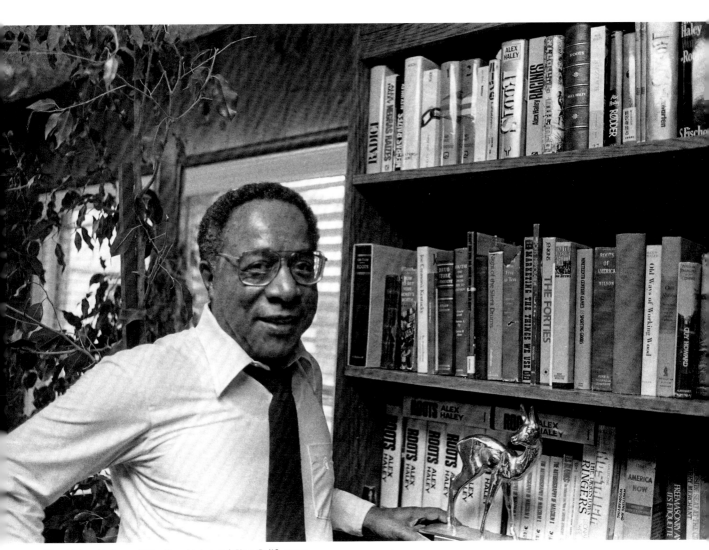

Alex Haley, Universal Studios, Universal City, Calif., 1979

My grandmother and her sisters would get in rocking chairs and would just rock. They would run their hands down into their apron pockets and come up with Kansas Sweet Garrett Snuff, load up their lower lips, and start taking shots out over the honeysuckle vines. The champion—I remember so well—was my great-aunt Liz from Oklahoma. Aunt Liz could drop a lightning bug at four yards.

They would talk there on the front porch night after night after night about the family. They told it as it had been passed down. Their grandfather was a man named Chicken George. His mother was Miss Kizzy, and her father was an African. I grew up hearing those stories so much that they became a part of me.

Alex Haley's legacy is forever tied to his legendary works—*The Autobiography of Malcolm X* and *Roots: The Saga of an American Family*, two of the most influential books on the black experience in the twentieth century. When his *Autobiography of Malcolm X* appeared in 1964, it transformed America's understanding of black life and culture. The book moved readers, just as Richard Wright's *Native Son* did when it was first published in 1940. Twenty-four years apart, Haley and Wright both parted the veil of race in America and exposed—with unvarnished clarity—black rage. Haley's work on Malcolm X was essential reading in the 1960s for students in the civil rights movement.

In 1976—twelve years after his *Autobiography of Malcolm X* was published—Haley's book and television miniseries *Roots* marked a historic moment in publishing and media history. One hundred and thirty million Americans watched the miniseries over eight nights, and his book sold six million copies during its first year of publication. The *Roots* television series featured LeVar Burton (Kunta Kinte), Leslie Uggams (Kizzy), and Ben Vereen (Chicken George), as well as a musical score by Quincy Jones. The series won nine Emmys and a Peabody, and the book won the Pulitzer Prize.

Alex Haley's two books reflect the complex person who created them. Haley is completely absent from the pages of *The Autobiography of Malcolm X*. With consummate skill, he shapes his interviews with Malcolm X into a powerful, first-person narrative driven by the voice of the speaker. *Roots*, in contrast, builds its narrative with Haley's own voice and uses his personal life as its anchor. Haley's story achieves a rare universality as each reader or viewer reflects, "There, but for the grace of God, go I." The book also

unleashed an interest in genealogy that continues to grow.

During the sixties and seventies, I felt a special kinship with Alex Haley. In the eighties, he called and invited me to spend a weekend with him on his beautiful farm in Norris, Tennessee. He hosted my family and friends from throughout the country for three days of conversation, music, and meals. My brother, Grey Ferris, and his wife, Jann, were among the guests. During the weekend, Grey spoke with Haley about his effort to consolidate county and city school systems in Vicksburg, Mississippi. Grey believed that the recently completed consolidation would avoid a predominantly black city and white county school system. The process had been difficult, and Grey invited Haley to visit Vicksburg and spend time with teachers and students who were part of this change. Haley graciously accepted.

Haley visited Vicksburg in 1989 to bless the merging of predominantly white county schools with predominantly black city schools. He understood the work that my brother Grey and other black and white leaders on the school board had done to build a better future for their children. As my mother served Haley dinner in our home, he reflected on how far our worlds had moved since his childhood in Henning, Tennessee.

In 1990, Haley was a featured speaker on the University of Mississippi Center for the Study of Southern Culture's historic "College on the Mississippi" *Delta Queen* trip. He was joined by Mose Allison, Eli Evans, Shelby Foote, B. B. King, and Jeff MacNelly, all of whom spoke or performed during the weeklong trip from Memphis to New Orleans. During his final talk, Haley related the story of "Amazing Grace" and explained that the hymn was inspired by the suffering of Africans who crossed the Atlantic on slave ships. He said, "One of every four enslaved Africans died on the slave ships. Their shrieks became part of the wind." At the end of Haley's talk, Roy Yost, a waiter on the *Delta Queen*, stepped forward and led the passengers in singing "Amazing Grace." There were tears in every eye when we stopped singing.

In 1992, the center cosponsored an international symposium on black expatriates at the Sorbonne in Paris, where I learned that Haley had died. Several days later, I sat in the pew of a large black church in Memphis as Mayor Willie Herenton, Lamar Alexander, and many others spoke eloquently about the loss of their friend Alex Haley. After the ceremony, I drove in a long, slow processional through the streets of Memphis and up Highway 51 to Haley's childhood home in Henning, Tennessee. White and black residents lined the highway holding their hats over their hearts as they paid final respects to a man whose work touched them in enduring ways.

In his foreword to the *Encyclopedia of Southern Culture*, Haley describes the region's people, whom he deeply loved. "Can you remember those southern elder men who 'jes' set' in their favored chair or bench for hours, every day—and a year later they could tell you at about what time of day someone's dog had trotted by? And the counterpart elderly ladies, their hands deeply wrinkled from decades of quilting, canning, washing collective tons of clothing in black cast-iron pots. . . . These southern ancestors, black and white, have always struck me as the Foundation Timbers of our South, and I think that we who were reared and raised by them, and amongst them, are blessed that we were."

Alex Haley was—in his own words—one of the "Foundation Timbers of the American South."

I recorded this conversation with Haley in Vicksburg, Mississippi, in 1989.

Grandpa and Grandma's bedroom had a screened window, and outside was a thick, matted growth of honeysuckle vines. Sometimes after Grandpa got sick, I used to get under the honeysuckle vines, right by the window at their bedroom. I would think about how different the vines looked underneath. The vines underneath were black and drab, but out front they were just gorgeous. I would reflect on how something so pretty could have such an unattractive underside. I saw hummingbirds come with their whirring iridescent wings, hang in the air, and run their bill in the crystal of those flowers. I fantasized that the hummingbirds were little angels coming to watch over Grandpa because he was very sick.

I saw this little hummingbird come up over the honeysuckle and hover the way they can do, their wings supporting. I went in my back pocket, pulled out my slingshot, *ding*, never in the world expecting to actually to hit the hummingbird. To my absolute horror, I saw the hummingbird drop. I rushed over there, and, bless my soul, there it was, with a big drop of blood dropping down on the beak. I had this awful feeling that I had shot an angel who was watching my Grandpa. I scooped it up and went flying across the backyard into the pasture. We had a plot of ground behind the barn covered with corrugated tin that was soft earth, spongy earth, where we got earthworms for fishing.

I scooped down and got enough dirt out to make a little grave, and I put the hummingbird in and packed the earth over him. Grandma's big persimmon tree was there, and I got a big green persimmon leaf and put it over the grave. I was convinced that I had killed a hummingbird angel that was looking out for Grandpa. People were saying, "What is the matter with you, Boy? You are acting funny." I could not help it, because I had done that horrible thing. From that day to this, I have a reverence for hummingbirds, and I do not go hunting. I would not shoot anything for the world.

When I was a boy in Henning, Tennessee, I went to a little church—New Hope CME—which meant "Colored Methodist Episcopal." We were first "colored." Then we became "negro." At that time, if someone called you "black," you had to fight. Now people call us "African American." It is just semantics.

On Sunday, after church about twilight, about six to eight little boys, aged nine to twelve, would go down behind the white Baptist church. We would go quietly and sit there. We would be humble, with our hands folded, as white people going to their evening service would pass on a path not far away. They would glance over to see us. They knew most of us, knew who our parents were. I am sure they thought we were sitting there being respectful because they were white people going to church. The truth of the matter was we would gather there every evening before the evening service to appreciate how pitiful their singing was.

I grew up at the time of the greatest internal migration any nation ever knew. Young people

were leaving the South, many of them black, and most of them were going north. The saying floating around was, "Go north and do good." The image—the illusion, really—was that the North was socially fantastic, and there was work.

Pete Goss was a strong young man, and Pete left Henning and went north. The next question always expected was, "When did he write his mother?" The community would quickly know, because a mother would boast that her child had written. Once they got a card—usually from a child who was hardly literate—then the next question the community asked was, "Had he sent his mother money?" If things went well, the boy would get a job. Then he would save up and send his mother five dollars, which she would announce everywhere.

Pete did not. No word from Pete, at all. Miss Fanny, his mother, was just so embarrassed. Finally, word got around that people in Chicago had seen Pete. The community felt that he had done badly for his mother. In time, word came back to Henning that Pete Goss had gotten a job as a waiter on an Illinois Central line train.

Now, to us, the greatest train that ever rode the rails was the Panama Limited. It went from Chicago to New Orleans and back. It would come through Henning in the evening. People would stand on the highway and look up at the tracks, and here it would come. There would be this Cyclops eye. Then the whistle, and the sound of the whistle would hang in the air. Next would come this nexus of light and *swhew*—it went through, and the most colorful thing you could see was the dining car and these little square tables with a white tablecloth, crystal, silver shining. White people were sitting, holding a drink or fork, and the black waiters were regal with their trays and a cloth over their arms. It was like something from Mars that came through every night. So when word came that Pete had gotten such a job, we felt like we had a star. He was on another line. It went another way. But we thought maybe one day he might get on the Panama Limited, and would not that be something. We could stand, and we could wave at Pete as he went by.

Fifteen years had passed since Pete left Henning when his mother got a card that she flew around town showing. He was going to come to visit. One day the morning train stopped, and a man got off. Henning was like every little town. People were always looking. The old men sitting on the benches playing checkers saw. Everybody saw. This man got off the train dressed in a homburg hat, a black man, brown-skinned as he was, carrying a very elegant Gladstone bag. He had on the kind of shoes preachers wear with that white around the edge. He walked through town and looked neither right nor left. He went up the road, and people were looking out from behind curtains. Nobody wanted to let him know they were watching. When Pete got up to where his mother was—this little boy had run ahead and told Miss Fanny, his mother, he was coming—she came out. He looked so elegant that nobody knew how to act.

Miss Fanny told the story later. When he came in, she said, he took his hat off, and he hung it on a nail on the door. It was only a four-room house where he had been raised, along with his seven

sisters and brothers. He sat down, and she did not know what to say to him. He was not the boy who left home. It was very much an effort to say anything. Finally, Sister Fanny said, "Would you care for some coffee, some tea?"

And he rejoiced. He said, "I would like a cup of tea."

Sister Fanny sprang up and ran into the kitchen. There was a curtain between the living room and the kitchen, and she ran in to stoke up the fire and put the water on and make some tea. This gave her something to do. It gave her a little relief, because this son of hers in there was nobody she knew. She was reaching up in the cupboard, reaching for the tea, when she sensed something behind her. She turned, and there he was.

He had taken his coat off, and he was standing in the doorway. The curtains were draped over his shoulders. She realized what a big man he was—a big, powerful man—standing there. He filled the doorway. He was strong, and he had on these garters. She said his face frightened her because of the intense hatred in it. But he was not looking at her. He was looking at the stove. This was the stove that had cooked meals for him and his seven brothers and sisters from the time they were little babies. The stove was beat up. One leg was gone and propped up with stove wood. The old pipes were held up by baling wire. It was an old stove, and it had done all this work.

There was a malevolent hatred on his face. She did not know what to make of it, standing there with the tea in her hand. She watched him step into the kitchen, one big step. He bent down, put his hands under this stove, and wrenched it up from the floor. The linoleum floor now had holes in it. She flattened back against the wall, scared to death. He wrenched this stove so that it broke loose from the pipes, and soot came down. She heard steam, because the water in the kettle had jostled out into the fire. Her son wrested this stove up, held it up with fire in it, and he stepped toward the rusted screen door leading to the back porch. Somehow, by strength, he got that stove turned through the back door, out on the back porch, and he threw it as far as he could. The stove hit the ground and split across the top. The kettle water hit the hot embers.

Miss Fanny said she was terrified. What do you do in a case like this?

He adjusted himself. It was a great exertion, as strong as he was. Then, he turned and walked back into the living room. She followed to see what would happen. He put his coat back on and his homburg hat, and he said, "I'll be back." She went to the window, looked out the curtains like everybody else, and saw him going up the road, headed back downtown.

Now, Spunk Johnson worked as a general assistant and delivery man for Mr. Anthony, who owned the Henning hardware store downtown. Spunk was in the back, kind of messing around, when he heard the front door open. He heard Mr. Anthony, who was white, speak in a way that he had heard Mr. Anthony speak when something was happening that made him a little uncomfortable.

Mr. Anthony said, "Can I help you?"

Then Spunk heard the voice he knew, of this new Pete, who had come home after fifteen years. "I would like to see a cookstove."

"Well, back this way."

Spunk looked out between some packing cases, and they got to where Mr. Anthony had three stoves set up. Mr. Anthony gathered himself and said, "Well, this is the kind of stove that your people usually buy, and it is thirty-two dollars."

Pete said, "I want the best you have got."

Mr. Anthony moved over to the best and said, "That is this one. It has a warming-up, and it has a tank, a water tank. It holds ten gallons. But this one," he said, "is sixty dollars."

"I will take it." Pete pulled out his wallet. It was the first time Spunk had ever seen anybody count out six ten-dollar bills. Pete handed them to Mr. Anthony.

Mr. Anthony had to gather himself, because Mr. Anthony had not seen six ten-dollar bills either. "You will need some pipe to set it up, but I will throw that in."

Then Pete said, "I wonder if I could have this delivered right away to my mother and installed."

Mr. Anthony said quickly, "Of course." And then he turned. "Spunk!"

Spunk ran back to the loading dock to appear that he had been out there, and then he came in. "Yes, sir." When Spunk walked in, he found himself looking at Mr. Anthony and Pete Goss, with whom he used to go to school. Spunk felt he ought to say something, and he said, "Look like you have been doing well."

"I would appreciate you installing the stove."

Spunk said, "I will do it."

Spunk put the stove on a wagon drawn by a horse. Pete, meanwhile, had gone up to the house and told his mother that he was going to have to catch another train, going to Memphis and back to Chicago. He left the very day he arrived, before

the stove came. People along "the lane," as they called it, where the black people lived, began to filter up. At first, it was the Golden Aid Society. They would go sit with the sick. Here came the Golden Aid Society, went up to pray with her. What they wanted was to see the new stove. They inspected it inside and out, because no one in the whole black community had such a stove as that. The word spread all over. When country people came to town, lots of people would go from downtown, up the sidewalk, and over to Miss Fanny's little old four-room house that had been there for the longest kind of time.

Sister Fanny was in the house behind the curtains, watching all those people coming up to her house. These people were fascinated with the old stove. They would go in the backyard, and there it was, lying, ashes trickled out, cracked completely across the top.

"Oh, he sure threw it, didn't he?" People would just look at it and make remarks. "That boy sure done good by his mamma." Nobody had ever done anything like that—come back and buy a brand new stove and give it to his mother in that manner.

The old stove stayed there, and I grew up. It stayed there from the 1920s. People went to see the old stove for the next two decades. Finally, in 1940, there was talk around town. They had a U.S. scrap-iron drive. People who had any scrap iron would take it to the blacksmith shop, and a mounting pile of scrap iron was growing. One day Mr. Willie James Sims, who had been appointed as the black-side-of-town collector of scrap iron, dropped by to see Sister Fanny. He spoke about the weather, seemed to be nice. Sister Fanny said,

"I know what you are coming to. You want to get that old stove."

"Well, if you do not have any use for it, it would help this country."

Sister Fanny kept rocking. "Well, if you feel like it would do any good, you go ahead and take it."

Willie James Sims thanked her. He went with his sons, George and Arthur, loaded that old stove onto the truck and took it down to the scrap-iron pile.

Years later Willie James Sims's oldest son, Arthur, wanted to go to Tennessee State in Nashville, and he needed fifty dollars. Willie James went to Dr. Ford and asked him to help. Dr. Ford was said to be the wealthiest man in town, but Dr. Ford said he did not think that boy Arthur needed to go to college. Willie James harbored that. When World War II came along, the whole community began to change. Into this world of five-dollar-a-week maids, there now came defense plants, which were paying people thirty-five dollars a week.

Dr. Ford was such a powerful man that nobody would ever think of crossing him. The story was that Dr. Ford got up one morning and, following the traditional pattern of things, sat down at his table for breakfast. The table was set as always. After a while, Dr. Ford began to think, where was his paper? So he went and got his own paper from the front porch, sat down, and was reading the paper. It was a while before he realized he did not smell coffee, that Willie James was not in the kitchen that he had worked in for the last fifteen years. Dr. Ford finally went out, saw some guy on the sidewalk and asked him to go find out if Willie James was sick. The fact of the matter was that Willie James had gone to New York. He had left the night before for a job in Rome, New York. It was a legendary story, how he left Dr. Ford sitting where he was.

If you live in a city, you have to really do something to have people pay attention to you. But in a small town, you can be the lady who cooks the best peach pie. You can be the strongest man in town, the tallest boy, or whatever. And you are somebody on that account.

My teachers always told my parents that I was a daydreamer, which was very true. I loved to get a seat by the window where I could look at the clouds and think, "That cloud looks like a kangaroo."

I am going to tell you exactly why I am a writer. As a young sailor in the U.S. Coast Guard, I never thought about writing. It never crossed my mind. At that time, if you were black, you automatically went into what was called a steward department. That meant you would make up beds, shine shoes, do things like that. And when you advanced, you would become a cook or a steward. I became a cook. I was on a ship that would go out for thirty days on patrol, and there was nothing to do in the evenings.

I began to write letters to my father's students. He was a teacher. I wrote dramatic accounts of how adventurous it was. It really was not all that dramatic. I made it sound like more than it was. They would answer me, and the sailors saw that I wrote more mail and received more mail than anybody on the ship. So sailors, being sailors, began to ask me if I would help them write let-

ters to their girls. And I began to do that. I would write love letters for my shipmates. They did so well with my letters they paid me a dollar a letter. That gave me the first thought that there might be something for me in trying to write. I began writing for magazines and began to collect rejection slips, as you will if you write for a living. I stayed on in the service. I loved going to sea. I still go to sea to write. That is how eventually I became a writer.

I principally wrote for *Reader's Digest*, and I did interviews for *Playboy*, two contrasting magazines. One of my interviews was with Malcolm X. That led to my first book, *The Autobiography of Malcolm X*. I was a conduit who saw the Malcolm book come into being. Malcolm's life without that book would be a mass of gratuitous tales, told by people who were in varying degrees of closeness to him. People come up to me—grown men— and say, "I used to go to school with Red in Boston." Malcolm never went to school in Massachusetts. You hear these things, and you realize these people really believe them. My book is out of his mouth. If the book did not exist, his life would be like a confetti of stories. One of the more important things I have been blessed to do in my life was to write that book. Malcolm was a symbol of a lot of things.

I feel *Roots* was a meant-to-be. I am honored to have done it. I did not say at the age of twelve, "I shall go forth and become a writer." Things happen. With both *The Autobiography of Malcolm X* and *Roots*, I hear people say Olympian things about the books, what they contribute, what they represent, what they mean. I am reluctant to agree

with them. I wrote hard. I wrote as well as I could. And I wrote as sincerely as I could—two different types of books. And I am grateful that they both did well. Indeed, they continue to do well.

The Autobiography of Malcolm X was published in 1965, and this is 1989. So we are talking about twenty-four years. My God, twenty-four years. This morning, when we were down having breakfast, a young man was sitting at the table across from us. I went up for a second helping, and he came up to tell me how much *The Autobiography of Malcolm X* influenced him twenty-some years ago, which is very moving.

In the case of *Roots*, I also feel I was the conduit. When I grew up in Henning, it was a little town of about 470 people. It was the town where my grandmother raised me, as we say in the South. My grandfather died when I was five, and my grandmother was devastated. She invited her sisters to come and visit her the next summer. She had five sisters, and my grandmother made six. So they came to visit that summer. I was six, and every evening after the supper meal, they would go out on the front porch. The front porch was surrounded by big, billowing honeysuckle vines, and over the vines were lightning bugs, flickering on and off. My grandmother and her sisters would get in rocking chairs and would just rock. They would run their hands down into their apron pockets and come up with Kansas Sweet Garrett Snuff, load up their lower lips, and start taking shots out over the honeysuckle vines. The champion—I remember so well—was my great-aunt Liz from Oklahoma. Aunt Liz could drop a lightning bug at four yards.

Alex Haley, Norris, Tenn., 1990

They would talk there on the front porch night after night after night about the family. They told it as it had been passed down. Their grandfather was a man named Chicken George. His mother was Miss Kizzy, and her father was an African. I grew up hearing those stories so much that they became a part of me. It was a little town, where all children went to Sunday school. In Sunday school we would study the biblical parables. By the time I was eleven years old, my head was a jumble of David and Goliath, Chicken George, Miss Kizzy, and Moses. It was all mixed up. Grandma and my great-aunts sat on the front porch talking. I had not the faintest idea of what they were talking about.

When I look back, there were specific steps along the way, each of which seemed at the time to have been accidental. But when I put them all together, they do seem to have a pattern—how I read a lot of books, how I got the idea that, if somebody wrote these books, maybe someday I could write a book. It was not thought of in a serious way—just speculation.

People would say, "Genealogy is not something for you blacks to write about. That is for white writers." I got sick of hearing that, and I began to think, "I do not care who it is. He or she is going to have to go a long way to do a better job than I on this book." When *Roots* came out, the *New York Times* announced that it was the greatest seller in one year of any book in U.S. publishing history. That gave me a special thrill, because I was black and from the South. We are the people whom others like to imply are not as able as they. *Roots* was one of those things that is a phenomenon, a book that went around the world, in all these languages.

My grandmother was one of those people who have dreams for you, who have been through things that you will never go through. They lived in another time—a hard time. These people picked cotton, washed clothes. And they have ambitions for you that you do not have for yourself. Right here in this state of Mississippi is one of the loveliest stories of a little girl. Her mother thought she could not have children because she had been married ten years and had not had children. When the girl was born, her mother put her up beside a crank Victrola and played Caruso records and read the Bible when the records were not playing.

I asked the mother later, "Did you want her to sing?"

She said, "No, it was all I had to work with."

She put that girl on a stool beside her in a church choir, and the girl began to sing around town. She became well known. When people would die, they would put her over the casket, and she would sing "Precious Lord Take My Hand." People would scream and make her stop—it was so emotional. That girl went on, and I talked to her teacher at the Metropolitan Opera. When that girl was in Juilliard, her teacher told me, "I had four students at the time come through. And I would have them sing a little. I would never look at them. I would hold my head down and close my eyes. One afternoon I heard what was like a flower that opened its petals and then closed them. I knew I had to keep those petals open." That girl was Leontyne Price.

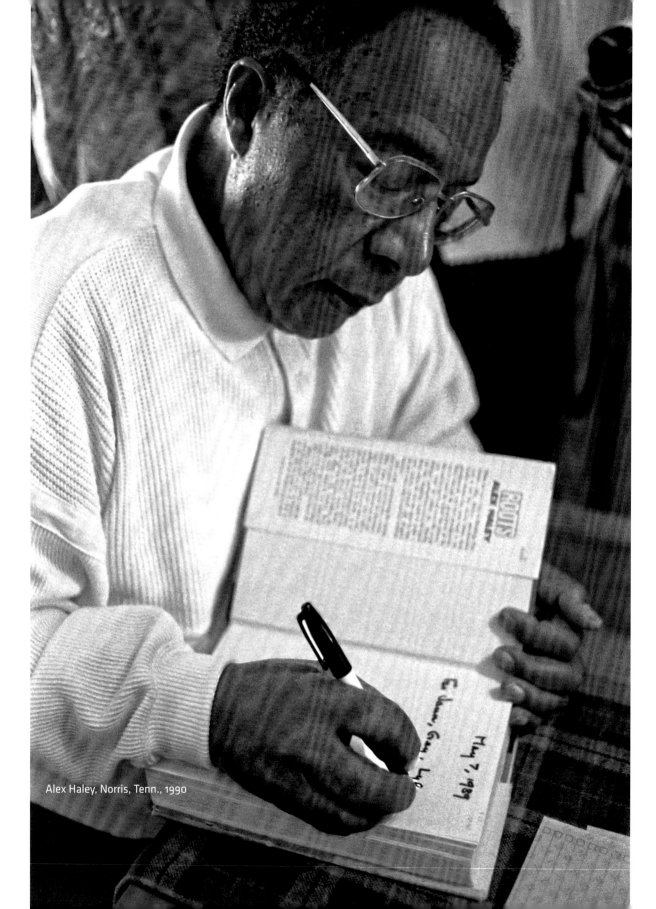

Alex Haley, Norris, Tenn., 1990

When I was a boy, there was strict segregation, and few people questioned it. That is the way it was. Then came the 1960s and their challenges to the system. There was a lot of ugly stuff.

The times have changed. At the University of Mississippi, of Georgia, of Alabama, of Tennessee, South Carolina, Florida, and no doubt some others I have not thought of, twenty years ago there would not have been a single black person on their football team. Not one. Now their gridirons look like an NAACP convention. I cheer it on the one hand, and I am concerned about it on another hand, because it is not real. It is not what this society is about. If you would track every player on that team for five years after college, you would come up with some pretty shocking things for most of them.

There is an illusion at work. You see kids who in their minds want to be Bo Jackson. There is nothing wrong with that, except their odds. Arthur Ashe told a group of black students that their odds were better to become a neurosurgeon than to become a pro athlete. It is probably true.

It really bemuses me—having grown up in Henning—to look at little children—kindergarten through third or fourth grade. The most impressive are the little children—black and white—seated randomly together. They are a symbol of our future. These children will get the best of what a school can offer them. They can grow up not shackled mentally by the things that have shackled both races up until now.

I instinctively love the South. I think it is the best place in this country to live. I like the people. People do things with their hands. If you look at the hands of an old lady, they tell you about her life. Women's hands, in particular, show their age and what their life has been. The South is a place of hands. It is a place of touch, of caress. It is a softer, sweeter culture. I would not want to live anywhere but the South. People know how to say "yes, sir" and "no, ma'am." People know how to speak, to be kind, and to smile. This is home.

I love our shared feeling of the richness of southern culture and the interdependence of black and white. I was talking to Tom T. Hall and Will Campbell about how many a white youngster was suckled by a black surrogate mother. That was part of the interaction when this house was built. It is joyous to see this culture, which we are a part of. It is growing up. It is becoming mature now. And it is beautiful.

Margaret Walker 1915–1998

BORN IN BIRMINGHAM, ALABAMA

Margaret Walker, New Haven, Conn., 1978

It is late in the day for me. I am looking at a setting sun. And all of the things inside, I would hate to die with them inside of me. I want to get them down. I always meant to be a writer and ended up not much of a writer. I should have done a dozen books by now. I have down almost two hundred pages of autobiography, one hundred pages of one novel, blocked out another novel, and have ideas for more. It takes a lot of energy to write. You need more than physical energy. You need psychic energy. I have to get this work finished before the parade passes by.

I met Margaret Walker in the fall of 1970 at Jackson State University. We both taught in the English Department, and I will never forget a lecture that she gave my students on Zora Neale Hurston. In her lecture she recalled meeting Hurston, Richard Wright, and Langston Hughes. Her memories of Wright were especially powerful, and I reminded my students that Wright once lived on Lynch Street—the street that runs through the Jackson State campus—before he moved to Chicago.

Walker founded and directed the Institute for the Study of the History, Life, and Culture of Black People (now the Margaret Walker Center) at Jackson State. The center hosted visiting writers, such as Nikki Giovanni, and sponsored a memorable program in which Fannie Lou Hamer spoke about her struggle for civil rights in Mississippi and sang spirituals.

While teaching at Jackson State, my former wife Josette Rossi and I lived on Guynes Street—now Margaret Walker Alexander Street—in one of the first black middle-class neighborhoods in Jackson. Walker lived several doors to the east of our home, and two doors to the west was the home where Medgar Evers was assassinated by Byron De La Beckwith as Evers returned to his family on the evening of June 12, 1963. Our neighbors told us about that tragic night, a night forever etched in their memories.

Margaret Walker, Alice Walker, and Eudora Welty all lived in Jackson at that time. Alice Walker was an aspiring young writer who had just finished her novel *The Third Life of Grange Copeland*, and Margaret encouraged her to pursue a literary career.

Margaret Walker and Eudora Welty often appeared together at literary events in Jackson, and they enjoyed a friendship for many years as the city's leading literary figures. Each had a circle of close friends, and

they both hosted literary salons where conversation and food were shared. Walker loved to cook, and her journals are filled with references to food.

Walker's close friends in Jackson included poets and literary scholars Virgie Brock-Shedd and Jerry Ward, librarians Ernestine Lipscomb and Bernice Bell, music teacher Aurelia Young, Jackson's president of the National Council of Negro Women Jesse B. Mosely, historian Alferdteen Harrison, literary scholar Jean Clayton, and Margaret's devoted administrative assistant Alleane Currie. Mosely later directed the Smith Robertson Museum and Cultural Center, housed in the building where Richard Wright attended high school. For many years, Alferdteen Harrison directed the Margaret Walker Alexander National Research Center at Jackson State. Walker's former student Maryemma Graham now teaches in the Department of English at the University of Kansas and is finishing a long-awaited biography of Walker.

As a nationally acclaimed writer, Walker was a celebrity on campus and an important role model for young African American women. Many students at Jackson State were the first in their families to attend college, and they were inspired by Walker's stature as a distinguished poet and novelist. Her first book of poetry, *For My People* (1942), was selected by Stephen Vincent Benét as the winner of the Yale Series of Younger Poets Competition. Walker's novel, *Jubilee* (1966), was based on her grandmother's life as a slave and is referred to as the black response to *Gone with the Wind*.

While teaching at Yale, I brought Walker to read and speak to my students. She was an old friend of Charles Davis, chair of the Afro-American studies program and master of Calhoun College, where I lived as a resident fellow. Davis hosted Walker's visit

and introduced her when she spoke to students at a Master's Tea in Calhoun College in 1978. During her visit, she also reread her letters to Richard Wright. Donald Gallup, then curator of the Yale Collection of American Literature, met with Walker and discussed her letters, which are housed in the Richard Wright Papers in Yale's Beinecke Rare Book and Manuscript Library.

While at the Center for the Study of Southern Culture at the University of Mississippi from 1979 to 1995, I worked with Walker on a number of projects. Her poetry and fiction were featured in anthologies of Mississippi writers that Dorothy Abbott published while working at the center. In 1988, we sponsored a lecture by Walker when she signed copies of her book *Richard Wright, Daemonic Genius: A Portrait of the Man, a Critical Look at His Work* at Square Books.

Throughout her life, Walker negotiated her roles as mother, teacher, poet, novelist, and fearless voice for the history and culture of African Americans. From our first meeting in 1970 to her death in 1998, we shared a special friendship that I will always treasure.

This conversation is drawn from a presentation Walker gave at Yale University in 1978 and an interview I did at her home in Jackson, Mississippi, in 1982.

As a small child in the 1920s, I was very much affected by the Harlem Renaissance. As early as age eleven, I read poetry by Langston Hughes. The president of New Orleans College, where my parents taught at that time, gave them a little booklet called "Four Lincoln Poets." They brought it home and gave it to me. Langston Hughes first impressed me then. When I was twelve, my parents brought home a copy of Countee Cullen's *Copper*

Sun. My sister and I memorized both Countee Cullen's and Langston Hughes's verses.

In that early period between age ten and seventeen, I saw and heard in lectures and recitals Langston Hughes, James Weldon Johnson, Marian Anderson, and Roland Hayes. These were significant events in my life. Zora Neale Hurston came to the college to talk to my mother about folk materials in New Orleans, but my mother said she could not help her. Zora studied under what they call the two-headed doctors of voodoo and hoodoo in New Orleans.

I caught a glimpse of Zora, though I had no idea then who she was nor how significant she was. I remember she had on a knee-length, sleeveless flapper dress and wore bobbed hair. I was impressed with how short her dress was. My mother's dress was still well below her knees and did not come to her kneecap until much later.

Langston Hughes's appearance was a most exciting occasion. I felt partly responsible for his coming to New Orleans, because I told my parents they had to get him there. I had never seen a real live poet before. He came in February, shortly after his thirtieth birthday, and the college could not promise to guarantee the $100 fee. But he made more than the $100, because he sold his books. He had already published *The Weary Blues*, *Fine Clothes to the Jew*, and *Not Without Laughter*.

He and his manager-companion, who disappeared as soon as Langston arrived, were traveling through the South in what he termed "a beat-up old Ford car." Langston has a description of that trip in his autobiography, *The Big Sea*. He talks about meeting me and reading my poetry on that first visit.

Langston urged my parents to send me out of the South. The next year, they did just that. On the advice of my freshman English teacher and on the basis of their own experience, they decided to send me to Northwestern University. It made all the difference in my life.

In February of 1936, I saw Langston Hughes in Chicago at the National Negro Congress. I had finished Northwestern by that time. For the next three years, I saw Langston at least once a year when he came to Chicago. I also had the rare pleasure of meeting James Weldon Johnson in Chicago in the 1930s and shook his hand at that time. Soon after that he was killed in a car accident.

When we worked together on the Federal Writers' Project, Richard Wright suggested that we go see Arna Bontemps. In New York, Wright also took me to meet Sterling Brown, who was then director of Negro affairs for the New York project. Later, when I lived in New York, I met Gwendolyn Bennett. When *For My People* was published in 1942, I received letters of interest from two notable figures in the Harlem Renaissance, Alain Locke and Countee Cullen. Sometime early in the 1940s I visited friends in Lynchburg, Virginia, and there I met Anne Spencer and saw her in her garden.

I did not meet Charles Johnson, the great sociologist who was godfather to the Harlem Renaissance and also my benefactor through the Rosenwald Fund, until I was invited to Fisk University in the 1950s. Dr. Johnson was the president at Fisk. I went to dinner at his home and had the seat of honor at his right. I was too excited to speak anything but inanities. The next year he was dead of

a heart attack. He died in a train station, between trains, on his way to fight against segregation and for school integration.

Of all the figures in the Renaissance, my idol was Langston Hughes. Our friendship dated from that first night we met in February 1936 until the day he died in May 1967. I saw him last in New York in 1966, in October, and remember until now his big bear hug at that meeting. Through the years I saw Langston in sundry places like Texas; Boston; Cambridge; High Point, North Carolina; and Jackson, Mississippi, as well as in New York and Chicago. We spent six weeks one summer with a group of writers at Yaddo. Almost as wonderful were his cards and letters that came from all over the world—Carmel, California; the war in Spain; Mexico; London; and Nigeria. Everywhere he went, he wrote cards and letters, and he sent me his books for Christmas presents. I have sixteen autographed copies of Langston's books.

I saw him in the apartment he shared with Toy and Emerson Harper, first on St. Nicholas Place and again in the house on East 127th Street. He visited us in New Orleans, took me out to lunch in Chicago at the Grand Hotel. When both *For My People* and *Jubilee* were published, he wrote glowing letters of congratulations. When Wright died in Paris, Langston wrote me a note on his Christmas card, "Imagine my surprise to get to London and see in the papers that he was dead."

I remember Langston with genuine affection. During the years since his passing, I feel an acute sense of loss of his wonderful friendship. His easy, carefree manner belied his serious dedication to the art of writing. He claimed that he belonged to the cult of the simple and that he was like Jesse B. Semple. But Jesse B. Semple gives you just a little bit of Langston Hughes. He was a complex, sophisticated, cosmopolitan man, the humanist par excellence, always in love with life and people. Of all the Renaissance writers, Langston seems to me to be the paramount. Next to W. E. B. Du Bois, he left the greatest literary legacy. In his poetry he made an unusual contribution to the blues idiom and to jazz rhythms. In Jesse B. Semple, he created a folk character whom we all love. Langston loved Harlem. He immortalized the street culture of that community as no one else has.

Most of the Renaissance poets considered Langston their leader. Certainly Arna Bontemps did. I sometimes think that Arna Bontemps stood in Langston's shadow for most of his career. They genuinely loved each other. There was never any jealousy between them. They collaborated on many books.

When I think of Langston, I see a collage of the places we were together and of all the books he wrote. He read poetry in so many different places. He sent flowers when my first child was born. He played a game of poker at a party and kept an absolutely poker face. One night in Orange, Texas, he spilled a drink on my dress and said, "You look like something straight out of *Vogue* magazine." When I went out to Iowa he wrote, "Don't get too many degrees, or you will be smarter than I am," pulling my leg, you see.

I heard his death announced on the radio, and it stunned me so I could not bear to talk about it. How would it be to come to New York and not see Langston? What he said on an autographed picture he gave me is my epitaph for him: "To Margaret, who is such fun to be with." I would like to

say of Langston, who was always such great fun, that those of us who knew him best miss him very much.

One night in 1939, Langston treated me to a ride on top of a double-decker Manhattan bus up Fifth Avenue from the Village to 150th Street. After the ride, which I found quite exciting because Langston pointed out all the sights and landmarks, we went to the opening of a new bar called Fat Man. I like to think that was the night when Jesse B. Semple was born. The place was crowded, and we could scarcely elbow our way through the throng of black people celebrating the opening of a new black business in Harlem. Everybody seemed to know Langston, and he was laughing, smiling, cracking jokes as usual. He was slapping shoulders, shaking hands, and being greeted in turn.

Langston considered Harlem his home for forty-five years. He went to New York when he was a teenager to study at Columbia University. He quit or failed or ran out of money, or all three because his father stopped sending money. Then he went to sea. He sailed around the world, went to the West Coast of Africa and to the streets of Paris, where he had a doorman's job in a nightclub for a while, where he met Ada "Bricktop" Smith. He was also once a beachcomber.

In his early twenties, Langston returned to Harlem, and in the late 1920s he became the leader of the new black school of literature, the Harlem Renaissance. I prefer to limit the Renaissance to the decade of the twenties. We need to remember the two decades preceding the twenties as the flowering of Afro-American culture leading up to the Renaissance. In the lead-up to the twenties, we already had the published works of James Weldon Johnson, Claude McKay, and Frances Ellen Watkins Harper, who is the author of the first novel by a black woman. The works of these artists were precursors of the Renaissance and served as a bridge between the turn of the century and the twenties.

I consider Langston the greatest success story in the Renaissance because of his literary contributions in poetry, prose, and drama. Langston was unique. His work is touched with the magic of his personality—his ingenious manner of expressing himself, his genial disposition, his serious discipline, his dedication, and his remarkable versatility. Arna Bontemps told me just before he died that Langston left a legacy of eighty-six published works. In addition to that, he left 200 pages of the third volume of his autobiography in manuscript and such a voluminous set of papers that two years of work by his devoted friend and executor were not sufficient time to collate and organize all those materials.

Langston's use of jazz rhythms and blues was the first use of black idiom in poetry since Paul Laurence Dunbar. Langston's *The Weary Blues* came out in '26, and James Weldon Johnson's *God's Trombones* appeared in '27. They were working about the same time.

I regard Langston as a master craftsman in prose-fiction, whether in the short story or in his longer fiction. His five books of Semple tales are largely collected from columns that first appeared in the *Defender*. Many of us read Semple first in those columns, and they were always delightful. You could almost see Langston's tongue in his cheek and hear him laughing. I see him pulling a leg in those stories. I still do.

Langston uses folk material to delineate character, to deal with racial issues, and to comment critically on contemporary society. Semple said he wished Congress would set up game preserves for Negroes down South, the way you have preserves for animals. You do not let people kill deer indiscriminately, but you can lynch black people in Mississippi any time you get ready. He said, "Why don't they set up some preserves with signs that say 'Posted,' where you can't kill Negroes?"

At midnight Langston sat down at his typewriter to write. Between four and five o'clock in the morning, he went to bed and rose at noon. That was the way his day went. He rarely revised his poems. All his prose, however, was painstakingly written and carefully revised. He was methodical, organized, and always a serious writer. For many years, he was the only black writer living who made his living solely from writing.

Langston wrote across forty-odd years. His writing changed with each decade. In the thirties he was a writer of social protest; in the forties, the war was the eminent thing; in the Cold War period of the fifties it was different; then in the sixties he joined the revolutionary black writers.

Langston and Arna both spoke about Zora Neale Hurston disgracefully. She and Langston had a feud, a real falling-out after an ill-fated collaboration. I think it is very interesting to read both her side of the story and Langston's side. Then read what her biographer has to say, because the three give a fairly rounded picture of that fracas.

Zora Neale Hurston is the bright, colorful figure of the Harlem Renaissance, and no one should forget it. There were at least a baker's dozen of these women in the Renaissance who overlapped in the twenties, some younger, some older. None of the men could eclipse Zora Neale Hurston, even though they tried. She was a natural-born storyteller. Zora could not tell a poor story nor write a bad book. *Jonah's Gourd Vine*, her first book, was based almost entirely on folklore. It may not measure up to her excellent novel *Their Eyes Were Watching God*, but it is a book well worth reading, as are her other books—*Mules and Men*; *Moses, Man of the Mountain*; *Tell My Horse*; *Seraph on the Suwanee*; and *Dust Tracks on a Road*. Most of these are not novels, but they read as if they were.

Zora is a gal after my own heart. Arna told me once that I reminded him of Zora. Then when I bristled and got my hackles up, remembering how he talked about her, he backed off by saying she was exuberant and brilliant. But I know he was also saying she was contentious and extremely ambitious. I do not think he intended to include me in her reputation for vulgarity. I do not see how he could have. But I am sure Zora and I have much in common for unwittingly getting into scrapes and controversial issues. She did not take cover because she was a woman. She put up her dukes and stood her ground with the best of them.

Zora was a woman, black, and poor. She came up from Florida, and she went to school for a while both at Morgan and at Howard. Then she went to New York seeking her literary fortune, and she really hoped to get her degrees at Columbia. Even though she was an excellent student, there was no hope for Zora.

She died a pauper, after having worked as a domestic for a pittance. But she remains one of the brightest stars in the Renaissance.

Sleep well, Zora. We love you.

Carl Van Vechten is not nearly as important an influence on the Harlem Renaissance as one has been led to believe. His *Nigger Heaven* comes in that period. What he is saying is that Harlem is *Nigger Heaven*—that there was a period of prosperity in America, and everyone was on a hayride. After World War I, America was making all kinds of money. You had these famous parties that began on Park Avenue and ended in Florida. And black people were the entertainers. They played the music, they sang the blues, and they read poetry at these parties. From the white critics' point of view, this was an example of the exotic, unusual, primitive, childlike black person.

Nigger Heaven is very minor in the picture. Van Vechten was like all the other white angels. There was no such thing as a person getting published without assistance from some white body. That continued right straight through the forties and into the fifties.

Van Vechten made photographs of me in the forties. I was never invited to those famous parties that he and his wife had. But they did invite me to their apartment. I remember that I had my hair in an upsweep. I did not have much hair, and he said, "Do you always wear your hair that short?"

I said, "Yes, I was born with it that short." I didn't have any more hair than that.

What the black writer was saying—and Langston says it best in his essay on the racial malady "The Negro Artist and the Racial Mountain"—is

that we black writers are going to express ourselves as we feel we want to express ourselves. If white people like us, that is fine. If they do not like us, that is fine. And if black people like us, it is fine. And if they do not like us, it is fine. We are going to do what we want to do. When company comes, you may send me to the kitchen, but I will eat and grow fat, beautiful, and strong. One day you will see how beautiful I am, and you will not send me to the kitchen anymore.

You should have heard Richard Wright. He said everything he could against Langston. Wright said, "Why do we have to beg the question of our humanity to anybody? We look in the mirror every day. We see what color we are. And we know we are not dogs. So we do not have to go along with that Shakespearean business, 'If you prick me, do I not bleed?'"

If you look at Wright, or if you look at me, we are not begging the question of black humanity. We accept it.

The image of the black woman in American literature has been a negative, derogatory image. The black woman was always seen as the beast of burden, the menial, the domestic, the buffoon, the clown, the sex object, the amoral prostitute, Scarlet Sister, Mary, or Mamba's daughters and Mamba. You had no humanity whatsoever. You have the black woman bearing the burden of color, whether she looked black, or whether she looked white. Her role in literature was the same as her role in society. There was no job too low for her to do, whether it was work in the field, or work on the railroad, or as a domestic servant. She would carry clothes on her head. We built up

that matriarchal myth—"She is strong. She is the matriarch of the race." We did away completely with the black male as a strong figure by building up the myth of strong black women.

We come up against two things in the black American novel—the sentimental and the gothic. Zora Neale Hurston's *Jonah's Gourd Vine* and *Their Eyes Were Watching God* follow a folk pattern and a sentimental tradition. Modern black women novelists like Alice Walker and Toni Morrison are marvelous writers of the gothic. Toni Morrison is much better in *The Bluest Eye* and *Sula* than in the book that won the National Book Circle Award, *The Song of Solomon*. What she is doing with those black women is to exorcise that demon, and she does it in *Sula* even more so than in *The Bluest Eye*.

Toni is a marvelous craftswoman, and so is Alice. Toni is older than Alice—Alice is around my children's age. They both understand that the welter of folk material in the black race is inexhaustible.

In the South, there is more interest in literature than in painting. Painters have a tendency to leave the South and never come back, whereas many writers come back or stay here. Painters interested in the southern scene have been of two kinds. There are those who are political and rebellious, who deal with the social horrors of the South rather than its physical beauty and serenity. And there are those who paint the landscape, the slave shacks and quarters. They paint the poverty without trying to make a political statement. There is also that painter who is interested only in portraits. He does not want to deal with the social picture or even the physical landscape. He wants

to deal with the individual. The contemporary artist is closely related to the writer, but southerners boast about their writers much more than they do about their painters.

In the Deep South, writers and painters are not as closely allied as they have been in other parts of the world. Look at writers in Paris in post World War I, the people around Gertrude Stein—Hemingway, Pound, and Fitzgerald—and the painters that she had around her—Picasso and others. Stein had a group of Impressionist painters who were as close to her as the writers. In the Deep South, a major writer like Faulkner had a brother who painted and another brother who wrote. They were an artistic family.

I like to go back to the WPA. At that time in the Deep South you still had very great segregation. Writers and painters were separated by race. In the contemporary scene, writers and artists are no longer divided in the South by race or class. They have a tendency to find each other and deal with the same problems, whether economic, political, or racial.

The long relationship between black and white cultures in the South has deep historical roots. First, black people are forced into American life as slaves. After slavery, the black worker was literally a peon on the land. Then you have a revolution around 1950, when the industrial revolution came to the South. For the first time, there were no longer a large number of black people on the land. They were driven from the land to the cities, from the rural areas to urban centers in search of economic relief, as well as political freedom and educational opportunity. The long racial relationship in the South of slavery and

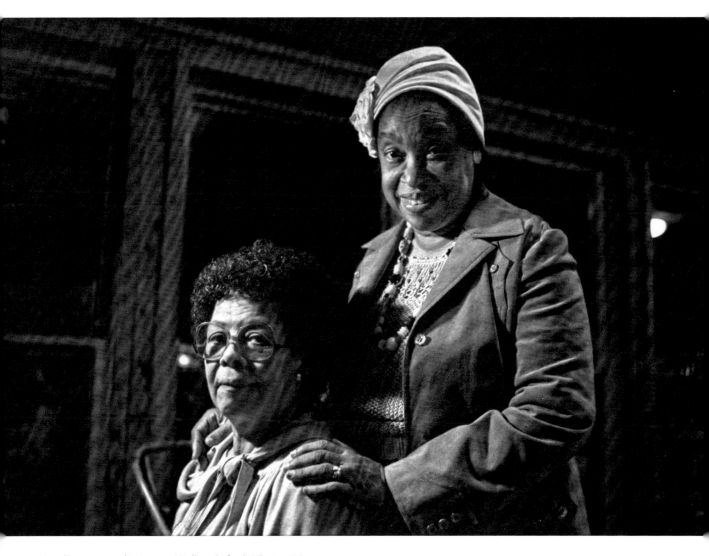

Aurelia Young and Margaret Walker, Oxford, Miss., 1988

of segregation was that of white master and the black slave or servant. That changed markedly in the twentieth century. You no longer have the purely master-servant relationship. Integration is a token expression of freedom because you still have large numbers of black people in the South affected by the depressed southern economy. Greater poverty always existed in the South, along with great affluence, great wealth, great fortune. Black people have almost without exception been among the poorest of the lot.

But the poor white, the hillbilly, the redneck, was as deprived and dispossessed as the poor black. He had little political opportunity. And if he had it, he did not take advantage of it. He was as exploited as the black, and the only way that this could go on was through the use of demagoguery. Political demagoguery worked against that poor white, the hillbilly, the redneck, the mountaineer, the factory worker, the migrant worker. He was as displaced on the land as the black, but he thought that his color made him superior. The two cultures grew up together, but they never merged. Blacks and whites lived side by side, but the two remained apart because of the political system and the economy.

I wrote the poem "For My People" when I was twenty-two years old. It took fifteen minutes on a typewriter. I took the poem to the WPA project and showed it to Nelson Alderidge. Richard Wright had already gone to New York. So I showed it to Nelson, and he said, "Margaret, if you are able to say what you want for your people, I believe you will have a poem there."

I told someone the other day that this poem was the rallying cry of the civil rights movement.

It was read all over the country by young people—students in the South, in the Middle West, as far away as California.

I think paintings also make such cries. You can think of Picasso's *Guernica*. That is certainly a cry against war. Jacob Lawrence's flat, one-dimensional figures of black people make a very great statement. His paintings make very important political statements. Charles White's images of dignity describe the search of black people for freedom, for peace, for human dignity. Those paintings are poignant representations of the cry that black people are constantly making. I have pieces here in my house done by Elizabeth Catlett that make the same statement. I have her print of a Mexican woman selling newspapers. Her face tells you the whole story.

The look of the region is the first consideration when people think of the South. They think of a physical place, a landscape that belongs to the South only. They think of the warm waters, the gulf-blue streams, the rivers—whether they are muddy or clear—the creeks and the bayous, the woods, the thick virgin forests, the wildflowers, and the great number and variety of birds, brightly plumed birds. I look out of my window in the winter and see redbirds, bluebirds, mockingbirds, hummingbirds, and the woodpecker. These are ordinary birds. But you also see the thrush and the wren. You sometimes see Baltimore orioles. We see wonderful birds.

Across the southern landscape in the winter, you have warm air, warm water, beautiful birds, green trees that almost never become brown—and the land itself sometimes does not turn brown even in the coldest winter. During the past two

years, my geraniums have lived through the winter. If you travel just a few degrees farther south to New Orleans, you have a subtropical paradise. In February you will see flowers growing in New Orleans. You will see azaleas and tulips blooming early. I once took a trip from New Orleans to Jackson and then went to Atlanta and Memphis, and up to Chicago. I saw three or four springs. As early as February, the magnolia blooms in Louisiana. Then in March in Mississippi we have azaleas blooming. On the side of the road, you see red clover, bouncing betty, and all kinds of wildflowers.

There is a beauty in the South that does not exist anywhere else in the country. And in the Gulf States, we have the most beautiful scenes of all. I live in Mississippi, and out of 365 days of the year, I would say that there are not 30 days without sunshine. It is amazing to me in the winter, when I go into the Middle West and up to the East, I do not see the sun. I see gray days. The only time I have a gray day in the South is when it is raining. The sun shines all the time. Florida claims it. California claims it. But the whole southern region is a sunbelt.

Southern land has always been precious to the southerner. He looks upon it as his own. He forgets that he is only a steward. Faulkner reminds us that the abuse of land is the abuse of privilege. Its nature is to be guarded and held in trust. Man is only a steward for the land. He should not overwork it, and he should not abuse it. He should treat it with care, as if it were another human being.

You know, I have a number of friends who are painters. And when I stop and think about them, I realize the southern painter is more concerned with scene than the middle westerner or New Englander.

I have no real interest in abstract painting. I know very few black artists who deal with abstracts. They paint people and places. They do landscapes. They do seascapes. They do social scenes. They look at society and do the rural or urban community. The painter looks at folk roots. He looks at quilts and basket making and blues singing and guitars. He paints the woman who is selling blackberries. He captures the shoeshine boy and the blues singer or the guitar player. Those are subjects for the artists. He paints the huckster who is selling vegetables and fruits and fish, who peddles his wares through the city streets. He paints farmland, fields of cotton, fields of corn. The old man and the child sitting by a stream fishing, the barefoot boy with his sunhat that is ragged and torn, these are subjects for the southern painter. People everywhere relate to these homely rural and urban subjects.

It is late in the day for me. I am looking at a setting sun. And all of the things inside, I would hate to die with them inside of me. I want to get them down. I always meant to be a writer and ended up not much of a writer. I should have done a dozen books by now. I have down almost two hundred pages of autobiography, one hundred pages of one novel, blocked out another novel, and have ideas for more. It takes a lot of energy to write. You need more than physical energy. You need psychic energy. I have to get my work finished before the parade passes by.

Sterling Brown 1901–1989

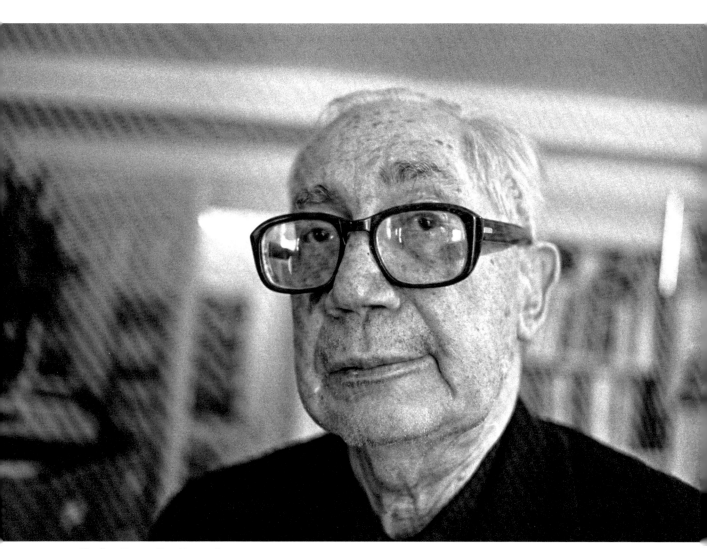

Sterling Brown, New Haven, Conn., 1979

The white interviewers were anxious to show the benevolent guardianship of slavery. There is no black person I know of in the South who, when a strange white man comes in and says, "Was your master good to you?" is going to say what the master was really like. Most of them said, "He was a good man. But on the plantation across the way, that other master was awful." They always shifted to another master. But they did not do that when the interviewer was black.

I first met Sterling Brown when he spoke and read his poetry at Yale in 1979. His visit was organized by Robert Stepto and Michael Harper, who dedicated their book *Chant of Saints: A Gathering of Afro-American Literature, Art, and Scholarship* to Brown. In his foreword to the volume, John Hope Franklin describes Brown as the "dean of Afro-American letters."

I had long admired Sterling Brown's poetry and asked if he would speak with me about his interest in folklore and his experience at the Works Progress Administration when he collected oral histories of blacks in Virginia. Brown and Zora Neale Hurston were among the few blacks who did these interviews for the WPA.

We also spoke about whites who collected black folklore. He told me that he had used my book *Blues From the Delta* (1970) in his classes at Howard University and had followed my work with interest. He admired a woodcut of William Faulkner hanging over my desk and spoke about the importance of his work for black writers.

Several months later I visited Brown at his home in Washington, D.C. We had coffee in his library, and he spoke about his classes at Howard University, where he was a legend among students. Brown was a controversial figure who supported student protests and invited Malcolm X to speak on campus in the sixties. He connected black folklore with literature in powerful ways through his poetry and told me about Big Boy, a blues singer with whom he had worked. In the tradition of W. C. Handy and Langston Hughes, Sterling Brown wrote blues poetry that captured the worlds of singers like Ma Rainey. His language in this interview echoes his graphic blues poetry. Brown saw himself as a bluesman and read his poems with a powerful, rhythmic style.

This conversation was recorded at Yale University in 1979.

I ain't no folklorist. I am a man with a good ear, a good memory, and a love for people. You can never succeed in folklore until you learn how to smoke. You got to smoke with the people. You got to drink with the people. You got to lie with the people, especially my people.

I do not want to have to learn about black folklore from white people only. A white folklorist must make a whole lot of adaptations to get into the field, because our people are close-mouthed when it comes to a white interviewer. Two interviewers with the same person are going to get two different stories if the racial identification is different.

There were very few Negro writers on the Federal Writers' Project interviewing ex-slaves, because there were very few Negroes making a living from writing. When I became editor of Negro affairs, I worked to get Negroes on the project. Most of the people on the project were white, and most of the interviews were done by whites. When we finally got a few Negro interviewers, they would come up with different stories from the ex-slaves than the white interviewers. Of course, the editors would say, "The first story is right because a white interviewer got it. You can't expect Negro interviewers to get this right, can you?"

The white interviewers were anxious to show the benevolent guardianship of slavery. There is no black person I know of in the South who, when a strange white man comes in and says, "Was your master good to you?" is going to say what the master was really like. Most of them said, "He was a good man. But on the plantation across the way, that other master was awful." They always shifted to another master. But they did not do that when the interviewer was black.

The original idea for the Federal Writers' Project was that of Lawrence Reddick, a Negro and a very able and militant historian. Before the WPA Writers Project, he did a study of ex-slaves in Kentucky and Tennessee for another Roosevelt program.

John Lomax was the first folklore editor. Lomax was an unreconstructed rebel. He wrote an article in *The Nation* on self-pity and the blues, and he wondered what the Negro had to be blue about. I answered it in my article, "The Blues as Folk Poetry" in 1930, which is a much-neglected article.

On the WPA project, Lomax was concerned with the slave's relationship to the master, but I had a lot of other questions. Roscoe Lewis and I set up a Jim Crow project in Virginia, and we published *The Negro in Virginia*. Lewis had been interviewing ex-slaves, and we got a staff together and did more interviews. *The Negro in Virginia* is a fascinating, powerful book.

I had a hell of a fight with a woman in Beaufort, South Carolina. She said that I used only "Yankee authorities" in that book. I told her that I used Guy Johnson, Arthur Raper, and Howard Odum, who all taught at the University of North Carolina. She wrote back, "That University of North Carolina ain't nothing but a Yankee school anyway."

I taught a full load at Howard University while working on the book. They would not let me free at Howard. So I taught in the mornings, went

down to Virginia in the afternoons, and worked my ass off.

I wrote an essay called "The Negro in Washington" in which I said that George Washington Parke Custis had a colored daughter, and they called me a communist for that. Senator Reynolds of North Carolina and another guy named Keefe from Wisconsin read me into the *Congressional Record* as being a communist. I pointed out that in the shadow of the capital were some of the worst ghettoes and slums in the world. I attacked the segregated school system. I just attacked left and right. Nothing that strong had ever been written in a government publication. All the reviewers pointed out the importance of the Washington essay for Negroes.

I did that essay with the help of Ulysses Lee. Ulysses Lee turned up the fact about George Washington Parke Custis. Representative Keefe said that even if it were true, it was wrong years later to bring something up blackening a man's name. Well, I did not think it blackened his name. I mean, that was common. Now they talk about Jefferson's illegitimate children. There is a whole lot of folklore about George Washington and his handling of Negro women. Negro folklore says that George Washington caught his death of cold because when the Negro woman's husband came home, Washington had to go out the window and stand outside in his bare feet. Now whether that is true or not, a lot of Negroes believe it. And I know a lot of Negroes who swear that they are descendants of George Washington.

Slave masters with Negro children were widespread. Zora Neale Hurston says we are a mingled people. So when the man says to me, "Go trace your roots to the Congo," I can also trace them to some river in Ireland and to some damn river in the Cherokee country. Melville Herskovits pointed out that the American Negro is a blend of Caucasian, American Indian, and African. And he said, of these, the Caucasian is the most obvious to be seen and the least documented. All of them are poorly documented.

I think it was a damned good thing to have *Roots* on television. It showed the brutality of the slave trade and of slavery. But I do not believe that Alex Haley found anybody kin to him over in Africa. And I do not believe that the descendants of Kunta Kinte were the only ones that hated to be slaves. I think that is a lot of bullshit. Frederick Douglass is not talking about no damn Kunta Kinte. Frederick Douglass says that there ain't no banana in him, which is a lie. There was some. But there was also some Scotch in him. His name was Bailey, but he changed it to Douglass. Harriet Tubman was probably more what you call pure black than Fred Douglass. But she did not run away because Kunta Kinte run away. She ran away because she was tired of slavery.

I became interested in Negro folk speech when I was at the Virginia Seminary. Then I got interested in every aspect of our lives. I got fascinated by the lives of my people and the misinterpretations about my people. I have devoted my life to studying literature and history. And I studied the hell out of slavery. I never had a course in history in college. I am not a historian, but people respect me as a historian. And I am respected by folklorists. But I am not a folklorist. I want folklore to be available. I do not want it to be just in a learned journal.

Sterling Brown, New Haven, Conn., 1979

George Lyman Kittredge was wonderful. What a man! I sat in on his courses on Shakespeare and Beowulf at Harvard. I learned a lot of folklore from those courses. You could not teach those courses without knowing something about folklore. But I am not a disciple of Kittredge the way Lomax is. I did not learn about the ballad from him. Big Boy taught me about ballads, not Kittredge. Big Boy was a wandering guitar player. He is the one I wrote "When the Saints Come Marching Home" for. He was broad shouldered, with a scar down his cheek. He was much taller than I am and a hell of a ladies' man. He was also illiterate and crazy about me. He came from Greenville, South Carolina. He came to my house, did a little work around the house, and I got him out of trouble. He could play the hell out of a guitar with a bottle on his finger. I got him out of jail three or four times for vagrancy. He worked in a coal mine and could not sing because he had dust on his lungs. Otherwise he would have been just as famous as Blind Lemon Jefferson. He taught me "John Henry." I thought that I had made a find. He would sing three different versions of "John Henry" and get them all fucked up. He would have John Henry be on his mammy's knee in the last stanza, and he would have him die in the first stanza. Sometimes he would forget a stanza, and I would prompt him. He would say, "Oh yeah," and put it in.

I rearranged his songs for *The Negro Caravan*, and that, of course, is bad folklore. You ought to give them actually as said. Instead of putting in, "Who's gonna glove your hand / who's gonna kiss your rosy, rosy cheek," I changed the lyrics from "your rosy, rosy cheek" to "your pretty, pretty cheek," because it was about a black woman who did not have no rosy, rosy cheek. I fucked with it, so I am not a good folklorist.

On history, I may not be able to give you facts and figures on Reconstruction and things like that. But on the general grasp of history, they say I am in the tradition of Du Bois, which ain't too good because Du Bois had a lot of flaws. In *Black Reconstruction in America*, Du Bois has black and white joining hands together, and they did not do too much of that. I read the book in proof, and I did not have nerve enough to attack his ideas. I sent it back, and I showed where the misspelling was. Du Bois wrote me a nasty letter saying that he could get a secretary to correct his spelling. What he wanted from me was comments about the content. I could not give my comments to him because the book was full of ill-digested Marxism. Abe Harris, who was a thorough student of Marx, cussed it out in *The Nation* and broke up their very close friendship. The book had a wonderful purpose though, especially the chapter in which he takes William Dunning and those other Reconstruction historians to task. But he talked of a revolution in the South where white and black joined together. They did not do that. They started it under Tom Watson, and Tom Watson had to give it up.

I got a poem in my very left-wing period called "Side by Side." It is about "Joe Nig," the Negro, and a white man. They are living on different sides of the track, but neither one of them has any money. They are pitted against each other. I say they got to get together. But then I got another poem, which is kind of an answer to it. The white worker says to the black worker, "Let's get together." I refer to the

folktale about an eagle that picks up a frog and flies with him high in the sky. So this Negro says he has been afraid to give a white man his hand before because he is afraid he is gonna pull back a nub. That is one of our expressions: "Stretch out a hand, pull back a nub," meaning "I give you my hand, and the next thing I know, you chop it off. And then I ain't got nothing but a nub."

In the last stanza of this poem, the black man says to the white man, "I told you like the frog said to the eagle, flying cross the stone quarry high in the sky, 'Don't do it, Big Boy. Don't do it to me, not while we is up so high.'" "Don't do it" means, "Don't shit me, Big Boy." But I had to change it to "Don't do it, Big Boy. Don't do it to me, now that we up so high." I was talking about the AFL-CIO not coming clean. "I will give you my hand but don't shit us." That is the attitude of Negro labor.

I think a lot of Faulkner in *Go Down Moses*, less in *Intruder in the Dust*. Some of his short stories are great. *Absalom! Absalom!* is a great novel. I never am sure when Faulkner is Gavin Stevens and when he is not. But if he is Gavin Stevens in *Light in August*, he is really messed up. Gavin Stevens is a little better in "The Bear." "The Bear" is a great story. But "The Bear" is full of crap in the business about "They will endure." They prevail, but not because of any of their own drive. Dilsey is a black woman of determination who holds the family together. But she works for a white family, and I am concerned about her kids.

I love Margaret Walker. I think the world of her.

Margaret says that she is the only black writer who stayed faithful to the black college. She is the only one who stayed in the Deep South as a teacher.

Carl Sandburg is hell on wheels. But Sandburg threw the word "nigger" around real loosely. He threw around the word "honky" too. He has got one beautiful poem called "Jazz Fantasia" about jazzmen, not just Negro jazzmen. Robert Frost was one of my idols, but Frost was not straight on race. He knew nothing about Negroes in his work, but he has people in his work that I identify with.

Yankees did not care for Negroes either. But, by God, you could at least stand on your feet among the Yankees. If a Yankee called you a son of bitch, you could at least knock him in his head, and you would not get lynched. Southerners tell this whole foolishness that when the Negro goes north and goes knocking on the door for food, the white man shuts it in his face. But in the South, the white man says, "What the hell you doing at my front door? Come around back." The Negro goes around back and gets a lot of eats. That is a lot of crap. I ain't got no illusions about lack of prejudice in the North. Boston is a bad god-damned place for Negroes. But that do not make Atlanta better, and that do not make Memphis better.

The North and South relationship is not simple, but it is not North versus South, with one perfect and the other imperfect. If I got to take my chances on violence and insult, I will take the North any day.

Scholars

When I was a teenager, I was given the run of
a very small school library that had Frederick
Douglass's autobiography, which I read. The
book created a hunger to know more.

—John Blassingame

Scholars help us understand the literature, history, and music of the American South. Cleanth Brooks, John Blassingame, and C. Vann Woodward were born in the region; Charles Seeger and John Dollard approached it from outside. Each wrestled with southern worlds, and their research on the region forever defined their careers as scholars and teachers.

Brooks, Blassingame, Dollard, and Woodward taught at Yale, and Seeger at the University of California, Los Angeles. Each wrote major books on the South, and their students expanded their work in the next generation. Blassingame studied under Woodward for his PhD in history at Yale. Seeger's best-known student was his son Pete, whom he introduced to southern music in 1936.

My son Pete came down in '36 to Washington to visit me when he was about seventeen. He had a four-string banjo. He had driven his older brothers crazy by singing Broadway tunes on the ukulele for several years.

I said, "What do you play that wretched thing for?"

"Well, what should I play?"

I said, "You should play a five-string banjo."

"Never heard of it."

I said, "Come with me."

We went down to a pawnshop, and there was a row of five-string banjos, a great long row twenty-five feet long. You could buy them for a dollar apiece in those days. Some

Robert Penn Warren, C. Vann Woodward, and Cleanth Brooks, Fairfield, Conn., 1979

of them were in pretty good condition, and others were wrecks.

I bought him one and said, "If you want to hear this played, come with me tomorrow. I am going down to a fiddle contest in Asheville, North Carolina, and you will hear some of the best banjo players in the country."

So we went. From that time on, Pete thumbed his way all over from Maryland to Florida to Texas.

Cleanth Brooks pioneered the study of William Faulkner when he taught his first contemporary literature seminar at Yale University in 1947. Brooks added Faulkner's work to the literary canon of Joyce, Eliot, Yeats, and Lawrence in his seminar. He noted that when he first taught the seminar, few books by Faulkner were in print: "When Yale asked me to teach a course on contemporary literature, I decided right away that it must include Faulkner. . . . Faulkner was a figure of equal stature, but I found it was very hard to get his books because a lot of them were out of print." John Blassingame stressed the importance of oral history as a tool for study of the South and especially for black history. He pointed out that the region is where much black history is set and praised the Works Progress Administration staff who recorded interviews with former slaves during the New Deal: "One of the single most important things a historian can do is collect documentary material. The people who were involved in the collection of the WPA interviews did—from the standpoint of scholars of the nineteenth century—the single most important thing that was ever done. They collected so much data that other people will be able to use, whether they write about folklore or music or history."

Each of these scholars frames our understanding of the southern voice and its story. They help us understand how storytelling is grounded in the region's history, music, and literature.

Cleanth Brooks 1906–1994

BORN IN MURRAY, KENTUCKY

The New Criticism basically meant a return from mere biography or mere history to a look at the achieved text. What does it say? What does it mean in itself? There is a relationship to the classical education that Tate, Warren, and I had in the beginning—an attention to words, to taking the text carefully into account, as you have to do if you are reading Latin or Greek or any foreign language. How is the text put together? What do these words mean?

Cleanth Brooks was a major figure in twentieth-century literary criticism. As a younger member of the Vanderbilt Agrarians, a Rhodes Scholar, cofounder with Robert Penn Warren of the *Southern Review*, a distinguished professor at Yale, and the author of important books on William Faulkner and the study of literature, Brooks had a profound influence on both southern and American letters.

Brooks's best-known works, *The Well Wrought Urn: Studies in the Structure of Poetry* (1947) and *Modern Poetry and the Tradition* (1939), are landmark studies that established him as a central figure in New Criticism, an important movement that shaped American literary criticism in the middle decades of the twentieth century. Brooks called for a careful reading of the text—especially of poetry—to study how a work of literature functions as a self-contained artistic work. He and Robert Penn Warren coauthored the textbooks *Understanding Poetry* (1938) and *Understanding Fiction* (1943), which were widely used in American high schools and colleges during the 1950s, 1960s, and 1970s.

Brooks's deep love for literature and a close reading of the text began at the age of five when his father gave him a "simplified translation of Homer's *Iliad*." He remembered that his father used to "read it to me before I could read."

Brooks's curiosity about language was clear one evening when he and his wife Tinkham invited me to their home for dinner with Robert Penn Warren and

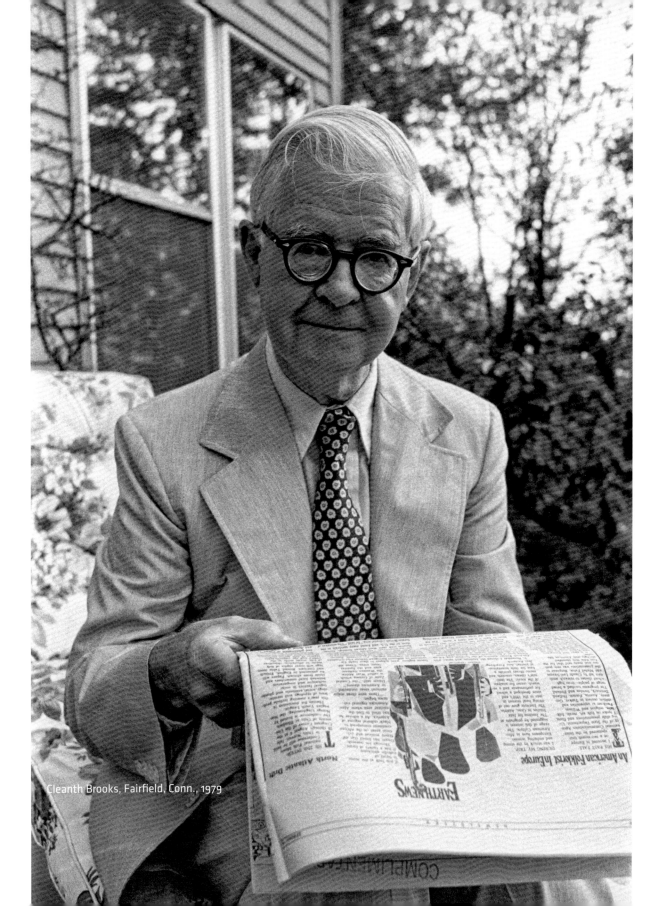
Cleanth Brooks, Fairfield, Conn., 1979

his wife, Eleanor Clark. As often happened at these dinners, Warren told stories about his childhood in Guthrie, Kentucky. He then wondered aloud about the correct definition of "shoat," a word used to describe a young pig. A debate between Warren and Brooks ensued as to whether a shoat was a male or female pig. To resolve the question, Warren called his brother, a farmer in Guthrie, who told him that he thought a shoat was a male pig.

Warren then related a story of two old men who were talking in the lobby of a Nashville hotel when their conversation was interrupted as a beautiful young woman wearing a tight skirt walked by. After she had passed, one turned to the other and said, "Just like two shoats wrestling in a rug."

Brooks then speculated on why Faulkner's work was appreciated more in France than in England. With his brow furrowed, he declared that "those who love to ride horses do not like to read, and those who read do not like to ride horses. So as lovers of horses, the British never took to Faulkner."

Such exchanges happened each time Brooks and Warren were together. Their deep love for language inspired discussions they had shared since first meeting as undergraduates at Vanderbilt University. At Yale, Brooks and Warren were often seen together, and a member of the English Department once compared them to the Roman twins Castor and Pollux with his remark, "If Castor comes, can Pollux be far behind?"

Like Warren, Brooks had a long, deep friendship with Eudora Welty that began when they published her first short story, "Death of a Traveling Salesman," in the *Southern Review* in 1936. During one visit I had with Brooks in Mississippi, we drove from my home in Oxford to Jackson with Caroline Taylor, who had come to interview Brooks and Welty for *Humanities* magazine. When we arrived at Welty's home at 1119 Pinehurst Street in Jackson, she walked out to our car and hugged Cleanth. They then turned and walked arm-in-arm back to her house singing a hymn together. Later that night we had dinner at the Mayflower Restaurant, where a waitress greeted Welty with, "What will you have tonight, Honey?"

I brought along a bottle of Welty's favorite Maker's Mark bourbon, and as we began our dinner, I poured a generous glass for both Welty and Brooks. They then spoke about literary biographies of their friends that had recently appeared and how wrong the biographers were about their lives.

Several years later, Welty and Brooks visited my family on our farm near Vicksburg. Welty brought her camera and took numerous photographs of Brooks. After a large noon dinner that my mother prepared, we all sat and talked, and Tinkham Brooks dozed off. An hour later, she awoke, rose to her feet, clapped her hands, and declared, "Lecture's over, Professor! Time to go." We walked out to the car and bid them farewell.

I told Brooks that he reminded me of my grandfather Eugene Ferris, a shy, retiring man who also often dressed in a coat and tie. Brooks's gentle manner belied his steel will and sharp mind. He was always kind and open to others. Once he visited our home in Oxford and read from a children's book to our daughter, Virginia, a moment that I will always treasure.

In 1987, Brooks joined Welty at the University of Mississippi when the William Faulkner stamp was released by the U.S. Post Office in Oxford, Mississippi.

Welty read from her short story "Why I Live at the P.O." and Brooks spoke about Faulkner's short-lived experience as Oxford's postmaster. When asked why he was fired from the position, Faulkner replied that he refused to be "at the beck and call of every son of a bitch who's got two cents to buy a stamp."

Brooks was a regular speaker at the University of Mississippi's annual Faulkner and Yoknapatawpha Conference. Toward the end of his life, when he was almost blinded by cataracts, he stood before an admiring audience and presented his paper from memory.

Of all the interviews I did, those with Cleanth Brooks required the least editing. His concise conversational prose matched the disciplined style of his writing. His friendship with Robert Penn Warren marks a unique moment in southern and American letters, as a gifted critic and an equally gifted poet and novelist spent a lifetime together in the literary vineyard.

This conversation is drawn from my interviews with Brooks at his home in Northford, Connecticut, in 1979, at the Warren summer home in West Wardsboro, Vermont, in 1987, and with Eudora Welty at the Mississippi Old Capitol Museum in Jackson, Mississippi, in 1988. The interview in West Wardsboro is included on the DVD with this book.

My father loved to read. He was not a greatly learned man, but he wanted to be. He was into Latin and Greek, and very much interested in history and literature. I learned to read from him. My first book was a book he gave me when I was five years old. It was a simplified translation of Homer's *Iliad*, and he read it to me before I could read. I heard stories of Greek warriors and their quarrels long before I heard any other tales.

I had a Methodist pastor as a father. In his denomination, they move the ministers every two or three years. It was a marvelous custom in my opinion, but it meant that I lived in a half a dozen places throughout my childhood. Every two or three years, I would start a new school and make new acquaintances. That, I am sure, conditioned my childhood to some extent, as it kept me from having a feeling of deep roots that many people have. I also had to bear the burden of being the preacher's son, and having this damned odd name Cleanth. But it was not too bad. I got along. I learned to put up my fists when anybody called me a son of a bitch, so I could go ahead and make good grades without being persecuted.

I went to this academy where my father had a good friend who was the headmaster. It was a small boarding school with about fifty or sixty boys and a few girls. I was away from home for the first time, and I was intensely homesick for the first three weeks—so homesick that my father noticed it and said, "You can call it quits, and I will take you home if you like." But I knew I would get over it, so I stayed and learned to like it very much. I played on the football and the basketball teams, and I got a good grounding in the classics and mathematics. I was prepared for Vanderbilt. That was my youth.

I do not think my college days were nearly as happy as my prep school days. In looking back, I think that my education was rather bungled. I read Latin and Greek fairly well at that time. If

I had had instructors who said, "Look, you are ready to read Latin and Greek poetry, philosophy, and history. You ought to go on ahead and read them," it would have been much better for me. I got diverted to English by getting to know people like Robert Penn Warren, Andrew Lytle, and John Ransom very early. That was recompense enough. I owe Vanderbilt University a great deal in the people I met there.

A Vanderbilt student named Saville Clark, who knew my headmaster, gave us a lecture. I talked with him about my ambitions and about wanting to come to Vanderbilt. Out of the goodness of his heart, I do not know why, he said, "Well, come on and room with me, and I will help you get a job." So we occupied a large double suite in the men's dormitory together at Vanderbilt. Saville Clark was a senior and a friend of Robert Penn Warren, Andrew Lytle, and Lyle Lanier. I got to know them first through Saville.

I met Red Warren at Vanderbilt in the fall of '24. I saw something of him from time to time, though we were not close. He was in a completely different set of courses. I was still waking up as a freshman to the great world. I remember that Red was kind enough to look over one or two of my freshman essays and told me that I wrote in a good, natural style, something to that effect—an encouraging word.

I remember one time Red came in late one night. I think he had had a fair amount to drink, and he did not want to go all the way home. So he crawled into bed with me. There was plenty of room, so I said, "Fine." The next morning he said, "Cleanth, would you go down and get me a cup of tea?" which I was glad to do.

All of the Fugitives had a good classical education. Vanderbilt required Greek, and you had to have a good deal of Latin. Ransom had done work at Oxford as a Rhodes Scholar in Latin and Greek. He studied ancient classical civilization, including its history and philosophy and politics, as well as its literature. Warren had had a good dose of the classics, and so had I. If you want to find a common denominator for the Fugitives, look at their classical education. Every one of them had it. That clearly influenced the textbooks that Warren and I did. I am sure that had we not had Latin and Greek, we might not have easily swung into what was later called "close reading."

At Vanderbilt, Warren was kind to me, though I was much his junior as a student. But I saw only a little of him in those days. After he left Vanderbilt, he got a Rhodes Scholarship to Oxford. I got one too, in time. And when I got to my college in Oxford, Exeter College, there was, lying on my table, a note from Robert Penn Warren indicating that he still remembered me from years past, that he had heard I was coming to Oxford, and that he looked forward to seeing me. So our association began again, after years. It was his last year at Oxford, but it was my first year. We saw a good deal of each other then. By that time he was doing a great deal of writing. He was finishing his first biography, and he was beginning to write his first fiction. He was bubbling over with ideas. He was not only a year and a half older than I, but he had simply become so precocious. Because he had entered college much earlier than I, he was well advanced in his reading and in his knowledge of literature. It was a pleasure seeing him in Oxford, but we were both busy. He was doing a bachelor

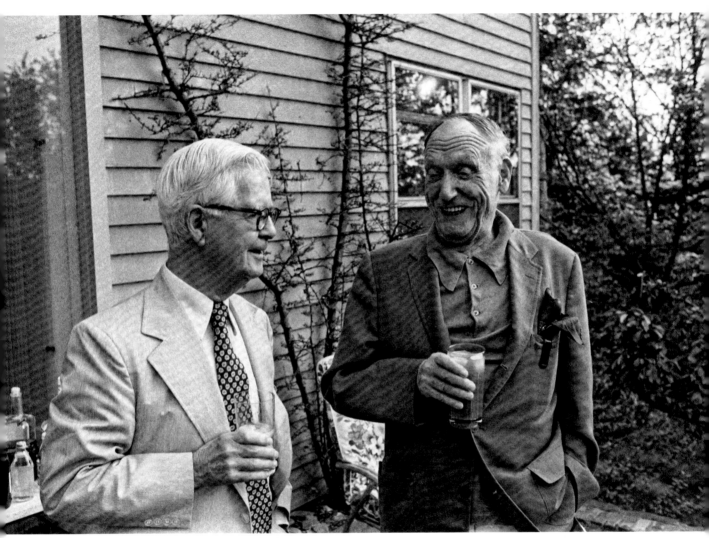

Cleanth Brooks and Robert Penn Warren, Fairfield, Conn., 1979

of literature degree, and I was doing the ordinary BA in English, but we still saw a good deal of each other.

Then we parted again. I stayed on in Oxford two more years. He got a job at Southwestern College in Memphis. After Oxford, I came on back to my first job at Louisiana State University in 1932. In 1934, two years after I got my job at LSU, the dean of the graduate school met Red. He was eager to build up our faculty, and I got in touch with Warren to invite him down to give a lecture, hoping that the English Department would offer him a post, which they did. So Red and I found ourselves at LSU in 1934, joined again, and we were together there for eight years. In the next few months, the *Southern Review* was founded, and we found ourselves working together on it as editors. Then we worked together on our first textbooks. Those were years in which I saw him practically every day of the week, as well as socially in the evenings.

At LSU, we found that our students did not know how to read a poem or a novel. The textbooks that they had gave biographical information and historical information, but did not tell them how to read fiction or how to read a poem, analyze it, and synthesize it. Out of that arose our textbooks, not to put theories into the heads of our young sophomore students, but to help them learn how to read.

We worked very hard on the textbooks. We began with word-by-word collaborations, discussing them again and again until we got consensus on what we wanted to say. Red came into my office one day and had mimeographed twenty-five or thirty pages, mostly about meter and imagery. I wanted to add a little on imagery, and Red said, "Fine." We put that little thing between cardboard covers and sold it for a quarter to the class. That was for our first literature class.

We were teaching ourselves. These were case studies, with questions like: "Why in the hell did this fiction writer end this way? What did this poet mean by this image? What did it do for the poem?" We asked ourselves these questions, back and forth. We did not always agree. I learned a great deal of theory, but I learned it in a practical context. It was a lot of fun. We had some very good experiences at LSU—what my father used to call, "life on the high seas"—with Huey Long and the start of the *Southern Review*.

Part of the excitement during those years was having the most remarkably bright and lively talk I have ever heard in my life. They were throwing a net wide at LSU and were one of the few schools actually adding faculty. There was also this vast mediocrity at the bottom, the real unspeakables, the ones who had no business being at the university at all. So you had the whole variety, all of America, represented—the best, the worst, and the middlings—all right there. Life was exciting.

We had some good classes with some bright students and some strange students. With the *Southern Review* and the university's growth, we attracted exciting students and speakers. Peter Taylor came there. Robert Lowell came there. The local students picked up and began to do well.

Before Red and I got there, Huey Long expelled several students for writing a nasty comment about him—not a nasty, but a fair comment—in the student newspaper. The student newspaper could not do that because it was Long's university.

That incident attracted a lot of attention. In the meantime, Bilbo acted even more high-handedly in Mississippi and had hell to pay for it. So Huey quickly learned. He was smart as a devil, and he left the faculty alone.

Then an adverse article came out in *Harper's Magazine* on Huey Long. We had asked some of our students to take a six-month subscription to *Harper's* to find models for how to write an essay. The students were wild to read the article about Huey Long, and word came down to the English Department—"Yes. Teach it." Huey was smart. He left the faculty alone. He had the president of the university politicized. He had his own picked appointee. Long had his charisma and his tricks, but he learned some certain fundamental truths and kept right to them.

I am satisfied that Long never knew the *Southern Review* existed. No doubt, some of the money he was pumping into the university was siphoned off to make the *Southern Review* possible. But I do not think Huey Long ever knew it existed. Why should he? He was up there in Washington getting ready to run for president. He was dead before the second issue came out.

The *Southern Review* was established in 1935. Soon after that, we received a letter from someone we had never heard of, a young woman in Jackson, Mississippi, named Eudora Welty, who said she was interested in writing fiction and doing photography. She did not know which she really was most concerned about. She would like to submit a story. The story was awfully good. We published it right away in the *Southern Review*, and the first thing we knew, we had published six or eight of her stories.

Eudora came down from Jackson and stopped at our little bungalow in Baton Rouge for the evening. Tink and I found her delightful and have known her ever since. We do not see her as much as we would like, mostly up here in New Haven, sometimes in Jackson, and of late in Oxford. I greatly admire her work and think she is a delightful person.

I would call Warren intensely southern and intensely American. I think the South is a part of America, a very true part. In fact, I think it represents values of the old America. We have preserved a great many of the earlier values. One can be typically regional and also typically national. Warren is quite American. He differs, however, from the more callow, utopian American, the American who thinks that America has made a new start, has shaken the dust of the Old World off its feet and is going into a new future. Warren is too sensible for that. He is too European for that. He is too southern for that. He knows that this is simply not true. Man cannot change essential man that much. On the other hand, he is very proud of the accomplishments that, under the stimulus of a new continent, America has made. And he duly chronicles that.

We have entirely too much emphasis on theory in our study of literature. Theory is important. You cannot work without theory. But in our eagerness to find something fresh, something startlingly new, we now have extravagant theories that are damaging to sound literary criticism. What I would like to see in America would be a little more reason, a little more moderation in our prosecution of theory, a little more concern to understand each other, and an improvement in practical criti-

Cleanth Brooks and Eudora Welty, Oxford, Miss., 1987

cism. It is a shame to have theorizing about literary criticism, and then find in the papers written misreadings of people like Warren and Faulkner. What is the use of having all the theory in the world if you cannot practice intelligent criticism?

The New Criticism basically meant a return from mere biography or mere history to a look at the achieved text. What does it say? What does it mean in itself? There is a relationship to the classical education that Tate, Warren, and I had in the beginning—an attention to words, to taking the text carefully into account, as you have to do if you are reading Latin or Greek or any foreign language. How is the text put together? What do these words mean? What is a proper translation? What is the meaning of this statement? Even with vast changes in religion and technology, we still respond to Homer's heroes. We still value courage, modesty, decency, and we still disdain treachery, trickery, lying. These values are assailed in the modern world.

It seems that the American Dream is really just a dream to get ahead as fast as you can and make as much money as you can. That spirit is destructive to civilization. I hope I do not sound too much like a pulpit orator saying that. The New Critics were people who were concerned with how to live and not just how to make a living. The threat to American colleges and universities is that they are more and more seen as places to learn how to make a living, rather than as places that turn out good men and women who know how to live a good life.

While I was in Oxford as a student in 1929, the English edition of Faulkner's first novel, *Soldiers' Pay*, appeared. I had missed it in America three years earlier, but I did read it at Oxford. I was impressed. It was interesting and well done, but it was a young man's book. Coming back to the United States, I plunged into so many things that I did not pay much attention to Faulkner until *Go Down Moses* came out in 1942.

We tried to get Faulkner to contribute to the *Southern Review*. He was polite, but we were not able to get a contribution from him. In 1935, we tried to get him to attend the Writers' Conference at Baton Rouge and again received a polite telegram from him, "Sorry, but I have nothing to say." In other words, "I have no speech to give." It was not until 1942, when I read "The Bear" and *Go Down Moses*, that I said, "Look, this is highly interesting."

I read it, and I was completely convinced that Faulkner was a great author. When Yale asked me to teach a course on contemporary literature, I decided right away that it must include Faulkner, along with Joyce, Eliot, Yeats, and Lawrence. Faulkner was a figure of equal stature, but I found it was very hard to get his books because a lot of them were out of print.

As we read Faulkner, I tried to observe the stumbling blocks that kept my students from making an adequate reading of him. I did not plan to do a book on Faulkner until the editor of the *Sewanee Review* in the 1950s said, "Mr. Brooks is planning a book on Faulkner." I was not. He misunderstood. But the more I thought about it, the more I thought it was a good idea. So I began work on my first Faulkner book.

About a year ago, I looked up the reviews of Faulkner's early books. I was surprised to find how seriously people took Faulkner as a writer.

They testified that he was a writer of great power and great force. But one after another wrote that his material was degrading and poor. "We cannot be interested in the characters. . . . It goes nowhere. . . . Pity that he is wasting his undoubted talent on such . . ." In other words, he was wasting his time writing about the South.

The one time I met Faulkner was when Albert Erskine, a good friend of mine who was his editor, called and said, "He is in New York, Cleanth. Come on down if you would like to meet him. He is in the office every day at Random House." I did, and I had a very interesting talk with him. I was very careful. I knew if he heard I was an English professor from Yale, he would go right back in his shell. He was afraid of academic people, dreaded them, did not understand them, thought they were all trying to pick his brains. So I started talking to him about coon dogs. I do not know much about coon dogs, but I knew he would be interested. I know a little about them. Then we got on the Dixiecrats—what their chances were in north Mississippi, what he made of the movement, and one thing or another. Before long, we were talking about his novels, thank goodness, and I got some very interesting insights into the way the man wrote and the way he regarded his work from some of the answers he gave. But that came very late. I knew better than to just plunge in with, "Mr. Faulkner, what did you mean by such and such?" He answered exactly to what I had been told about him—a man with dignity, terribly shy, a self-taught man, which is the best way to be taught in literature, by reading. He was a little fearful, a little skeptical of the literary critic, or the literary scholar, or the professor. If you respected his shyness and tried to be as easy as an old shoe, he might very well open up and tell you anything.

Southerners tend to fare rather well at Yale. Whatever New England has thought about the South, the concrete individual southerner has been treated rather handsomely at Yale. We are valued, maybe overvalued, for certain traits, which our friends notice as being different. There is a great advantage if you are a southerner and interested in your native section to be acquainted with other sections, to have done some traveling, to have seen other places, even to have lived for a while in other places. We are finding not only more books about the South, but more truthful books about the South, books that put the region in the proper perspective. I think that is all to the good. But that does not mean that the stereotypes are gone or are likely to disappear.

There is the stereotype of the dashing young cavalry officer in the Confederate army—reckless and brave. It was not an unrealistic stereotype. They existed. I quote Sherman to that effect, and he is a pretty good authority. He says the Confederates were fine shots and wonderful horsemen. But he went on to make what I think is a very foolish statement that "until we can kill them all or get them to come over to our side, we cannot win this war." Well they did win the war without killing them all, and I do not know any that ever came over to the Federal cause.

My grandfather, my mother's father, rode in the cavalry with Nathan Bedford Forrest and was very proud of it. I knew him when I was a child of six, seven, and eight. He spent the last years of his life fighting the Civil War all over again. He would tell about how he used his wits to keep himself

from getting hanged. He was a west Tennessee boy. When the troops he was serving went to north Mississippi, volunteers were asked to go back into west Tennessee and estimate the strength of the Federal forces around Jackson, Tennessee, which is right in the middle of the state. My grandfather volunteered to go out of patriotism, courage, and a chance to see his mother and father. So he went back and saw his mother and father. He actually slipped in and had a few moments with his sweetheart. Then he made contact with a serviceman who had been in the Confederate army, but had been badly wounded and was out of the war. The Federals already suspected this man of gathering information for the Confederate side. In fact a federal patrol suddenly appeared when he and my grandfather were meeting together and picked them up. It looked bad for my grandfather—a soldier deep in enemy territory talking to a suspected Confederate agent.

They took my grandfather to Jackson and subjected him to a court-martial. His only hope, he quickly saw, was to play up to a southern stereotype. Yankees were quite sure that most southerners were ill-educated, ignorant people who had been seduced into the Confederate army by the rich slaveholders. So he played the part, giving them nonsensical, funny answers. He said that he was not a spy, that his name was Bill Witherspoon. His name was not "Spy." Anybody could tell you who old Bill Witherspoon was, and so on. He got the Federal officers laughing, and they were probably not eager to hang this rather apple-cheeked young man of twenty-three. They let him out of the room to go over the case, and he had a chance to talk to this other Confederate suspected spy and told him what he had told the Federal officers so he could back him up. And, sure enough, he talked them both out of trouble.

But then he started being a little reckless. He asked the Federal officers to give him a voucher for his horse. He had downgraded his fine Kentucky thoroughbred to Old Charlie, the plow horse. He was going to need him if he was going to go back with his ma and pa. It was their only support to make a crop. The good-natured Federal officer said, "All right. You can have your horse." Well, he went out to find him and of course he could not. There were thousands of Federal troops and all kinds of horses there. His friend said, "For God's sake, let's get out of here alive." Then luck played into his hands. Just outside the courtroom, he saw the very patrol that had picked him up the night before. They identified him as the man they had picked up, and he got his horse. And back he rode the seventy-five miles to General Forrest.

It is a nice story. He was a pretty plausible liar when he had to be, when his neck was at stake. He did not panic. I take it as an indication that he had a cooler head than I have. And he certainly was much more reckless than I. I would have started plodding that seventy-five miles on foot. I would not have tried to get my horse. He wrote it up and published it in a little pamphlet in 1910. He tells it very well with a rather nice, natural prose style. It was reprinted in a book called *They Rode with Forrest*.

The Civil War was a very curious war, where opponents spoke the same language. The occupied territory was occupied by troops who shared not only language, but much the same life back home. Extremes of human kindness and brother-

hood broke through the ruthlessness of the war. A good deal of humanity peeped up here and there, along with the ferocity of the bloody battles. I wish we could have found an easier way, a less cruel way, a less bloody way, to get rid of slavery. But we did not. Slavery was not the only issue in the war, but that is all people want to talk about now. The war determined whether the United States would become a great financial industrial power, and eventually a superpower, or whether it would remain a loose confederation, with the conservative, agricultural South balancing the industrial North.

The South, more than any other section in this country, except for Down East Maine, is a total community with a great deal in common. This is one reason it has been so hard to define the South. People have constantly taken the South apart and said, "There is an Appalachian South and a Tidewater South and a Piedmont South, and there is a Mississippi South," all of which is perfectly true.

There are a lot of Souths. A friend of mine said, "The South is the only part of the country where if you get three or four southerners together in Washington, they will recognize themselves. They don't know each other personally, but they know they belong together."

One of the difficulties in trying to define the South is that you have to face this intangible, difficult problem of community. The South is a community, and communities are always hard to define. If you try to define it in terms of differences in climate or by mountain, hill, or alluvial delta, you run into difficulties. The thing will splinter into pieces before your eyes.

Slavery was part of our history, and we have to accept it. On the other hand, I am not ashamed of my past. I am sorry that slavery ever happened. But the fact that I had a grandfather who owned slaves, I do not think should put the mark of Cain on my brow.

John Blassingame 1940–2000

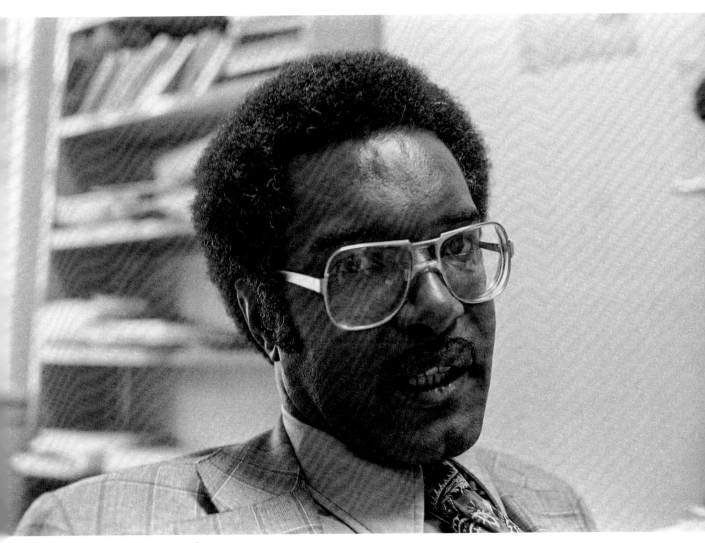

John Blassingame, New Haven, Conn., 1979

The South is where the action took place for blacks. There were more black people historically in the South than in the North. There is an obligation that one always feels to explain your own generation, as you look at segregation and lynching. Both black and white southerners have a passion for trying to understand why those things took place. Many of our best histories have been written about the South, about blacks in the South, and about race relations.

To say that I always looked up to John Blassingame would be an understatement. Blassingame's tall, thin, Lincolnesque figure, his wry smile, and his glasses slipping down his nose were a beloved, familiar part of my seven years at Yale. He was a towering man, literally and figuratively. The picture I carry of Blassingame in my mind is of him bending over to speak to one of his many admirers, always smiling, always with a twinkle in his eye. Blassingame hired me from Jackson State University as the first white scholar brought to Yale to teach in the Afro-American studies program, an honor I will always treasure.

When I arrived at Yale from Jackson State University, Blassingame told me that he had considered going to Alcorn State College in Lorman, Mississippi, on a basketball scholarship. When he visited Lorman, his coach had the team run several miles up and down the hills around Alcorn. After that experience, Blassingame decided to study at Fort Valley State College. The hills he continued to climb were academic, as he completed his MA in history at Howard University and his PhD in history at Yale, where he worked with C. Vann Woodward as his mentor. He then built the finest Afro-American studies program in the nation at Yale during the 1970s.

The first week I arrived in the fall of 1972, Blassingame put Larry Neal, Willie Ruff, Robert Farris Thompson, and me in a room and told us not to come out until we had designed a team-taught introduction to Afro-American studies. I quickly learned that when Blassingame moved mountains, he did it with a smile and a wink. The four of us taught an exciting class that introduced over one hundred students each fall to the field of Afro-American studies. The course later served as a model for a team-taught introduc-

tory course on southern studies that I helped launch at the University of Mississippi in 1979.

Blassingame's classic study *The Slave Community: Plantation Life in the Antebellum South* (1972) drew on music and folktales to underscore the importance of folklore in Afro-American history and was an inspiration for my own work. This seminal study and his later *Slave Testimony: Two Centuries of Letters, Speeches, Interviews, and Autobiographies* (1977) significantly deepen our understanding of the slave experience through the voices and writings of the slaves themselves.

Editor of the first six volumes of the Frederick Douglass Papers Edition, Blassingame launched the project in 1973 and headed it for the next twenty years. He secured over $800,000 from the National Endowment for the Humanities during that time. As editor of the Douglass Papers, Blassingame mentored an editorial team, many of whom later became leading scholars in the field of history. Those whom I was privileged to know included Mae Henderson, Clarence Mohr, Larry Powell, and Pete Ripley, all of whom became lifelong friends. Mae Henderson is my colleague and a professor of English and comparative literature at the University of North Carolina at Chapel Hill. Henderson coedited with Blassingame the five-volume *Antislavery Newspapers and Periodicals: An Annotated Index of Letters, 1817–1871* (1980–84). Clarence Mohr joined me at the University of Mississippi from 1979 to 1981, where he helped launch our *Encyclopedia of Southern Culture*. Mohr is now chair of the Department of History at the University of South Alabama and editor of *The New Encyclopedia of Southern Culture: Education* (2011). Larry Powell recently retired from the History Department at Tulane University, where he held the James H. Clark Endowed Chair in American Civilization and was director of the New Orleans Gulf South Center. Like Blassingame, Powell did his PhD dissertation with C. Vann Woodward. He is the author of nine books, including his classic *New Masters: Northern Planters During the Civil War and Reconstruction* (1980) and his recent *The Accidental City: Improvising New Orleans* (2012). Pete Ripley taught in the History Department at Florida State University and edited the five-volume *Black Abolitionist Papers*.

Each morning, I joined Blassingame at his "other" office in Naples Pizza on Wall Street, where he spread out his papers on a table and held court over coffee. Blassingame's students, faculty colleagues, and other admirers moved in and out of conversations. When *Roots* first appeared, he spoke with excitement about the new public interest and appreciation for black history that the book and television series inspired.

Blassingame's greatest pride was reserved for his family, of whom he spoke often. His wife, Teasie; his son, John Jr.; and his daughter, Tia, were the center of his life.

I often worked late in my office in the Afro-American studies program. When I left the building at night, I always looked up to the second floor and saw lights still burning in Blassingame's office. His passion for scholarship and teaching knew no bounds.

Our last visit was when he spoke at the University of Mississippi Center for the Study of Southern Culture in 1989. After his death, I spoke at a memorial service in Battell Chapel at Yale on May 13, 2000. It was a final farewell to a friend and colleague whom I deeply loved. He was my dear friend, and I loved

him like a brother. I closed my remarks at his memorial service by recalling how his office lights always burned late at night and said, "His light will always shine for the rest of us—no matter how late it is—no matter how dark the night."

We spoke in Blassingame's office at Yale University in 1979.

When I was a teenager, I was given the run of a very small school library that had Frederick Douglass's autobiography, which I read. The book created a hunger to know more. I learned more about him when I was at Howard University. He lived during exciting times in the nineteenth century, and he was attractive to me because he was a very modern nineteenth-century man. He supported a lot of the things that, had I lived then, I think that I would have supported. But I would not have been half as good at supporting them as he was.

I was attracted to Douglass because he was an extremely able writer. When I read his newspaper editorials and his autobiography, I was astounded. I could never forget that I was reading words written by a man who had never been to school. That struck me with great force after I finished my master's thesis at Howard. I spent that summer reading Douglass's newspapers as a research assistant for one of my professors. I was always crushed at the end of each day because I knew that this man—who had never been to school—was a better writer than I was after twelve years of high school, four years of college, and a year of graduate school. Even though I have

added a few more years of education and writing experience, I still do not think I come anywhere near possessing the kind of skill that he had.

Douglass was a man who believed in humankind and insisted that he was attacking an oppressive system, not people. He had no hatred for the people who were wrapped up in that system—whether it be slavery or segregation—because he believed so firmly in the Bible and in the Declaration of Independence. All of humankind were his clients. He was attacking oppression rather than the oppressor. All these things I found very interesting in him. He is not the kind of individual that you get tired of.

One is impressed by Douglass's analytical skill. He was much sharper analytically about slavery than subsequent historians have been. I think that his published papers will give historians new analytical categories for looking at the institution of slavery. I was also attracted to his sense of humor. You always find things to laugh about when Douglass is speaking and when he is writing, and that is not common when one looks at historical figures. In the midst of adversity, he could laugh at himself and at his situation. That is an extremely important lesson that Douglass can teach us today, when we are overwhelmed by so many things.

Douglass was very strong, both physically and mentally. He is a man not easily crushed by the enormity of the task that he sees ahead of him. He is dealing with large issues. He is not talking about Frederick Douglass. He is talking about the church. He is talking about religion and slavery. He is talking about prejudice. He is talking about

temperance, peace, and women's rights. He is talking about American Indians. Through him, the whole of the nineteenth century opens to you. You have a man who was born as a slave. He runs away. He fights with his overseers. He is involved in planning the John Brown raid and has to flee the country for his life. He was a newspaper editor, a diplomat, and a Civil War recruiter.

All kinds of conflict go on in his mind about whether to reform society through violence or through nonviolence. There is also conflict over whether one should leave the United States, or stay and fight for his rights. There is conflict over the role of women in American society, which he comes to grips with very early. He has a very modern outlook on this. He touches on many questions that are important in both the nineteenth and the twentieth century. He is looking at segregated schools. He is looking at integrated schools, at segregated churches. He looks at issues that have been perennial in American society. He adopted the tactic of nonviolent resistance before the Civil War. He studied oratory. He read the *Columbian Orator*, which had rules for public speaking in it. I think he memorized those rules, because when he first starts as a speaker, he does everything that Caleb Bingham, who wrote the *Columbian Orator*, says a speaker should do. And when he writes about the art of public speaking, he uses some of those same rules.

I do not think that Malcolm X was any more effective or fiery an orator than Douglass. There is a presence about Douglass that I do not think is matched either by King or Malcolm. There was an electricity that people felt when Douglass showed up. I do not think Malcolm had that. I think King had some of it in a church setting, but he had to evoke it, whereas Douglass's mere presence started the sparks going.

It is difficult to maintain a sense of objectivity in looking at what Douglass says and what he writes. We often have interesting debates among our staff as a result of that. As long as we are willing to debate each other about the meaning, we can maintain a degree of distance between Douglass and ourselves, and as historians we are required to do that. If we present a man, we must present him warts and all, and if he is a great man, the warts will not make any difference.

Early in the seventies, I was asked by Charles Wesley—who was at that time executive secretary of the Association for African American and Latin American History—if I would be interested in editing the Douglass papers. My first response was no. There were a lot of other people whom I thought were better qualified. He persisted, and I made some calls, mainly wanting to know whether there was enough material that had not been published to warrant an editing project. In the end, there was no question that there was enough material that could be uncovered with a systematic search. That was the main problem I had initially in trying to make up my mind to edit the papers. I had no problem at all about Douglass as a historical figure.

The first volume covers basically 1841 to 1846. It is part of what we are calling series one, which includes all of Douglass's speeches, debates, and interviews. That series will constitute approximately four volumes. What we have in volume

one is about 60 or 70 percent newly discovered speeches. Then we have series two, which will consist of Douglass's published work, and that will be about three volumes. The last series, series three, is Douglass's correspondence and diaries, and we estimate that will be about seven volumes. It has been an exciting pursuit, and I think it will continue to be exciting.

One of the single most important things a historian can do is collect documentary material. The people who were involved in the collection of the WPA interviews did—from the standpoint of scholars of the nineteenth century—the single most important thing that was ever done. They collected so much data that other people will be able to use, whether they write about folklore or music or history.

As a kid, I was taken by detective stories, and I read a lot of them. I read the collected works of Sherlock Holmes. The historian is the personification of the detective when it comes to an editing project. You are not writing a biography. You are not writing an analytical piece about an aspect of the nineteenth century. You are trying to find out where this man was on a given date. What did he do on a given date? What record is left of what he did, and how can I find it? Every day you get to play detective. It may be that I simply have not grown up, but that is the part of the enterprise I really like. I always approach historical work by asking a lot of questions about the documents. When I wrote *The Slave Community*, I started with slave autobiographies that historians had dismissed as evidence for a number of reasons. One of the primary reasons was they felt a large number of these autobiographies were ghostwritten by abo-

litionists and therefore were not reliable. My own research convinced me that they were reliable. I learned as much as I could from sociologists, political scientists, and folklorists who wrote about the interview. You must learn about the situation in which the interview was conducted. Every interview has two authors, the person who asks the questions and the person who answers them. I eventually wrote an article about my own reflections on the interview. I compared the interviews with an autobiography. I have complete confidence in the WPA interviews and in the interview in general. There are questions that one has to ask as a historian about such data. But I do not think those questions are any different from what I would ask about a diary left by a planter, from what I would ask about an autobiography, or from what I would ask about a newspaper account of a particular event. All of those are categories of evidence, and each one may be correct or false. A historian would be foolish, and certainly not true to his craft, if he accepted or rejected any body of data without asking a long series of questions about it.

I believe that when folklorists and musicologists fully study the WPA interviews, our picture of music in the slave quarters will be totally reversed. The popular opinion is that slaves primarily sang spirituals, which is a totally illogical perception of any community. Outside of a monastery, no community spends 90 percent of its time thinking about God and religion. When you turn to the WPA interviews, you find that people spent a lot of time dancing, playing the banjo, and singing secular songs as opposed to spirituals. One problem with the WPA interviews is that most of the speakers

were very old when they were interviewed. I do not emphasize going to church, and if you ask me about my religious views, I would move quickly to talking about James Brown. But when I am seventy, I can assure you I will not talk a lot about James Brown. I will probably talk about how I love going to church, and that is exactly what shows up in the WPA interviews. The slave community was a much more normal community when it came to the range of interests in that community than I think historians have given them credit for.

The other thing I am convinced will change as a result of more intense investigation of the WPA interviews are theories about origins of the blues. The evidence is overwhelming that by 1850, blues existed in the slave quarters. The motifs in their secular songs are the same, and a lot of the structure is the same. The poetry is not as fully developed as in the blues, but you can see it there in embryonic form. The blues are a direct descendant of the slave secular songs. There is no break in that music. It is totally the same. We have a lot to learn about black culture by going through those interviews. All that material is there to be exploited, and folklorists are in a lot better shape to use it than historians. I think that historians must begin to make much heavier use of the interview.

There has been serious, systematic research on the black community and what is happening within that community, as opposed to a simple focus on race relations. We now have studies of race relations that are much more sophisticated than was true in the past. There is also a great deal more interest in biography. That interest existed even before Alex Haley's *Roots* appeared. What is

interesting now is that black scholars focus more on slavery than they did before the seventies. Before the seventies the major focus of black scholars was on free blacks and the Civil War and Reconstruction. That has changed. There is also much more interest in black nationalists, and a much more sympathetic treatment of them than before the sixties and seventies. People have more interest in studies that extend beyond simple politics, beyond the institutional histories that we historians were prone to do before the sixties. We were more interested in studying the history of segregation laws, for example, than studying the impact of those laws on people, both black and white. Our studies have grown more sophisticated analytically, more tough, than those that preceded them.

I am very impressed with Larry Levine's work. It is a systematic attempt to analyze black culture and see its elements. I think his work is stronger on twentieth-century black culture than he is on the nineteenth century. I have voiced my disagreement with what he sees as the predominately sacred worldview of the slaves. I think that is a quirk of his evidence rather than a true reflection of what that worldview was. I do not fault him. He wrote the book that he wanted to write, and not the one that I would have written.

I like Ted Rosengarten's *All God's Dangers*. I think it will have the same kind of effect that *Roots* has had. I think of the two together, because they increase the interest historians have in looking at specific characters in the black community. *All God's Dangers* and *Roots* spur people to look into their roots. It is difficult for anyone to read *All God's Dangers* and not believe that older people

are the repositories of wisdom. And it is very sad to have repositories around you and not to take advantage of them. That is God's gift to the young. I think that more and more of the young, particularly as a result of *All God's Dangers*, are going to those repositories to learn lessons because there is no other place we can go.

The South is where the action took place for blacks. There were more black people historically in the South than in the North. There is an obligation that one always feels to explain your own generation, as you look at segregation and lynching. Both black and white southerners have a passion for trying to understand why those things took place. Many of our best histories have been written about the South, about blacks in the South, and about race relations. In the last twenty years, the astounding energy released by the civil rights movement impelled historians to examine the deeper roots of problems we encounter in the twentieth century.

I do not have any clearly formed plans for the future. I would like to study the slaveholder, the slave master. Since I have studied the slaves, that seems to be the next natural step. I am also interested in antebellum southern religion. If one is going to look at race relations and slavery, you must also look at the church. You cannot discuss whether masters felt guilt about holding slaves unless you look at the church, because if there is guilt, that is where it will come from. And if there is relief for guilt, that is where it will come from. We will also learn a great deal about forces leading to protection of the slave if we look at the church. You miss a vital element of nineteenth-century southern life—both black and white—without understanding the church.

Religion helps us understand the penetration of black culture into white and of white culture into black. That is where the most important interpenetration took place. Church and family are the key institutions in the nineteenth century. It was a time when people took their religion very seriously.

Charles Seeger 1886–1979

BORN IN MEXICO CITY, MEXICO

I got a pile of commercial records made in '23, '24, and '25. I took them home, and they were absolutely marvelous. I remember especially Dock Boggs, Gid Tanner and the Skillet Lickers, and the Ridge Runners. They were selling by the millions throughout the country, and I never knew it.

On May 12, 1975, I spent a memorable day with Charles Seeger at Yale. We met as he walked on the cross campus green with his elegant, long stride. Under his arm, he carried a first edition of *The Social Harp* that he donated to the Yale Music Library. Later that day, Seeger agreed to let me interview him and recalled the history of his family and his discovery of American folk music. At the age of eighty-nine, both his eloquence and his vivid memory were striking.

Seeger occupies a unique place in American and southern music. A distinguished composer, scholar, and teacher, his long career transformed our understanding of how folk and classical music interact and define American culture. Seeger graduated from Harvard University in 1908, and during a long, productive career he taught at the University of California at Berkeley, the Juilliard School, the New School for Social Research, the University of California at Los Angeles, and Yale University. He also worked for the federal government's Resettlement Administration, the Works Projects Administration Federal Music Project, and the Pan America Union.

Seeger's second wife, Ruth Crawford Seeger, was a distinguished composer and musician who worked closely with him throughout her life. Three of his children—Pete, Mike, and Peggy—are beloved figures known for both their collecting and their performance of folk music. Seeger worked closely with folk music collectors John and Alan Lomax, composer Henry Cowell, and artist Thomas Hart Benton.

Charles Seeger, New Haven, Conn., 1975

As a scholar and composer, Charles Seeger is best known for his writings on "dissonant counterpoint," a classical music concept that describes how musical lines that are very different from each other sound harmonious when they are played together. The greatest composer of dissonant counterpoint was Johann Sebastian Bach. Seeger was understandably drawn to Sacred Harp hymns composed by William Billings, a tanner of hides who lived in Boston during the colonial period and developed shaped notes to assist music teachers. Considered the first American composer, Billings is known for his four-part "fuguing tunes" that use dissonant counterpoint with striking effect. Sacred Harp music has been sung by black and white congregations in the South for over two centuries.

While John and Alan Lomax are remembered for the vast body of field recordings they collected, Charles Seeger's great contribution is how he embraced and merged classical and folk music traditions. With a rigorous academic eye, he approached the two traditions as part of a common musical spectrum and argued that, viewed together, they define American music. Seeger's career spanned more than five decades. During that time he founded the field of ethnomusicology as he studied folk music with the tools of musicology. He explained how, "gradually, in the course of the thirties and forties and fifties and sixties and seventies, I knit folk music, popular music—and even what we call primitive music—in with my composed music. To me, it is one whole community process that you cannot separate."

Charles Seeger seemed eternal as he recalled his long life and his fascinating ties with family and professional colleagues whose names—like his—are revered for their pioneering work on southern music.

We spoke in my resident fellow's apartment in Calhoun College at Yale University in 1975.

I was brought up like all well-to-do children were at the end of the nineteenth century. I was taught to accept the establishment and behave discreetly with respect to it. When I went to the university in 1904, I was incredibly naive and innocent. Being inclined to music and rather against talking, I had a hard time realizing that in the 1920s and '30s, music was increasingly dominated by talking. Composers, performers, and listeners had to talk about music before they could do anything much about it. A composer would work out a plan in words, then fill it out with actual musical sound. A painter would do the same thing, and a sculptor too.

In the early '30s, I met the painter Thomas Hart Benton. Benton was an abstract painter and his paintings did not sell. One day at breakfast, when he and his wife, Rita, faced a particularly stringent economic problem, he said, "You know, Rita, something is the matter with me and my painting. The American public will not buy it. They do not seem to like it. I have got to paint for the American people."

She said, "How are you going to paint for the American people?"

"I am going to paint the American people."

Benton made a mural of American life for the New School for Social Research in New York. Rita said to me, "You know, Charles, we have got to initiate this exhibition for all the white-ties and tails who gave money to the New School. We have got to give them some music."

137

I knew that Benton played a Bach aria on the harmonica rather well. So he said to me, "A couple of my students can play banjo and guitar, but not very good. Do you want to play the guitar?"

I said, "I used to play the guitar when I was a boy."

He said, "Come around and see if we can put a little hillbilly band together."

So I went around and said, "What shall we play?"

"Oh, let's play 'Cindy.'"

"I have never heard of 'Cindy.'"

"What? You do not know 'Cindy'? You are a musicologist, an American, and you do not know 'Cindy'? Well, how about 'Boll Weevil'? How about 'Red River Valley'?"

I had never heard of any of them. I learned from him, and we put on a show. We set down five chairs in the middle of this little room and started our program. There was not a soul in the room. People came in. By the time our program was over, they were packed in there like sardines.

"More! More!"

"We do not have any more."

"Well, play it over again."

We played that damn thing twenty or thirty times. Then Benton gave me a real lecture: "You know, Brother, you ought to know something about your business."

I said, "How am I going to know it?"

I got a pile of commercial records made in '23, '24, and '25. I took them home, and they were absolutely marvelous. I remember especially Dock Boggs, Gid Tanner and the Skillet Lickers, and the Ridge Runners. They were selling by the millions throughout the country, and I never knew it.

About the same time George Pullen Jackson at Vanderbilt University put out his book *White Spirituals in the Southern Uplands* (1933). I read that and had a shock. Two hundred families would meet and sing out of a hymnbook for two days. The hymns are conducted by older people, sometimes by children, and there is weeping and all kinds of sentimental outpouring. He told how farm families in the South might travel all day, sometimes for two days, to gather together on the county courthouse green. They would sing from a hymnbook for two solid days, taking turns conducting. Here I am, a musicologist practicing in the United States, and I never heard of this. "What were the hymnbooks like?"

"Oh, they were shape notes."

"What are shape notes?" My fall from the high horse of advanced musicology was dramatic.

One other thing happened at the same time. It was the Depression, and I was asked to speak to a group of Marxist composers about American folk music. I did not know much about American folk music. So I gave a lecture on the "Dictatorship of Language," knowing that one of their slogans was "Dictatorship for the Proletariat," and it was appreciated.

A group of these young composers gathered together in a club to make music. They wanted to compose music to keep the spirits of people up when they were making a demonstration at City Hall. We had a lot of fun, and we wrote some very nice things. But I found that we were not writing music that the people wanted.

One day a weather-beaten old lady named Aunt Molly Jackson showed up and sat right back of the piano. Aunt Molly Jackson made songs that had been sung all around Harlan County, Kentucky, where she came from—and from whence she had been taken by the state police to the border and told to go out and stay out if she knew what was good for her. Harlan County was surrounded by a chain-link fence topped with barbed wire, and men with high-powered rifles were at the exits and entrances.

The second time Aunt Molly came, she sat off a little distance, and the third time she was way off in a corner. I went to her and said, "Aunt Molly, I know that you cannot make out what under the sun we are doing here, and we do not have the slightest understanding of what you have done. But you are on the right track, and we are on the wrong track."

To make a long story short, I discovered there was a discipline called folklore. I had never heard of it before. Very few musicologists had ever heard of folklore. They thought, "Oh, folk music. Folksongs were all written by the great composers. Then they were heard down the back stairs and through the windows. They got run down and simplified." So it went.

In Washington, D.C., I was trying to put 300 good musicians into 300 of President and Mrs. Roosevelt's resettlement communities for displaced farmers and other rural populations within six months. I started interviewing people on relief that might be trusted to work in a resettlement community. I took the job because I saw a marvelous chance to carry out my idea that

we should work with music they could sing themselves. And if I sent anybody into these camps, it would be great to find out what music could be performed by these people and to help them perform it—not to go there and sing *Aida*.

My son Pete came down in '36 to Washington to visit me when he was about seventeen. He had a four-string banjo. He had driven his older brothers crazy by singing Broadway tunes on the ukulele for several years.

I said, "What do you play that wretched thing for?"

"Well, what should I play?"

I said, "You should play a five-string banjo."

"Never heard of it."

I said, "Come with me."

We went down to a pawnshop, and there was a row of five-string banjos, a great long row twenty-five feet long. You could buy them for a dollar apiece in those days. Some of them were in pretty good condition, and others were wrecks.

I bought him one and said, "If you want to hear this played, come with me tomorrow. I am going down to a fiddle contest in Asheville, North Carolina, and you will hear some of the best banjo players in the country."

So we went. From that time on, Pete thumbed his way all over from Maryland to Florida to Texas. Whenever he saw someone carrying a banjo or guitar, he would cotton up to them. If they knew anything he did not know he would learn to do it. I took exception to his riding the rods on freight trains, and he promised he would not do it anymore. The folklore was that there was an ex-sheriff outside of Scottsboro, Alabama, who sat out on

his front porch with a gun and shot at the men on the rods just for the fun of it.

In the early thirties, Henry Cowell and I were asked by Macmillan Publishers to advise them about a manuscript that had come from two men named Lomax. Well, they came in—John and Alan Lomax—and the manuscript was there. Alan was ready to punch either Henry or me in the face: "These goddamned expert musicians. They do not know anything about folk music."

Henry and I opened the manuscript and said, "My God, these are marvelous songs. These are perfectly marvelous songs. But the notations are terrible. There is practically not one there that does not have mistakes—wrong clefs and every-thing else." I said, "You have got to have these notations made over, and then the book will be very successful." It was *American Ballads and Folk Songs*, and it was published. Alan softened up a little bit towards the end, and we presently became good friends.

When Peter became interested in playing the banjo and singing songs accompanied by the banjo, I sent him to study the Lomax recordings in the Library of Congress, which is about the best school that there is. You just go in there and lis-ten to recordings, and once you get saturated with them, you know something.

One day, John Lomax asked me if I would go to a recording session with him at a penitentiary in Richmond. We drove down there, and Lomax was in the depths of despair. "Mr. Lomax," I said, "what is the matter? You seem very depressed."

"It is the saddest day of my life, Mr. Seeger. Lead Belly has left me." They had been traveling together all over the country, and Lead Belly sang the songs John lectured on.

"Why did he leave you?"

"I don't know," he said. "There he was, just like one of my own sons. He just told me he was leaving, and he went away."

I began to ask him a few questions. "You know, Mr. Lomax, one of the things I have been quite interested to know is how did you travel with him?"

"How did I travel with him? Well, I bought the tickets, and we traveled."

"Did you sit together on the train?"

"Sit together? No, of course not."

"Where did Lead Belly sit?"

"In the rear."

"When you went to a hotel, could you get him a room?"

"Of course, I could get him a room."

"How did you do it?"

"We had the same room."

"How did you get up to it? Did you go up the elevator together?"

"Of course not."

"How did Lead Belly get up?"

"He went on the freight elevator."

The questions went that way. "Well, did you get twin beds?"

"Twin beds?"

"Where did Lead Belly sleep?"

"On the floor."

I asked him, "What about money? What did you pay him?"

"Pay him? I do not pay my children. When he needs money—just like Alan and John and Bess—I give them what they need."

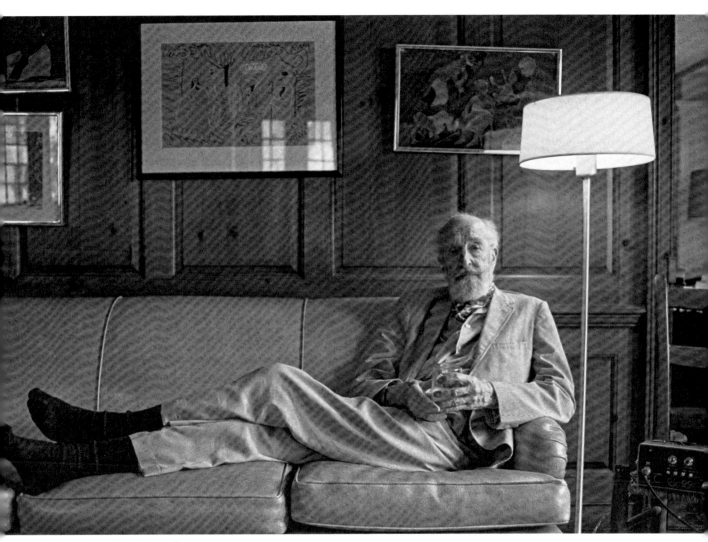

Charles Seeger, New Haven, Conn., 1975

Well, Lead Belly, you see, felt that he was at least equal in the programs with John. He wanted to be treated the same way as anyone else. You can understand it perfectly well. I talked to Lead Belly about this afterwards, and he confirmed that this was just about what happened.

So John Lomax and I started our recording with a group of Negro convicts in this penitentiary in Richmond. The director had gotten together a choral group of sixteen—no whites—and they sang things that Lomax asked them to. He said, "Boys, can you sing a work song?"

They put their heads together, and they came out with a work song. At the place where they catch their breath, there was a most extraordinary kind of a hiss. Lomax stopped them and said, "Not 'sh,' but 'huh.' Do you hear me?"

"Yes, Boss."

So the song was sung that way. I was pretty much aghast at that. I could not object before the convicts because that would have undercut Lomax's authority, and I would have lost his friendship. It did not seem to be the thing to do.

Finally, a bunch were singing a spiritual, and there was a young convict who improvised a high descant in the style of Louis Armstrong's trumpet. As soon as Lomax heard it, he pointed to him and said, "Hey, you there. Shut up."

And he did. I would have given anything to have had a recording of that. It was superb. I always had a certain amount of love for old Lomax. You took him as he was.

I was visiting the South a good deal at the time. In fact, I got along with the southerners very well. They told me they were going to make a southerner of a damn Yankee yet! The South was very run down. I had just visited a school—I think it was the first eight grades—in South Carolina. You could look through the boards and see the ground underneath. We passed another building and did not stop. So I called out to my guide, "Oh, let's go in there. It looks interesting."

It looked more like a cow barn than anything else. But we kept right on driving, and I waited for an answer. The answer was, "Mr. Seeger, we cannot go in there."

"Why not?"

"That is a Negro school."

In the South I was not allowed to visit any Negro schools. They were so shabby that they did not want Washington to know it. Who knows but what this northerner would take a story back, and then their congressman or their representative would be on their neck saying, "Why the hell did you take a northerner around to our Negro schools for? Don't you know better than that?" That was way back, you see, in '36 and '37 and early '38.

In the early 1920s, I made one of the first live-in trailers, and I pulled it with a Model T Ford with four speeds. My wife was an excellent violinist, and we wanted to take good music to the music-less people of America. We spent most of our time playing in little country churches and schools and granges and in the houses of people who wanted to swap music with us. We did it for about a year and had a wonderful experience living in a community in North Carolina, where there was a stone mill that ground corn for the neighborhood.

It was the headquarters of the MacDonald family, who were descended from Flora Mac-Donald, who aided Bonnie Prince Charlie for the

succession to the British Crown. Before we set up camp for the winter there, we were examined by the patriarch of the family, a little man about five feet high with a beautiful white handlebar mustache. He came and made us a formal call. He approved of us, so we were allowed to stay there.

Getting along with people on the basis of their own viewpoint and their own way of talking and acting was something I learned then. Thirteen or fourteen years before I had discovered folklore, and I got training on how to get along with people. One early morning, one of them knocked on the trailer door. "Mr. Seeger, we have a job to unload tiles from the local freight station, and it takes four people, and so-and-so is sick. Could you help us out for the day? You will get paid."

"Of course."

So I hand tiles out to a man on the ground, and he hands them to another, who stacks them on the truck. At the end of the day, I was offered three dollars. I would ordinarily say, "Don't bother. I am glad to do it for you." But that would have been a mortal insult. So I pocketed the money in as professional a way as I could.

That evening, I put on my black tie and my wife took her beautiful Italian violin. We went to dinner at the house of the man on whose house the tiles were going to be put. This is the sort of thing you do when you live with the people. You cannot learn it out of books. And you cry when you leave after staying with them a few months. They do, too. You cannot help yourself.

John Dollard 1900–1980

BORN IN MENASHA, WISCONSIN

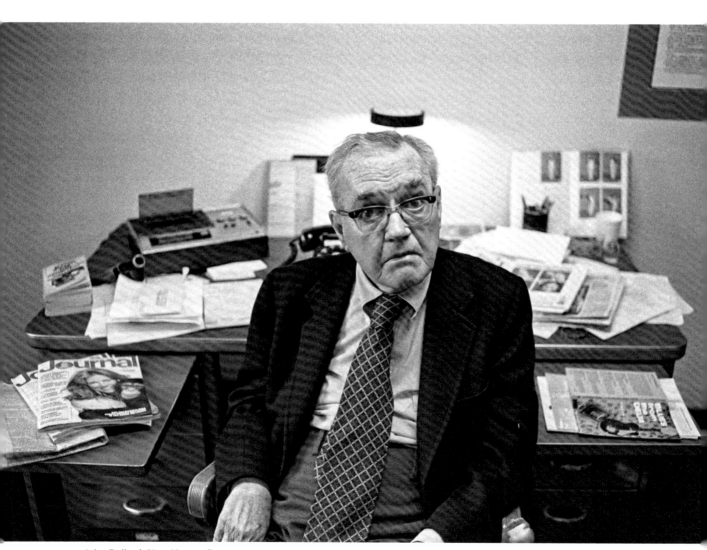

John Dollard, New Haven, Conn., 1975

One evening I came dressed in a summer jacket and tie, and when I was asked where I was going, I was dumb enough to tell them I was going to the house of a Negro woman whom I knew. After that, I was ostracized from the town, and that is a dreadful experience.

John Dollard's *Caste and Class in a Southern Town* (1937) offers a psychologist's perspective on how caste and class shape race relations in the Deep South. Dollard's interest in caste and class was inspired by William Lloyd Warner, a sociologist and anthropologist who studied class structure in American society in his *Social Class in America* (1949).

Dollard spent five months in Indianola, Mississippi, doing field research for his book. Anthropologist Hortense Powdermaker completed research in Indianola earlier, and her *After Freedom* (1939) is an equally important study. At the same time that Dollard and Powdermaker conducted their research in Indianola, an interracial team of sociologists and anthropologists that included Allison Davis, Burleigh B. Gardner, and Mary R. Gardner wrote *Deep South* (1941), a study of race relations in Natchez, Mississippi. These three books on Indianola and Natchez, Mississippi, are classic works for the study of race relations in the American South.

As a folklore graduate student at the University of Pennsylvania in the late sixties, I relied heavily on each of these books to develop my research on black folklore in the Mississippi Delta. I found it interesting that Dollard was deeply moved by black gospel music in Indianola, but he never mentions the blues. Indianola is the home of B. B. King, who was nine years old when Dollard lived there.

While working in Indianola, Dollard stayed in a boardinghouse that was operated by Mary Kathleen Craig Claiborne. Claiborne's son Craig was fourteen at the time. Forty-eight years later, he recalled meeting Dollard in *Craig Claiborne's A Feast Made for Laughter: A Memoir with Recipes* (1982):

One of the most distinguished roomers and boarders in my mother's house was a scholarly gentleman, well known in academic circles, the late Dr. John Dollard, a highly praised Yale psychologist and social scientist. Dr. Dollard had come to Indianola to do research on a book called *Caste and Class in a Southern Town* and with what might have been an uncanny sense of direction or perception, had chosen my house as his base of operation.

Dr. Dollard, a patient, kindly, amiable man was, of course, a Yankee and thus had a "funny accent." The other boarders did not take kindly to him for no other reason than that he was an "outsider." In the beginning he criticized the cooking of the greens, complaining that there was not a vitamin left in the lot. And as a result of his well-intentioned explanations and at the base encouragement of the other boarders, my mother willingly committed one of the most wicked acts of her life. Dr. Dollard was placed at a bridge table covered, of course, with linen, and set with sterling, and he was served a mess of raw greens that he ate with considerable and admirable composure and lack of resentment. Always the detached and critical observer, I found my mother's role in this little game almost intolerable, although I said nothing.

Odd coincidences have occurred often in my life. One day, a decade or so ago, I wandered into the photographic studio where portraits bearing the title *New York Times Studio* were taken. I glanced at an assignment sheet and saw the name John Dollard, Yale.

As I walked out, John walked in.

"John," I said. "I'm Craig Claiborne."

"How's your mother?" he asked. "She's a great woman."

While teaching at Yale, I discovered that although John Dollard had been retired for many years, he still worked in his office. I knocked on his door, introduced myself, and explained that I admired his work. He invited me to dinner at his home and introduced me to his wife, Joan. Dollard generously agreed to do an interview with me in which he reflected on his work in Indianola. Thus began a friendship that lasted until his death on October 8, 1980.

We spoke in Dollard's office at Yale University in 1975.

It was strange to be in Indianola in 1934. Up to this time I never mentioned where the study was done. I think I will still call it "Southerntown."

I was alone, and being alone on a social investigation was very hard to explain to people in Southerntown. Since I was a stranger in their eyes, "a Yankee," they thought I might be a labor organizer.

I announced that I was studying socialization among Negro children. Some southerners wondered how a man could be so stupid as to have any interest in that topic. But at least it did not seem dangerous. I use the word "Negro" without disrespect to those who use the word "black." It is simply more familiar to me. It is the term of respect that I learned.

I got the idea of caste and class from Lloyd Warner, Allison Davis, and Burleigh Gardner. To

speak of class and caste, and to notice and delineate social stratification is rather un-American. We are supposed to believe that each person is equal in the eyes of sociology, as he is indeed in the eyes of God. But there has to be some way to explain why integrating Negroes into the middle class—bringing whites and blacks together onto the same cultural level—does not easily produce friendship groups or family groups. Beyond class, there is another set of evaluations that these individuals have for one another, and that is caste. It is just as true for how Negroes view whites as it is for how whites view Negroes.

I became interested in doing research in the South for a number of reasons. Among social anthropologists at that time, there was the idea that one could do objective research within one's own culture, that one did not have to go to a foreign culture to do it. I felt that if I could work in an American area, which was far easier to reach and where I knew the language, I could do my research more effectively and much more quickly.

Hortense Powdermaker had already been in the South, and she helped me find Indianola. The fact that Powdermaker had already been there made it seem more possible and reachable. Lloyd Warner and his students influenced my decision to go south because they were in Natchez when I was in Indianola. I was very fond of Warner. I freely exchanged my thoughts with him, and he with me.

I went to visit Burleigh and Jackie Gardner and Allison Davis, who were doing a study in Natchez about the same time as mine. They had an excellent design—one side was studying the white caste and class system, and the other the black caste and class system. I was certainly influenced by their work. What I brought to my study that they did not have was a strong basis in Freudian analysis. To get a complete sense of the southerner, I wanted to show him loving and hating, laughing and breathing. In this way, Freud is unparalleled in describing human life.

As a description of the local situation, though, their study is far superior to what I did, because they had more manpower and spent more time at it. They were in Natchez several years, and I could not spend more than five months in Indianola. I think our studies are really complementary. Theirs should be read for the caste analysis, and mine should be read for the emotional structures of feeling and hatred.

The caste system describes a code in which whites avoid social contact with Negroes. Caste is based on social contamination, which includes familial and sexual contamination. One of the instructive mistakes that I made was to make a date with a Negro teacher. He was a little bit brassy apparently because he came to the front door of my boardinghouse, and my landlords did not turn him away, which was very decent of them according to their code. I came out and talked with him for a while. When he left, they bawled me out and said that I had broken a point of caste etiquette.

One evening I came dressed in a summer jacket and tie, and when I was asked where I was going, I was dumb enough to tell them I was going to the house of a Negro woman whom I knew. After that, I was ostracized from the town, and that is a dreadful experience. There were other north-

erners in Indianola at this time who had similar experiences. People would deal with Negroes in business relations, but not socially at all. If a white person broke the caste taboo, he became socially unacceptable. Since I had some close white friends in the town, this was very painful. My close friends did not abandon me entirely. They were willing to be seen with me, but they could not bring me to a party. It was very distressing, and it limited what I could do. It made me more lonely.

One of the curious breaks in the caste taboo, however, was in the area of music. The only white woman from Southerntown who had Negroes come into her house via the front door was an organist in the church. She was a musical fanatic, and she had, under the holy name of music, resisted the caste taboo.

I met a man from Illinois in Southerntown who was the head of a large farm. It had taken him about ten years, but he had assumed all the typical southern beliefs. He could have been a model for the southern man, except that he could say much more effectively than a native southerner, "You do not understand," or, "You would not feel the way you do if you lived here." He was an unsophisticated man who was under the terrific pressure of the southern caste system. If he had not changed as he did, he would not have been there. Only the guys who changed survived. If a guy came in and stuck to his attitudes, they would get rid of him. He would be perceived as unreliable.

I never was afraid of doing my work because the people in positions of authority in and around Southerntown were intelligent, cosmopolitan

people. They had their representatives of the law under control.

I knew of the existence of upper-class people, but I did not find them in Southerntown. On the border of the town was a big house where maybe one hundred Negroes worked on two to four thousand acres of land. The master had a traditional, well-known name in the South. I never saw him, nor did I have anything to do with him. I imagine that he must have known that I was there, but he was not concerned with me. I did not have any sense of being under his protection, but I think one would have been. Anybody who goes there under these circumstances would be under the protection of the political people. But you cannot forbid a Yankee to come and live in a lousy hotel and talk to Negro teachers, not any more you cannot.

I met five or six white people there who became lifelong friends and were the most wonderful people. The family that I stayed with were really very kind to me. For a while they even went to the trouble of letting me dine with them at their own table. My southern white friends in the town really did a lot for me. They did their very best even when they did not understand what I was doing. If a southerner is bad, he can be one of the most benighted people on earth. But if he is a man of liberal sprits, if he is tortured by doubts about the South, he can be the most wonderful person. There is nothing like a southerner's courtesy and the way in which their courtesy informs their sympathy and their ability to understand someone else in a personal way. I have never found anything equal to it. They made it seem to

me as if their courtesy was an instinctive outpouring of feeling.

That left me ambivalent about the South. I do not think I could bear to live in the South, because it would encourage all the worst parts of my nature. I have a very stubborn antiauthoritarian streak, and I think the South would encourage that.

People generally fail to see the importance of caste regulations that prevent intimate social and sexual intercourse. There are immense gains being made by including Negroes in formal organizations. But there is very little change socially to include Negroes in friendship groups and family groups. We are in my opinion making a valiant effort to cope with this problem. We are really fighting it. But it is, and it will continue to be, slow. I believe that the only salvation for the Negroes is complete integration with American society, so that there is no possibility of a separate group. We have to keep on this painful road until we get it all together.

In *Caste and Class*, my approach was that in addition to the great losses, exclusions, and limitations in the Negro life, there are also great gains that include a rich folk life and musical tradition. I heard "When the Saints Come Marching In" sung in a country church by this great big black soprano with her lovely clear voice. The whole church sang in such a way that it rocks me to think of it. That whole church was a riot of the most beautiful songs. To be in the middle of it was for me an ecstasy, one of the greatest experiences of my life. I found it heavenly and unbelievably delightful, freeing, and liberating. The singing would never completely die down. It would swell up gloriously and then die down, down, down, down, until finally only one little patch of humming would still exist. Then the preacher's voice would rise up as the singing died down and speak. As the preacher came to his conclusion, the singing would come up again. The congregation played opposite him musically. That experience of music in a black country church was a very great one for me.

About four or five years after my book was published, Allison Davis was teaching at Dillard University in New Orleans. He asked me to come down and help him with some studies on children that he was doing and also help him write a book on the studies. I went down and spent a summer there. I worked with his students at Dillard who were getting biographical statements from Negro lower-class and middle-class children. We wrote a book together called *Children of Bondage* (1940).

It was during that study that "the dozens"—a verbal game among lower-class children—came to my attention. The dozens is a teasing pattern with a very simple rhyme scheme. It could start with a phrase like "I saw your mother's big fat genital" as an insult. And to counter, the other person would say, "I saw your mother's, too." If those words had been said in any other context, it would have been an occasion for violence. But as a game of the dozens, it was a permitted form of insult. It is a pattern of ventilating aggression that paralleled the much more aggressive and dangerous life of Negro society.

The white lawmen did not regard crimes that

149

happened between Negroes as equivalent in value to those that happened between whites. I sat in on a court scene where one Negro woman had shot at another about ten feet away and had missed. That is an assault with a deadly weapon and probably with the intent to kill. So it is a felony. The judge's attitude was that it was all kind of funny, and he did not keep order in the court. When the defendant, in a really exaggerated Negro dialect, said, "Judge, she was playing around with my man," the audience—all Negro—burst into laughter. The judge then smiled behind his hand and tapped with his gavel. The defendant was fined ten dollars and put on probation.

Often white landlords would complain, "You got my nigger down there at Parchman Penitentiary. Send him back because I need him." The prisoner is then paroled to his boss, and a murderer is allowed to go back to work cotton. Aggression was freer in Negro society because it was a frontier society, where strength and courage were the best defense. If someone was a person that other people feared, he was likely to be safer. If they did not fear him, he was less safe. In other words, overt aggression was freer throughout the whole Negro society, and so covert aggression—like the dozens—would find a natural place in it.

Jokes and stories often convey some deeply felt belief that people, black and white, would hesitate to say quite so brutally. When they came to trust me, my Negro friends would make jokes or hostile allusions to white people. A joke told by whites about Negroes went, "A southern planter went to Africa, found an ape, and brought him back to Georgia. He trained the ape to pick cotton and then sent back for a hundred more. His

friends tried to dissuade him and told him it would be worthless. He said, 'Why?' And they said, 'As soon as the Yankees find out about it, they will come down here and free them.'" This was told by people who thought that they were not prejudiced. It is a brutal story that shows the common stereotype of the Negro as animal-like and essentially without culture.

Southern white people also made jokes about the matriarchal form of the Negro family. They say that when a Negro crosses the county line, he thinks that is getting a divorce. And if he crosses the state line, he thinks he does not have to worry about the eleven children he had by his first wife.

It is saddening to think that when Negroes are properly socialized, as will occur very rapidly, they are probably going to have a lot less fun. They will be under the powerful example of the culture to change and approximate themselves to the white middle-class norm of society. Middle-class life is really limiting and restrictive, with its concern for time, cleanliness, and morality. There is no philosophical device by which I could ever see how one would compare the relative sexual and aggressive freedom that lower-class Negroes have with the satisfaction of social position and prestige that middle- and upper-class whites have. All we know is that if people get a chance, they will approximate themselves to the middle-class white model.

They never did any studies among lower-class whites, but it is believed that their sexual standards are certainly lower than middle-class whites. They do not seem to have as much guilt as the middle-class whites, which would make it somewhat more like the Negro situation.

If you believe my book, you have to believe that change is going to be slow because it will have to be a cultural change, and that has to be, in the end, a willing change, change with the consent of the participants. That is going to be very slow, but you have to start somewhere. The law is the easiest thing to change. I hear an occasional cynical political scientist say, "Ah, we should have let the South go. To hell with it. We should have left them with their Negro problem and be glad we did not have it, instead of getting it distributed nationally." But I do not feel that way. I do not think anyone at that time could have dodged that challenge. Nor do I think anyone could have not been defensive if he had been in the South.

I never went back to Southerntown. I had the feeling that it was a closed chapter for me. I went as far as I could with it and was very glad that I did. I went as far as my life would permit, and then I dropped it. I have never gone back. I am on record, and that will just have to be good enough.

C. Vann Woodward 1908–1999

BORN IN VANNDALE, ARKANSAS

Southern history has to be written with what skill the writer can muster, or it will not be readable. That is true of all history. The historian must be true to the rule of his craft.

C. Vann Woodward is one of the leading historians of the twentieth century. Born in Vanndale, Arkansas, his work focused on the American South and race. The topic of his PhD dissertation at the University of North Carolina at Chapel Hill was Georgia populist Tom Watson. During a long, distinguished career as a teacher and scholar Woodward published fourteen major books that transformed the field of southern history. His *The Strange Career of Jim Crow* (1955) traces the African American community from Reconstruction to the civil rights movement. Martin Luther King called the book "the historical Bible of the civil rights movement."

As the leading scholar of southern history, Woodward was pleased with the growing interest in the topic among historians: "During the past thirty years, the South has attracted a great many talented historians, and they have come from all over. I think it marks a healthy change that the subject has ceased to be appealing only to southerners, as it once was, and has become instead a subject that attracts historians from all parts of the country. . . . The subject has an inherent fascination for Americans because it offers so many contrasts with the predominant American story. It has the appeal during recent years of the civil rights movement and the black rights movement. Since the South was the seat of that activity, it naturally attracted attention." Woodward greatly admired William Faulkner and felt the writer "helped to call attention to the region." Like Faulkner,

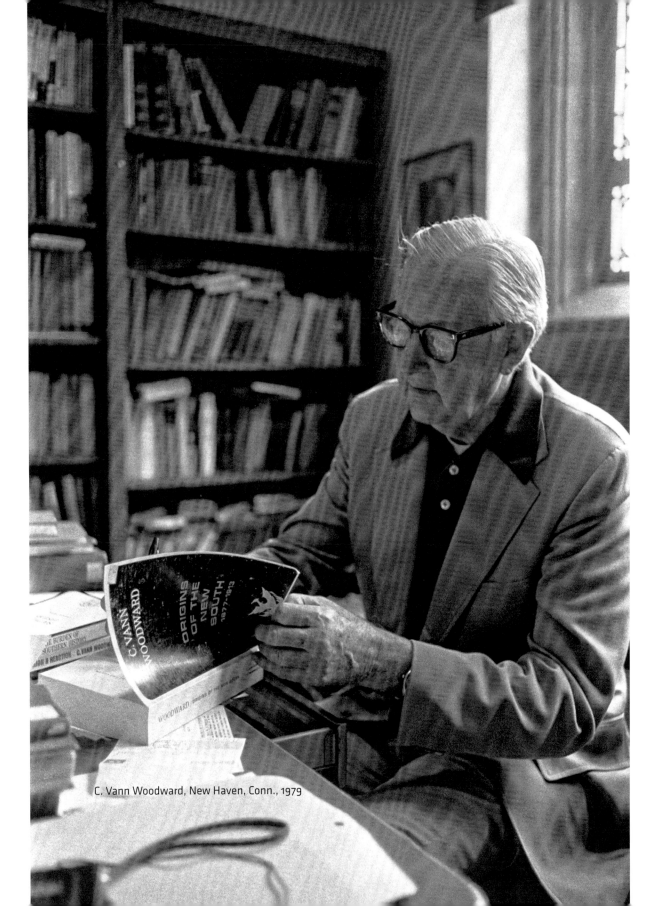

C. Vann Woodward, New Haven, Conn., 1979

Woodward was a shy man. He recalled seeing Faulkner in New York City "at the Algonquin Hotel, where I found myself in line at the cashier's desk right behind him. But my nerve failed me. I was conscious of his shyness and his distaste for casual encounters, so I missed that opportunity that I might have had to speak with him."

Woodward admired Faulkner's writing because it was deeply rooted in southern history. He recalled that "Faulkner said writers have to write what they know, and that was why he wrote about the South. His work was not a thing simply of the passing moment. It had origins and roots and a dimension deeper than the present. He was always conscious of that, as were other southern writers."

When once asked about his children, Woodward waved his hand across a bookshelf in his study where books by his former students were grouped together. Those students included John Blassingame, Barbara Fields, Sheldon Hackney, Patricia Nelson Limerick, James McPherson, Larry Powell, and Michael Wayne. During one of her visits at Yale, Eudora Welty met Woodward walking down Temple Street, and they spoke about southern writers. Woodward was a close friend of Robert Penn Warren and Cleanth Brooks, whose careers as writers and literary critics complemented his own as a historian.

We spoke in Woodward's office at Yale University in 1979.

I grew up in Arkansas. Accidents of origins, I suppose, greatly influence our choices. To be sure, I cannot imagine my having quite the interest that I took in southern history without having been born and reared there. I have always been inter-ested in literature, but not in a professional way, except that I got my first job teaching freshman English. I did my graduate work in history at the University of North Carolina at Chapel Hill largely because the papers of Tom Watson were located there. It proved attractive from that standpoint.

During the past thirty years, the South has attracted a great many talented historians, and they have come from all over. I think it marks a healthy change that the subject has ceased to be appealing only to southerners, as it once was, and has become instead a subject that attracts historians from all parts of the country. That has resulted in a great rebirth of the subject, an enlivening of it. There are many reasons to account for that. The subject has an inherent fascination for Americans because it offers so many contrasts with the predominant American story. It has the appeal during recent years of the civil rights movement and the black rights movement. Since the South was the seat of that activity, it naturally attracted attention. The existence of a thriving literary school also helped to call attention to the region.

The growing interest in oral history means working with people who are living witnesses to what they experienced. I certainly applaud such interests, though I have never quite seen the importance of making a distinction between oral and written evidence. Usually oral history is taped and then transcribed. It is as much written as a letter is, except that it originates in an interview rather than as a composition. But if it provides recorded memory that is otherwise unavailable, it is of use. My former student John Blassingame has used interviews that were taken long before he was born and were reduced to the publications

in which he read them. John's editorial work on the Frederick Douglass papers is important. It provides authentic sources for historians, and it should be encouraged and seriously treated.

My current work on Mary Boykin Chesnut's diary is a return to an old interest I discovered about twenty years ago. The nature of her diary was not disclosed by the previous editions at all. The fact that it was not a diary but a revision of a diary done twenty years after the writing of it and the comparison of the original with the eventual version is what inspired my interest. As a writer, Chesnut brought a special astuteness and intelligence to the task she set herself, and I think she is an extraordinary writer.

The South is changing, but that is nothing new. It has been changing since the start. If there is anything distinctive about the South, it is that very history of change with its basic leaps and jumps of alteration. From a pretty early time, I think it achieved a consciousness of continuity that goes along with those changes. That persists, I believe, despite previous and present and possibly even future changes. Nothing so far has lasted forever, and this self-conscious regionalism will have its demise eventually, too. But it does not seem to be right around the corner.

I think the southern experience is not a matter of geography, but of culture. It can be transported elsewhere and can thrive in other parts so long as it is a lasting experience. A few exiled southerners that I have run across have taken pains to renounce or disavow their origins and their ties with their regional past. Expatriate southerners seem to cling to the region with varying degrees of tenacity.

I once saw William Faulkner at the Algonquin Hotel, where I found myself in line at the cashier's desk right behind him. But my nerve failed me. I was conscious of his shyness and his distaste for casual encounters, so I missed that opportunity that I might have had to speak with him.

I think a southern historian of the South ought to know Faulkner's work and profit from it. They can profit from it—not as a source of history—but through an awareness of its richness and its distinctiveness. It is impossible to think of the South without some reference to Faulkner and his perception of the region.

Faulkner said writers have to write what they know, and that was why he wrote about the South. His work was not a thing simply of the passing moment. It had origins and roots and a dimension deeper than the present. He was always conscious of that, as were other southern writers.

In looking at how southern fiction and history relate, I do not think that books are accidents or are written from the transcription of tapes. Any resemblance between such transcriptions and the work of an artist is highly accidental. My guess is that whenever oral sources are used by a writer, they are consciously molded and shaped if they are to be used in literature. I think literature is a product of hard work rather than of accident.

Both William Faulkner and Robert Penn Warren are thoroughly suffused with the historical spirit of their generation. They both live in the past, as well as the present, and they interweave them.

Both have a profound understanding of how the past lives into the present and determines the future—of how future, present, and past are inter-

mixed. You can pick a quotation from Faulkner as readily as from Warren to illustrate that.

Since the rise of the novel in the eighteenth century, there has been a fear on the part of historians that novelists are a threat to our control over the past. They view novelists as a craft of writers who propose to take over a function that we consider our special function. I think that is a foolish sense of rivalry and a misplaced one.

I do not, however, think it is misplaced when the novelist writes "fictional history." There I will take my stand. The novelist is going too far. Neither Warren nor Faulkner ever did that. They wrote within a historical framework, but never fictional history. Warren believes that the historian essentially writes "about" rather than "of" history. The historian must not reach for the license that is granted to the novelist.

I agree with Warren when he says that both the novelist and the historian must imagine what happened. The historian uses all types of scientific devices to re-create the past. But in the end, he has to imagine how it happened. He was not there. He tries to explain something he did not participate in. There is much, therefore, that he shares with the novelist. But there is a distinction—the historian cannot invent. He must only imagine within the limits of his discipline, which confines him to the evidence that he has.

The historian simply knows the evidence, and he has to step forward and tell the story himself, unless he wants to be an editor. The novelist, on the other hand, is not tied down by evidence, but he is tied down by history.

Southern history has to be written with what skill the writer can muster, or it will not be readable. That is true of all history. The historian must be true to the rule of his craft. I struggle with the papers of my students and try to help them express themselves. But I cannot say that I have ever taught anybody to write.

Musicians

These people came out of the hills singing a wide variety of songs, cotton mill protest songs—[sings] "I'm a going to starve, and everybody will, 'cause you can't make a living in a cotton mill." Ralph Peer would put it out on a record, and it would sell a few thousand. So I heard a huge amount of stuff on record.

—Pete Seeger

Southern music is revered throughout the world. From nineteenth-century ballads and spirituals to twentieth-century country music, blues, gospel, jazz, and rock and roll, the region's singers defined the sound of popular music. British rock groups such as the Beatles and the Rolling Stones were inspired by blues, and the Stones took their name from the Muddy Waters song "I'm a Rolling Stone."

Bobby Rush and Pete Seeger bring two complementary musical voices to the South. Both have spent their lives performing on the road, and both are beloved by fans at their concerts.

Rush grew up in Louisiana, where he played both gospel and blues. At his concerts he dances, sings, and plays the harmonica in a fast-paced performance that features costume changes between each song. He is passionate about the blues and is impatient with blacks who do not appreciate the music: "I think some people are ashamed of the blues. They are ashamed of where they come from. I had a black disc jockey tell me one time—I took him a record of mine—he said, 'Well, Bobby, I can play this record, but this really does not fit my format. This sounds too black.' It was a cold shot to me—a black guy tells me that my record sounds too black. He could not play it on the air. I turned my head and started to cry. I did not cry about him not giving me airplay. I cried about a man who does not know where his roots lie."

Pete Seeger grew up in New England. He recalls that "the painter Thomas Hart Benton played a good harmonica and first sang me 'John Henry' in 1932 when I was thirteen." Seeger was drawn to southern music as a political radical who viewed songs as a way to organize working people to protest conditions in coal mines and cotton mills. These songs introduced him to a part of southern history that he never encountered growing up in New England: "I was a political radical, and I was interested to find that these songs brought out a history of the South that I had not known about. I had never heard about the Coal Creek rebellion of 1892, when miners were trying to organize a union, and the governor brought in state prisoners and gave them to the company." Rush and Seeger bring dynamic, engaged voices to the southern story through their music. Their long careers offer a richly textured view of the region and its history.

Bobby Rush 1935–

Bobby Rush, Oxford, Miss., 1987

I have been out here for a long time. After thirty years in the business, I know a lot to write about. That is how songs come about—about your experience in life, what you see and what you do not see, what you put together with your imagination.

Bobby Rush's musical career has carried him from his birthplace in Homer, Louisiana, to Arkansas, Chicago, and now Jackson, Mississippi, where he has lived since the early 1980s. His first musical instrument was a one-strand diddley bow that he made from the wire on a broom handle. Rush's father, Emmit Ellis Sr., was a minister who played guitar and harmonica in his church and encouraged his son to play music.

Born Emmit Ellis Jr., Rush first discovered that he "really loved the blues" as a child. He listened to Nashville's 50,000-watt radio station WLAC and its disc jockeys Bill "Hoss Man" Allen and "John R." Richbourg, who co-hosted a late-night blues program heard throughout the South. Allen and Richbourg promoted records by Ray Charles, Fats Domino, Little Richard, and John Lee Hooker with their "jive talk" commercials. On the air for forty-five years, they inspired a love for the blues in generations of black and white listeners throughout the South.

The consummate entertainer, Rush changes into colorful outfits between songs, and he dances and interacts with his audience during his performance. At concerts, he reaches out to women in his audience, as he tries to "put them in my arm, and kind of give them the upper hand." He proudly works the Chitlin' Circuit of black clubs in small Mississippi Delta towns like Tchula. Rush describes his music as a "cross range of sound" and draws his inspiration from performers as diverse as Chuck Berry, Johnny Cash, Ray Charles, Sammy Davis Jr., John Lee Hooker, Big Maybelle, Elvis Presley, Prince, Muddy Waters, and Tony Joe White. By merging a broad range of musical styles, Rush creates what he calls "the fusion. I think that is why I draw white and black to my concerts."

A thoughtful, committed performer who has a de-

voted audience of black and white fans, Bobby Rush brings a distinct sound to southern music.

I filmed this interview with Rush in my office in Barnard Observatory at the University of Mississippi and his concert at the Hoka in Oxford in 1987. Selections from both the interview and the film are included on the DVD with this book.

I was born in a little place called Homer, Louisiana, and I first heard the blues when I was a young boy listening to a radio station in Nashville, Tennessee. Bill "Hoss Man" Allen was the guy who played the blues on the radio. When I first heard the blues as a young kid, I recognized that I really loved the music. I was about a seven- or eight-year-old kid. At that time, the only radio station that was playing the blues was WLAC, which was out of Nashville. There was no other way to get the blues—other than to sing them myself or hear somebody in my neighborhood singing them. I fell in love with what I could relate to, and I could relate to what I knew. That was my first establishing myself, being a bluesman.

To personally define the blues, it does not have to be things that are bad or good. The blues go in both directions. You can be happy about some things and have the blues, but it is a temporary happiness. When a guy feels bad, he comes to the blues club. He is down. I try to sing a song so I can lift him up, entertain him, make him forget about his problems. Blues makes you forget about your problems.

For me to define what is the blues and what is not the blues is not easy. It is very, very hard to say you do not have the blues when you have prob-

lems. Even if you have money and are living in a rich neighborhood, there is a time you will feel bad, and that is the blues. It could be the president of the United States. He has the blues when things are not going right. He has the blues. It is hard times. That is the blues to me. I think any man can have them.

When I am on the stage, I am trying to get Bobby Rush across. And if that gets the blues across, that is a plus. But I first try to get across as an artist, as an entertainer. I try to get the people in my hand. Once I get them in my hand, I can tell them what I have come to tell. I come to tell them about the blues. It is just like a preacher. You can only preach to the people once you get them in your hand. Other than that, they are not going to heed.

The bluesman tells a story, and the preacher tells a story. I am not saying that the bluesman is the only one to tell a story. I think the preacher and the bluesman are very, very much hand in hand. Very much.

I lean to the women. I often stress to my kids, "Regardless of what you do, take care of your mother." First of all, I lean to the women because a woman is the thing in my life. Not that they always are right about what they do or say. But when you talk about a mother, you are talking about a woman. You are talking about someone who loves you probably a little bit harder than your dad. I am not saying your dad does not love you. In my songs and in my performances, I lean to the ladies. I put them in my arm, and give them the upper hand.

I have an old album called *What's Good for the Goose Is Good for the Gander Too*. So many times

guys want to do what they want to do, and they do not want the lady to do anything. I have a brand new album called *A Man Can Give It, but He Sure Can't Take It.* Now I tell the truth, because I can give it, but I cannot take it. That is the truth. I am not saying that is every man. I am saying that out of a hundred men, ninety-five of them are like that. So that is why I lean to the ladies. I am leaning to things that I know about, and I can measure the situation.

My music comes from a lot of people, and that is why I come up with a cross range of sound. I am not just blues. I am not just pop. I love John Lee Hooker. I love Prince. I love Big Maybelle. I love Elvis Presley, Ray Charles, Muddy Waters, the whole bit.

There have been artists that I was not a particular fan of who would come up with a song I fell in love with. Take Tony Joe White. I fell in love with his performance. Johnny Cash—I just love his songs. There are several guys who strike my heart. That gives me the fusion. I think that is why I draw white and black to my concerts. I am not just a one-track kind of a guy.

There are several artists who, if you brought them to Greenville, Mississippi, today, probably could not draw five blacks. If the blues talked up to blacks instead of down, they would get into it and come to see them. There are some good blues guys, but I do think they need to educate their licks. They have to modify what they are doing, because you do not build a house today like you did in 1950. New things come along. You do not change the foundation. You add to it. That is what I do for my music. I do not lose the blues. I add enough so that young blacks can relate to me.

I write 98 percent of the songs I sing. You have to write with good taste, newness, the good and different. I do not think anybody can write without experience. It is just like writing a book. You can only write about what you know about. Songs come to you about what you know. I have been out here for a long time. After thirty years in the business, I know a lot to write about. That is how songs come about—about your experience in life, what you see and what you do not see, what you put together with your imagination.

Can I satisfy the audience with my performance? That is first to me. If I satisfy them in my performance, then after that we get to a business relationship. When I say a business relationship, I mean, will they follow me through the country wherever I go? Will they buy my records? That is a bigger side of it to me. First, do they like me? Next step, do they like me enough for it to be a business situation?

I have people who come up to me and say, "Bobby, I have been following you for ten, twenty years." Oh God, I am so flattered by that. You do not know how that touches me. You cannot buy that. A lady came up about three weeks ago, said, "I saw you sixteen times." Oh God. Sixteen times. I do not know why people see artists sixteen times. I will take my hat off to a person who comes to see an artist sixteen times.

I heard a bunch of guys talk about how fans followed them. A lot of time they say, "Oh yeah, I appreciate that." But deep down inside, it is more than just appreciate. They really love it. Anybody has got to love someone who followed them more than one time or through the years, more than one year. I just love it.

I am doing exactly what I want to do. I want the world to see me and know about me. I think I am in the ballpark—from Sammy Davis Jr. to John Lee Hooker. I look from the white side to the black side, from up to down. I think my music has to be heard and seen. Now some music can be heard only. I am one of the few black artists and blues guys that has to be seen. I have been very successful up to this point with records, but I think the big dollar and the big notice of me is going to be in video.

I worked so hard at it for nothing, for zero, for no money, until the last four or five or eight years, when something started to happen. Now I am a pro on the bandstand. There was no drawn-out plan for me to get good at this. It seemed like I would get there the next year. Then the next year, it seemed like I would get there. It just kept delaying me and delaying me. I drew out ten or fifteen years working on the bandstand, and it made a pro out of me. I would like to have had a hit record twenty-five years ago. But I probably could not have handled it like I could handle it today. I am ready for everything.

After thirty years on the bandstand, when I walk out, you can tell this is a pro. If a guy walks out on the bandstand who has been doing it five years, ten years, twenty years, I can determine. You can tell a person who has been cooking one year, or who has been cooking twenty years. If a guy wants to talk to you about the army, and you have been there, you can tell whether he is a soldier or not by what he says. A soldier can always tell another soldier when you talk to him.

In '59, '60, '61, '62, I played in the Punch Club, the Swing Club, and Mr. Kelly's. We were playing rock 'n' roll, you know, Chuck Berry stuff. They had the go-go girls at that time. One night, one of the girls did not show up. The boss of the club told me, "Listen, I want you to do fifteen minutes on the stage by yourself."

So I jump on the stage with my bass, did a little twist, and the crowd went wild.

He said, "Why don't you try it for a week?"

I tried it for a week, and two weeks later, he got rid of another girl. Then it was thirty minutes. I worked there for a year. He got rid of every girl but one. So I would do an hour a night.

Somebody asked me, "Where did you get the change in clothes bit?" Well, the change of clothes came from when I was working in 1958 and '59, maybe '60, at a little club called Havana Club. The gentleman told me, "Bobby, I am going to pay you fifty dollars a night. I will give you ten dollars for the bandleader, which makes sixty dollars for the night. But we need an emcee and a comedian."

I said, "Look, I've got a guy who will work for seventy-five dollars."

Who was this guy? Me. I did not have a mustache at that time. I put a false mustache on and some old tramp clothes. I dressed in the tramp clothes. So I come out and tell my jokes. Then I'd say, "Now ladies and gentleman, here is Bobby Rush." I step back behind the curtain, take off the clothes, and come back on. I was picking up two monies for about a year before the guy caught on.

"Man," he said, "listen, I really need to meet this guy, this emcee, because he is good."

At that time, I had made enough money. I had gained a relationship with the guy enough to tell him, "Man, there is no such thing. There is no such a thing as the tramp. You are looking at him."

He did not believe me. I had to put the clothes back on and show him. So that is where the change of clothes bit come in. I have been doing it ever since, been doing it a long time. I personally think that I am a blues singer. Plus, I am an entertainer. I am good at what I do. If I am not good at what I do now, I never will be.

I spent thirty-some-odd years in Chicago. I guess you could say I was raised in Chicago. I left Chicago in '81 and came to Jackson, Mississippi. And I have been in Jackson ever since. I call Jackson my home, and I love it. I am just twenty years late. I should have been here twenty years ago. I love it, love it.

I looked on a map and said, "Here is the center of the South, and here is a town that is big enough to accommodate the musicians that I need." I work the South. Eighty percent of my work is in the South. And being a blues singer, if I work the South, why not get in the center and just leak out to all points? I was looking at the economical thing for travel. If I went out to work Friday, Saturday, Sunday from Chicago and went to Jackson or to New Orleans, look at the distance—eight, nine, twelve hundred miles I would have to drive back and forth. In Jackson, I can reach all these points from where I am within a day. I only have to drive three or four hundred miles.

Eighty, eighty-five percent of my clubs are black clubs. I think black people in the South accept me better than the northern black people. In Chicago, although they are from the South, they forget about where they come from quicker than the guy who is in Jackson. I do not know why.

Some people are ashamed of the blues. They are ashamed of where they come from. I had a

black disc jockey tell me one time—I took him a record of mine—he said, "Well, Bobby, I can play this record, but this really does not fit my format. This sounds too black." It was a cold shot to me—a black guy tells me that my record sounds too black. He could not play it on the air. I turned my head and started to cry. I did not cry about him not giving me airplay. I cried about a man who does not know where his roots lie.

I had another gentlemen that made me feel just as bad. He said, "Well, I play the blues, but I really do not like the blues." I respect him for saying what he does not like. But when a man—a black man, especially—tells me he does not like the blues, he is saying he does not like his mother. That is where he comes from. How can you say you do not like where you come from? I think he just did not realize it, and that is what I was sad about. It hurts when a guy is not really up on what he is saying. It hurts.

I love it when I go into the small clubs. First, I am flattered that I am giving a service to a small town. Sometimes they say, "Is the real Bobby Rush coming here?" Man, you do not know what that does. I am giving a service, plus I am performing. Some of the small towns never got a chance to see an artist of my status, and I see it in their eyes. What artist has been to Tchula, Mississippi? If they are going to see B. B., they have got to go some other place. I appreciate them being my fans. But I also appreciate giving a service to someone who would never get a chance to see me if I did not go to their small town.

At this time in my career, I am not trying to duck the Chitlin' Circuit. I will forever work the Chitlin' Circuit. Life is a gamble. I think about the

fights that break out in the clubs. But you can also get hurt in Buffalo, New York, in a fabulous theater. I just cross my fingers and say, "God, do not let it happen to me or anyone else here." There is nothing you can do about it. It is just like riding a plane. They can all fall. I try not to think about it falling. Who knows when one will fall? I am not trying to duck the Chitlin' Circuit, believe me. I just want the other circuit to know about Bobby Rush also.

If you are enthused, you can survive. But when you are not enthused, you cannot survive. I heard Muhammad Ali say one time, "I fought the best. I have got nobody to fight now. I am not enthused." When you are not enthused, you are on your way to lose. You have got to walk on the bandstand and be enthused. There are a whole lot of people out there that never saw me. I am enthused about the ones that never saw me. I am honored by the ones that have.

Monday, Tuesday, and Wednesday of every week, I am going to be home. The weekends, I will be gone someplace—every weekend.

Pete Seeger 1919–

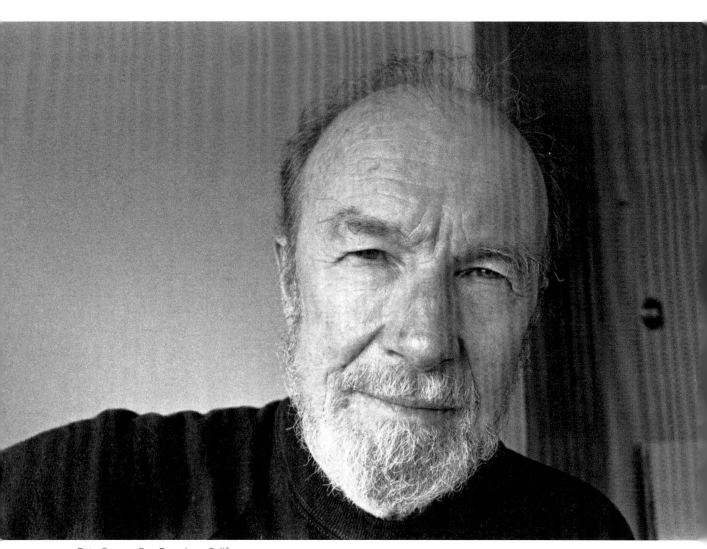

Pete Seeger, San Francisco, Calif., 1990

Those were the days when Ralph Peer and others traveled through the southern states. They would rent a hotel room and put an advertisement in the paper saying, "Any song we accept, you will get twenty-five dollars."

There would be a corridor full of people with their fiddles and banjos and guitars waiting to try out. "Boy, if he takes my song, I get twenty-five dollars. That is a couple of weeks' pay!"

Pete Seeger has long been my hero. As an undergraduate at Davidson College in the early sixties, I listened to his records and learned to sing folksongs from them. When we organized civil rights meetings and marches at Davidson, his music and his unwavering commitment to human rights were an inspiration. "We Shall Overcome" was our anthem, and we sang it often at gatherings in the early sixties.

During my graduate study in English literature at Northwestern University in 1965, I attended a concert that Seeger gave at Orchestra Hall in Chicago. My seat was at the very top of the large hall, and I watched as he stood alone on the stage with his guitar and banjo before an adoring audience. At the close of his concert, Seeger played ten encores before he left the stage. I marveled at how he held the audience with his strong, clear voice. We sang along with his verses and choruses and felt a deep bond with him. He inspired a belief in human rights that touched me and every other person in Orchestra Hall that evening. The tall, lean figure of Pete Seeger holding his banjo is familiar throughout the world. His concerts offer hope and joy to all who struggle to bring civil rights to their people.

While spending a year as a fellow at the Stanford Humanities Center at Stanford University in 1989–90, I learned that Seeger was coming to San Francisco for a concert. Historian Michael Honey was also a fellow at the center, and we decided to interview Seeger during his visit. I had interviewed his father, Charles Seeger, ten years earlier, and I wanted to follow up on our conversations about the American South and his family's ties to the Lomax family. I wanted to learn more about the father-son teams of Charles and Pete Seeger and John and Alan Lomax and how they collected, archived, studied, and performed American

folksongs. The Seegers and Lomaxes are our nation's "first families" of folksong research, and Pete Seeger describes their friendship. His stepmother, Ruth Crawford Seeger, did musical transcriptions of the Lomaxes' field recordings and was herself an important American composer.

I filmed this interview with a Sony Super 8 camcorder. During the interview Seeger reflects on his childhood, his travels with Woody Guthrie, and his role in creating the song "We Shall Overcome." Like his father, Pete Seeger indelibly shaped my understanding of American folksong. His career demonstrates how songs can inspire social movements throughout the world and are a force for change. He reminisces about his family, including his father, Charles Seeger, and his stepmother, Ruth Crawford Seeger, as well as his siblings, Mike, Peggy, and Penny Seeger, all of whom had important musical careers.

In recent years, Pete Seeger's career has had an important revival. The DVD *We Shall Overcome: The Seeger Sessions* (2006), produced by Bruce Springsteen, and the Library of Congress tribute to Seeger and his family, "How Can I Keep From Singing?" (2007), affirm the enduring power of his music. Seeger's voice and his music touch the hearts of all who love folk music. From his travel as a child to North Carolina with his parents to his courageous leadership in the civil rights movement, Pete Seeger has maintained a deep, enduring connection to the American South and its music.

I filmed this interview in San Francisco in 1990, and selections are included on the DVD with this book.

I was raised in New England. My grandparents that I knew best were from Massachusetts, and I went to a little alternative school in Connecticut. I first learned about the South when we sang, "Oh, Susannah, . . . I come from Alabama with a banjo on my knee." The South was a distant, romantic place, like the Far West or the islands of the Caribbean. I did not think I would ever go down there.

My father got interested in folklore when he was a professor of musicology. He went through the books of Cecil Sharp, and I remember him pointing out a magnificent melody to me. When I was ten years old, he pointed out unusual melodies that had come out of the southern mountains.

My life changed forever when my father took me to Bascom Lunsford's Mountain Dance and Folk Festival. It was held in a baseball park in Asheville, North Carolina. Five or ten thousand people were in the audience—local people, not many tourists. Bascom had a great way of staging things. He put a spotlight on the mike on stage right, and there would be the Bogtrotter String Band playing "Sally Gooden." While they were playing, he would set up the next string band on stage left. In the dark, he would group them around the mike, saying, "Now, you all in tune? You know what you are going to play? When the light comes on, you start playing."

So the Bogtrotters finish, and Bascom steps in the spotlight. "Give them a hand, folks. Wasn't that wonderful? Now over here we have the . . ." whatever their names were. The spotlight would shift over to the other side of the stage, and they started playing right away.

You had a fast-moving show. People would stumble onto stage, get in tune, and get grouped around the microphone. I remember Samantha

Baumgardner, a woman in her fifties, leaning back in her rocking chair. She decorated her banjo with beautiful colored butterflies that she painted on its head. She was singing old ballads about Lord and Lady So-and-So. I fell hook, line, and sinker in love with southern mountain music and tried to learn it. I had heard some of the songs before. The painter Thomas Hart Benton played a good harmonica and first sang me "John Henry" in 1932 when I was thirteen.

That was an overwhelming experience—seeing and hearing the real thing and meeting the people. In the next five years, through the Library of Congress, I got to hear thousands of recordings of southern music. I confess I was in love with southern music. Alan Lomax hired me for fifteen dollars a week to listen to old commercial records of the twenties.

Those were the days when Ralph Peer and others traveled through the southern states. They would rent a hotel room and put an advertisement in the paper saying, "Any song we accept, you will get twenty-five dollars."

There would be a corridor full of people with their fiddles and banjos and guitars waiting to try out. "Boy, if he takes my song, I get twenty-five dollars. That is a couple of weeks' pay!"

These people came out of the hills singing a wide variety of songs, cotton mill protest songs— [sings] "I'm a going to starve, and everybody will, / 'cause you can't make a living in a cotton mill." Ralph Peer would put the song out on a record, and it would sell a few thousand. So I heard a huge amount of stuff on record.

I had not traveled much in the South, and I wanted to learn how to play a banjo. In the summer of 1940, I learned how to hitchhike. I had dropped out of college in 1938, and Woody Guthrie taught me how to pick up change in bars. Woody says, "You walk into a bar. You get a nickel beer. And you just sip it. Nurse it along. Sooner or later, somebody is going to say, 'Hey, can you play that banjo?' You have it slung on your back. Do not get too eager. 'Well, maybe a little.' Keep on sipping your beer. Finally, somebody is going to say, 'Kid, I got a quarter. Play me a tune.' Now you start playing."

So I was picking and eating.

I went to Alabama and stayed at the home of a radical professor named Joseph Gelders. He was a civil rights activist and a labor organizer in Birmingham, Alabama, in the 1920s and 1930s and was also a member of the Communist Party. He had been beaten terribly by the Ku Klux Klan, almost killed, and was the first secretary of the Southern Conference for Human Welfare. I stayed with him a few weeks. Then I went up in northeastern Alabama. I was walking down a little side road hitchhiking when I met three brothers, the Smith brothers, who played mandolin, fiddle, and guitar. My banjo fit right in with them. They were dead broke. They would go around and play for their supper with neighbors, who would take pity on them. They would play music all evening, and the neighbors would give them supper. It might be their only good meal for the week.

By the end of that summer I had learned double thumbing and how to "hammer on." I invented that phrase "hammer on." I am quite proud that it is now used by banjo and guitar pickers all over the country. You come down with your left hand and hit a note. Then you strike the same string first with

your right hand. Wow, what a discovery! You get notes with your left hand as well as your right. And I invented that phrase "pulling off." My mother told me, "That is called left-hand pizzicato."

I was a political radical, and these protest songs brought out a history of the South that I had not known about. I had never heard about the Coal Creek rebellion of 1892, when miners were trying to organize a union, and the governor brought in state prisoners and gave them to the company. The Tennessee Coal and Iron Corporation was owned by J. P. Morgan, up in Wall Street. They brought in Tennessee state prisoners to work the mines. The miners went down with guns one night and demanded that the warden free the prisoners. They burned the stockade down, gave civilian clothing to the convict miners, and helped them escape across state borders.

I came to New York in 1940 and met Lee Hays from Arkansas. We started singing together and called ourselves the Almanac Singers. His roommate, Millard Lampell, joined us. In June, Woody Guthrie came back from the West Coast after one more attempt to make up with his wife. He joined us, and we went west as the Almanac Singers, singing a variety of union songs and old songs. Woody thought I was a queer duck. I did not drink. I did not smoke. I did not chase girls. What was wrong with me? But Woody liked my banjo. I did not try anything too fancy. When he led off, I gave him a good, solid backing, a good steady rhythm.

My younger brother, Mike, loved southern music. He was raised in Washington, and he started learning the banjo out of my book, *How to Play the Five-String Banjo*, which I wrote in 1948. Mike went far, far beyond me in learning banjo,

fiddle, dulcimer, mouth harp, singing old time, and yodeling. I was one of the first of thousands of Yankee college students who said, "Boy, this is great music. I got to learn some of it."

My father built one of the first trailers in this country and hauled it behind a Model T Ford. It looked like a covered wagon, had a canvas roof, very heavy. My father did a meticulous job of building it with tongue-and-groove maple and brass screws. It had four wheels. He put a special low gear on the Model T so he could pull it up hills. When we went down South, the roads were dirt roads. They did not have blacktop except in a few cities. Once it rained, and the puddles got bigger and bigger. Finally the entire road was one big puddle. My mother said, "Charlie, aren't you going to turn around?"

He said, "I can't turn around. The road is too narrow. I have to go ahead."

The road went completely out of sight, but my father said he could tell where he was going by the fence posts on either side. He stayed in the middle of the road. The water was up to the hubcaps. It got over the hubcaps. My mother was getting hysterical. They could not see anything except fog and rain on all sides. They kept putt-putt-putting ahead. Finally, away in the distance, they saw the road rising out of the water. My father used to tell that to me. He would make a twenty-minute story about it, with all the suspense, when I was four or five or six years old.

They got as far as Pinehurst, North Carolina. Could not go any farther. Too much mud. My poor mother, she was trying to change my diapers and boil them in a big iron pot. My father bought a six-shooter just in case anybody should try to rob

them and a shillelagh stick to beat away the wild pigs. They found a farming family named McKenzee. And McKenzee said, "Yes, you can park this thing—whatever you call it—in our woods if you want to."

My father built a log frame—sixteen feet square—and put a sixteen-foot-square army squad tent on top of it—World War I surplus. And they spent the winter there in Pinehurst. One evening they took their music up to the McKenzees' farmhouse and played Debussy, Bach, Brahms. My father played a little pump organ, like chaplains used in World War I, with a four-octave keyboard. The McKenzees were very polite. They said, "Very nice music. Of course, we make music, too."

They took their banjos and fiddles off the wall and fiddled up a storm. My father said, "For the first time, I realized these people had a lot of good music already. They did not need my music quite as much as I thought."

My father worked very closely with a lot of communists in the early thirties. The economic system had fallen to pieces. It looked like it was either going to be fascism or socialism. It was chaos. My father felt that only a very disciplined group could bring some kind of order out of it, and the communists were disciplined. But after about five years he decided that their music was not reaching the people. So my father brought Aunt Molly Jackson, the Kentucky coal miner's wife, around, and she sings,

I am a union woman
Just brave as I can be.
I do not like the bosses
And the bosses don't like me.

They listened to her and said, "Surely this is music of the past. We are supposed to be creating music of the future."

My father took Aunt Molly home. He said, "Do not feel bad, Molly. They did not understand you, but I know some young people who are going to want to learn your music." I was one of them. I got home on vacation, went around to see Molly, and latched onto her and her music.

Harry Sims was a young Jew from Springfield, Massachusetts, who volunteered to go down South and help the union. The union leader says, "Harry, I do not think I should send you down there. It is dangerous. It is like the Wild West down there. They shoot people."

Harry says, "I will be careful. Send me down."

Jim Garland said he was one of the most inspiring speakers he ever heard. Can you imagine this Springfield, Massachusetts, Jewish kid of nineteen? His father and his uncle both fled Russia after 1905, and they dedicated their lives to bring working-class change to the world. Harry had not been down there more than a month before the company gun thugs walked in and shot him in the stomach. Jim Garland said he took him to the company hospital, and they would not take him in. They said he did not have money to pay. Harry sat on the curb holding his guts in his hand for an hour, bleeding to death. They finally got money, took him in, and he died on the operating table. The song that Jim wrote about him I have sung for fifty years now. Jim put new words to an old ballad melody:

Come and listen to my story, come and listen to my song.

I'll tell you of a hero who is now dead and
 gone.
I'll tell you of a young boy whose age was
 nineteen.
He was the bravest union man that I have
 ever seen.
Come and listen to my story.

The Lomax family made a trip to Asheville. Old man John Lomax was in his sixties, cantankerous, a terrible driver. When he would make a mistake, he would shout at the other car. Alan was about twenty at the time, maybe twenty-one. His father put him in charge of the Archive of Folksong in the Library of Congress. He had no degrees, just a lot of youth and energy and the experience of working as his father's assistant for a number of years. Within five years he did more than most other archivists had done in fifty years. He was a whirlwind of energy. He had no budget to speak of and did not have a secretary. He hired me for fifteen dollars a week to give him a little assistance.

Alan went to the CBS radio network and said, "You should be telling America about America's music. We have the best music in the world here. We can have the best singers come and perform."

He had Lead Belly sing on the School of the Air. Alan meets an actor named Burl Ives, and he says, "Burl, why are you wasting your time being an actor? You should be giving concerts of folksongs."

I was on the radio program when he taught Burl "Blue Tail Fly." He says, "Take it lightly. Don't push it."

He went to a nightclub owner, Max Gordon, at the Village Vanguard, and he says, "Here is Josh White. Here is Lead Belly. Why don't you have them sing at your nightclub?"

Josh had a very successful career as a nightclub performer. Alan started it off. He tried to help Lead Belly, but Lead Belly's Deep South pronunciation was such that many people could not understand it. I think if Lead Belly had just lived another two or three years, his career would have taken off. He was cut down at about age sixty-two by the same disease that got Lou Gehrig, the baseball player.

We thought he would live forever. He was so strong. He had muscles like a prizefighter. If he had not gone to jail, I think he would have been a great athlete. He had a very strong competitive streak in him. When he was young, he landed in jail because he got involved in fights, and people were killed. In his early sixties, he was one of the strongest men I have ever known in my life. When he took off his jacket or took off his shirt, there was not an ounce of fat on him.

What Lead Belly did with the twelve-string was carry on a great southern black tradition. African Americans in the southern states got hold of this instrument called the guitar, and they treated it like an African instrument. There is the bass drum with the thumb, and the index finger takes the off beats like the little drums. Everybody in the world knows this style of playing now. Oftentimes that style of picking is associated with Merle Travis. Travis himself said he learned how to pick his style of guitar from black musicians. Bill Monroe will tell you how he was inspired by black people for the syncopated music that his bluegrass band did.

The song "We Shall Overcome" is now known

worldwide. How it came to be is a long story. In 1903 Reverend Charles Tindley had a big church in Philadelphia. He wrote a song that went, "I'll overcome someday. I'll overcome someday. If in my heart I do not yield, I'll overcome someday."

He put out a book called *Gospel Pearls* [1921] and started to use the phrase "gospel music." Some of his students, like Lucie Campbell, became gospel songwriters. Somewhere between 1903 and 1945 "I'll Overcome" got a quite different melody and a quite different rhythm. "I'll overcome. I'll overcome. I'll overcome someday. If in my heart I do not yield, I'll overcome someday."

Some people say, "Deep in my heart, I do believe, I'll overcome someday."

It was a well-known gospel song in this fast version throughout North Carolina and South Carolina. In 1945 or 1946, 300 tobacco workers, mostly black and mostly women, went on strike in Charleston, South Carolina. People took turns on the picket line. Music-loving people are always going to sing. They sang hymns most of the time on the picket line. Once in a while they would sing a union song, but mostly they sang hymns.

Lucille Simmons loved to sing "I'll Overcome," but she changed it to, "We Will Overcome."

She loved to sing it the slow way. You know, any hymn can be sung long meter or short meter. She liked to sing "We Will Overcome" in long meter. She had a beautiful voice, and they said, "Oh, here is Lucille. We are going to hear that long, slow song."

She would sing it, "We will overcome. / We will overcome. . . . / We'll get higher wages. . . . / We'll get shorter hours."

Zilphia Horton, a white woman, was an or-ganizer from the Highlander Folk School. She comes down to help, and she is completely capti-vated by this song. Zilphia had a lovely alto voice and an accordion. She taught the song to me on one of her fundraising trips up North. I liked it. I found myself singing it and teaching it to audi-ences. "We will overcome. / We will overcome."

I added some verses. "We shall live in peace, / the whole wide world around. . . . / We will walk hand in hand."

Out in Los Angeles, I met a young fellow named Guy Carawan, and I taught it to him. Guy Carawan's family had come from North Carolina. He wanted to get acquainted with the South, as I had done. Next thing you know, he was helping the Highlander Folk School with workshops. In 1960, they had an all-South workshop on the use of music in the freedom movement at the High-lander Center. So Guy sings this song. He gave it the Motown beat, the famous soul beat.

I had changed the "will" to "shall"—me and my Harvard education. "We shall." I think it opens up the mouth better, and we changed the rhythm. "We shall overcome. / We shall overcome."

Within one month, it spread through the South. It was the favorite song at the founding conven-tion of SNCC three weeks later in April 1960 in Raleigh, North Carolina, where people came from all through the South.

Dr. King heard me sing the song three or four years before. He came to the Highlander Center, and Miles Horton, Zilphia's husband, says, "Pete, won't you come down and lead some songs. We can't have a gathering here without music."

I sang "We Shall Overcome." Anne Braden later told me that she drove Dr. King to Kentucky the

next day and remembers King in the back seat saying, "'We shall overcome.' That song really sticks with you, doesn't it?"

The song means different things to different people. In Selma, Alabama, a lot of people were singing it because they wanted to overcome Sheriff Jim Clark, who was beating people up and throwing them in jail. When I am singing it, the most important word is "we" because the human race is either all going to make it, or we are all *not* going to make it. In my more optimistic moments, I think we shall overcome.

Photographers

I am attracted to things that are decaying, that are rapidly vanishing from the landscape in the South. I cannot say I am obsessively attracted to them. I find beauty in things that are old and changing, like we all are changing. I do not find them ugly.

—William Christenberry

Photography has long been an important part of the American South. Mathew Brady's graphic images of the Civil War and cherished tintypes of ancestors are examples of how photographs captured the region's history in the nineteenth century. Generations of twentieth-century photographers have documented and defined the changing worlds of the South. During the New Deal, Farm Security Administration photographers focused on the region's poverty in an effort to bring social change to communities. During the civil rights movement photographers graphically captured marches and sit-ins.

Walker Evans is the acknowledged master of black-and-white photography. His images have a luminescent quality that distinguishes them from the work of other photographers. Evans grew up in the Midwest and told me that he was drawn to the South by its "romanticism and history and heritage. The Civil War was a great trauma, a historic shock to this country. But it had its romantic side, too. The horror of those men fighting each other, cousin to cousin, and the legend of Abraham Lincoln interested me enormously. I was awfully impressed with the whole business as a boy and in my teens."

Evans took his most famous photographs when he and James Agee collaborated on their book *Let Us Now Praise Famous Men* (1941). Evans and Agee saw the book as a cry against social injustice and the plight of the sharecropper families with whom they lived in Hale County, Alabama.

The book is a classic study of the American South, and Evans's portraits of sharecroppers are forever etched in our memory. His comments about injustice resonate as strongly today as when the work was originally done. Evans told me that "social injustice is the shocking work of the devil. I still feel it today. Anybody with any sensitivity can hardly stand social injustice, and we are living in the middle of it all the time."

There is a fascinating symmetry between the life of Walker Evans and that of William Christenberry. Christenberry was born in 1936, the same year that Evans made his photographs in Hale County, where many of Christenberry's family lived. Christenberry initially took photographs as "references for my paintings. I never thought of them as art or as serious photographs until later. When I met Walker Evans in New York, he asked to see some of my little snapshots." In 1973, the two photographers returned together to photograph the Hale County community.

Unlike Evans, Christenberry returns each year to Hale County to photograph the landscape and its decaying buildings. These images are a central part of his work as a photographer, painter, and sculptor. He explains that "photography is a part of my total means of expression that crosses over between several mediums."

When Christenberry began to teach in the Art Department at Memphis State University in 1972, he met William Eggleston, who encouraged him to pursue color photography. Christenberry acknowledges that Eggleston's "interest in color photography inspired me. I continued to make those little snapshots for a number of years." Thus began a long, close friendship. Eggleston and Christenberry speak regularly on the phone, and they refer to each other by last name. Eggleston will tell me, "I spoke with Christenberry last week, and he thinks we need to get together soon." Each refers to the other in a serious, respectful tone, as brothers might talk.

Eggleston acknowledges the influence of both Christenberry and Evans on his work. Their photography connects with his own in the deepest way. "Bill Christenberry's work has had a big influence on my work. Christenberry works in color. He is one of the few that does. And Walker Evans, of course, is an influence. You cannot forget images like his. It is impossible not to be influenced."

Using the dye transfer printing process, Eggleston drenches his photographs with intense, rich color and transforms how we view color photography. His early work focuses on the Mississippi Delta and his home in Sumner, Mississippi. Eggleston captures the intense yellow of late afternoon sunsets in the Delta so vividly that the color is now called "Egg yellow" to acknowledge his eye as the photographer. His photographs lead us beyond the old, decaying South—the focus of Evans's and Christenberry's work—into surreal, frightening worlds that are both rural and urban. He works on the edge as an artist and forces us to consider his photographs for both their content and their rich use of color. His images of the South open an exciting new frontier within the photography world.

Walker Evans 1903–1975

BORN IN ST. LOUIS, MISSOURI

They were tenant farmers. I told them we were looking for a family to interview and write about, and they said, "All right. You can come home with us."

Few books touched me as deeply as *Let Us Now Praise Famous Men* (1941). I read it first as an undergraduate student at Davidson College in the early sixties and was struck by both James Agee's prose and Walker Evans's photographs. Encountering their portrait of white sharecroppers in Hale County, Alabama, was an epiphany. The book captured the South's stark poverty through Agee's eloquent prose and Evan's striking photography in a manner that was both shocking and beautiful.

A decade later, in the fall of 1972, I began teaching at Yale and met Evans in the home of our mutual friend Alan Trachtenberg, who was chairman of the American Studies Program. Trachtenberg's daughter Lizzie asked me to photograph her with Evans, and I snapped several shots of them with her camera.

Thus began a treasured friendship. In future visits with Evans we spoke about his love for the American South, and he recalled photographs he had made in my hometown of Vicksburg, Mississippi, where he captured street scenes and Civil War monuments in the Vicksburg National Military Park.

In 1935, both Evans and Ben Shahn photographed the Ray Lum livestock barn in Natchez, Mississippi. I explained to Evans that my father was a farmer who at that time was buying mules from Lum, and that I was working on a film and book on Lum's life as a livestock auctioneer and storyteller. Evans was drawn to the same worlds that I photographed and filmed as a folklorist thirty years later.

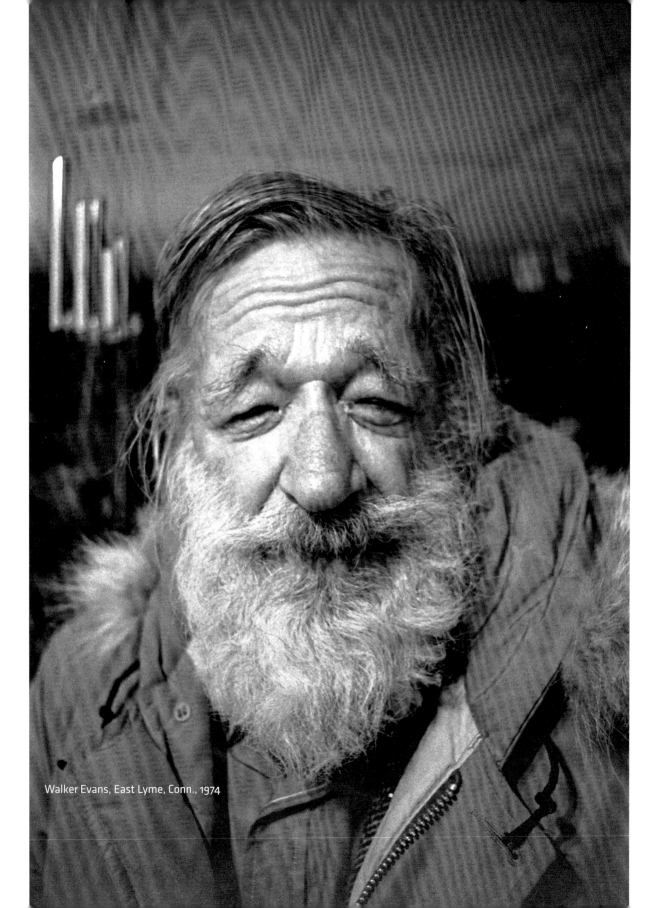

Walker Evans, East Lyme, Conn., 1974

My work as a folklorist led me from Mississippi to New Haven and a friendship with a man whose work I revered. While at Yale, I was part of a circle of friends, all of whom adored Evans. The group included Jerry Thompson and Michael Lesy. Thompson was a gifted photographer who taught at Yale. Lesy's *Wisconsin Death Trip* (1973) had recently appeared, and he was a visiting professor in the American Studies Program.

I asked Evans if he would allow me to tape a conversation with him. He invited me to dinner at a local restaurant, and afterward we discussed Evans's background in the Midwest and Chicago and his attraction to the American South. Through his camera lens he captured the region's faces, homes, and landscape. The South's strong sense of place shaped both the images he photographed and his own identity as an artist. It was a proving ground for his most important work. Evans's sensitivity to southern people is reflected in photographs of farm life, country fairs, and Civil War battlefields through which he unveils an intimate panorama of the South.

Evans's photographs of southern worlds inspired my own work as a folklorist. While photographing families in Mississippi, I often thought of Evans, who was there before me. I imagined him visiting small communities and appreciated the grace and care with which he shaped his portraits. Our conversation explores the role of the artist as a witness to culture, and offers a glimpse into his life as a photographer.

We spoke in my resident fellow's apartment in Calhoun College at Yale University in 1974.

I do not know how to explain my attraction to the South. It has to do with romanticism and history and heritage. The Civil War was a great trauma, a historic shock to this country. But it had its romantic side, too. The horror of those men fighting each other, cousin to cousin, and the legend of Abraham Lincoln interested me enormously. I was awfully impressed with the whole business as a boy and in my teens.

I can understand why southerners are haunted by their landscape and are in love with it. When I was in Natchez, I saw a mule barn. I am very interested in folk art—what I call flash painting—and there was a naïve, beautiful painting of horses on the wall. I had to record it. It was a marvelous painting with a picture of some horses' heads that was extremely moving and touching.

The texture of unpainted wood is very attractive to me. It is hard to say why—just an instinctive natural love. That is America, and I am deeply in love with traditional, old-style America. When I go out and see those houses painted over, I am dismayed. I do not want them to be painted.

I met James Agee because everybody in Greenwich Village who was serious seemed to know each other in those days. He lived on Charles Street, and I lived on Bethune Street. He was younger, but he was very interested in my work. He looked me up and talked to me all night. I used to walk him home, and then he would walk me back home again. We would talk all night. He was a great talker. He was indefatigable. He had much more physical energy than I had. I could not outlast him.

Agee was interested in what I was doing, and he got an assignment from *Fortune* magazine, where he was working. He wanted to work on southern tenant farms, and *Fortune* at that time did not know what the hell to do with itself edi-

torially. So they said, "All right. You go and do that."

Off we went. I went because I thought it was a wonderful assignment. And it was. It was very intense. It was hard work, but work done with love, interest, and dedication. We worked night and day—very intensely—because we loved it. We wanted to do something important.

I felt pretty much at home, perhaps not as much as Agee did, because he came from Tennessee stock and had a rural background. I do not know much about my forebearers, but I think some of them must have been dirt farmers. They came from Massachusetts and Virginia, went west into Missouri, and they had an attachment to the land. I was divorced from it. I was a suburban son of a Chicago businessman, so I did not really know a hell of a lot about the land. But I felt almost a blood relationship with what was going on in those people. I have a love for that kind of old, hard-working, rural southern human being. They appeal to me enormously from both the heart and the brain.

I saw in them Old America, which goes so far back that some of the people speak with something reminiscent of Elizabethan English, and their faces are like that too. That sharecropper's wife is a classic portrait of a real old pioneer, an American woman of English stock.

We lived with one couple. Agee gave them fictitious names in the book. I think he called them Burroughs. I am not sure I even know what their names really were. Budger, I think. She was twenty-seven, and he was about thirty. They were destitute. We found them because they were in line for welfare, and they were living penniless in a little shack. They were tenant farmers. I told them we were looking for a family to interview and write about, and they said, "All right. You can come home with us."

They were simple, good-hearted people, quite nice and loveable. We lived with them for three weeks. We told them exactly what we were doing, and we worked intensely and separately. I did not see Agee. He was working all day interviewing and taking notes, and I was photographing. We knew what we were doing. We were doing a documentary. We told them exactly what we were doing, and we paid our way—paid our board and also paid them a stipend for letting us work with them.

Agee really was touched with genius, a passionate, great writer. We did not work together at all, but we cared a lot about each other's work. We left each other alone. To this day, I do not know why *Let Us Now Praise Famous Men* has become as well known as it is. I say I do not know because greatness, which Agee put into it, does not usually become known right away. It was a strange turn of events that made the book famous in its revival because it was absolutely unnoticed at first. When it was reissued in the sixties, it was reborn like the phoenix. It was right for the time because the young wanted honesty. They had been lied to so much. They thought this was a form of truth. I am sure that is what happened with both the photography and the writing. It is remarkable to think that Agee was only twenty-seven years old. He put his very soul into that work because he was an intense, born writer. He almost wrote himself to death on that book, and it shows. It shows his immaturity, but it also shows his greatness and dedication. He was a great poet.

Agee was very young, you must remember. What he wanted to do was to shock and scare people. He wanted to make people who were not poor feel what it was like to be up against it. He wanted to rub it in. He was angry. He wanted to say, "Look, you sons of bitches and you bastards! What the hell do you think you are doing? Living this way while these people are living *that* way. The hell with you! I wish you would all go to hell!"

This is a young and immature attitude, but he was that way. Some of the pages in that book try to rub it in. He was very angry about middle-class Americans, who buy security and take things for granted, while these people, who were human beings whom he loved, were shut out. Not only shut out, but suffering deeply because of being shut out because of money, which is really an evil thing. Social injustice is the shocking work of the devil. I still feel it today. Anybody with sensitivity can hardly stand social injustice, and we are living in the middle of it all the time.

Agee wrote a poem to me. To this day it embarrasses me. We had a great love for each other. But between two normal males you do not express love so openly. He had a love for me that he put down in lines that embarrass me very much and misled a lot of people. There is such a thing as a great male love between two men that is a deepening expression of friendship. That is all.

I do not know if I would want to return to Hale County. I am mixed about that. I have an idea I better leave it alone. Going back is not a very good idea. When you go back to your childhood home, what a mistake that is. Better leave the past alone, geographically speaking. You carry it around in your mind anyway. Let it stay there, because the reality is not the same reality that you remember. You violate it if you go back.

From childhood on, I always had an eye and a desire to use it. I used to draw and paint, and I used my eye. You teach yourself how to see more or less unconsciously from childhood. If you have an eye, you develop it. I went through the usual little-boy camera, Brownie, darkroom, developing films, dark light in the bathroom, and all that. I went through all that as a hobby, and then I dropped it because I got interested in girls. I forgot the camera for a while.

I grew up in an aspiring gentility, which I now have a respect for. The aristocratic ideal is at least idealism, and I believe my mother and father had it. I went to Andover. I always wanted to go there because I thought it was the best old school with a tradition. It is the oldest secondary school in America. In those days it was very easy. All you had to do was present yourself, have your father pay the bill, and you got in. I loved it. I felt I was in the place I ought to be, although I did not do very well. I did not take it very seriously. I have no scholarly or academic distinction about my mind. But I had a literary mind, and I read on the side.

I was very attracted to and lived emotionally off the jazz of the thirties. We were all really poor. It was hard for us to spend ten dollars for an evening in a good jazz nightclub. We never had the ten dollars, but we got the records. I suppose the reason we did not become alcoholics is that we could not afford a drink.

I was in the generation that came to intellectual maturity in the twenties. At that time America was scandalously materialistic—really fascist—and so awful that we just had to get the hell out. Paris was

the place to go. It was cheap. You could go there and live on almost nothing. I went to classes at the Sorbonne, and I lived on fifteen dollars a week, which my father sent me. I could buy books and live well on that small amount of money. It was a great experience for me.

I left Williams College to go to Paris. I convinced my father that instead of paying for the rest of my college education, he should let me go to Paris and study at the Sorbonne. I did not study formally. I did not want a degree. French history and French civilization and the French language influenced me deeply. I still am a Francophile. There is hardly anything as impressive as what the French intellectual—literary intellectual—was like then. I saw James Joyce. Sylvia Beach wanted to introduce me to Joyce, and I said I did not dare meet him. The few times that he came in her bookshop, I left. André Gide was always around, and I saw him having lunch alone. I did not get to know them, but I read them carefully.

There was a community of escapees in the sixties that we never had. Those of us who rebelled against the establishment that we came from had nowhere to go. I found a few people who felt the way I did. If a young person wanted to run away from a middle-class home, he had no place to go. But in the sixties, there was a whole crowd of them, epitomized by Woodstock. Two or three hundred thousand of these kids all got together, and they had a certain community. We never had anything like that. We had just a few people to talk to who felt some interest in the Depression and the stockbroker jumping out the window. We thought that was fine! Let them kill themselves. Let them stop playing golf.

It is still confusing to me, because I find that I am at heart an aristocrat, if there is such a thing. I do believe in aristocracy. But if I examine it very carefully, I find that it is based on money that is almost always stolen. You do not amass a fortune without ruining a lot of other people. And yet it has produced a cultural distinction. Aristocracy is unjust socially. I have to reconcile myself to this dichotomy and this schizophrenia.

I am in love with civilization. I feel that art is aristocratic, and an artist is an aristocrat. It is economically and socially impossible to be an artist unless you have a tremendous amount of strength. Great artists have been very poor to begin with, and they have had the guts and the strength to get through that. Before Picasso became a multimillionaire he painted furniture on the wall to pretend that he had some. Many a great artist has died young and not been able to survive. That includes Mozart and Modigliani, and many others. If I had a lot of money, I would produce an anti-foundation. I would get a few friends who know what is good and fine, seek them out, and say, "Here is a lot of money. You just take it because you are a gifted person. Here is a hundred thousand dollars. Take it and get to work. Live on it." If I ever make any money, I will do something like that.

Ten or twenty years ago, many intellectuals in this country entered academia. We used to disdain it, but now academics are interested in poets and creative people, as I think they should be. I feel I offer experience. Students want that. I do not think they want somebody who just studied something all his life and is repeating it. They want somebody who has been out and done something

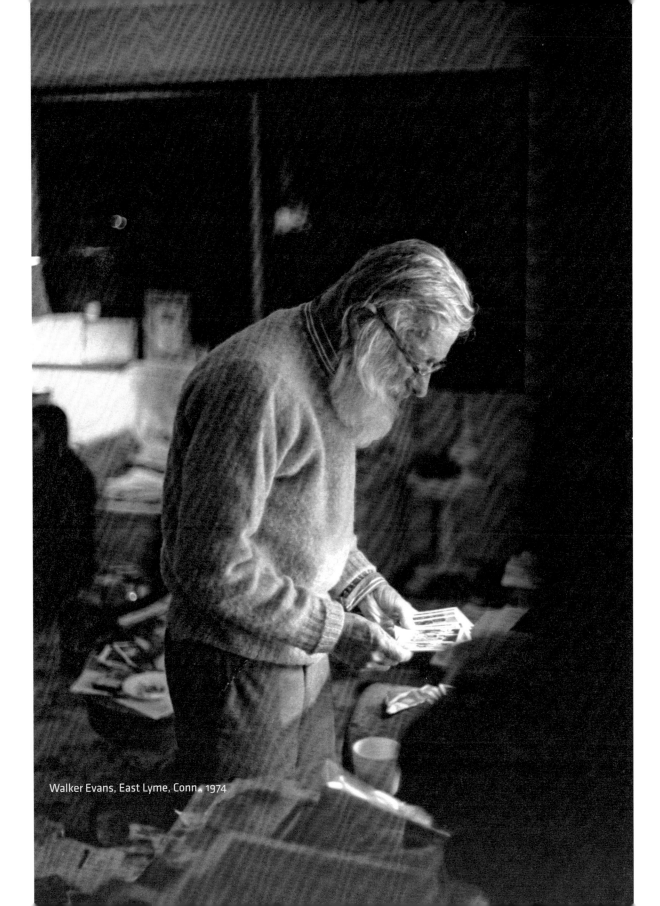
Walker Evans, East Lyme, Conn. 1974

creative, somebody with experience. I would too. I would want an active, producing man to tell me something about his experiences, rather than somebody who just read about something. There is a difference between what is considered dead and what is considered living and active.

I discovered a few protégés whom I tried to help. The people I discovered are now almost old masters, like Lee Friedlander and Bob Frank and Diane Arbus. They are all people that I helped discover. And the younger, more talented people are beyond me. I do not know who they are. Jerry Thompson is very important. He is the youngest protégé I have now. I think he has enormous talent.

Michael Lesy makes me happy because he is delightfully crazy. I think he is touched with genius. When he gets going, he can put on a performance that sends me into a lot of excitement. He is a divine creature. He has a great eye and an instinctive knowledge of photography and its relation to social history. I think he is perfectly wonderful.

To new photographers, I would say get in there and do it up to the hilt—people going to the bathroom—the whole damn business, how they wash their clothes, how they eat. What we are interested in is people and how they really live. I am a realist, and I am interested in the deepest reality of life.

The word "documentary" and the words "social history" put you off. I am interested in realism, the way Flaubert was. I do not think you would call him a social documentarian. What I am interested in is art and being an artist. Photography is important. I am photographer, and I believe it is an art.

Originality and truth and direct simplicity and honesty are what I look for in a photograph. I approach things as a moralist because honesty and truth are moral values. But beauty is something else. It is a word that should be used damned carefully. I do not know if I can tell you what I think beauty is, but it has got to be there.

There is love in everybody, and you have to evoke it. You evoke it by feeling it yourself. Mine is excessive. It is almost more than I can stand emotionally. Lately I notice that if I ride around in an automobile and see children playing, I almost burst into tears. I have never loved children much before, but I am beginning to love them, too. I must be going backwards.

I am a born lover, and I love what I do. I put my life in my work. I love life, and I love people deeply. That is what keeps me alive and keeps me happy.

William Christenberry 1936–

BORN IN TUSCALOOSA, ALABAMA

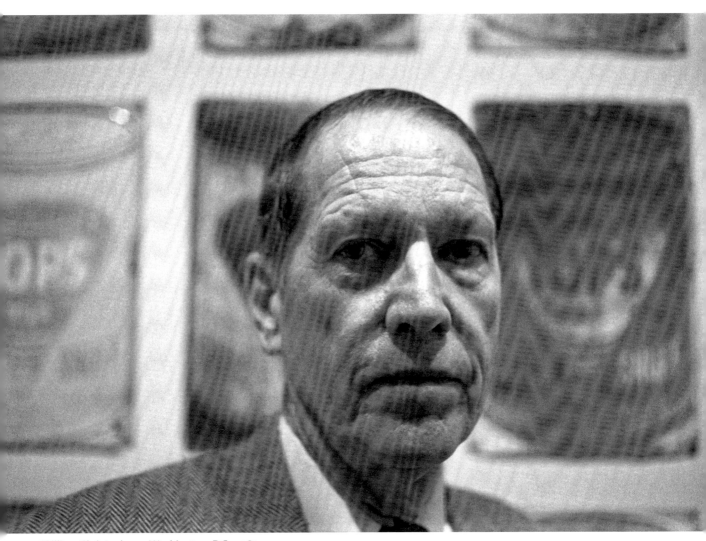

William Christenberry, Washington, D.C., 1982

I certainly do not think I am making a picture of a "decaying South" or anything like that. I find old things more beautiful than the new, and I go back to them every year until sooner or later they are gone. They have blown away, burned, fallen down, or just simply disappeared.

William Christenberry, William Eggleston, and Walker Evans define southern photography just as surely as Cleanth Brooks, Robert Penn Warren, and C. Vann Woodward shape southern literature and history. Both groups are bound by their deep love for the American South and by their admiration for one another's work—an admiration that I share. Walker Evans introduced me to Bill Christenberry's work in 1973, shortly after he and Christenberry had traveled together to Hale County, Alabama. I met Christenberry not long after that trip, and we have been close friends ever since.

Our understanding of place and how it shapes southerners is sharpened by Christenberry's vision for his work. His desire to "possess" dog-trot houses, country stores, and churches in Hale County led him to first photograph and then build miniature sculptures of these buildings inspired by the photographs. Once he completes a sculpture, he places it on a base of Alabama red clay soil. While these miniature buildings evoke pastoral memories of the rural South, Christenberry is not hesitant to address the region's "ugly or dark aspects." His Ku Klux Klan series is "the most difficult to express." It summons the terror of Klan violence in tableaus that reveal "a strange and secret brutality."

Christenberry is nurtured by his Hale County roots and has drawn on them throughout his teaching career at the Corcoran College of Art and Design in Washington, D.C., where he has worked since 1968. Just as William Faulkner created a mythic Yoknapatawpha County to frame his literary world, Christenberry uses his own "little postage stamp of native soil" in Hale County as the inspiration for his photography, painting, and sculpture.

I filmed this interview during the summer of 1982 at Christenberry's studio in Washington, D.C., as part of my film *Painting in the South*. The film accompanied the exhibit Painting in the South, 1564–1980, which was organized by the Virginia Museum of Fine Arts in Richmond, Virginia.

My interest in photography comes out of a background in painting. As a student at the University of Alabama in the mid- to late 1950s, I looked around west-central Alabama—the part of Alabama that I am from—and saw things I wanted to paint. Santa Claus brought me a small Brownie camera in the late 1940s. I loaded it with color film, went out into the Alabama landscape, and photographed rural architecture and graveyards. Back in my studio, those little color snapshots were references for paintings I did that were expressionistic—with gesture and rich surface quality—but also with subject matter.

I first met Bill Eggleston in 1962, when I moved to Memphis. His interest in color photography inspired me. I continued to make those little snapshots for a number of years. They were references for my paintings. I never thought of them as art or as serious photographs until later. When I met Walker Evans in New York, he asked to see my little snapshots. And when I moved to Washington, D.C., in 1968, Walter Hopps was director of the Corcoran Gallery, and he encouraged me to exhibit my snapshots.

Photography for me is a wonderful means of expression, but it is not the only thing that I do as an artist. It is just part of what I do, along with drawing, sculpture, and painting. Photography is part of my total means of expression that crosses over between several mediums.

Southern literature has had a greater influence on my art than the work of other visual artists. I do not deny that visual artists have played a big part in what I do. In more recent years, however, Walker Percy has had a profound influence on what I try to express in my work. I do not know if it is possible to do visually what he does with the written word. But I feel very strongly that it is worth a challenge.

I often wonder if I would be doing the kind of work I do if I still lived in Alabama. I find that being 900 miles away in Washington gives me a perspective on my home—a sense of mystery—that I enjoy. It takes me a while to get adjusted to a landscape other than Alabama. If I go to California, or even Washington, D.C., I do not make photographs. I never quite understood that about myself. I am caught up in one particular place in Alabama. When I come home in the summer, I cannot wait to go out in the country. I am so charged up after being all those months in Washington. But when I look at Bill Eggleston, who lives in Memphis and makes his forays and pictures down there, I respect that. I am not saying that if I lived in Alabama I could not do my art. I just wonder about it.

I left the Deep South because I felt there were no exhibitions and sales opportunities for my art in the South. I miss living in the South a lot. I have such an attachment, such a deep feeling about it. But there is a sense of distance and mystery that you have when you live outside of the Deep South.

My photographs are better known than my sculpture because it is so much easier to send photographs around. You can mail them to Japan, and it will not cost an arm and a leg. A sculpture or even a painting are another matter.

I have done work on what I see as the beautiful aspects of where I am from and what I consider the ugly or dark aspects. I began work in the early sixties dealing with the Ku Klux Klan. That work is done through drawing and sculpture. I have not worked with the Klan through photography, at least not yet. There is a fascination with evil, and my Klan work is an attempt to deal with evil. Whether or not it is successful in visual terms depends on how the viewer responds to it. I choose to reveal what we might call a strange and secret brutality, the Ku Klux Klan. My Klan work is the most difficult to express. Their satin costumes and bright colors allow for an eerie beauty to occur. You have to see the totality of my Klan work before you can understand what I am trying to say. It is an ongoing body of work that comprises over 200 pieces that I have made since 1961.

The Klan is something I have known all my life. I never actually saw a Klansman in Alabama until 1961. In the mid-sixties, they came out of cover, and I saw a lot of them. I fully realize as an artist that it is difficult, if not impossible, to deal with such loaded political subject matter. But I feel it is something I have to do, whether successful or not. I hold the position that an artist should be involved with the times in which he lives and deal with things that are good as well as bad. My Klan work was first shown in the fall of 1981 at the Menil Collection in Houston. From what I know of the response, the public is very much in sup-port of what I am trying to do. There were a few dissenting voices, but by and large they were very supportive of the effort.

In 1971, during Christmastime, I photographed a country church in Alabama. The lens of my little Brownie camera and where I was standing made the image seem quite small. I kept that snapshot with me until 1974. One night I mentioned to a friend at the studio that I had a desire to possess this church, but I knew it was impossible to bring the real church back to Washington. I had an idea that I could build a small version of it. I said, "I do not know if it is worth my while. It will probably be a waste of time, since I have never done anything like this."

My friend looked at me and said, "You will never know until you try."

I went to work using that little photograph of the actual church, and I spent one whole year building it. There would be moments of real frustration or near depression in that year. Other days, there would be moments of excitement, like, "This might make sense after all." When the year was out and the church was completed, I sat it on a field of Alabama red dirt that I brought to Washington. Then it made sense, visual sense.

I have now built eleven structures based on Alabama country stores, churches, and other sites I see. There is considerable interest around the country, and even abroad, in artists who are influenced by architecture. I am not the only one. My pieces have a narrative, literal quality to them. I will not deny that. They come from the real, existing landscape. I also make buildings that deal with childhood memories that I recall.

Sometimes I build things that are inspired by

my dreams. I value what comes in dreams. I just wish they would come more often. I made four "dream buildings" that I saw in a dream in 1979. They vary in color, but their size is the same. I enjoy working this way. First, I build the structure. Then, after it is built, I paint it to look weather-beaten. Painting is at least 50 percent of the task, because it is not easy to make something look old when you have just built it. I feel very good about the direction that my work has taken me in the last ten or twelve years, and there are endless subjects for future building constructions.

It is harder for me to say why I choose the subject matter for my photographs than it is for my sculpture. With the sculpture, the photograph has already been made, and I study it. "Study" is not the right word. I have it around. I live with it for months, sometimes years, until I feel it would make a good sculpture. It is more than a response to something in the landscape, than just going out to make a picture of a certain object.

I am fascinated by rural graveyards where people make wonderful objects out of necessity. If they cannot afford to buy elaborate flower decorations, they use egg cartons. They stitch them together, cut them with shears, and make a Styrofoam egg carton look like a rose bush, or make a Styrofoam cross—stitched together. What people make out of necessity is folk art, and I am intrigued by that. It catches your eye.

I cannot say why a certain object appeals to me more than another. It is just there, and I do not think of it as, "Hey, that would make a good color photograph." I never really made anything but color photographs. When I started making snap-shots, they were always in color.

I am in love with where I am from—Alabama, the Deep South—and up to this point, there has not been a lack of subjects when I am out in the country. There is always something to look at. And if it is not something specific like a building or a grave, there is the landscape, what I call the pure landscape, just the sky and the earth. That intrigues me to no end.

As Alabama changes, I see fewer and fewer of the objects that attracted me earlier. They are gone. Oftentimes it has to do with something that nature, man, or a combination of those two have altered, have shaped, have reworked, have left in a different way than what it was before.

I do not dwell on the Civil War or the past. I am attracted to things that are decaying, that are rapidly vanishing from the landscape in the South. I cannot say I am obsessively attracted to them. I find beauty in things that are old and changing, like we all are changing. I do not find them ugly. I certainly do not think I am making a picture of a "decaying South" or anything like that. I find old things more beautiful than the new, and I go back to them every year until sooner or later they are gone. They have blown away, burned, fallen down, or just simply disappeared.

William Eggleston 1939–

BORN IN MEMPHIS, TENNESSEE

I think a series of photographs is like a novel. There are 320 images in this series. If a person went slowly through that body of work, it would be roughly like reading a novel. Now and then, you would remember. Information would add up. At the end, you would remember a lot of things. The order is not significant. The order is random. I do not really care about the value of one picture over another.

I first met Bill Eggleston during the summer of 1975 when two Memphis photographers, Mary Hohenberg and Perry Walker, took me to his home to see his color photography. It was late at night, and I was surprised to see his home fully lit and family and friends moving through the home. Eggleston greeted me warmly and took me into his living room where large piles of dye transfer color prints were stacked on top of his piano. I looked through the images and was stunned by their beauty and freshness. It was like an epiphany. Thus began a friendship that I treasure.

Eggleston is not a talker. When asked about his work, he smiles with a knowing look and shakes his head either affirmatively or negatively. I quickly learned that he is a master of both the aesthetics and the technology of still photographs and moving images. To relax, he plays Buxtehude on his piano and drifts away in thought.

In 1976, I invited Eggleston to present his photography and film to my students at Yale. He set up a display of his black-and-white photographs on the walls of the master's living room at Calhoun College, where he first showed color slides, then films of nightlife that he shot between two and four o'clock in the morning in Memphis and New Orleans. He was accompanied by the actress Viva and her daughter Alex. Eggleston had recently shaken the photography world with his one-person color photography show at the Museum of Modern Art and its catalog *William*

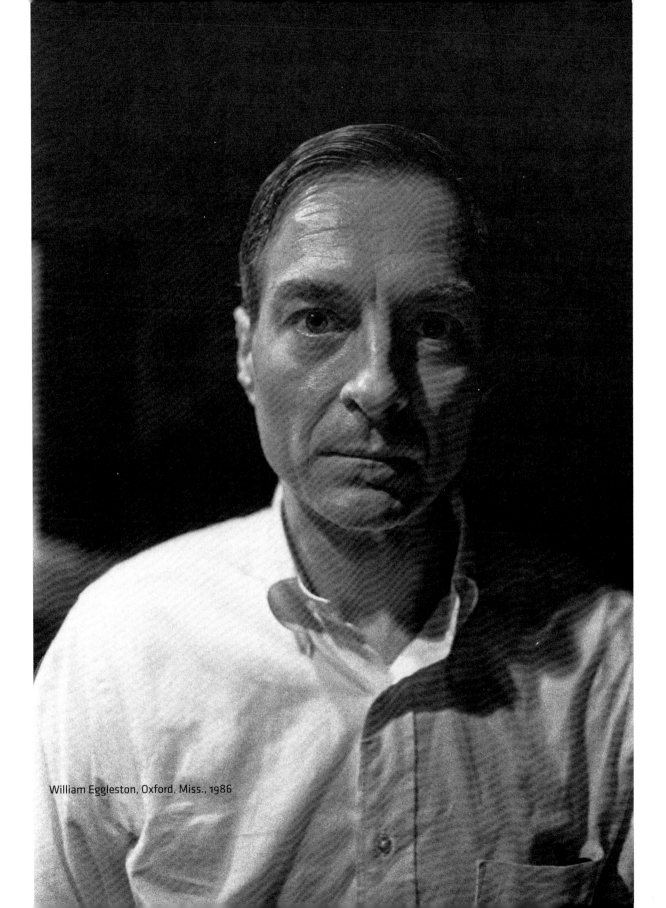

William Eggleston, Oxford, Miss., 1986

Eggleston's Guide (1976). He had just made a series of photographs near Plains, Georgia, to capture the worlds of Jimmy Carter on the eve of the 1976 presidential election.

Eggleston explains that he shoots his films at night in Memphis clubs where he and a small crew move quickly to capture the life they find there. "One person would have one of these hunting spotlights to shine on people's eyes, nose, cheek, breasts, or forehead, for focusing really quickly. We get very detailed images of people as they are in a bar or nightclub. . . . These people come out frequently. They spend a lot of their time out. At night, the thing they like to do is go out to these places and get out of their minds. These people are in various states, and they are that way a lot of the time. This is during the popularity of Quaalude and alcohol."

My students were clearly disturbed by Eggleston's photographs and films. They capture worlds that are far different from the scenes of rural southern life photographed by Walker Evans and William Christenberry. Eggleston explains that some of the people in his films "are my friends. Some of them are strangers. The man who sang 'Hoochie Coochie Man' is in jail for bank robbery right now. Four people on those tapes are dead now. One was murdered. Three committed suicide. They were kind of headed that way, I guess."

While living in Oxford from 1979 to 1997, I saw Eggleston regularly. He often came to Oxford for the weekend, and we spent time photographing together in the area. I loved watching him set up shots and move gracefully with his camera in and out of positions to find the best angle.

Eggleston's photography and film capture the edgy underbelly of the contemporary American South. He pushes us to see color, landscape, and people in new, exciting ways. His photographs are closely associated with Memphis musicians and are featured on album covers of performers Alex Chilton, Jim Dickinson, and Sid Selvidge. Beginning with images taken around his home in Sumner, Mississippi, he tracks the changing South, and his eye has defined modern color photography.

This conversation is drawn from Eggleston's presentation in the master's living room in Calhoun College at Yale University in 1976.

I grew up in a part of Mississippi called the Delta region, the northwestern part. Most of my early photographs are taken in Mississippi. They range from Memphis to New Orleans. I started taking pictures in 1958. A friend of mine in college got me interested. It turned out to be real interesting. I liked it better than college.

These photographs are one discrete work. I call it an essay. I think a series of photographs is like a novel. There are 320 images in this series. If a person went slowly through that body of work, it would be roughly like reading a novel. Now and then, you would remember. Information would add up. At the end, you would remember a lot of things. The order is not significant. The order is random. I do not really care about the value of one picture over another.

Some of my work has to do with people, and some of it does not. Some of it deals with the way a sign is held up with wires, or the way unplanned architecture comes about, like a grocery store that nobody really designed. I could have shown a project that had to do almost entirely with people. These particular images just happen

to be about things like roadside architecture. They do not have much to do with people.

The catalog for my exhibit at the Museum of Modern Art used around fifty pictures that were taken from a series of 375 pictures. The museum exhibit and catalog is a good cross section of that essay. In other words, it would have been impossible to exhibit and publish the whole thing. The catalog is called *William Eggleston's Guide*. It is a kind of guide, but I do not know how it could be used.

When I go out for a shoot, there is no plan at all. I may shoot one image one day and twenty another day. Then I will be depressed for a couple of weeks and not do anything. In a couple of years' time, you find that you have put a whole body of work together, like these we just saw. There are a lot more, but this is pretty boiled down. These photographs are extracted from five or ten thousand, I guess. The ten thousand photographs you did not see are rejects. They are not as good as these. They are redundant, and some of them are stupid.

I know Martin Dain's book on Faulkner's country. Some of these photographs are taken near Oxford, Mississippi. This might be a guide to Faulkner's stuff, too. He is writing about what it is like in that region.

I just came back from driving around Plains, Georgia. I have not figured out yet what we were doing there. We were in Plains—where Carter is from—to check up on him. We were trying to be objective during picture taking—just as if it were anywhere.

Two projectors are best to show my photographs. I have tried three or four sometimes.

Two works out better. If the audience is patient enough, one is fine. I guess that would be the best way to project if you had a big screen, a much larger image, a brighter light source, and the time to go through them.

I used two projectors to show my slides today. I figured it was the easiest way to show this many images in a short period of time so that everybody would not get saturated. If we had shown all of these on one screen, it would have taken a long, long time. It is really hard to see so many pictures at once. It is hard to see this many even on two screens. You are lucky to remember just a few of them. I would rather look at the prints. I prefer to see a photograph rather than project it.

My videotapes relate to my black-and-white pictures. I did a dovetail project in pictures and tape. The idea is to get a close look at something you really do not often see up close. For instance, you are in a loud bar. It is dark, and there are people. If you wanted to go up to a certain person and carefully scrutinize them with a magnifying glass that is something you could not do. These pictures are taken without any warning by going up to people with a large-view camera, a flash, and an umbrella. A couple of people would assist me in crowded places. They would help decide on some person across the room, and everything would be set in motion. One person would have one of these hunting spotlights to shine on people's eyes, nose, cheek, breasts, or forehead, for focusing really quickly. We get very detailed images of people as they are in a bar or nightclub. These are mostly taken between two and four o'clock in the morning. The films are taken from New Orleans to Memphis. These people come out

frequently. They spend a lot of their time out. At night, the thing they like to do is go out to these places and get out of their minds. These people are in various states, and they are that way a lot of the time. This is during the popularity of Quaalude and alcohol.

I never got in any fights. It was always done so quickly. It was so very dark that you cannot tell that immediately behind and in front and to the sides of these people is a lot of crowd, high noise level, and movement. People are dancing and just going crazy. This guy here had to be held up so as not to fall down.

Videotapes have sound, of course, and the video camera can move all the time. You can show different sides of a person, whereas you see only one side in a photograph. But the tapes are limited in sharpness and resolution. These photographs are less limited because of the large negative. The information that the tapes lack can be found in these photographs. And a lot of information that these photographs lack can be found in the tapes because you hear things that are going on and see people change their expressions. The photographs are also shot close, at very close range.

I am interested in taking a large number of images and working in color. It is very expensive. I like the way that unmanipulated prints look. They look better to me than carefully produced prints—color prints. Bill Christenberry's work has had a big influence on my work. Christenberry works in color. He is one of the few that does. And Walker Evans, of course, is an influence. You cannot forget images like his. It is impossible not to be influenced.

With color slides, you have to go to a dye transfer print to get a good print, and that is not easy. I shoot slides and consider them as an intermediate step. I like prints. I do not like slides really. Some of these slides are printed now. Maybe 30 percent of what we just saw is in print form. I much prefer the prints to slides. I have a lab do the dye transfers. It takes a lot of time. Otherwise, it would take all my time just to print. I would have no free time to take pictures. When I am not working with photography, I play the piano. I take it easy. And I worry.

My work is about the New South. There are a lot of new buildings down there and new roads. There are not many new people down there. A lot of them have left. That is about the way it is as far as I can see today. There are a few big cities down there that have industrial complexes around them, but there is not really much out there.

Ninety percent of my photographs are taken with a 35 mm lens on a 35 mm camera. I do not use a camera with anything wider than a 35 mm lens. I will use a 35 mm lens for a while—just one lens—say for a month or two. And then I may use a 50 mm lens for a month or two. I do not change lenses. I just have one camera and use whatever lens is on it. I try to tailor the pictures to the lens I am working with.

My film is all raw and unedited. The video equipment I used had mikes that ranged from built-in microphones to a condenser mike with the soundtrack on the recording. I shot the camera from about six inches to two feet from my subject most of the time. None of my cameras had a zoom. I used close-up lenses shot real close to faces and always moving. They are all taken with

William Eggleston, Waterford, Miss., 1984

one lens—one fixed 25 mm lens. Television cameras do not make any noise. Most of the time so much was going on in other areas of the room that the camera was hardly noticeable. Other things were more important than the presence of the camera.

I think the people I filmed kind of got off on it. They respected the fact that the camera was there, and they were not mad at the camera. This series was mostly men. A lot of my other tapes are of women. Some of these people are my friends. Some of them are strangers. The man who sang "Hoochie Coochie Man" is in jail for bank robbery right now. Four people on those tapes are dead now. One was murdered. Three committed suicide. They were kind of headed that way, I guess.

The transvestite lives in New Orleans and makes Mardi Gras masks. He makes those during the year and sells them for Mardi Gras. He acts just like he did on those tapes. That was not an unusual night for him. The man who had an argument with his wife, and she was screaming, they both committed suicide about a year after those tapes were made. He was a veterinarian. He froze somebody's dog and got his license revoked. One person in the film broke out my light and left. He was on his way out the door. There is an open door there to the right. I think he was headed that way. The girls who were there, two or three of them were back-up singers. Memphis has a lot of recording studios, and some of those girls work in studios. They are on a lot of records and tapes that come out of Memphis.

This video is nothing like a film. It started out as a project to complement still pictures, and I still look at it that way. There is no story or sequence or plot intended. It is not anything like a film. What I do is nothing like film. We only saw a portion of this video—about two hours. It would not matter where somebody entered. Somebody could walk in halfway through and only see the last part. There is no order.

When I film, I have one assistant who is dependable at being available. Two other people aid technically and are also kind of crazy. They are a distraction themselves, so that the camera is not noticed as much. But my assistant makes sure the power supply, the portable power supply's battery is charged. I bought my equipment. I do not do anything else but this. I have no luxuries to speak of, just these necessities.

My black-and-white photographs are just to supply information that is not on the videotapes. They are real sharp and clear, and the tapes are not. I never show those black-and-white photographs by themselves. Just with the tapes. This thing is finished. I am going to assemble the tapes. I want to get them onto two-inch and leave them there, but not edit them like a film. I will correct the synchronization error so that the image will be stable, and the highlights and the blacks will be as good as I can get them. Right now the machine is running off speed. That is usually caused by the wrong amount of tension on the supply reel. Some of what we saw is caused by the head and the capstan not running synchronously.

I love all these people. There is a lot of work to be done in the South, and I have just scratched the surface. I still have unfinished business down there.

Painters

I would be working picking cotton, hoeing cotton, or whatever we would be doing, and I would be making pictures up. Sometimes I would stop and draw in the sand. And at night—when I would go home—I would draw some of those things I had seen in the clouds. Even now, I can look up and just make up whole illustrations across the sky. That had to do with that raw, austere thing to survive.
—Benny Andrews

These southern painters grew up in a region that lacked museums and galleries where they could find inspiration for their own work. They turned instead to writers such as William Faulkner, whose stream-of-consciousness style transformed the southern story into a modern, abstract form. As a successful literary artist, Faulkner was an important model for aspiring painters. Each of these painters wrestles with the southern story and how to tell it using paint and canvas. Sam Gilliam explains that "southern artists use visual memory, visual histories, and visual images. In literature—and particularly in the literature of Faulkner—works appear to rise as a whole, as if they exist wholly unto themselves."

Ed McGowin draws a parallel "between southern writers like Faulkner and southern artists like myself. We both try to work with visual and verbal traditions. I grew up in a setting where storytelling was highly prized, highly developed, and highly cultivated. I try to do narrative work with a visual metaphor, whereas Faulkner did this same kind of work in literature."

McGowin believes that the challenge for both the writer and the painter in the South is how to move from a specific story to the universal, how to make art out of a story. The literary and visual problems are very similar. "Faulkner was not simply telling stories in southern dialect. He was telling stories in southern dialect that were great literature. The visual artist faces the same prob-

lem. I can use southern stories as a point of departure until I drop dead. But if I do not do it in a way that formally relates to the art context, it will just be an esoteric gesture. . . . What I need to do is make the connection between my own particular, subjective interest in the southern story and the art world as a greater whole."

Carroll Cloar argues that there is an artistic evolution in the South through which writers emerge first and are then followed by painters. Both groups focus on the region's stories. He explains, "You have writers before you have painters. It seems to be a natural development. I was more influenced and inspired by southern writers than by other painters. From the southern writers, I learned that I knew similar people and similar places. My work is of a literary nature. I like to tell stories and show character instead of merely decorative things. There is an important relationship between southern writers and southern painters."

George Wardlaw studied painting at the University of Mississippi and often saw William Faulkner in a local restaurant. Wardlaw identified with Faulkner and viewed the writer as an inspiration for his own work as a painter. "It was one of the happiest days of my life when William Faulkner won the Nobel Prize for literature. He was already a hero for me, and this made him a bigger hero. He was a model for me as another artist working in a different medium. It was in that sense that writers influenced me, not so much by what they had to say, but by their presence."

Rebecca Davenport remembers when she first read Flannery O'Connor. She was inspired to paint worlds like those O'Connor described in her fiction. "I started reading her short stories, and I was just 'Oh, my god! This stuff is wonderful. This is what I want to say visually.'"

Davenport sees William Christenberry as a kindred spirit whose photographs are "evocative of the stillness in the South. . . . An event has already taken place, and now it is gone. It is over. It is abandoned. I find a great poetic quality in that and am drawn to it."

Just as Christenberry's photographs capture decaying buildings that will soon disappear, the painter preserves objects and people in a similar way, Davenport believes. "Painters are like preservers because they make you look at things. The purpose of art for me is to focus on something. I want to alter a person's perceptions, so that they never look at that person or object the same way again."

Maud Gatewood notes the transforming influence of artists who taught aspiring young southern painters at Black Mountain College in Black Mountain, North Carolina. She believes that "painters like Josef Albers and Willem de Kooning influenced southern artists to paint in a more abstract vein. Until that time, southern painting basically dealt with what artists found around them—the people, the land, the various features of the region."

Abstract painter Sam Gilliam suggests that "abstract content has a valid place in talking about the South and southern art. I have never felt separate from southern landscape, southern attitude, and southern humor. They are the basis for my art and my creative work."

Each of these artists captures the southern story with paint and canvas. As painters, they eloquently explain how they transform their stories into visual images.

These interviews of southern painters were recorded during the filming of *Painting in the South*. The interviews in this section are briefer because they were collected as part of that film project. Our conversations led to lifelong friendships with many of the painters. The film accompanied the exhibit Painting in the South, 1564–1980, which was organized by the Virginia Museum of Fine Arts in Richmond, Virginia. A copy of the film is included on the DVD with this book.

Sam Gilliam 1933–

BORN IN TUPELO, MISSISSIPPI

When I came back to visit Louisville, I knew I was home when I first saw the river. There may have been twenty-five or thirty miles to go still, but the excitement was to drive along and watch it. It would give me that feeling of being wed to land and spirit, all of which is caught up with one's memory about a place.

Entering Sam Gilliam's studio is like walking through a field of paint. Large painted canvases are laid out one after the other on the floor, and the floor itself is covered with splashed paint. Canvases hang from the walls, leaving only the windows uncovered to allow light into the large space. Gilliam walks between and beside canvases that frame his studio in a powerful way.

Gilliam's abstract style has deep roots in the American South. "These paintings are closely related to a feeling of having been born in a certain region. A vast array of southern artists are abstract. The abstract form or abstract collage is just as southern as the exact images that we know."

Gilliam notes that he and many other southern artists use abstract art to describe their region. Like the relationship of blues to jazz, the painter transforms literal images into an abstract form: "Artists like Kenneth Nolan and Jasper Johns are both southern in origin, but they are not connected to the South in terms of surface or image, as most persons you would deem southern are. In much the same way, blues connects itself to jazz. Blues songs relate to the experiences that you find within the South. When you deal with the South, you deal with images of sights, of sounds, and of literature. I think of these images in terms of abstractions, and of black literature and its roots without the particulars of single issues and images."

Working in Washington, D.C., Gilliam is an old

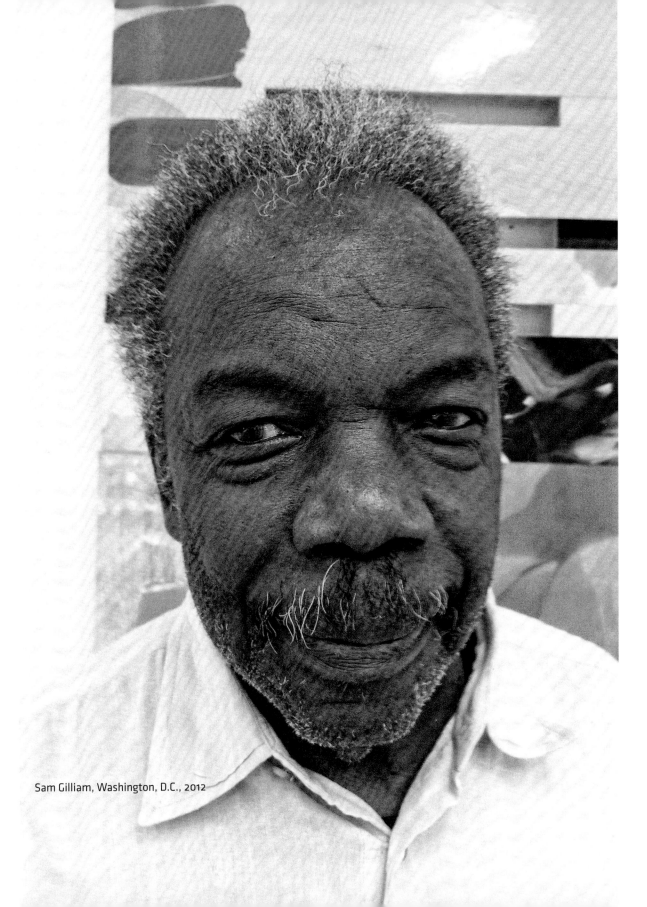

Sam Gilliam, Washington, D.C., 2012

friend of Bill Christenberry. He is both drawn to and disturbed by Christenberry's sculptures of Ku Klux Klan figures. "Bill Christenberry's Klan material is of interest to me. It is just there, just like the Coca-Cola signs. If anything, I think it is too beautiful. Its presence is the strongest, most stimulating part of his work for me."

Gilliam embraces the southern story with the eye of an abstract artist, and he anchors his paintings in worlds he knew as a child in Louisville, Kentucky. Those worlds continue to speak through his art, as surely as the Ohio River flows through Louisville.

This conversation was filmed at Gilliam's studio in Washington, D.C., in 1982, and portions are included in *Painting in the South.*

I like rivers in my work. They are moving water. My first memory of a river was of one near our home. I have had a lot of paintings that dealt with rivers. Particularly in Kentucky, rivers constitute the most amazing, dynamic forces. They always flooded, and one was always conscious of them. They elicited fear and amazement. I remember one time when there was a flood. In the morning, the water was at the end of the street. By the afternoon, it was suddenly in the front yard, and everybody had to move. When it was flooding, you spent all your time going to watch the waters. If you grew up in Kentucky, and you did not swim very well, you stayed away from the river. There are enough drowning deaths in rivers to make you amply afraid of them.

When I came back to visit Louisville, I knew I was home when I first saw the river. There may have been twenty-five or thirty miles to go still,

but the excitement was to drive along and watch it. It would give me that feeling of being wed to land and spirit, all of which is caught up with one's memory about a place. The sun used to play on the river, and that light became an element of substance. When I think of something very large in scale and very moving, I often see this river, particularly in paintings. It is this same river that I refer to in a number of my titles.

I remember playing a lot in the South. I remember the things in nature I have not seen for some forty-two years. I retain a sense of the spaces, the light, and the trees. In remembering Kentucky, I have a sense of grass, of friends when they were young people, and of beautiful nights. That part of my life was filled with optimism, lots of dreaming, and lots of solidity.

Family was very important to me. I was number seven in a family of eight, which meant that I learned a lot because I was responsible for a lot. I was encouraged by my mother to be an artist. I grew up with a great deal of fondness for her.

For me, art was a way of rebelling, of trying to choose things in which nobody else was interested. Other people simply wanted to put them down. This rebelling always left one with a good feeling about oneself, because it meant that one was an individual.

I grew up drawing and have drawn all my life. Drawing gave me a feeling of immediate emotional satisfaction. I went through my other chores in a hurry to have time to make drawings. They satisfied me so much. From the time I was a little kid on, I made art. I conceived of myself through art. I majored in art in college, and after college I learned to think in terms of making art. I

always feel very relaxed making art. I did not have to pretend. It is an easy thing for me. I feel I have done it all my life.

Art was a revolt, an ongoing one. I did not make much art in Kentucky. I really became an artist in Washington. In terms of process and style, I became an abstract artist when I was thirty.

Southern artists use visual memory, visual histories, and visual images. In literature—and particularly in the literature of Faulkner—works appear to rise as a whole, as if they exist wholly unto themselves. Jazz, an offshoot of the blues, is much like a new art form. Many aspects of the South derive their own chosen distinct forms.

These paintings are closely related to my feeling of having been born in a certain region. A vast array of southern artists are abstract. The abstract form or abstract collage is just as southern as the literal images that we know.

The magical aspects of dialogue are very important. They are an aspect of surrealism, and surrealism is like a conscious dream. Abstract art shares in this mode, in the sense that lots of things come together. I am fond of stories, but I am not an imagist. My work is not that conscious. It is not directed toward specifics. Sometimes my work is funny. Sometimes it is very serious. Sometimes it is romantic. Sometimes it is all the things that make up the whole of life.

The diversity in the work of southern artists reflects our working along a spectrum with similar content. When artists leave the South, their southernness takes on guises. They synthesize it with art. I think we are all better for it. We are better that there is not a single identity that one can point to, as artists might have done in the thirties, or in the forties and fifties. Those identifications were a condition of a time when we were more directly related to the land, or more directly conscious of being away from the land.

Most of the dreams I paint are about art. I get colors and compositions together that seem to work in a dream, and I make the piece. It is not a work that is arrived at by conscious consideration. I wish I could dream numbers, and go out and hit them. But I am not that lucky.

Most of my dreams are waking dreams. You work them out spontaneously. You deal with the same unconscious element wide awake that you would if you were sleeping. You let things happen in the studio, trust them, and work without a great deal of thought. It is like working in a conscious dream. That impromptu is also part of blues and gospel songs, where you improvise.

This collage is very simple. The colors are cut in a minor way. The linear elements are cut out, painted, given definition, and then reinserted within the painting. It starts as a structure with linear definition and ends very much the same way. It is part of a very large series of works that I refer to as Red and Black. The drawings relate both to the shape of the canvas and its relationship to the space that surrounds the painting.

One starts with a notion and works through a series of colors that define certain depictions. Very light colors tend not to defy or resist the wall at all. Working with very light colors is like working with the actual space itself. Very dark colors are absolute. They work against the wall and are in contrast to a situational possibility.

One deals with specific images, and those are the visual, recognizable images that one always

sees. We never think of blues as a part of jazz, or of Jackson Pollock having been a student of Thomas Hart Benton. Pollock was a regionalist who later became an abstractionist. A lot of abstract painting came from realism. It represents the other side of realism.

I see myself and my work as being an extended consciousness of visual narration. These things tend to work as a whole, which is what an abstract is. It is not a part of something else that is real. It is part of itself. It does its own thing, for its own reasons.

New York artists revolutionized things. Artists such as Pollock, Newman, Rothko, and Frank Stella presented contemporary art to New York. It was in work like theirs that I came to be interested. I like jazz musicians who revolutionized music and brought about change. I wanted to be part of an avant-garde. So I chose to work, to imitate, to believe, to follow those kinds of people.

One of the things that interested me first was the scale of the work. The relationship of the work to architecture also attracted me, as did its relationship to color and to open form, without any real subject. Most particularly, the fact that the content of the work was the work itself was appealing to me.

I do not see myself as a particularly Afro-American artist, in the sense that it is the subject of my art. I am an Afro-American artist. I am who I am in that regard. But I feel that specific questions raised about race do not relate to what I do.

Bill Christenberry's Klan material is of interest to me. It is just there, just like the Coca-Cola signs. If anything, I think it is too beautiful. Its presence

is the strongest, most stimulating part of his work for me.

This pottery-shaped canvas includes metal elements. The element serves both as a frame and to give more information about the piece. It helps to extend the piece more into the wall, as well as to close off and give more information about the painting. The interplay between the flat space and the protruding space is rather interesting. It is part painting and part sculpture. But it is controlled by the color that is on the surface of the painting and the surface of the metal. The abstract content—the sense of void and nonform—have their parallels in Faulkner, where they are similar to his long historical narratives. My visual solutions are analogous to his verbal and literary ones.

Artists like Kenneth Nolan and Jasper Johns are both southern in origin, but they are not connected to the South in terms of surface or image, as most persons you would deem southern are. In much the same way, jazz connects itself to blues. Blues songs relate to experiences that you find within the South. When you deal with the South, you deal with images of sights, of sounds, and of literature. I think of these images in terms of abstraction, just as black literature has its roots without the particulars of single issues and images.

The traditional sense of southernness as an artist means that one is an imagist, which I am not. I am an abstractionist, and I deal in an abstraction that is devoid of origins. It provides the ability to work with color, open experience, and open forms for spaces that are no different from spaces anywhere else. I want to tell things as if

they were a part of my life. My art actually began when I was thirty years old, when I started to paint on my own, and in that sense it is contemporary.

Somewhere along the line, I became aware of dealing with one's life as if it is part of a whole. The writing of Faulkner tends to move almost as a slice right from life, with all the same complexities that are a part of it. Jazz is an extension of the blues. It contains relics of the South in its art. This is also true in the colors of Kenneth Nolan, Jasper Johns, and Robert Rauschenberg. I believe abstract content has a valid place in talking about the South and southern art. I have never felt separate from southern landscape, southern attitude, and southern humor. They are the basis for my art and my creative work.

Ed McGowin 1938–

BORN IN HATTIESBURG, MISSISSIPPI

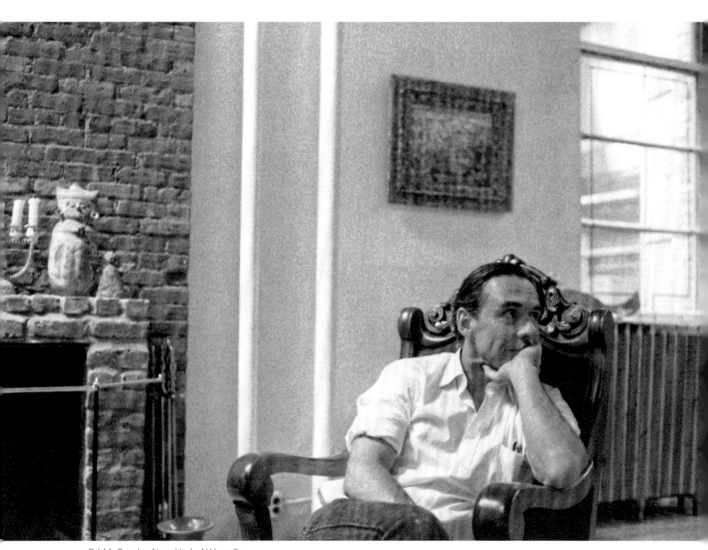

Ed McGowin, New York, N.Y., 1982

I see a link between southern writers like Faulkner and southern artists like myself. We both try to work with visual and verbal traditions. I grew up in a setting where storytelling was highly prized, highly developed, and highly cultivated. I try to do narrative work with a visual metaphor, whereas Faulkner did this same kind of work in literature.

Ed McGowin lives in New York City and is acutely aware of how his southern roots define him. His wife, Claudia DeMonte, is a successful artist who grew up in New York City, and McGowin reflects on how language defines their very different backgrounds. "In New York, everything is one-liners. My wife is a New Yorker. We have culture clashes daily that are indescribable. My wife can speak pages in a three-sentence burst in very rapid fire. I can try to give you directions to get around the corner, and it will take half an hour. It is very confusing sometimes."

McGowin chooses to live in New York "because it is the center of the art world. It is the focus of all the developments that are taking place in the art world today." But he is consumed by stories of his youth, and he blends the southern narrative voice into his art. He is drawn to subjects "with issues related to narrative in my art. That is fundamental to me."

McGowin is still haunted by a traumatic memory he experienced as a young child. At a family reunion, when his grandmother was dying, an eccentric uncle summoned everyone to witness his latest feat. The family gathered in the yard and discovered that the uncle had buried baby chicks along the driveway, with their heads sticking up going, "Peep. Peep. Peep." These little birds.

When the whole family got out there and were marveling at what Sam had done, Sam pulled out a lawnmower, ran over all those chicken heads. And after he dropped the lawnmower, he just kept going. The uncles were chasing him through the field trying to catch him.

Cutting all those chickens' heads off was Sam's way of making a statement to the family that was so pointed and so angry, and really frightening.

We did not see Sam for another fifteen or twenty years. But the image of the chickens was so graphic that it was very easy for me to make art about it. I think that southern surreal lends itself to the visual images that we make today.

Southern stories define how McGowin approaches his art, and his artistic vision remains rooted in the American South. Images like the chicken are motifs that haunt his paintings.

This conversation was filmed at McGowin's home in New York City in 1982.

The southern verbal tradition as it relates to visual arts is heavily loaded with a surreal, ironic, macabre view of the world. This is particularly evident in southern stories—à la Faulkner—that you hear when you sit around and talk. You tell tales that have a magnificent climax. In other cultures, you might speak in one-liners. But in the South, stories go on and on and on, at great length and very slowly. Within the visual context, that surreal quality—that Dada quality—relates to southern storytelling. You see that in Rauschenberg's work and in the Expressionists.

We are beginning to see the potential for telling stories in the most elaborate ways surface in the visual arts. Traditional storytelling in visual art—from hieroglyphics all the way up—is still very primitive. I think that in the future the southern verbal tradition will greatly expand in visual arts.

The thing that interests me about Faulkner is how he took the southern vernacular and translated it into literature. He was on the cutting edge of the development of literature. It came di-

rectly out of Joyce's idea of what literature had to be. Faulkner was able to take the southern story and the southern language and translate them into extremely important formal developments. The visual artist is faced with that same problem today. A Faulkner scholar named Carvel Collins told me that *As I Lay Dying* was an exercise for Faulkner. It was a Greek myth that Faulkner translated directly into southern jargon. And it worked. From there, he elaborated on stories of his own, much more personal stories.

I see a link between southern writers like Faulkner and southern artists like myself. We both try to work with visual and verbal traditions. I grew up in a setting where storytelling was highly prized, highly developed, and highly cultivated. I try to do narrative work with a visual metaphor, whereas Faulkner did this same kind of work in literature. The problems are very much the same. Faulkner was not simply telling stories in southern dialect. He was telling stories in southern dialect that were great literature. The visual artist faces the same problem. I can use southern stories as a point of departure until I drop dead. But if I do not do it in a way that formally relates to the art context, it will just be an esoteric gesture. I will be playing with myself. What I need to do is make the connection between my own particular, subjective interest in the southern story and the art world as a greater whole. That is possible today. But I do not think it was possible fifteen years ago. Putting the southern verbal tradition into the visual art context today is an important development in art.

The relationship between black and white artists, between black and white culture in the South

is totally intertwined. I was deeply involved in the black culture. Black rhythm and blues music—the music of my generation—black spirituals, and the black woman who raised me until I was old enough to go to school all had a profound effect on me. I have strong memories and strong relationships to things that come essentially and fundamentally from black culture. I imagine that some similar feeling is true for black artists who grew up in the South in what was then a totally white power structure. Living within that context must have made a profound, indelible imprint on the black artist.

I had a dream recently. I had injured myself, and I woke up in the middle of the night in pain. And in this dream, I was feeling much better. These huge black hands were caressing me from the top of my head to my toes. The hands were the size of my entire body. In the dream these very soft hands were warmly holding me completely. When I thought about it later, I realized that was the situation for much of my infancy. The person who took care of me was black. I was being held. I was seeing a vision of the most soothing and affectionate caress that I could anticipate as a baby, the one from the nurse who would pick me up and take care of me. The connection between the black and white cultures in the South is more than I could ever try to elaborate on.

The way I see myself as an artist deals with the southern narrative, but I live in New York City. It makes things a bit schizophrenic. It is funny to be here talking about worlds that I have been removed from for twenty years. I have been away from the South for twenty years. I am in New York because it is the center of all the developments that are taking place in the art world today. That was my motivation for moving here. But my sensibilities are still very southern.

In New York, everything is one-liners. My wife is a New Yorker. We have culture clashes daily that are indescribable. My wife can speak pages in a three-sentence burst in very rapid fire. I can try to give you directions to get around the corner, and it will take half an hour. It is very confusing sometimes.

That southern tradition and the importance of the narrative in my own work are important in New York. If I bring these elements to the surface in a way that is intelligible to other artists in New York, then I get instant gratification for it. If I am living in Yazoo City, Mississippi, it is more difficult to get that instant gratification. It is a longer reach. That is why I find New York exciting and why I tolerate it. I do not look to the South for inspiration. I do not have a vision of the South as a place to investigate and interpret. In fact, I do not even think about it that much. It is just simply there.

There is this character, Bobby D. I had to change his name so my family would not be too upset with me. He was the source of a lot of speculation when I was a child. This uncle of mine had run away from home as a young man. He had been injured as a child, and in his anger over the injury, he ran away from home and became a juvenile delinquent. He became a tragic alcoholic and a derelict who lived on the streets in Detroit. He worked in factories. My family down in south Alabama were so genteel, and he was not at all.

When he would come home—which was very rarely—he would have nothing to do with the

family. My family, in particular my grandfather, used to send detectives to find him and bring him back, so that we could rehabilitate him. He disliked my family. He hated them, really. He was always exotic to me because he had this really strange accent. I thought it was strange. He was living in Detroit, so his accent had been changed a bit by that. But he was also deaf. He could not hear himself, so he had a peculiar speech pattern that made him really interesting to me.

This exotic uncle would come back to Chapman, Alabama, in south Alabama, when I was a little boy. It was exciting to see him and hear him talk. The things that he said and the things that he did were often scandalous to my grandmother and the rest of my family. But to me they were exciting and very memorable. He played with the children a lot more than he played with the adults. He did not have much to do with the adults, but he was a favorite of the children. He would tell us outrageous stories. He always had funny stories to tell, but he was really mad. I suspect he was very psychotic. Some of the things he did were just awful.

My grandmother was dying, and they had a big family reunion. This mad uncle showed up drunk, and he said, "I want y'all to come out in the back yard."

My grandmother said, "No, Sam. Sit down and have your meal."

He said, "No. I want y'all to come out."

The uncles were saying, "Sam, shut up and sit down."

He would not. So finally he talked all the adults into going into the backyard. We went out through the back of the house. I was only about three feet tall, just a little bitty kid. I could not see over the hedgerow that divided the yard from the driveway that went back to the lot where they kept the cows and chickens. But as I went around the hedgerow—sort of between the adults' legs—I saw this line of baby chickens that Sam had buried in the driveway about eighteen inches apart in a line that followed back to the lot. All these little chickens were in the center of the driveway with their heads sticking up going, "Peep. Peep. Peep." These little birds.

When the whole family got out there and were marveling at what Sam had done, Sam pulled out a lawnmower, ran over all those chicken heads. And after he dropped the lawnmower, he just kept going. The uncles were chasing him through the field trying to catch him.

Cutting all those chickens' heads off was Sam's way of making a statement to the family that was so pointed and so angry, and really frightening. We did not see Sam for another fifteen or twenty years. But the image of the chickens was so graphic that it was very easy for me to make art about it. I think that southern surreal lends itself to the visual images that we make today.

Many of my memories of Sam have served as the inspiration for paintings and sculptures over the years. He said he found a cabin where a blind boy had lived, and in the cabin the blind boy's sister gave him a mirror. The blind boy had been in the habit of touching the mirror to see what he looked like. He understood that if you looked at it you could see yourself, and his way of looking was with his fingers. So he would feel this mirror to get a sense of himself. He would never let anybody clean it because he did not want his image to

go away. Stories like that gave me wonderful fantasies about what mirrors are good for and different ways to use them. It became a part of my art.

My experience as a southerner is reflected in my work. It has a narrative content that is intended to be intelligible to a viewer. Such a narrative is a very southern tradition. It is part of that verbal tradition we have in the South, of telling stories, elaborating on them, and making them interesting and exotic. My need to tell stories is very southern, and I deal with issues related to narrative in my art. That is fundamental to me.

Benny Andrews 1930–2006

BORN IN PLAINVIEW, GEORGIA

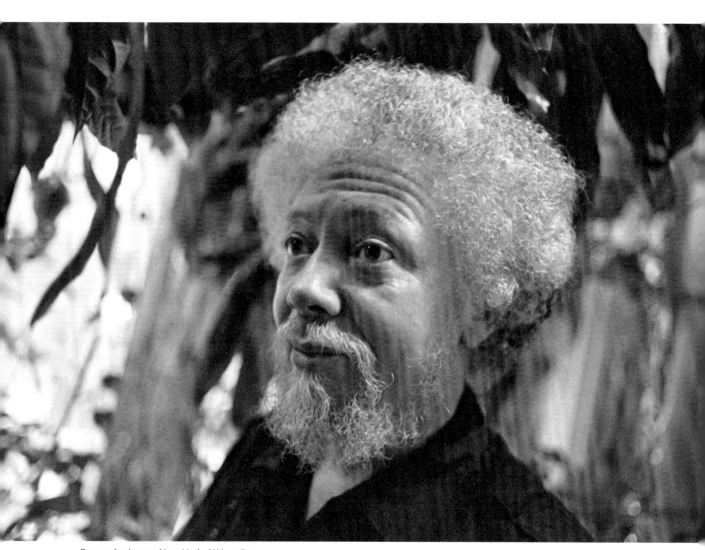

Benny Andrews, New York, N.Y., 1982

These are my report cards. That is cotton-picking time. What happened is that the principal would take my drawings around to the different teachers after I was back in school in the latter part of November or December. And he would negotiate with the teachers to give me credit. So I drew my way through high school.

Benny Andrews chronicles stories of rural black experience in Georgia, where he grew up as one of ten children born in a sharecropper's family. He vividly remembers working "from sunup to sundown in flat lands of cotton. Just as far as you could see would be cotton. It would be hot, and you would be doing this repetitive thing."

Andrews explains that he had a white grandfather and a black grandmother. His grandmother had a secret room in her home where his grandfather hid when the Ku Klux Klan came looking for him. "They had said that it would be OK if the black people or the Ku Klux Klan killed him because he was going against the grain."

Andrews studied at the Art Institute of Chicago, where he began to develop a more abstract style in his paintings. He is comfortable with this shift in his art and feels "the further I get away from being illustrative, the better I am. I have never ended up with an abstract painting, but to me, the heart of art is the abstract part of it."

In his role as director of visual arts at the National Endowment for the Arts from 1962 to 1984, Andrews played a major role in supporting artists throughout the nation. His sense of social justice and his love for the arts has deep roots in the American South.

This conversation was filmed at Andrews's home in New York City in 1982.

We would work from sunup to sundown in flat lands of cotton. Just as far as you could see would be cotton. It would be hot, and you would be doing this repetitive thing. You would go from one end of a row to the other, and that would be just unbelievably long. You had to do something, some-

thing to keep your mind occupied. I would look up at the clouds, and I got to a place where I could make pictures out of clouds. I would be picking cotton, hoeing cotton, or whatever we would be doing, and I would be making pictures up. Sometimes I would stop and draw in the sand. And at night—when I would go home—I would draw some of those things I had seen in the clouds. Even now, I can look up and make up whole illustrations across the sky. That had to do with that raw, austere thing to survive.

Our grandfather, the white one, lived with our black grandmother, and the people in town had heard about that. The Ku Klux Klan was going to get him for that. So at the entranceway to my grandmother's house, near the stairs, there was a place where a coat was hung. That was in my grandmother's home. Behind that coat was a little doorway that had a hidden, hideaway room where my grandfather could jump in whenever the Ku Klux Klan came around looking for him. They had said that it would be OK if the black people or the Ku Klux Klan killed him because he was going against the grain.

This photograph is of my grandmother—grandmother Jessie. And this was our grandfather, Jim Orr. He is the one who used to hide behind the coat when the Ku Klux Klan came around. And these are my father's parents. This is my father, George. They called him G.

Arrangements were made that I would go to school when it rained or after the cotton-picking season was over. I had to quit going to school in the fall when it came time to pick cotton. So I actually went to school five months a year. These are my report cards. That is cotton-picking time. What happened is that the principal would take my drawings around to the different teachers after I was back in school in the latter part of November or December. And he would negotiate with the teachers to give me credit. So I drew my way through high school. They saved all the biology examples, geometry, and things like that—even things that were higher than the one I was in, which was eighth grade.

When I came to a more sophisticated art world, I started dropping some of the illustrative parts of my work because I realized that that was more commercial. And now in my work, the further I get away from being illustrative, the better I am. I have never ended up with an abstract painting, but to me, the heart of art is the abstract part of it.

Carroll Cloar 1913–1993

BORN IN EARLE, ARKANSAS

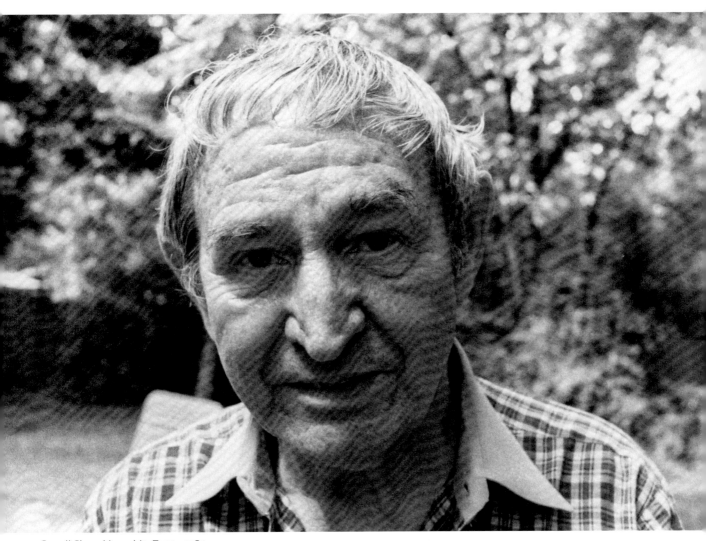

Carroll Cloar, Memphis, Tenn., 1982

The light in the South, well, we have lots of it. Since I paint in the studio, I make the light however I want it, regardless of how it was when I saw it. If I want a blue sky, I paint a blue sky. Or if I want it gray, I paint it gray. Artists used to struggle to capture the light just the way it was at the time they saw it. Then the light would change, and they would be very frustrated.

Carroll Cloar's pointillist paintings depict scenes from the artist's childhood in Earle, Arkansas. Cloar studied at the Memphis College of Art and the Art Students League of New York from 1936 to 1940. He returned to Memphis to familiar worlds that he wanted to paint. He recalls, "I feel that I understand the South—its history, its landscape, its places. I have a great affection for it. And since I came back, I know this is where I belong. When I think of the South, I think of the places I have known—country houses, cotton fields, country stores, and country churches."

Inspired by W. C. Handy's "Yellow Dog Blues," Cloar painted his most famous work, *Where the Southern Crosses the Yellow Dog*. The painting shows two people crossing the railroad tracks in Morehead, Mississippi, "the place where the Southern Railroad crossed the 'Yellow Dog' Railroad, or the Yazoo Delta Line." Southern stories and childhood memories define Cloar's work in significant ways, and his rich, dynamic colors animate his paintings.

This conversation was filmed at Cloar's home in Memphis, Tennessee, in 1982.

I grew up on a farm three miles north of Earle, Arkansas, and went to country schools and a country church until the fifth grade. Then I was bused to town and went to grammar school and high school in Earle. My parents were early settlers in eastern Arkansas. My father died of a heart attack when he was sixty-five, and my mother went into shock and died three days later. I was fifteen then, and my sister and her husband and my older brother and I lived together there in the house for a while. Then I went to live with my oldest brother and his wife and son during my college years.

I drew before I could read and write, and I assumed that everybody drew. I never was interested in painting, but I drew all the time. I went to art school to develop my drawing and hoped to become a cartoonist.

I got a fellowship from the Art Students League and went to Mexico for a year. It was a great experience. Mexico was a good place to be at that time. Diego Rivera was still around, and I began to experiment with painting. About 1954, I went to Europe and spent the year in Spain and Italy.

When I was in Venice, I suddenly had this stream of ideas, which I later called "Childhood Imagery." I was sitting at a sidewalk café one evening, and all of a sudden I began to have these ideas that were from childhood. They were memories of childhood. I jotted down a whole list of ideas. They poured in. I could hardly wait to get back and get to work on them. I had been in Europe about six months at that time.

When I came back, I settled in Memphis, where I had access to the places, people, and old photographs I needed for ideas that I was developing. By the end of the year, I finished my list of childhood imagery and was convinced that Memphis was where I belonged. The material here was what I knew best, what interested me the most, and I have been here ever since—twenty-seven years now.

The first childhood image I did was called *My Father Was Big as a Tree*. I remembered thinking my father was huge. I was not too pleased with him. I promised myself that one day I would measure him against the oak tree that stood between the store and our house to see which was taller. I soon forgot that and never did actually do it.

Sometimes I work from songs. I remembered W. C. Handy's "Yellow Dog Blues." Over the years I had forgotten the words except "my easy rider's done gone, he's gone where the Southern crosses the Yellow Dog." I discovered that Morehead, Mississippi, was the place where the Southern Railroad crossed the "Yellow Dog" Railroad, or the Yazoo Delta Line. I decided to go down there and see what I would find. It seemed like a good title for a painting. So, I went down there, and actually did two paintings. One was *The Red Caboose*, the tail end of a train with the Morehead station in the background. The other was *Where the Southern Crosses the Yellow Dog*, showing the actual crossing of the tracks and two people walking along.

I feel that I understand the South—its history, its landscape, its places. I have a great affection for it. And since I came back, I know this is where I belong. When I think of the South, I think of the places I have known—country houses, cotton fields, country stores, and country churches.

You have writers before you have painters. It seems to be a natural development. I was more influenced and inspired by southern writers than by other painters. From the southern writers, I learned that I knew similar people and similar places. My work is of a literary nature. I like to tell stories and show character instead of merely decorative things. There is an important relationship between southern writers and southern painters.

I grew up in the midst of white and black people. They both appear in my paintings, and I feel their cultures are very intermingled. I think we are going to have more and more black painters.

We had black writers before we had painters, and we had black musicians before we had writers. It seems to be a natural progression.

Women are playing a larger role in all the arts. Women in the past did not think of careers other than marriage and motherhood. I know when I went to college, which was quite some years ago, none of the girls had career plans. Only one girl in my class went to work, and she worked for a radio station after graduation. Now, they think differently. Ambition stirs many to be great at whatever they do. We are getting more and more good women artists.

The South is changing rapidly. In a short time the old houses in the country will be gone, because everybody will live in town. The farms are plowed and harvested by machines. Old barns, which were so picturesque, are disappearing. People are changing too—I think for the better in many ways. Southerners are much more tolerant to the race question now. There has been a tremendous shift in their attitudes in that respect, though whether that is reflected in the art yet I am not sure.

This wall in my studio is done in sharecropper style. I remember from my childhood how the walls of old houses in the country were papered with newspapers. Some of these are old papers that I found in the attic, and people have brought me some of their old papers. One friend brought me old copies of the *Literary Digest* published in the twenties and early thirties. That magazine was my first experience with art. I had never seen a painting and never been to a museum. But the *Literary Digest* had paintings—works of art—on

its covers, and I saved quite a lot of those. I have a couple of *Literary Digests* here. I remember there was a story of Grant Wood and his *American Gothic*. These newspapers are like a scrapbook. You can tell their age by their color. The yellowest ones are the oldest ones, and the more recent ones are whiter. I suppose there is some kind of artistic arrangement of them on the wall.

Here is William Faulkner. Here is our governor, Lamar Alexander. And here is Dr. Charles Diehl, who was a much-beloved president of Southwestern College when I was a student there. That page was during the trouble in Little Rock when they were integrating the school. I have several headlines with Faubus, and some with Faubus and Eisenhower. I saved a bunch of those papers because I thought they were historic.

Before I begin a painting I do pencil drawings on paper. I do a number of preliminary sketches. This painting, for example, is in its early stages. I have sketched in the cornstalks. The color will be autumn colors. Here is a man on his wagon with the mules. I usually do people last. I do the least interesting things first to get them out of the way. Since people are more interesting, I save them for last.

A little black girl named Charlie Mae appears in six or seven of my paintings. Charlie Mae lived across the pasture from us when I was a small boy. We were both eight years old at the time. In the country, any playmate is most welcome, boy or girl, black or white. For a year or so, she was my playmate.

Charlie Mae lived across the pasture from us, and this painting is about the time we found an

abandoned hay mower in the field. Charlie Mae lived with her grandmother, Mattie, and her uncle Disheye. About half a mile from our houses, there was a thicket that I refer to as the "forbidden thicket." It had been put off-limits by my mother because of mosquitoes and water moccasins. Charlie Mae and I were sure there were panthers in it. Charlie Mae said she had been there, and there were panthers. "But," she said, "they friendly." We finally went, and we saw something. And when we stopped running, we decided that we had seen panthers.

I use the tempera technique, although I work now in acrylic. I use thin transparent paint that is quick drying instead of the thick colors in oil paint. That requires undertones and overtones. You do your final color once the others have been laid down. You develop it slowly—either through texture, such as leaves on the trees—or from overlays of color.

The light in the South, well, we have lots of it. Since I paint in the studio, I make the light however I want it, regardless of how it was when I saw it. If I want a blue sky, I paint a blue sky. Or if I want it gray, I paint it gray. Artists used to struggle to capture the light just the way it was at the time they saw it. Then the light would change, and they would be very frustrated.

This painting is of a tent revival. Church services were a big part of our lives when I was growing up. I used to go to a lot of those camp meetings when I was a boy. When the crops were laid by, they would stretch a tent and have a meeting every night. The revival was a time when souls were saved. The meetings would run for two or three weeks. Then they would have a big baptizing of all the new saints. I was never baptized, though I came close. You had to decide whether you were saved. I tried once and failed. I never got saved.

At the end of the preaching they would have the altar call. Sinners who felt repentant would go up to the mourners' bench and kneel down. Then one of the saints would come and pray with them and try to pull them through. Getting saved was a personal thing. You had to know when you had come through. It was not a simple matter of signing a paper and joining up. I went once, and I could not think of anything to say when I tried to pray. So I did not get baptized. I did not feel I was worthy of baptizing. I never did get baptized.

Rebecca Davenport 1943–

BORN IN ALEXANDRIA, VIRGINIA

Rebecca Davenport, Washington, D.C., 1982

I have been criticized by people who say that I make these people into freaks, which is not at all true. This goes back to reading Flannery O'Connor. Her characters are freaks, but they are also whole people because they have a dignity of the human spirit. I hope that spirit comes through in my work as well. There is a story behind every painting in White Soul.

Rebecca Davenport is inspired by writers such as Flannery O'Connor, whose literary work she tries to translate into her paintings. She did a series that began with a piece she calls *Frantic Fran*. These works "possess a narrative quality. They tell a story. You are given information about a person by the things that are there on the canvas."

Davenport feels strongly that the past influences her work as a painter: "There is a sense of the past living in the present, of tradition. That is the thing that is so unique about the South which I have not experienced in any other place. . . . There is a sense of nostalgia. It is hard to put these feelings into words, because they are intuitive." She transfers her feelings into her paintings and has an emotional connection with her work: "To be a good painter you have to trust your emotions. You go with those and evoke emotions in other people. It is hard to describe how I feel a painting is going to work, or what it is like when there is a subject I want to deal with. Your heart starts to flutter, and you say, 'Oh wow! This is the stuff. It is all here. It is going to be great!'"

Davenport views her paintings as a visual extension of the southern narrative tradition that she discovered in writers. She tells her version of that narrative on canvas and focuses on women and their experience in the region.

This conversation was filmed at Davenport's home in Washington, D.C., in 1982.

The idea of White Soul came about from my experience growing up on a farm in Virginia. When I was eighteen years old, I met a country musician by the name of John Pancake, who played honkytonks around Washington. I got involved with

him. It was quite an experience being with this kind of person who was from Texas, had come to Washington, and never fit in. He was not a country person. He was not a city person. These experiences inspired me to start painting because I had no other way of expressing them.

I realized I should paint subjects that are important to me, people I know and things I know. This is how my idea of painting poor rural whites started. I call it White Soul because it is about pride, race, and dignity, all mixed up with feelings of both defeat and success—the very same thing as black soul. I worked on that series of paintings for five or six years. There is a lot of anger and a lot of strength in them.

I have been criticized by people who say that I make these people into freaks, which is not at all true. This goes back to reading Flannery O'Connor. Her characters are freaks, but they are also whole people because they have a dignity of the human spirit. I hope that spirit comes through in my work as well. There is a story behind every painting in White Soul. I did one painting called *The Arkansas Madonna* of this enormously fat woman with these enormous breasts, holding a baby bottle with a child on her shoulder.

It goes back to the strong feelings in the South about rules and traditions. You are supposed to act a certain way and do certain things. You have certain roles. I said, "Well gee, I would love to paint a whole series of older people naked." Frantic Fran seemed like the perfect possibility. She is this mad lady. She is a professional comedian who performed in a hotel in New Jersey for twenty-five years. She has grown enormously fat

in the last couple of years, a true eccentric, and a marvelous, wonderful, special person. I asked her if I could take photographs of her, and she said, "Certainly." At first I went to her house on the beach. She has a little place in New Jersey where she planned to open up an antique shop. She is a compulsive filler-upper of spaces. She had filled up this whole place so that nobody could get in it anymore. So she had to close her shop. It was not a good place to take photographs anyway. So we went to her home in Brooklyn instead.

It was an unbelievable experience. She has this apartment she has lived in for four years. Because she does not throw anything away, the place was overflowing. It was just filled. You could not even get the front door open. She said, "Now, look down when you walk." There were aisles that she made through the stacks of newspapers. It was not dirty. It was just clutter. Oddly enough, there was an order to her clutter, and it was a wonderful experience to see it. I said, "Fran, would you pose nude for me?"

She said, "Well, I really do not think I want to because you are not part of my family, and I feel uncomfortable."

I told her to wear what she normally wore at home, and she said, "Okay."

She put on a short little pink nightie, and one white sock, because that is all she could find. When she was dressed, she started posing. She is a performer—a professional performer—so she has no trouble getting into this whole act. There she is with this little pink nightie on and this one white sock. She is doing her thing, and I am standing there taking these pictures. Then all of

a sudden, she gets into the spirit of it. She took her nightie, pulled it up, and threw it across her shoulder. She went, "Ta-da!" And there she was—Fran. She is sixty-five years old with this one white sock on. She started doing all these poses, and it was great. I said, "My God, this is the most wonderful thing that has ever happened to me. This is everything I have ever wanted to paint, all right here, this woman."

My camera jammed. I lost a roll of film. I was so excited that I did not know what to do. There was this rapport between us, which was magic. We started laughing. It was very special.

I came rushing back to Washington thinking this was going to be the best painting I had ever done in my entire life. I started the canvas immediately. But there is a funny thing about painting. It is the same way with literature, I am sure. Things have to grow. It takes a while for things to develop. I started too fast on the painting, and nothing worked. I had this great big canvas with all of Fran's possessions and Fran in the middle nude, and the painting was absolutely dead. I worked on the painting for three months, and it was nothing. Finally, I said, "I have got to make a decision. Am I more interested in what is surrounding her, or in her?" Rather than go back and rephotograph Fran, knowing I could never get that same feeling back again, I decided to remove her from the canvas. It became a painting of Fran without Fran, and it really worked. It was wonderful because it worked on several different levels. She was right in the middle of the canvas. It is the only place where there is a little bit of space, and it is pentimento, which means repentance. That is

an artistic term that describes how oil paint, as it dries, becomes more and more transparent, and in time you see the original images that an artist made. So, in twenty to thirty years, the ghost image of Frantic Fran will emerge on this canvas.

That inspired a series of paintings of interiors. These were portraits of people without the people. The paintings told stories based on the information you were given about things in the interiors. These were older people who had collected things, and most of them were poor or destitute. They all had things with which they had surrounded themselves. Later, I felt that I just had to do another canvas of Frantic Fran, and I chose a picture I had taken when she was not naked. She had her little nightie on, and she was playing the piano. It came out and it was wonderful.

All the paintings in the series that I did—starting with Frantic Fran—possess a narrative quality. They tell a story. You are given information about a person by the things that are there on the canvas. They were mostly older people who lived in the same building that I lived in at that time.

A great deal of photography is evocative of the stillness in the South. Bill Christenberry does that kind of work. An event has already taken place, and now it is gone. It is over. It is abandoned. I find a great poetic quality in that and am drawn to it.

There is a sense of the past living in the present, of tradition. That is the thing that is so unique about the South that I have not experienced in any other place. My father's people are originally from the South. My mother is Hungarian, and that is a very different background. Perhaps it has

to do with the Civil War, with being defeated, with the idea that the South will rise again. There is a feeling of incompleteness. There is a possibility that something is coming back. There is a sense of nostalgia. It is hard to put these feelings into words, because they are intuitive. You can talk to somebody who is from the South, and they might say, "Oh, I understand that." There is a similar experience, a similar knowledge that someone from the North just misses completely. But it is there. It surfaces in creative ways in literature and in art.

It is an emotional thing to transfer feelings into paintings. To be a good painter you have to trust your emotions. You go with those and evoke emotions in other people. It is hard to describe how I feel a painting is going to work, or what it is like when there is a subject I want to deal with. Your heart starts to flutter, and you say, "Oh wow! This is the stuff. It is all here. It is going to be great!" It is like meeting Frantic Fran. You get this funny feeling, and you trust that instinct. It is part of me, of my background, of my feelings, and of my experience. An artist has to draw on their own ex-

perience, and that experience is formed by their region.

Painters are like preservers because they make you look at things. The purpose of art for me is to focus on something. I want to alter a person's perceptions, so that they never look at that person or object the same way again. When I do a painting of a pillow, someone will never look at a pillow the same way again. It might be a dirty wall or thumbprints on a wall that tell a story of who was there. It is magical.

This is a painting I have worked on for a number of years of the Manuel Episcopal Church. These are people that I grew up with. As a matter of fact, I am in it, along with my mother, my brother, my sister-in-law, and our preacher, Brother Dave. Brother Dave is the only Episcopal minister that has a tattoo on his right cheek—his rear end. He is very proud of that. He told everybody about it. This painting reminds me of a group portrait, where everybody is standing around, posing and presenting themselves. It is all my family and friends, and it is based on my narrative.

William Dunlap 1944–

William Dunlap, McLean, Va., 1982

I do not know if there is such a thing as a southern painting. I do know there are an awful lot of people making art in and about the South, and it is going to have a cumulative effect at some point. It is like when the floodwaters get close to the top of the levee and are about to run over.

William Dunlap is as celebrated for his storytelling as he is for his painting. An eloquent commentator on the southern arts scene, Dunlap acknowledges his debt to southern writers who inspired him to develop a narrative theme and a "visual vocabulary" for his paintings: "Writers have influenced me a lot more than painters. These pictures of mine are literary. They are the equivalent of allegories, of fables. These buildings, barns, dogs, and severed deer heads are all symbolic. I have developed a visual vocabulary. At this point in my career I feel like I have mastered the vocabulary, and I am composing sentences and even paragraphs in my art."

Working in his studio in McLean, Virginia, Dunlap describes his art as "off the interstate." During his travels, he photographs the landscape as viewed from his car and later uses those photographs to create paintings. He reflects on the importance of highways and feels, "Those roads are sustenance for me. They are the cornerstones of what I try to do. The time I spend on the interstate comes back. It doubles back and ends up in my art."

In his Nobel Prize acceptance speech, Faulkner speculated that at the end of time we will hear man's "inexhaustible voice, still talking." He might well have had in mind the voice of Dunlap, speaking about the American South and its painters.

This conversation was filmed at Dunlap's home in McLean, Virginia, in 1982.

I do not know how people figure out whether they are going to make paintings. When I grew up, I did not even know what an artist was. But I knew I wanted to be one. I did not have any formal train-

ing until I got to college. I have a vague memory of my grandfather drawing a picture of a train on the back of a shirt cardboard, and I embellished that when I was three or four years old. There was not any art in the public schools in Mississippi, which probably was a blessing. I found out later when I was teaching that you had to unlearn a lot after you went through the public school art programs.

What was most important to me was acquiring an eye every summer when I came back to visit my grandmother Cooper in Mathiston, Mississippi. She kept all those wonderful magazines—*Colliers*, *Look*, and *Life*—from World War II, and I looked through them every year until they finally just wore out. When I go back now, it is a time warp for me. I look at a picture and can remember exactly what was going on then. I learned to see by looking at that sort of action photograph. I always drew. I was one of those kids who seemed to have hand-eye coordination. Basically, I was visual. I do not know what the visual equivalent of perfect pitch is, but I aspired to be able to see things very clearly.

I do not know if there is such a thing as a southern painting. I do know there are an awful lot of people making art in and about the South, and it is going to have a cumulative effect at some point. It is like when the floodwaters get close to the top of the levee and are about to run over.

I am hardly an agrarian. I get a lot of energy from New York, and I get a lot of energy from Mississippi. I am halfway between the two. I think that is the place to be in that proverbial gap between life and art. The ten years that I spent in the mountains of North Carolina at Black Mountain

College were crucially important because that is where one goes to come of age. That was an important time to figure out what I was doing.

That storytelling, that narrative business we all grew up with down South led rather easily into a whole generation of artists. During the time we all grew up—the late forties and early fifties—the dominant theme in American art was expressionism. I am a product of that. I have come out of modernity on the other side. My work is about the narrative. It is about those stories.

Writers have influenced me a lot more than painters. These pictures of mine are literary. They are the equivalent of allegories, of fables. These buildings, barns, dogs and severed deer heads are all symbolic. I have developed a visual vocabulary. At this point in my career I feel like I have mastered the vocabulary, and I am composing sentences and even paragraphs in my art. It is time to do the magnum opus, to do the big work, so that this special language can be understood.

Every generation of people is conscious of where they live, of their place or sense of place. We are products of mobility. I moved around a lot. I was like those war babies who were displaced. I grew up all over the South, not just in Mississippi. Our southern landscape speaks of history, of what has happened to it and on it. It speaks of the people who have occupied it. That is implied in my work. I do not believe in moralizing. I want to keep a certain distance from my subject matter.

As interested as I am in history and the Civil War, I would never illustrate it. Since I have lived in Virginia, I have gotten more involved in the Civil War. I grew up with it in Mississippi. Grand-

mother told these stories about her aunts and uncles.

I found that in northern Virginia the landscape looks good. The first time I went out to Antietam was in the winter, and it looked so good. It is a beautiful place to have a battle, if you have to do it. There must have been some aesthetic value to choosing that spot.

The Valley of Virginia interests me because it has been struggled for, won, and lost. The Shenandoah and the Valley of Virginia are charged places for me because they are full of history. The poetry, the literature, the sense of tragedy creeps into my work, not the facts, figures, and dates. It is an implied kind of information. It is an allegory. The viewer has to bring something to the work, and whatever he brings allows him to fill in the blanks.

The absence of people in the landscape has to do with the advent of air conditioning. There is no reason for them to get out anymore. They just stay in the house where it is nice and cool. I seldom put a figure in the landscape, but his presence is there. It is dominant. He is the one who laid those light poles and cut that big old gap in the mountain and ran the road through it. He is the one who built this building, who built those fences to keep the stock in.

I like to paint early in the morning or late in the afternoon, when the light is more dramatic. The pictures evolve. They paint themselves. It is really an omnipotent kind of position to be in to make the landscape. It is very godlike. There is a lot more to it than just scenery, I can assure you. I am trying to work into my paintings that bombarding business—seeing all those images at once when you drive down the road. They come at you

all the time. Those silos that are in the valley are big old phallic symbols that stick up. They have a nice vertical countenance, almost the equivalent of a temple. The cube, the cylinder, and the sphere—they are all out there.

There is something brooding, dark, and ominous about the southern landscape—the way those thunderstorms come up immediately, do their damage, and get out. The landscape for me has always been in a state of flux. It is not an unchanging place. I go down roads I have driven down and see buildings. I have a noble task to steal these agrarian buildings—these old barns—back from those people who have been denigrating them for so long. The elements of cubism and modernism are there in the juxtaposition of all those angles. They are functional buildings, but for me they are manifestations of what modern man has done. I like the way they have evolved over the generations.

In North Carolina I used to see all these old nineteenth-century frame houses that have been turned into barns next to the brick veneer ranch-style home built by the young son who got a job at the factory. Then off to the side is a house trailer. It is an architectural evolution from that old nineteenth-century house that they all grew up in. Then the fellow got the job in the factory. And then he bought the house trailer. It all evolved, just as Mr. Faulkner suggested it might in *The Fable*. Man puts his house on wheels and rolls it down the road. It is a curious thing to see. But once you see four or five in a row, you know you are dealing with a phenomenon. The landscape is changing all the time. I find it fascinating, and I never tire of making these paintings. The land-

scape is like that white line down the center of the highway. I always come back to it for solidity.

I have gotten into quite a bit of trouble for making statements about being part of the first generation of southern painters. I am not denigrating any painters who came before. But I think the term "generation" implies a certain number, a certain quantity of people. There are enough postwar kids who stayed in touch with one another, who got art degrees and taught, to constitute a generation. There are enough of us out there, and I know it because I am in touch with them. We are working from the same body of information. I have no idea what sort of impact we will have on the art world, but we are not a retrograde, regionalist school. We are people with the same sensibilities who are the same age, who laugh at the same stuff. These folks are active in the art scene and are very successful in it. I am glad there is some company.

We are part of an energy, part of a force that is bigger than we are. Our imaginations are captivated by this idea. Everybody works a little different, but it all has that narrative quality. It all tells those stories. These guys are articulate, and they are good company. That is what I had in mind about this generation. There is a quantity to go with the quality. I am in touch with them but it is on a peripheral basis. We seldom get together and talk about art or techniques or dealers. The art scene is important, but making paintings is a private business. I make a lot of drawings. I shoot a lot of photographs. But basically I work in the studio with all the windows closed. I am enamored of the fact that my generation has produced something that will be worthwhile. I cele-

brate every success they have and vice versa. That is something you do not see very often in the art world.

I do not know if my generation can be called expatriates. The whole history of the expatriate southerner is an interesting one. For years they have left, done their work, and then eased on back down to the South. Mr. Faulkner got out, stumbled around, and came back home. It is a big cycle. I consider myself a roving ambassador because there is nothing I can do about my southernness, even if I want to. There is no way to get around it. I was always fluid and moved around, so it was not necessary for me to live in the South.

It is difficult to do what I am doing in Mississippi. The financial and intellectual market for what I do is on the East Coast—between Washington and Boston. I have situated myself about one hundred yards south of the Potomac, which is on the cusp of all that.

I still consider myself living in the South. Washington is still a southern city. God knows Virginia is a southern state. I do not apologize, and I do not feel a bit of guilt about having left the South. But those who stayed at home are just as articulate, sophisticated, and aware as those of us living in New York, Washington, and Los Angeles, which are the centers of art. Artists have always left the provinces and gone to the meccas, for better or worse. That is part of the temptation and the risk, dancing with the devil, if you will. It is difficult to sustain a highly charged intellectual approach to work if your only options are going to high school football games, drinking liquor, and riding up and down the roads with your buddies. It is easy to fall back into that. I am at a period in my life where I

want to get a lot of work done. I have found that the way I am living right now gives me the best time, and my energies are better concentrated. The end results are more easily achieved here in Virginia than they are down home in Mississippi.

I like to think that nineteenth-century American painters saw the landscape in a more romantic fashion. They saw the great wilderness. By 1955, the wilderness was gone, and the landscape stretched out there. I saw it through peripheral vision as I was driving. I would stop, make some photographs, make some drawings, and get some ideas from the landscape. In the mid-seventies, it occurred to me that I was chronicling an off-the-interstate series, whether I wanted to or not. When we go to Europe, we get on those little roads. We find those small villages, get lost in them, and think that is so exotic.

In America, we just slam from one interstate to another. Traveling is a real luxury for me. I fly, but without any pleasure. It is impersonal to look at the landscape as a quilt.

When you run up and down the roads, the landscape talks and is full of symbolism. I used to drive Interstate 40 through Tennessee, through a particular part in east Tennessee where these wonderful towers stand up as evidence of industry on the landscape.

The Starnes house in Webster County, Mississippi, is the same house I have been using for years in my paintings as a symbol of Gothic Victorian carpentry. I changed the roof, moved the chimneys around, but it is that high-peaked roof with its angles and straight lines that looks so good to me. I have moved that house around a good deal in my art.

There is something about those highways, about being close to them in the same way that ancient civilization used to get close to rivers and the savannahs. Those roads are sustenance for me. They are the cornerstones of what I try to do. The time I spend on the interstate comes back. It doubles back and ends up in my art.

I have a sense of the make-do idiom. I remember seeing those incredible old cars that folk had in their front yards. They would work on them with baling wire. That make-do idiom is something that has crept into my art, along with having been in the company of some good musicians at a time when they were inventing art out of nothing. The artist, the musician, the poet is a conduit for information that each generation has to relearn. As an artist, I am ready to be used. It is not easy making these paintings, but it is very gratifying. I cannot imagine doing anything else.

I try to make pictures that work on different levels, just as the culture I grew up in works on different levels. It is the most benevolent, the most understanding culture. And in other ways it is restrictive and highly disciplined. There are unspoken rules of behavior. We were always told to remember who we were and where we came from. That all feeds into what I am about. I am going directly against the mainstream of what is going on in art right now, and I am very comfortable doing that.

The most intimidating thing to me is a blank piece of paper in the studio. I do not have any working drawings. I just get an idea and initiate it. Once I get something down, something else usually shows up to take its place or to move it around or to be next to it. They develop that way.

They develop willy-nilly. Every time I come back from a road trip I have new ideas and new energy that I put into my art. I never know exactly where the pictures are going. The pictures will paint themselves, if you let them.

I like making photographs. I shoot a lot of film. It is a luxury that I insist on, and it is also a way to keep a visual journal. I have thousands of slides. If I ever take the time to go through them, I am sure I will find a narrative there. To turn your back on access to a camera and photography in this day and time is not only postmodernist, it is stupid. The camera is a tool, and I use it well. I enjoy it. I seldom show my photographs, but I probably will someday.

I work on several pictures at once. These paintings are all siblings or at least first cousins. There is a relationship from one painting to another. When I look back at the work I made in a given year, there is a similarity in the pictures. There are long, lean landscapes that are like peripheral vision. I like working on a large scale. Some of these paintings are four feet by eight feet. It is a delicate business because some of these pictures are on paper, which is delicate to work with.

When I start working, I work in spurts. There is a lot of dead time. Some people call it dead time when you stare at a blank piece of paper while in the studio. When it gets destructive in here, I get in my car and go somewhere. I hit the road. If I have a deadline, I will get the work done. Then I take a little time off, come back, and start all over again. That is the way the pictures get made. It is the best way for me to work. It is unorthodox and unwieldy, but I like it. Adrenaline is the only drug worth doing anymore. And the equivalent of that physical adrenaline rush is to get close to finishing a couple of paintings and getting them into the gallery wet. It pushes me. It is a luxury to be an artist.

Maud Gatewood 1934–2004

BORN IN YANCEYVILLE, NORTH CAROLINA

Maud Gatewood, Yanceyville, N.C., 1982

That home and the square have always shaped my work. Those were the first visual images I knew. I have painted the courthouse and the square a number of times through the years. . . . The landscape outside of the town has also influenced me. You do not have many people around here.

Maud Gatewood lived and painted in Yanceyville in Caswell County, North Carolina. She was a close observer of both the town and the countryside. Her front door looked out on downtown Yanceyville, and her back door opened into the countryside of Caswell County. She knew both worlds intimately and embraced them in her paintings. Gatewood's career as a painter was influenced by her family's long association with the community: "Living in Caswell County—and my family having lived here for more than 200 years—gives me a sense of place. I have no choice but to consider this my home because generations have lived here. It does affect you. I feel that to have a sense of the past—to have a sense of history—is essential to gauge the present and the future. If you do not feel the flow of time, then you are frozen in it."

Like many other southern painters, Gatewood acknowledges that her work develops a narrative technique similar to the work of the region's writers. Both use the story to capture the heart of the American South: "Southern writers and southern painters both deal with man's role on the land, his relationship to people, the warm climate, and a way of life. When a painter uses a narrative technique, he basically tells a story that reveals on canvas an episode or an event that he feels is worth commemorating. A great many southern painters use the storytelling technique, which is also used by the southern writer."

Gatewood's paintings of girls in swings, parasols, and a hoochie-coochie lady at a carnival capture special moments in her life. Like Eudora Welty, she focuses on everyday life and finds universal meaning in it.

This conversation was filmed at Gatewood's home in Yanceyville, North Carolina, in 1982.

When I was growing up, the square was my playground. I used to go to the courthouse, up in the tower, and onto the roof. My mother would look out the front door, see me on the roof, and literally shout me down from across the square. She had a very good voice for that.

Mother signed me up for piano lessons when I was eight years old, and after three months, the whole family voted that I could give it up. Trying to make me a southern lady, she then signed me up for art classes on Saturday mornings at Avery College in Danville, Virginia, where I now teach part-time. I started taking art when I was ten. I blame her and tell her she ought to support me in the manner in which I am accustomed. So far I have not gotten it. Basically, I started by taking art classes.

The first music I ever heard was the big band sound in the courthouse across the square. Sammy Kaye, Hal Kemp, and all the big band players of the thirties played Friday nights in Chapel Hill. The next night they would come up and play in the Yanceyville courthouse. The first live music I ever heard was Hal Kemp and Sammy Kaye playing in the courthouse across the square.

My father died when I was twenty. On the day he died, the black woman who was there when I was born took me aside. She told me that I would be all right because she had supervised my afterbirth's burial. She described how she had taken my father and gone to the fields—this was in January, with the ground frozen solid—and dug a hole three feet deep. They buried my afterbirth with stones on it to have it absolutely safe and secure, so my life would be good. I found out later that this is an African ritual—this belief in the preservation and the protection of the afterbirth. I think much of our life in the South—the white life in the South, as well as the black—has elements of African thinking and belief. Of course, the most obvious is Uncle Remus stories. But in many other small aspects, Africa has given us quite a bit in the South, and I am thankful for it. I have some very close black friends that I grew up with and know today, and I feel like I owe a great deal to them.

The woman who took care of me and buried my afterbirth died at ninety-eight, about five years ago. She was a very smart woman. She and her husband worked hard, reared five children, and sent them to college. Between the two of them, they accumulated a good deal of money and a great deal of respect.

The house I grew up in was built in 1820, added to in 1850, and remodeled by my grandfather in the early 1900s. That is why we have the Victorian porch in the front. When I grew up, I could go out the back door and be on the farm, and go out the front door and be on the square to get my ice cream cones and Cokes and visit with everybody. Growing up in a small town teaches you how to deal with all types of people, a knowledge that I have found invaluable through the years.

That home and the square have always shaped my work. Those were the first visual images I knew. I have painted the courthouse and the square a number of times through the years. The town streets often pop up in my paintings—the front porches and screen porches—time and again. The landscape outside of the town has also influenced me. You do not have many people around here. You see landscape without a lot of people.

You see evidence that people have been there in the structures and in the plowed fields. But quite often you see an absolutely empty landscape.

This town was established in the late eighteenth century as the county seat of Caswell County. An acre was laid off here in the center to serve as the town square. The courthouse was finished about 1850, and soon thereafter came the Civil War. The plaque here behind me is concerned with the murder of a scallywag named Chicken Stevens who came from an adjoining county during the Reconstruction period. This is supposed to have been one of the starting places of the Klan in that period. We have not had much trouble with them lately, thank goodness. The Klansman called Chicken Stevens out of court into his office in the courthouse, killed him, walked out, locked the door, and supposedly threw the key in the creek. It was a day or so before he was found. The only murder the Klan did here was of a white man, a scallywag, Chicken Stevens, as he was known. Supposedly bloodstains were on the floor until the thirties.

In my early days, the square was primarily Victorian storefronts, and a number of those have been covered with more modern facades. Then a whole section of stores and an old bank building were torn down to make room for the new bank building. The square is not as attractive now as it was forty years ago.

People have a strange concept of progress. They do not deal with the idea of permanence as much so as they did 100 or 150 years ago. They look for cheap, quick structures, and they cut expenses as far as design and architectural decorations are concerned. All they need is shelter, and

they forget what the shelter looks like. We still have very interesting older structures because progress has not hit the underdeveloped counties in North Carolina.

Caswell County, North Carolina, was one of the wealthiest counties in the state prior to the Civil War. The boom actually was 1810 to 1860. It had many beautiful homes that were mainly built in the town and some in the countryside. Many of them stand deserted now, and a few have been restored. The sense of design you see here, the sense of proportion, has come down from the Greeks, through the Renaissance, and into the Greek revival style. There is a great sense of design in these homes, and I think their beautiful architecture affected me.

Caswell County, this county that I live in, is very important as far as tobacco growing is concerned. It is in this county that the method for curing brightleaf tobacco was first developed back in the 1830s. Supposedly, slaves who were watching a tobacco barn fell asleep. The log they were making fire with was reduced to charcoal, and the charcoal turned the leaves a bright yellow, as opposed to a more smoky brown. The slaves' owners that year—this was in the 1830s—made a fortune on their tobacco crop when they brought in those beautiful golden leaves. Their method was perfected and gave us brightleaf tobacco. The tobacco heritage in the county is very strong, too strong, because we are tied to one agricultural product. We need to diversify, and I hope we do.

It is easy to define the geographic area of the South, but it is more difficult to define what you mean by southern. We know a great deal about southern literature, and we know a great deal

about southern architecture and decorative arts. But there is a lack of information about painting in the South. Unlike New England, a great many paintings were in private collections that were not readily accessible to art historians.

I have taken surveys of American art, and I have taught them. In most surveys, you begin with New England, go to the Hudson River Valley, then go West, and come back to New York. You rarely deal with anything below the Mason-Dixon Line. There is a general absence of information in most surveys of American art about what went on in the South.

In the twentieth century at Black Mountain, North Carolina, painters like Josef Albers and Willem de Kooning influenced southern artists to paint in a more abstract vein. Until that time, southern painting basically dealt with what artists found around them—the people, the land, the various features of the region.

Unlike other Americans who embrace America as the land of success, the southerner shares a kinship with Europeans in having suffered defeat in a major confrontation. You find this defeat reflected in the art of the South. It comes across with a poignancy, a nostalgia, a need to accept what has happened and to go on. Southern painting is important because it is American painting that deals with a certain region. We know about painting in other parts of our country. Now it is time to take a look at the South.

Southern writers and southern painters both deal with man's role on the land, his relationship to people, the warm climate, and a way of life. When a painter uses a narrative technique, he basically tells a story that reveals on canvas an episode or an event that he feels is worth commemorating. A great many southern painters use the storytelling technique, which is also used by the southern writer.

I am drawn to art, first of all, because I am a southerner. When I studied the history of art, I studied American art. So it is a natural extension to want to find out something more about the South, an area that is less well known.

In the last two years, I have painted ordinary people, ordinary events, and ordinary actions. The town of Yanceyville has had a great influence on me for a long time. The first image of Yanceyville I had was of the courthouse across the square. I live in a small community here—population-wise—so my paintings have been of landscapes that are mostly devoid of people. Out in the countryside you see a plowed field without people plowing. You see wheat fields growing without people there. My paintings are concerned with patterns like roads and fields. This environment affects me a lot.

I did a series on umbrellas—things that take place around and under them. And I also did a series on balloon ladies at the carnival and a hoochie-coochie show at a carnival. There is a canopy in all of them. I enjoy going to fairs and seeing what is happening. My paintings are done from memory, from sketches on the spot. I do not work with photographs. I watched the women in the balloon booth closely and the hustlers.

The hoochie-coochie show is painted in the interior. The stripper and the men are bathed in red light from the red floodlight inside the tent. The

tent was actually white, but the red light reflecting off the canvas makes the whole thing look a purple red, except for the hoochie-coochie lady, who had a white spot. She looks white, ghostlike, sheetlike, paperlike. It is an interesting visual combination. I worked my way in—even though women do not usually get in—watched for a little while, came home, made some sketches, and waited two years. I waited two years for no particular reason other than it finally gelled in my mind.

I like the round, circular pattern that umbrellas make. I have painted umbrellas off and on for twenty-five years. Many artists have themes that they come back to time and again. I painted a series of swings back in the early sixties. What I like there is the opposition of gravity. You have this suspended, floating figure swinging, rather than with feet planted firmly on the earth. I find myself going back to the swing. I guess we go back to the same old things, as we cycle around and around.

I do not think there is a problem about being a woman artist in the South any more than there is about being a woman artist anywhere else. You probably have fewer problems in the South, actually, because you find the competition is less cutthroat. I think you would experience more disadvantages as a woman in the art centers than you would in the South.

Living in Caswell County—and my family having lived here for more than 200 years—gives me a sense of place. I have no choice but to consider this my home because generations have lived here. It does affect you. I feel that to have a sense of the past—to have a sense of history—

is essential to gauge the present and the future. If you do not feel the flow of time, then you are frozen in it. I do believe a sense of history is important, though not as important as some people make it out to be in the South. I tell people around here that I wonder if their ancestors would be as proud of them as they are of their ancestors. I think quite often that southerners think their ancestors were so great, and I wonder if their ancestors would be proud of them. I think we need this balance. My father said, "It does not matter who you come from. It is what you do that counts." That is the most accurate way to say it. You need to know the past, to feel the past.

Alex Haley grew up in Tennessee, but this is the county where Kizzy, his great-great-grandmother, was brought from Virginia. In his novel, I think he called it "Faction," where Kizzy was brought, and where his great-grandfather, Chicken George, was born. Fifty percent of *Roots* takes place here in Caswell County.

My cats tend to grow in number. I have six now. I swore I would never have any again. I started out with two white ones, and it did not take long before the two white ones got together. Then I ended up with four white ones. My cats come and go. I lost two cats last fall. I picked up two new ones this spring at a vacant house that my mother rented, including one with no tail. They are very interesting animals. They take you on their terms. Dogs are nice and pleasant, but cats you have to cater to. They make you more humble than a dog.

This is Sugar. She is the mother of the two younger white ones. She is the smallest and the smartest. She was out for two days catting around,

and now she is resting and recouping. Then she will go out and hit the road again. They stay in the studio. They help me work, and they give me good criticism on my work.

I was away from home from the time I was sixteen until seven years ago. I moved back home to Caswell County and ran for county commissioner in 1976. I did that because my family was in politics through the years, and I was reared to feel a sense of obligation to the community. I filed for county commissioner, and I ran unopposed and served a four-year term. I was chairman of the board my last year, and my term expired in 1980. I could not run again, but I could have run in 1982. I chose not to run. I served a four-year term on the board, out of a sense of responsibility to the area.

I am not much of a politician. But I did not have to campaign that much, seeing as I had no opponents. Politicking is different from painting in that in politics you work with a board, and a painter works alone. I prefer to handle my work by myself, rather than work with a group. Politics teaches you patience though, and the whole pro-

cess is interesting—not necessarily fun, but interesting—and time consuming. It does not pay very well, and you get a lot of criticism.

When I walk in the mornings, I remember playing on the streets here. That was forty years ago. It is hard to say where my art might go from here. I am old enough to know to never say never. Who knows? The minute you say you are going to take it one way, it will go somewhere else. It keeps moving. One painting leads to another. I really cannot make any grand, long-range plans because it is a step-by-step process. I am damned if I know why I keep doing it.

Sometimes I wish I was somewhere else. But then, where do you go? I am not sure it makes that much difference where you are. It might to some people. I prefer not to live in New York. I think all of my energy would be exhausted coping with living in New York, because I was not born in that environment. So if I moved somewhere else, it would probably be near the ocean or somewhere in Europe. I question why I am here. I guess I am here because it is home.

George Wardlaw 1927–

George Wardlaw, Amherst, Mass., 1982

My mother was a quilt maker, and the images she used in her patterns—her colors and designs—had a tremendous impact on me visually when I was younger. It has only been within the last several years that I realized the enormous influence those quilts had on me and how I integrated them into my work.

George Wardlaw draws on multiple southern narratives for his paintings. His father was an artist and storyteller, and his mother was a quilt maker. These early influences were enriched later when Wardlaw learned he had Chickasaw and Choctaw ancestry. He integrates stories, quilts, and Indian images into his paintings as an expression of his southern roots.

Religion strongly influences how Wardlaw views the artist's role in society. As a child, he admired the Old Testament prophets because they were "the ones with the ideas, with the visions, with the insights. After thinking about it, I announced to my cousins that when I grew up I would be a prophet. Being an artist is to some degree like being a prophet. An artist looks into the future, the present, and the past. So that connection is relevant to what I do as an artist."

During a casual conversation, a friend suggested that Wardlaw study art and make a career of painting. He enrolled in the Memphis Academy of Arts, where he began to paint. While first studying and then teaching art at the University of Mississippi, Wardlaw saw William Faulkner at a local restaurant in Oxford. He felt a special pride when Faulkner won the Nobel Prize in Literature. "He was a model for me as another artist working in a different medium. It was in that sense that writers influenced me, not so much by what they had to say, but by their presence."

In his later work, Wardlaw experiments with three-dimensional paintings that allow the viewer to see his art from different angles. "From one angle you see only one color, while from another angle, you see three colors. Sometimes you may see seven colors, the interactions of those colors, and the influence of the shadows upon them. That is how I became involved in three-dimensional paintings."

Like Sam Gilliam and Ed McGowin, George Wardlaw transforms the southern narrative tradition into abstract paintings that have an imaginative power.

This conversation was filmed at Wardlaw's home in Amherst, Massachusetts, in 1982.

Growing up in north Mississippi, the only livelihood was farming. In addition to being a farmer, my father trained registered bird dogs. To register them, he drew a picture of each dog and sent it away to get the registration papers. He would map out the patterns of colors on these dogs, and I would watch him. This was an incredible mystery for me. It intrigued me enormously and stimulated me visually very early on.

My father was also a great storyteller. He made up his material as he went along, as so many southerners do. I was deeply engrossed in his storytelling, and it eventually influenced my work as a visual artist. When I was growing up, I never had an opportunity to study art because it was not taught in any of the public schools in Mississippi. I drew a lot, but totally on my own. I had an aunt who took a great interest in my drawings and collected them. It impressed me that somebody valued my work enough to want to keep it. Another thing that led me toward the visual arts was a teacher I had in the fifth grade. He did a frieze painting in chalk along the top of our classroom blackboard that was enormous. Looking at it, I was absolutely astounded, and I secretly dreamed that I might do something like that.

Church-related activities made me think the most important people were the prophets. They were the ones with the ideas, with the visions, with the insights. After thinking about it, I announced to my cousins that when I grew up I would be a prophet. Being an artist is to some degree like being a prophet. An artist looks into the future, the present, and the past. So that connection is relevant to what I do as an artist.

My mother was a quilt maker, and the images she used in her patterns—her colors and designs—had a tremendous impact on me visually when I was younger. It has only been within the last several years that I realized the enormous influence those quilts had on me and how I integrated them into my work. I still have quilts that my mother and my aunt sewed. You can see how pattern plays a very important role in my work, and that goes back to my mother's quilt making.

At age nineteen, I got out of the navy. I was walking down the street in my hometown in Baldwyn, Mississippi, and I met a high school friend. He asked me if I still made drawings. I said, "Well, yes. Once in a while I do."

He said, "Why don't you go to an art school?"

I was so naive that I asked, "What is an art school?"

I thought that you were either an "artist" or you were not an artist. He explained to me that there was a professional art school in Memphis called the Memphis Academy of Arts. He suggested that, since I was a veteran, I should go to the Veterans Administration and see if they had any information on this school. I went to my car and proceeded directly to Tupelo, the nearest city where there is a VA office. They gave me the information, and within a week and a half I enrolled at mid-

semester in the Memphis Academy of Arts. That was my entry into the visual arts.

I have gone through many styles. In my most recent work I made my paintings into three-dimensional forms. One critic referred to them as "paintings in the round." I take the flat images off the canvas and extend them into space, so that the painting is experienced in time rather than all at once, as you do with a painting on a canvas. I made a work that the viewer has to walk around in a circle to see.

My Doors series began in 1980 and grew out of my three-dimensional paintings, my paintings in the round. The inspiration for this series came from a book that my oldest son, Greg, gave me, a book called *Doors*. It is a book with pictures of doors from around the world. When Greg gave me this book, he said, "I thought you might be able to use this in your work."

I thought that was a nice thought for a sixteen-year-old. I looked at the book, thanked him profusely, and left it on the table. Two months later, I picked up the book and started reading it. It suddenly occurred to me that doors are a metaphor for many kinds of ideas. So the idea of doors gave me the opportunity to evolve many of the themes in my paintings.

My work has gone back and forth between being two-dimensional and three-dimensional. Early in my career I gained a national reputation as a jeweler and a silversmith. However, in 1963, I got poisoned from the materials that I was using to do those works, and I turned totally to painting. I kept seeing the work three-dimensionally, so that you would walk around it and experience it in time. In 1975, I finally found the time and

the courage to take flat, traditional paintings and transform them into three-dimensional structures. From some angles they are still paintings, because they very much deal with color. But they also deal with color in space, and color in time. From one angle you see only one color. And from another angle, you see three colors. Sometimes you may see seven colors, and you feel the interactions of those colors and the influence of the shadows upon them. That is how I became involved in three-dimensional paintings.

I am one-eighth American Indian and am descended from the Chickasaw and Choctaw Indian tribes in north Mississippi. I was not aware of my Indian ancestry until I was in the fifth grade. I learned this not from my parents, but from my teacher. During an Indian pageant, she asked me to play the Indian chief, and she informed me that I was the logical person to do this since I was part American Indian. I later checked with my family and found this was true. This knowledge gave me enormous pride. All my life I have been proud of my Indian heritage. I spend much time looking at Indian art and reading about Indians.

I go to Mississippi once or twice a year to visit my mother, who lives on the family farm in north Mississippi. On my last visit, there was an article in one of the local papers about a dig. They were dredging in the Tombigbee River and discovered an Indian canoe. I looked at the images and was absolutely fascinated with their find. When I returned to Massachusetts, I did a series of works based on rivers and places in Mississippi named after Indian tribes. The pieces were named *Choctaw*, *Chickasaw*, *Tishomingo*, *Iuka*, and *Itawamba*. In creating one of my most recent pieces, I sud-

denly became aware of its relationship to Indian imagery. I felt like my ancestors were coming forward and speaking to me in a new tongue, with a new language.

This group belonged to the Doors series. They are my most recent works. In this piece, there is an homage to David Smith, as well as an homage to Jack Tworkov. They are my heroes. I came of age as a young artist really with them as my mentors and role models. I studied with David Smith and Jack Tworkov at the University of Mississippi, and they had a profound influence on me as a young artist. They were my inspirations.

An interesting phenomenon in southern culture is the notoriety that writers have enjoyed in the region. It has always been a mystery to me why visual artists have not enjoyed the same recognition and attention. There are an enormous number of southern artists whose work is superb. Thankfully, in recent years more attention has been given to the visual artists. The South now recognizes that it has an important heritage in visual arts, and the increased recognition of this heritage in the last twenty years is impressive.

I was not directly influenced by reading southern writers, but I was influenced by the attention they received. It was one of the happiest days of my life when William Faulkner won the Nobel Prize for literature. He was already a hero for me, and this made him a bigger hero. He was a model for me as another artist working in a different medium. It was in that sense that writers influenced me, not so much by what they had to say, but by their presence.

Faulkner had the same kind of a role for me as David Smith. I did not know Faulkner. When I was a student, and later when I taught art at the University of Mississippi, I often saw him. I went to the same restaurant that Faulkner did every Sunday evening because I wanted to sit next to him. I felt that some of his genius might rub off on me. I never spoke to the man, but he was one of my superheroes.

Julien Binford 1909–1997

BORN IN POWHATAN COUNTY, VIRGINIA

Through my paintings, I try to show the beauty—the color harmonies and the lines—that exists. The painter may be interested in light and dark. He may be interested in the lines. He may be interested in the subject matter. But that is not his primary province. His primary province is in the realm of color. If he is trying to tell a story, he should be doing some form of literature.

Julien Binford was born on Norwood Plantation in Powhatan County, Virginia. While a medical student at Emory University, his artistic talent was recognized by Roland McKinney, the first director of the High Museum of Art in Atlanta. At McKinney's suggestion, Binford enrolled in the Art Institute of Chicago and later studied for three years in Paris, where he married the poet Elisabeth Bollée. They moved back to Virginia in 1935 and spent the rest of their lives in a home that once belonged to Robert E. Lee's brother Charles Carter Lee.

Binford is deeply influenced by French painters and feels the primary focus of the artist should be color rather than story. His favorite subject for his art is his beloved wife, Elisabeth. He recalls affectionately, "I sketch my wife often because she is so pretty. Renoir said that you get used to a model, and you feel much more comfortable with one you know. I do see a link between my own work and that of European painters whom I think are great masters. That is sort of an axiom."

Binford frequently painted two black men—Deacon Bell and Charlie Fund—who lived near his home. Bell and Fund served both as models for his art and as critics of his paintings. They appear together in his painting of a razor fight that Binford witnessed in Atlanta "as a boy down on Decatur Street. It scared the daylights out of me. Two men were fighting there, and I ran away just as fast as I could. I had Deacon Bell and Charlie Fund pose for me. Charlie Fund was

Julien Binford, Powhatan County, Va., 1982

bright-skinned, and Deacon Bell was dark-skinned. They were very excellent models and became very good critics."

Binford grew up in the shadow of Civil War worlds and remembers "watching one of the old veterans sitting by the fire at home talking. He chewed tobacco, and he had deep creases in his face." Binford mixes these memories with his love of color, which is inspired by French Impressionist art. And he uses local black subjects Charlie Fund and Deacon Bell to develop his vision as a painter.

This conversation was filmed at Binford's home in Powhatan County, Virginia, in 1982.

I am sorry the garden is so dry. We are getting all that orange color in the leaves in July. You should not have it until way yonder in the fall. But this is an unusual time, as you can see from the creek. It has never been that low that I can remember in the thirty-one years we have lived here. But the lay of the land still shows up, with or without the proper color. The rocks are quite lovely out there.

There is not much to the stream now, because of the drought. But a little rain and it will fill out. Sometimes it brings whole trees with it and deposits them. Where you see that pool there, there used to be an island that it brought down and deposited there. It caught the earth and built it up. Then came another high water and tore it out. It keeps changing. That is what is interesting about the stream.

During the New Deal era, we lived down the road. We would come down here to visit and spend the day. My work was in the studio in the little house down the road on the first floor. Day after day, I would be in there painting. Sometimes I would paint animals. And sometimes I would paint people, usually black people because there were not many white people with time to pose in those days.

The most memorable black man I worked with was Charlie Fund. Charlie Fund was a remarkable person. He worked up on Long Island. He would put the crop in down here, and then leave to work on Long Island. He let his children and his wife harvest the crop. He would save his money up in Long Island and come back down here the next spring to put in another crop. More recently, he was the mailman who brought our mail over from Goochland, across the river. He would wait here and take the outgoing mail back in the evening. And during the day he would pose for me. He would pose for whatever painting I was doing, whether it was a razor fight, one of the prophets, or Jesus Christ himself.

The razor fight was a scene that I saw in Atlanta, Georgia, as a boy down on Decatur Street. It scared the daylights out of me. Two men were fighting there, and I ran away just as fast as I could. I had Deacon Bell and Charlie Fund pose for me. Charlie Fund was bright-skinned, and Deacon Bell was dark-skinned. They were very excellent models and became very good critics.

Living in the country, I do not see how you can keep from becoming interested in nature. Certainly I have been because it is so beautiful, and I know many other southern painters have been as well. Through my paintings, I try to show the beauty—the color harmonies and the lines—that

exists. The painter may be interested in light and dark. He may be interested in the lines. He may be interested in the subject matter. But that is not his primary province. His primary province is in the realm of color. If he is trying to tell a story, he should be doing some form of literature. If he is interested in sound, he should be a musician.

I often felt I was telling a story. But if it ever became the primary moving force in my creation of a painting, then that painting was a failure. I suppose each artist selects the combination of elements that he is most comfortable with.

I have told many stories. They were all true, of course. It is a lot of fun to tell a story, as long as it does not become the primary moving force in the creation of that painting. As long as the color harmony remains the main feeling that he is appealing to, then color—not story—is the province of the painting.

The drawings of the dissections I did in premedical school at Emory University in Atlanta served as my entry into painting. I had never seen any paintings, only reproductions. Fortunately, at that time a woman named Mrs. High left a house and a collection of paintings that she had acquired to the city of Atlanta for a museum. They brought a man down from the Art Institute of Chicago—Roland McKinney—who was the first director of this new museum, the first one Atlanta had ever had.

I showed him some dissections I had done and also some faces of people that I had done with pastels. Roland McKinney said they had character and that if I would do some drawings, he would criticize them. He said that the best place for me

to go was Chicago. He was from Chicago, and he had graduated from the Chicago Art Institute. That was the best advice I ever had in my life, and that is the way I started.

Painters and writers both need a place where they can get together, talk, and engage. I believe it was a French poet who said that the poet just puts his pencil behind his ear and goes on. But the painter has all that paraphernalia he has to lug around. So there was not much chance for the widely dispersed group of painters in the South to get together.

I sketch my wife often because she is so pretty. Renoir said that you get used to a model, and you feel much more comfortable with one you know. I do see a link between my own work and that of European painters whom I think are great masters. That is sort of an axiom.

I remember Civil War reunions of the veterans. My grandfather's brother and his friends met in Atlanta, Georgia. I must have been about five or six years old. These fellows were all in their uniforms, these old soldiers in tents out in Piedmont Park. I remember watching one of the old veterans sitting by the fire at home talking. He chewed tobacco, and he had deep creases in his face. You would not know that he was chewing tobacco, except that every now and then there would be a little drop from way down here in this corner, that worked its way all the way down under that crease in his face. We would stand by his chair waiting for that little drop to form and fall. That is not a very elegant image of the Civil War, but that is what I remember.

I particularly like painting the flowers around

247

here because they are so dependable, and they are beautiful to look at. I started out doing mostly figures. That was when I was in places where there were models to be had. Down here in the country now, models are no longer dependable. You get one here and there, but they are not as eager to pose as they used to be in the old days. I particularly enjoyed painting the Negroes around here. They had so much character and were so very accommodating.

Eddie Wilkinson had a firm understanding with his neighbors of both races. I loved to hear him when he met old Diana Bell, the mother of Deacon Bell, whom I painted so often. He would greet her from afar and would shout, "Diana, Diana, great goddess of the Romans." And she would answer, "My roamin' days is over, sir." That was their greeting. They had a great affection and understanding of one another.

The Forest, Mississippi, mural I painted was of a logging scene. I entered a competition at the Section of Fine Arts in Washington, which was a branch of the Treasury Department. I had entered a competition for a post office up in Harrisburg, Pennsylvania, and I did not win it. But as a runner-up prize, they gave me the job in Forest. I went down there and spoke to the postmaster. Logging and the sawmill business were important in that section of Mississippi. So I decided to do a logging scene, and I used the local people. There had been some trouble, and there was a feeling that people might not like Negroes in a painting in a public building. I was a bit frightened when I went down there for fear that some problem might arise if I wanted to do a painting of the working people. I went to see the sawmill people, and nobody had any objection to it. So I went ahead and put it up. It was the first mural that I had ever hung myself.

The Section of Fine Arts specified we were to do it with white lead and a four-hour varnish that you whip up to a very nice light cream, trowel on the wall, and then roll flat. It is permanent and very hard to get off. I had never done one myself, so I was afraid of that. We put the mural up. With the assistance of the postmaster, I got a carpenter to run a little bead around it, a little frame. And just for good measure, I had him drive some nails right through the top part so that if the thing ever did come loose it would not fall down. There was no chance of it ever coming loose.

When I finished, we left Forest that afternoon and got as far as Meridian, Mississippi. That was the first place I saw a motel. I said, "Look, Elisabeth, we had better spend the night here and go back and have another look at that mural in the morning to see if it is still hanging up." We did, and it was still there. I said, "I suppose it will last for a while." That was the end of the Forest job.

They have meetings up here at St. James, this little church on the hill that you pass as you go up the road. They have their meetings in August, and they do their baptizing in October. The revivals last for a week every year, and then all the sinners who are seeking the spirit go sit on what is called the mourners' bench. They sit there on that bench until finally the spirit moves them, and they are saved. They shout that out.

Conclusion

Each time I return home to the farm and visit with family and friends there, I plunge into stories, both familiar and new. They reassure me that I am home and that the worlds I knew as a child are still alive and well. It is the same feeling I have when reading these voices. Their stories are the water in which I love to swim, and their literature and art are drenched in it. While each speaker loves to tell tales, it is clear that the American South is also the spine for each person's life story.

These speakers and their stories provide an important intellectual foundation for study of the American South. Their lives and work foreshadowed the emergence of southern studies, an academic field that has made significant strides at Davidson College, Emory University, Mercer University, Middle Tennessee State University, Presbyterian College, the University of Mississippi, the University of North Carolina at Chapel Hill, the University of South Carolina, the University of Virginia, and Vanderbilt University. A growing number of courses on the region are offered at schools throughout the South and around the nation. The growth of the field of southern studies would have surprised and pleased these speakers.

Southern studies has evolved through new fields such as the "global South" (how the region connects with the rest of the world), "contested memory" (how white and black southerners view their distinctly different histories in the region), and "food studies" (the history and culture of southern foodways). Study of the South also embraces the contributions of Hispanic, Asian, and other ethnic communities in the region.

Speakers in this volume grew up and worked in an era before the computer and Internet. They could not have imagined the powerful new force that technology brings to the study of the South. Major archives such as the Southern Historical Collection and the Southern Folklife Collection at the University of North Carolina at Chapel Hill are rapidly digitizing their print materials, sound recordings, and films so students and scholars throughout the world can use them.

The original one-volume *Encyclopedia of Southern Culture* has been revised and expanded into twenty-four volumes. On-line encyclopedias and digital archives are now available in most southern states and provide deep access to local records. Documentary films with educational materials on the region can be viewed on FolkStreams (http://www.folkstreams.net/pages/about.html). Emory University's *Southern Spaces* (http://www.southernspaces.org/) is an on-line journal that features both topical and historical studies on the region. At the University of North Carolina, Documenting the American South (http://docsouth.unc.edu/) provides access to a rich body of texts, images, and audio resources on southern history, literature, and culture, and the Southern Folklife Collection (http://www.lib.unc.edu/mss/sfc1/) streams all of its symposia.

The Duke University Center for Documentary Studies (http://documentarystudies.duke.edu /about) has pioneered the study and practice of the documentary tradition in the American experience, and many of its courses and projects focus on the American South. The University of Mississippi Southern Foodways Alliance (http:// southernfoodways.org/) provides on-line access to its films, oral histories, and journal *Gravy*, all of which chronicle food traditions in the region.

We now better understand the South's impact on the rest of the nation thanks to Isabel Wilkerson's *The Warmth of Other Suns: The Epic Story of America's Great Migration*. Wilkerson's book builds on Alex Haley's *Roots* to show how black families migrated from the South and transformed American art, food, literature, music, politics, and sports in profound ways.

Haley would have been especially moved to see how technology has influenced genealogy. Rachel Swarns's *American Tapestry: The Story of the Black, White and Multiracial Ancestors of Michelle Obama* demonstrates how DNA testing can identify ancestors. Her work gives added meaning to Faulkner's phrase, "The past is never dead."

While new technological tools enrich the study of the South, we must never lose sight of the fundamental importance of language, place, and history that these speakers describe so eloquently. The enduring importance of oral history and folklore as resources that touch the heart of each speaker is clear. The voices, the faces, and the work of each person in this book remind us why they and their stories are essential resources for understanding both the American South and America.

Selected Bibliography, Discography, and Filmography

WRITERS

Eudora Welty

PUBLICATIONS

Welty, Eudora. *A Curtain of Green, and Other Stories.* New York: Harcourt, Brace and Co., 1941.

———. *The Robber Bridegroom.* New York: Harcourt, Brace and Co., 1942.

———. *The Wide Net, and Other Stories.* New York: Harcourt, Brace and Co., 1943.

———. *Delta Wedding.* New York: Harcourt, Brace and Co., 1946.

———. *The Golden Apples.* New York: Harcourt, Brace and Co., 1949.

———. *The Ponder Heart.* New York: Harcourt, Brace and Co., 1954.

———. *Losing Battles.* New York: Random House, 1970.

———. *One Time, One Place: Mississippi in the Depression; A Snapshot Album.* New York: Random House, 1971.

———. *The Optimist's Daughter.* New York: Random House, 1972.

———. *The Eye of the Story: Selected Essays and Reviews.* New York: Random House, 1978.

———. *One Writer's Beginnings.* Cambridge, Mass.: Harvard University Press, 1984.

———. *Eudora Welty: Photographs.* Jackson: University Press of Mississippi, 1989.

———, and Ronald A. Sharp. *The Norton Book of Friendship.* New York: Norton, 1991.

———. *Country Churchyards.* Jackson: University Press of Mississippi, 2000.

———. *On William Faulkner.* Jackson: University Press of Mississippi, 2003.

AUDIOTAPES

———. *Eudora Welty Reading from Her Works.* Daedmon, 1953.

———. *Eudora Welty's One Writer's Beginnings.* Cambridge, Mass: Harvard University Press, 1983.

———. *The Optimist's Daughter.* New York: Random House Audiobooks, 1986.

FILM

Four Women Artists. Dir. William Ferris. Center for Southern Folklore, 1977.

WEBSITE

Eudora Welty Foundation, http://www.eudorawelty.org/

Ernest Gaines

PUBLICATIONS

Gaines, Ernest. *Catherine Carmier.* New York: Vintage Books, 1964.

———. *Bloodline.* New York: Dial Press, 1968.

———. *The Autobiography of Miss Jane Pittman.* New York: Dial Press, 1971.

———. *A Long Day in November.* New York, Dial Press, 1971.

———. *In My Father's House.* New York: Knopf, 1978.

———. *A Gathering of Old Men.* New York: Knopf, 1983.

———. *A Lesson before Dying.* New York: A. A. Knopf, 1993.

———. *Mozart and Leadbelly.* New York: Knopf, 2005.

FILMS

The Autobiography of Miss Jane Pittman. Dir. John Korty. Columbia Broadcasting System, 1974.

The Sky Is Gray. Dir. Stan Latham. Public Broadcasting Service, 1980.

A Gathering of Old Men. Dir. Volker Schöndorff. Columbia Broadcasting System, 1987.

A Lesson before Dying. Dir. Joseph Sargent. Home Box Office, 1999.

WEBSITE

www.library.louisiana.edu/Gaines

Robert Penn Warren

PUBLICATIONS

Warren, Robert Penn, and Cleanth Brooks. *Understanding Poetry.* New York: H. Holt and Co., 1938.

——— and Cleanth Brooks. *Understanding Fiction.* New York: F. S. Crofts & Co., 1943.

———. *All The King's Men.* New York: Harcourt, Brace, 1946.

———. *World Enough and Time: A Romantic Novel.* New York: Random House, 1950.

———. *Band of Angels.* New York: Random House, 1955.

———. *Promises: Poems, 1954–1956.* New York: Random House, 1957.

———. *The Cave.* New York: Random House, 1959.

———. *Wilderness: A Tale of the Civil War.* New York: Random House, 1961.

———. *Flood: A Romance of Our Time.* New York: Random House, 1964.

———. *Who Speaks for the Negro?* New York: Random House, 1965.

———. *Meet Me in the Green Glen.* New York: Random House: 1971.

———. *A Place To Come To: A Novel.* New York: Random House, 1977.

———. *Now and Then: Poems, 1976–1978.* New York: Random House, 1978.

———. *Katherine Anne Porter: A Collection of Critical Essays.* Englewood Cliffs, N.J.: Prentice-Hall, 1979.

———. *Chief Joseph of the Nez Perce, Who Called Themselves the Nimipu, "The Real People": A Poem.* New York: Random House, 1983.

———. *New and Selected Poems, 1923–1985.* New York: Random House, 1985.

FILMS

All the King's Men. Dir. Robert Rossen. Columbia Pictures, 1949.

———. Dir. Steven Zaillian. Sony Pictures Entertainment, 2006.

Band of Angels. Dir. Raoul Walsh. Warner Brothers Pictures, 1957.

Carlisle Floyd's Willie Stark. Dir. Lawrence Kraman. Newport Classic, 2008.

WEBSITE

www.robertpennwarren.com

Alice Walker

PUBLICATIONS

Walker, Alice. *The Third Life of Grange Copeland.* New York: Harcourt Brace Jovanovich, 1970.

———. *Revolutionary Petunias and Other Poems.* New York: Harcourt, Brace, Jovanovich, 1973.

———, and Zora Neale Hurston. *I Love Myself When I Am Laughing . . . and Then Again When I Am Looking Mean and Impressive: A Zora Neale Hurston Reader.* Old Westbury, N.Y.: Feminist Press, 1979.

———. *You Can't Keep a Good Woman Down: Stories.* New York: Harcourt Brace Jovanovich, 1981.

———. *The Color Purple.* New York: Harcourt Brace Jovanovich, 1982.

———. *In Search of Our Mothers' Gardens: Womanist Prose.* San Diego: Harcourt Brace Jovanovich, 1983.

———. *The Temple of My Familiar.* San Diego: Harcourt Brace Jovanovich, 1989.

———. *Her Blue Body Everything We Know: Earthling Poems, 1965–1990 Complete.* San Diego: Harcourt Brace Jovanovich, 1991.

———. *Possessing the Secret of Joy.* New York: Harcourt Brace Jovanovich, 1992.

———. *Anything We Love Can Be Saved: A Writer's Activism.* New York: Random House, 1997.

———. *By the Light of My Father's Smile: A Novel.* New York: Random House, 1998.

———. *The Way Forward Is with a Broken Heart.* New York: Random House, 2000.

———. *Now Is the Time to Open Your Heart: A Novel.* New York, Random House, 2004.

FILM

The Color Purple. Dir. Steven Spielberg. Warner Brothers Pictures, 1985.

WEBSITE

http://alicewalkersgarden.com.

Alex Haley

PUBLICATIONS

Haley, Alex, and Malcolm X. *The Autobiography of Malcolm X.* New York: Grove Press, 1965.

———. *Roots: The Saga of an American Family.* Garden City, N.Y.: Doubleday, 1976.

———, and David Stevens. *Mama Flora's Family.* New York: Scribner, 1998.

FILM

Roots. Dir. Marvin J. Chomsky, David Greene, John Erman, and Gilbert Moses. American Broadcasting Company, 1977.

WEBSITE

www.kintehaley.org

Margaret Walker

PUBLICATIONS

Walker, Margaret, and Charlotte Moton Hubbard. *For My People.* New Haven: Yale University Press, 1942.

———. *Jubilee.* Boston: Houghton Mifflin, 1966.

———. *Richard Wright, Daemonic Genius: A Portrait of the Man, a Critical Look at His Work.* New York: Warner Books, 1988.

———. *This Is My Century: New and Collected Poems.* Athens: University of Georgia Press, 1989.

WEBSITE

Margaret Walker Center, www.jsums.edu/margaretwalker

Sterling Brown

PUBLICATIONS

Brown, Sterling. *Southern Road: Poems.* New York: Harcourt, Brace and Co., 1932.

———. *The Negro in American Fiction.* Port Washington, N.Y.: Kennikat Press, 1937.

———. *Negro Poetry and Drama, and the Negro in American Fiction.* New York: Atheneum, 1937.

———. *The Negro Caravan: Writings by American Negroes.* New York: New York Citadel Press, 1941.

———. *The Last Ride of Wild Bill, and Eleven Narrative Poems.* Detroit: Broadside Press, 1975.

———, and Michael S. Harper, ed. *The Collected Poems of Sterling A. Brown.* New York: Harper & Row, 1980.

SCHOLARS

Cleanth Brooks

PUBLICATIONS

Brooks, Cleanth, John Thibaut Purser, and Robert Penn Warren. *An Approach to Literature: A Collection of Prose and Verse with Analyses and Discussions.* Baton Rouge: Louisiana State University Press, 1936.

———, and Robert Penn Warren. *Understanding Poetry.* New York: H. Holt and Co., 1938.

———. *Modern Poetry and the Tradition.* Chapel Hill: University of North Carolina Press, 1939.

———, and Robert Penn Warren. *Understanding Fiction.* New York: F. S. Crofts & Co., 1943.

———. *The Well Wrought Urn: Studies in the Structure of Poetry.* New York: Reynal & Hitchcock, 1947.

———, and William K. Wimsatt. *Literary Criticism: A Short History.* New York: Knopf, 1957.

———. *The Hidden God: Studies in Hemingway, Faulkner, Yeats, Eliot, and Warren.* New Haven: Yale University Press, 1963.

———. *William Faulkner: The Yoknapatawpha Country.* New Haven: Yale University Press, 1963.

———. *William Faulkner: First Encounters.* New Haven: Yale University Press, 1983.

———. *The Language of the American South.* Athens: University of Georgia Press, 1985.

John Blassingame

PUBLICATIONS

Blassingame, John. *New Perspectives on Black Studies.* Urbana: University of Illinois Press, 1971.

———. *The Slave Community: Plantation Life in the Antebellum South.* New York: Oxford University Press, 1972.

———. *Black New Orleans, 1860–1880.* Chicago: University of Chicago Press, 1973.

———. *Frederick Douglass, the Clarion Voice.* Division of Publications, National Park Service, U.S. Department of the Interior, 1976.

———. *Slave Testimony: Two Centuries of Letters, Speeches, Interviews, and Autobiographies.* Baton Rouge: Louisiana State University Press, 1977.

———, and Mary Frances Berry. *Long Memory: The Black Experience in America.* New York: Oxford University Press, 1982.

Charles Seeger

PUBLICATIONS

Seeger, Charles, and A. P. Izvol'skii. *The Memoirs of Alexander Iswolsky, Formerly Russian Minister of Foreign Affairs and Ambassador to France.* London: Hutchinson & Co., 1920.

———. *Music as Recreation.* Washington, D.C.: Federal Works Agency, Works Projects Administration, Division of Professional and Service Projects, 1940.

———. *Music in Latin America, a Brief Survey.* Washington, D.C.: Pan American Union, 1942.

———, John A. Lomax, Alan Lomax, and Ruth Crawford Seeger. *Best Loved Folk Songs.* New York: Grosset & Dunlap, 1947. Musical score.

———. *Preface to the Description of a Music.* Den Haag, N.V. Drukkerij Trio, 1953.

———, and Mantle Hood. *The Ethnomusicologist.* New York: McGraw-Hill, 1971.

———. *The Foolish Frog.* New York: Macmillan, 1973. Musical score.

———. *Studies in Musicology, 1935–1975.* Berkeley: University of California Press, 1977.

———. *Studies in Musicology II, 1929–1979.* Berkeley: University of California Press, 1994.

RECORDING

Seeger, Charles, ed. "Versions and Variants of Barbara Allen." Washington, D.C.: Library of Congress, Division of Music, Recording Laboratory, 1933. Analog.

John Dollard

PUBLICATIONS

Dollard, John. *Caste and Class in a Southern Town.* New Haven: Pub. for the Institute of Human Relations by Yale University Press; London: Oxford University Press, 1937.

———, Leonard William Doob, Neal E. Miller, Orval Hobart Mowrer, and Robert R. Sears. *Frustration and Aggression.* New Haven: Yale University Press, 1939.

———. *Children of Bondage: The Personality Development of Negro Youth in the Urban South.* Washington, D.C.: American Council on Education, 1940.

———, and Neal E. Miller. *Social Learning and Imitation.* New Haven: Pub. for the Institute of Human Relations by Yale University Press, 1941.

———. *Victory over Fear.* New York: Reynal & Hitchcock, 1942.

———. *Criteria for the Life History, with Analyses of Six Notable Documents.* New York: P. Smith, 1949.

———, and Neal E. Miller. *Personality and Psychotherapy: An Analysis in Terms of Learning, Thinking, and Culture.* New York: McGraw-Hill, 1950.

———, and Frank Auld. *Scoring Human Motives: A Manual.* New Haven: Yale University Press, 1959.

C. Vann Woodward

PUBLICATIONS

Woodward, C. Vann. *Origins of the New South, 1877–1913.* Baton Rouge: Louisiana State University Press, 1951.

———. *Reunion and Reaction: The Compromise of 1877 and the End of Reconstruction.* Boston: Little, Brown, 1951.

———. *The Strange Career of Jim Crow*. New York: Oxford University Press, 1955.

———. *The Burden of Southern History*. New York: Vintage Books, 1960.

———. *American Counterpoint: Slavery and Racism in the North-South Dialogue*. Boston: Little, Brown, 1971.

———. *Mary Chesnut's Civil War*. New Haven: Yale University Press, 1981.

———, and Elisabeth Muhlenfeld, eds. *The Private Mary Chesnut: The Unpublished Civil War Diaries*. New York: Oxford University Press, 1984.

———. *Thinking Back: The Perils of Writing History*. Baton Rouge: Louisiana State University Press, 1986.

———. *The Future of the Past*. New York: Oxford University Press, 1989.

MUSICIANS

Bobby Rush

RECORDINGS

Rush, Bobby. *Rush Hour*. Philadelphia Intl., 1979.

———. *Sue*. La Jam, 1982.

———. *Gotta Have Money*. La Jam, 1984.

———. *What's Good for the Goose Is Good for the Gander*. La Jam, 1985.

———. *Man Can Give It but He Can't Take It*. La Jam, 1990.

———. *I Ain't Studdin' You*. Urgent, 1991.

———. *Handy Man*. Urgent, 1992.

———. *One Monkey Don't Stop No Show*. Waldoxy, 1995.

———. *She's a Good 'Un. It's Alright*, 1995.

———. *Hoochie Man*. Waldoxy, 2000.

———. *Undercover Lover*. Deep Rush, 2003.

———. *Raw*. Deep Rush, 2007.

———. *Blind Snake*. Deep Rush, 2009.

WEBSITE

www.bobbyrush.net

Pete Seeger

PUBLICATIONS

Seeger, Pete. *Henscratches and Flyspecks: How to Read Melodies from Songbooks in Twelve Confusing Lessons*. New York: Putnam, 1973.

———. *Everybody Says Freedom*. New York: Norton, 1989.

———. *How to Play the 5-String Banjo*. 1992.

———, and Paul DuBois Jacobs. *Pete Seeger's Storytelling Book*. New York: Harcourt, 2000.

———. *Where Have All the Flowers Gone: A Sing-along Memoir*. W. W. Norton & Company, 2009.

RECORDINGS

———. *How to Play a 5-String Banjo*. Folkways Records, 1954.

———. *The Pete Seeger Sampler*. Folkways Records, 1954.

———. *Bantu Choral Folk Songs*. Folkways Records, 1955.

———. *Love Songs for Friends and Foes*. Folkways Records, 1956.

———. *With Voices Together We Sing*. Folkways Records, 1956.

———. *American Ballads*. Folkways Records, 1957.

———. *At the Village Gate*. Folkways Records, 1960.

———. *Broadsides—Songs and Ballads*. Folkways Records, 1964.

———. *Songs of Struggle and Protest, 1930–1950*. Folkways Records, 1964.

———. *Rainbow Race*. Columbia Records, 1973.

———. *God Bless the Grass*. Folkways Records, 1980.

———. *American Folk Songs for Children*. Smithsonian Folkways Records, 1990.

———. *Darling Corey/Goofing-Off Suite*. Smithsonian Folkways Records, 1993.

———. *At 89*. Appleseed Recordings, 2008.

WEBSITE

www.peteseeger.net

PHOTOGRAPHERS

Walker Evans
PUBLICATIONS

Evans, Walker, and Lincoln Kirstein. *American Photographs*. New York: Museum of Modern Art, 1938.

———, and James Agee. *Let Us Now Praise Famous Men*. Boston: Houghton Mifflin, 1960.

———. *Many Are Called*. Boston: Houghton Mifflin, 1966.

———. *Walker Evans*. New York: Museum of Modern Art, 1971.

———. *Walker Evans, First and Last*. New York: Harper & Row, 1978.

———, and Gilles Mora. *Havana 1933*. New York: Pantheon Books, 1989.

———, and Robert Punket. *Walker Evans: Florida*. Los Angeles: J. Paul Getty Museum, 2000.

———. *Cuba*. Los Angeles: J. Paul Getty Museum, 2001.

———, and John T. Hill. *Walker Evans: Lyric Documentary*. Gottingen: Steidl, 2006.

FILM

Agee. Dir. Ross Spears. James Agee Film Project, 1980.

William Christenberry
PUBLICATIONS

Christenberry, William. *Southern Photographs*. Millerton, N.Y.: Aperture, 1983.

———. *Wall Constructions*. Washington, D.C.: Middendorf Gallery, 1985.

———. *William Christenberry*. Montgomery, Ala.: Montgomery Museum of Fine Arts, 1989.

———. *Christenberry Reconstruction: The Art of William Christenberry*. Jackson: University Press of Mississippi, 1996.

———. *William Christenberry: The Early Years, 1954–1968*. Tuscaloosa: University of Alabama Press, 1996.

———. *Art and Family*. New Orleans: University of New Orleans Press, 2000.

———. *Working from Memory*. Stiedl, 2008.

William Eggleston
PUBLICATIONS

Eggleston, William, and John Szarkowski. *William Eggleston's Guide*. New York: Museum of Modern Art, 1976.

———. *Election Eve*. New York: Caldecot Chubb, 1977.

———. *Flowers*. New York: Caldecot Chubb, 1978.

———. *Morals of Vision*. New York: Caldecot Chubb, 1978.

———. *Wedgwood Blue*. New York: Caldecot Chubb, 1979.

———, and Willie Morris. *Faulkner's Mississippi*. Birmingham: Oxmoor House, Inc.: 1990.

———. *The Hasselblad Award 1998: William Eggleston*. Goteborg: Hasselblad Center, 1999.

———. *2¼*. Santa Fe: Twin Palms, 1999.

———. *Democratic Camera: Photographs and Video, 1961–2008*. New Haven: Yale University Press, 2008.

———. *Before Color*. Germany: Stiedl, 2010.

FILMS

William Eggleston in the Real World. Dir. Michael Almereyda. Palm Pictures, 2005.

By the Ways: A Journey with William Eggleston. Dir. Vincent Gérard and Cédric Laty. Noblesse Oblige Distribution, 2007.

Stranded in Canton. Dir. William J. Eggleston. Eggleston Artistic Trust, 2008.

William Eggleston: Photographer. Dir. Rainer Holzemer. Microcinema International, 2008.

WEBSITE

www.egglestontrust.com

PAINTERS

Sam Gilliam
PUBLICATIONS

Gilliam, Sam. *Sam Gilliam, Paintings, 1950–1975, Fendrick Gallery, October 15 through November 8, 1975*. Washington: The Gallery, 1975.

———. *Sam Gilliam: Paintings and Works on Paper*. Louisville: J. B. Speed Art Museum, 1976.

———, and Jonathan P. Binstock. *Sam Gilliam: A Retrospective.* Berkeley: University of California Press, 2005.

Ed McGowin
PUBLICATIONS
McGowin, Ed. *Ed McGowin.* Washington, D.C.: Corcoran Gallery of Art, 1962.

———. *Name Change.* Baltimore: Baltimore Museum of Art, 1972.

———. *Ed McGowin's True Stories: September 13– October 26, 1975, Corcoran Gallery of Art.* Washington, D.C.: Corcoran Gallery of Art, 1975.

———, and Thomas W. Sokolowski. *Ed McGowin: New Paintings, 19 October thru 11 November 1989, Gracie Mansion Gallery.* New York: Gracie Mansion Gallery, 1989.

———, and Timothy A. Eaton. *Ed McGowin: Paintings.* Boca Raton, Fla.: Boca Raton Museum of Art, 1991.

———. *Ed McGowin Name Change: One Artist—Twelve Personas—Thirty-five Years.* Jackson: University Press of Mississippi, 2006.
WEBSITE
www.mcgowin.net

Benny Andrews
PUBLICATIONS
Andrews, Benny. *Benny Andrews: The Bicentennial Series: Exhibition Organized by the High Museum of Art, Atlanta.* Atlanta: The Museum, 1975.

———, and J. Richard Gruber. *American Icons from Madison to Manhattan: The Art of Benny Andrews.* Augusta, Ga.: Morris Museum of Art, 1997.

———, and Lisa Rowe Fraustino. *The Hickory Chair.* New York: Arthur Levine Books, 2000.

———, and Sandra Belton. *Pictures for Miss Josie.* New York: Greenwillow Books, 2003.
WEBSITE
http://bennyandrews.com

Carroll Cloar
PUBLICATIONS
Cloar, Carroll. *Carroll Cloar: Painter of the Mid-South.* Memphis: The Gallery, 1966.

———, and Guy Northrop. *Carroll Cloar at Kennedy Galleries, Inc., April 4 through May 5, 1973.* New York: The Galleries, 1973.

———. *Hostile Butterflies, and Other Paintings.* Memphis: Memphis University Press, 1977.

Rebecca Davenport
WEBSITE
http://rebeccadavenport.info

William Dunlap
PUBLICATION
Dunlap, William, Julia Reed, and J. Richard Gruber. *Dunlap.* Jackson, Miss.: 2006.
WEBSITE
www.billdunlap.com

Maud Gatewood
PUBLICATIONS
Gatewood, Maud. *Maud Gatewood, Exhibition. Oct. 31– Nov. 25, 1972.* New York: Willard Gallery, 1972.

———, and Huston Paschal. *Maud Gatewood: Figure Paintings.* Raleigh: North Carolina Museum of Art, 1983.

———, Deborah Velders, and Anne G. Brennan. *Maud Gatewood.* Wilmington, N.C.: Cameron Art Museum, 2005.

George Wardlaw
PUBLICATIONS
Wardlaw, George. *Recent Paintings.* Amherst: University of Massachusetts, 1970. Exhibition brochure, Herter Art Gallery.

Gruber, J. Richard, Ori Z. Soltes, and Suzette McAvoy. *George Wardlaw: Crossing Borders.* Ellsworth, Maine: Marshall Wilkes, Inc., 2012.

WEBSITE

www.georgewardlaw.com

Julien Binford

PUBLICATIONS

Binford, Julien. *Julien Binford, III.* Virginia Museum
of Fine Arts, 1940. Catalog of an exhibition held
Nov. 5–24, 1940.

———. *Binford: Exhibition of Paintings, November 9–28.*
New York: Midtown Galleries, 1942.

Index

Note: Page numbers in *italic* indicate illustrations.

Textual Credits

Some material in this book has been drawn from the following works:

Ferris, William. "William Faulkner and Phil Stone." *South Atlantic Quarterly* 67, no. 4 (Autumn 1969): 536–42.

———. *Images of the South: Visits with Eudora Welty and Walker Evans*. Memphis: Center for Southern Folklore, 1978.

Cochrane, William, Peter Lee, and Jim O'Neal. "Bobby Rush." *Living Blues* (January/February 1989): 22–23.

Ferris, William. "An Interview with Cleanth Brooks." *Southern Reader* 1, no. 1 (Summer 1989): 139–66.

———. "The Autobiography of Mr. Ernest Gaines." *Crossroads* (University of Mississippi) (Spring/Summer 1994): 42–45.

———. "Echoes of a Literary Renaissance: Cleanth Brooks, 'Life on the High Seas,' and Robert Penn Warren, 'My Cup Ran Over.'" *Reckon* (Premiere 1995): 120–27.

———. "'I Heard the Voices of My Louisiana People': A Conversation with Ernest Gaines." *Humanities* (July/August 1998): 4–7, 46–51.

———. "Eudora Welty: '. . . Standing under a Shower of Blessings.'" *Southern Cultures* (Fall 2003): 7–24.

———. "Alice Walker: 'I Know What the Earth Says.'" *Southern Cultures* (Spring 2004): 5–24.

———. "John Dollard: Caste and Class Revisited." *Southern Cultures* (Summer 2004): 7–19.

———. "Robert Penn Warren: 'Mad for Poetry.'" *Southern Cultures* (Winter 2004): 8–32.

———. "Walker Evans, 1974." *Southern Cultures* (Summer 2007): 29–51.

———, and Michael K. Honey. "Pete Seeger, San Francisco, 1989." *Southern Cultures* (Fall 2007): 5–38.

———. "Alex Haley: Vicksburg, Mississippi, 1989: Angels, Legends, and Grace." *Southern Cultures* (Fall 2008): 6–25.

———. "Margaret Walker Alexander: 'My Idol Was Langston Hughes': The Poet, the Renaissance, and Their Enduring Influence." *Southern Cultures* (Summer 2010): 53–71.

———. "Touching the Music: Charles Seeger." *Southern Cultures* (Fall 2010): 54–72.

———. "'Those Little Snapshots:' William Christenberry." *Southern Cultures* (Summer 2011): 61–70.

———. "Bobby Rush: Blues Singer—Plus." *Southern Cultures* (Winter 2011): 36–43.

CD and DVD Notes

The following is a list of the original audio recordings and film that can be found on the CD and DVD that accompany this book.

CD

WRITERS

1. Eudora Welty, "A Good Household," 0:52
 Jackson, MS, 1975
2. Eudora Welty, "WPA Memories," 1:47
 Jackson, MS, 1975
3. Ernest Gaines, "Creating the Voice of Miss Jane Pittman," 2:56
 San Francisco, CA, 1980
4. Robert Penn Warren, "The Decline in Human Values," 2:43
 Fairfield, CT, 1979
5. Alice Walker, "Regions of the Mind and Heart," 0:43
 Oxford, MS, 1994
6. Alice Walker, "Integrating Southern Writers," 1:06
 Oxford, MS, 1994
7. Alex Haley, "The South Is a Place of Hands," 1:30
 Atlanta, GA, 1989
8. Margaret Walker, "A Memory of Langston Hughes," 2:14
 New Haven, CT, 1978
9. Margaret Walker, "The Question of Black Humanity," 1:56
 New Haven, CT, 1978
10. Sterling Brown, "Not Simple North and South," 4:22
 New Haven, CT, 1979

SCHOLARS

11. Cleanth Brooks, "Accepting the Past," 2:17
 West Wardsboro, VT, 1989
12. John Blassingame, "The Historian's Tasks," 2:32
 New Haven, CT, 1979
13. Charles Seeger, "Memories of Pete," 1:58
 New Haven, CT, 1975

14. John Dollard, "Feelings about the South," 2:26
 New Haven, CT, 1975
15. C. Vann Woodward, "Why Historians Study the South," 2:08
 New Haven, CT, 1979
16. C. Vann Woodward, "Books Aren't Accidents," 1:19
 New Haven, CT, 1979

MUSICIANS

17. Bobby Rush, "The Blues to Me," 1:21
 Oxford, MS, 1987
18. Pete Seeger, "We Shall Overcome," 2:10
 San Francisco, CA, 1990

PHOTOGRAPHERS

19. Walker Evans, "Agee's Anger," 2:23
 New Haven, CT, 1974
20. Walker Evans, "The Unconscious Process," 1:39
 New Haven, CT, 1974
21. William Christenberry, "The Profound Influence of Southern Writers," 0:31
 Washington, DC, 1982
22. William Eggleston, "Beginnings in 1958," 0:32
 New Haven, CT, 1976
23. William Eggleston, "The Value of Photographs," 1:11
 New Haven, CT, 1976

PAINTERS

24. Sam Gilliam, "Memories of the South," 1:29
 Washington, DC, 1983
25. Ed McGowin, "On Southern Surreal," 1:34
 New York, NY, 1983
26. Benny Andrews, "Pictures out of Clouds," 0:53
 New York, NY, 1983
27. Carroll Cloar, "Childhood Imagery," 1:00
 Memphis, TN, 1983
28. Rebecca Davenport, "Appreciating Irony," 1:10
 Washington, DC, 1983

29. William Dunlap, "That Narrative Business," 0:28
 McLean, VA, 1983

30. Maud Gatewood, "Africa's Given Us Quite a Bit," 1:19
 Yanceyville, NC, 1983

31. Maud Gatewood, "Sense of Place," 1:31
 Yanceyville, NC, 1983

32. Julien Binford, "Painting the Sawmill," 1:03
 Powhatan County, VA, 1983

All tracks were digitized from the original ¼″ open-reel and cassette tapes in the William R. Ferris Collection, Southern Folklife Collection, Wilson Library, University of North Carolina at Chapel Hill.

Track list compiled by Ashley Melzer

DVD

WRITERS

Eudora Welty and Cleanth Brooks. Jackson, MS, 1988. Super 8 camcorder. Interviewed by William Ferris and Carolyn Taylor. Filmed by William Ferris; edited by Ashley Melzer. Topics: the first-person narrator, "olden times," photography, the *Southern Review*, the *Atlantic Monthly*, short stories. 8:19.

Eudora Welty in *Four Women Artists*. Center for Southern Folklore, Memphis, TN, 1977. 16 mm. Directed and filmed by William Ferris; produced and recorded by Judy Peiser; edited by Frank Fourmy, Lisa Freed, and Karen Sawyer; sound editing by Randy Robertson. Topics: "One detail can tell everything" and reading from "Why I Live at the P.O." 2:33.

Robert Penn Warren. West Wardsboro, VT, 1989. Super 8 camcorder. Interviewed and filmed by William Ferris; edited by Ashley Melzer. Topics: Grandfather, Natchez, Albert Erskine and William Faulkner, Houghton Mifflin prize. 8:38.

SCHOLARS

Cleanth Brooks. West Wardsboro, VT, 1989. Super 8 camcorder. Interviewed and filmed by William Ferris; edited by Ashley Melzer. Topics: childhood, prep school, Vanderbilt, Rhodes Scholarship in Oxford, Louisiana State University, the *Southern Review*, writing textbooks, literature. 11:33.

C. Vann Woodard. New Haven, CT, 1989. Super 8 camcorder. Filmed by William Ferris; edited by Ashley Melzer. Topics: historians, Robert Penn Warren and William Faulkner, fictional history and historical fiction, creative license. 6:06.

MUSICIANS

Bobby Rush. Interview and concert at the Hoka, Oxford, MS, 1987. Super 8 camcorder. Interviewed and filmed by William Ferris; edited by Ashley Melzer. Topics: blues, performing, artists, songwriting, northern and southern audiences, being a "pro on the bandstand." 14:41.

Pete Seeger. San Francisco, CA, 1990. Super 8 camcorder. Interviewed by William Ferris and Michael Honey. Filmed by William Ferris; edited by Ashley Melzer. Topics: Part 1: discovering the South, Charles Seeger, Bascom Lamar Lunsford, southern mountain music, playing the guitar and banjo, Woody Guthrie, Mike Seeger. 18:32. Part 2: Charles Seeger; trip to Pinehurst, NC; Ruth Crawford Seeger. 10:38. Part 3: John and Alan Lomax, Leadbelly's twelve-string guitar style, "We Shall Overcome" history. 17:57

PAINTERS

Painting in the South: Artists and Regional Heritage. University of Mississippi Center for the Study of Southern Culture, 1983. 16 mm. Narrated by James Earl Jones. Directed and filmed by William Ferris; produced by William Ferris and Kent Moorhead; edited by Nicholas Holmes. Features Benny Andrews, Romare Bearden, Julien Binford, Carroll Cloar, Rebecca Davenport, William Dunlap, Maud Gatewood, Sam Gilliam, Ed McGowin, and George Wardlaw. 27:01.

Producer: Ashley Melzer